This book, a companion volume to Professor Pollitt's *The Art of Rome: Sources and Documents* (Cambridge University Press 1983), presents a comprehensive collection in translation of ancient literary evidence relating to Greek sculpture, painting, architecture, and the decorative arts. Its purpose is to make this important evidence available to students who are not specialists in the Classical languages or Classical archaeology. The author's translations of a wide selection of Greek and Latin texts are accompanied by an introduction, explanatory commentary, and a full bibliography.

THE ART OF ANCIENT GREECE:
SOURCES AND DOCUMENTS

THE ART
OF ANCIENT GREECE:
SOURCES AND
DOCUMENTS

J. J. Pollitt

Professor of Classical Archaeology and History of Art, Yale University

The right of the
University of Cambridge
to print and sell
all manner of books
was granted by
Henry VIII in 1534.
The University has printed
and published continuously
since 1584.

CAMBRIDGE UNIVERSITY PRESS

Cambridge

New York Port Chester

Melbourne Sydney

Published by the Press Syndicate of the University of Cambridge
The Pitt Building, Trumpington Street, Cambridge CB2 1RP
40 West 20th Street, New York, NY 10011, USA
10 Stamford Road, Oakleigh, Melbourne 3166, Australia

First published by Prentice-Hall 1965, as *The Art of Greece, 1400–31 B.C.*

This edition first published 1990

Printed in Great Britain at the University Press, Cambridge

British Library cataloguing in publication data
Pollitt, J. J. (Jerry Jordan)
The art of ancient Greece : sources and documents.
1. Greek visual arts, ancient period
I. Title II. Pollitt, J. J. (Jerry Jordan). Art of
Greece, 1400–31 B.C.
709.38

Library of Congress cataloguing in publication data
Pollitt, J. J. (Jerome Jordan), 1934–
The art of ancient Greece: sources and documents / J.J. Pollitt.
– 2nd ed., rev. ed.
p. cm.
Rev. ed. of: The art of Greece, 1400–31 B.C. 1965.
Includes bibliographical references.
ISBN 0 521 25368 3 – ISBN 0 521 27366 8 (pbk)
1. Art, Greek – Sources. I. Pollitt, J. J. (Jerome Jordan), 1934–
Art of Greece, 1400–31 B.C. II. Title.
N5630.P56 1990
709'.38 – dc 20 90–1494 CIP

ISBN 0 521 25368 3 hardback
ISBN 0 521 27366 8 paperback

Contents

Illustrations

Preface

The present volume differs in some significant respects from its predecessor, which was published in 1965 under the title *The Art of Greece: 1400–31 B.C.* in the Sources and Documents in the History of Art series. I have added a substantial number of new passages, revised (and I hope improved) some of my earlier translations, and changed the basic order in which the texts are presented. Instead of collecting all the arts together in a series of chapters arranged in chronological order, I have separated all the passages on sculpture, painting, architecture, and the decorative arts respectively into four consecutive series, again arranged in chronological order. In the case of sculpture and painting (with which most of our texts deal) this revised order makes it easier for the reader to follow the developments of these arts as they were perceived by ancient writers. Pliny and his sources, for example, clearly saw no break at all between the careers of the painters Apollodoros and Zeuxis, and it seemed to me best not to separate them by 42 pages, as had been done in the original edition.

I have also added a substantial bibliography to the end of the volume. In addition to wanting to know how modern scholars have interpreted and evaluated the ancient texts on Greek art, serious students often want to examine what connections can be made between the texts and surviving monuments. The bibliography is directed toward both of these needs. The references in it are arranged in numbered units that follow the order in which topics are presented in the text. Within each section most of the references are listed in chronological order. In the text and the footnotes of the book I have most often simply referred the reader to the relevant sources by citing the appropriate number in the bibliography. If the section of the bibliography cited is a long one, I have also added to the citation the date of the article or book in question in order to make it easier to locate. Thus "Reisch (1906), Bibliography 26" means see the article by Reisch published in 1906 and listed in section 26 of the bibliography.

All the translations in this volume are my own except for the Linear B tablets, which are taken from Ventris and Chadwick, *Documents in Mycenaean Greek*.

Measurements expressed in feet refer to ancient foot-units. The dimension of the ancient foot varied over time and from area to area. Two basic foot-units seem, however, to have been common in the Greek world. One, called the "Attic–Aeginetan" or "Doric" foot, measured *c.* 0.326–8 m, and another, most common in Ionia, measured *c.* 0.294–6 m. The modern foot equals 0.3048 m.

I would like to express my thanks to Helen T. Sanders, who typed a substantial portion of the book and made valuable editorial suggestions. I am also extremely grateful to Mark Stansbury-O'Donnell for major assistance in the preparation of the bibliography and for permission to reproduce his impressive new reconstruction of Polygnotos's paintings at Delphi.

My thanks also to Cambridge University Press for giving me the opportunity to revise, expand, and improve this book.

Abbreviations

AA	*Archäologischer Anzeiger*
ActaA	*Acta Archaeologica*
AJA	*American Journal of Archaeology*
AntK	*Antike Kunst*
ArchCl	*Archeologia Classica*
ArchDelt	*Archaiologikon Deltion*
ArchEph	*Archaiologike Ephemeris*
Arias–Hirmer	Arias, P., Hirmer, M., Shefton, B., *A History of 1000 Years of Greek Vase Painting* (New York 1962)
ASAtene	*Annuario della Scuola Archeologica di Atene e delle Missioni Italiane in Oriente*
AthMitt	*Mitteilungen des Deutschen Archäologischen Instituts, Athenische Abteilung*
AttiMGrecia	*Atti e Memorie della Società Magna Grecia*
AttiVen	*Atti. Istituto Veneto di Scienze, Lettere, ed Arti*
BABesch	*Bulletin Antieke Beschaving*
BCH	*Bulletin de correspondance hellénique*
BdA	*Bollettino d'Arte*
Bieber, *SHA*	Bieber, Margarete, *The Sculpture of the Hellenistic Age* (revised edition, New York 1961)
Boardman, *Archaic Period*	Boardman, John, *Greek Sculpture, The Archaic Period* (New York 1978)
BonnJbb	*Bonner Jahrbücher*
Brunn, *GgK*	Brunn, Heinrich, *Geschichte der griechischen Künstler* (2nd edition, Stuttgart 1889)
Brunn-Bruckmann, *Denkmäler*	Brunn, H., *Denkmäler griechischer und römischer Skulptur in historischer Anordnung* (Munich 1888–1911)
Bruno, *FCGP*	Bruno, Vincent, *Form and Color in Greek Painting* (New York 1977)
BSA	*The Annual of the British School at Athens*

BSR	*Papers of the British School of Archaeology at Rome*
BullComm	*Bullettino della Commissione Archeologica Communale di- Roma*
CQ	*Classical Quarterly*
Curtius	Curtius, Ludwig, *Die Wandmalerei Pompejis* (Cologne 1929; reprint Hildesheim 1960)
EAA	*Enciclopedia dell' arte antica, classica e orientale*
Furtwängler, *Masterworks*	Furtwängler, Adolf, *Masterpieces of Greek Sculpture* (English translation by Eugenie Sellers, London 1895; edited reprint, Chicago 1964)
GBA	*Gazette des beaux-arts*
IG	*Inscriptiones Graecae*
IstMitt	*Istanbuler Mitteilungen*
JdI	*Jahrbuch des Deutschen Archäologischen Instituts*
JHS	*Journal of Hellenic Studies*
JRS	*Journal of Roman Studies*
JWarb	*Journal of the Warburg and Courtauld Institutes*
Kanon	*KANON. Festschrift Ernst Berger zum 60. Geburtstag* (*Antike Kunst, Beiheft*) ed. Margot Schmidt (Basel 1988)
Kraiker, *Malerei*	Kraiker, Wilhelm, *Die Malerei der Griechen* (Stuttgart 1958)
Lacroix, *Reproductions*	Lacroix, L., *Les reproductions de statues sur les monnaies grecques* (Liège 1949)
Lippold, *Gemäldekopien*	Lippold, Georg, *Antike Gemäldekopien* (Abhandlungen der Bayerischen Akademie der Wissenschaften, Phil.-Hist. Klasse. Heft 33) (Munich 1951)
Loewy, *IgB*	Loewy, E., *Inschriften griechischer Bildhauer* (Leipzig 1885; reprint Chicago 1976)
MAAR	*Memoirs of the American Academy in Rome*
Marinatos–Hirmer	Marinatos, S., Hirmer, M., *Crete and Mycenae* (New York 1960)
MélRom	*Mélanges d'archéologie et d'histoire de l'École Française de Rome*
MemLinc	*Memorie. Atti della Accademia Nazionale dei Lincei, Classe di scienze morali, storiche, filologiche*
MusHelv	*Museum Helveticum*
NJbb	*Neue Jahrbücher für Philologie und Pädagogik, klassische Altertum, Wissenschaft und Jugendbildung*
ÖJh	*Jahreshefte des Österreichischen Archäologischen Instituts in Wien*
Overbeck, *SQ*	Overbeck, J., *Die antiken Schriftquellen zur Geschichte*

	der bildenden Künste bei den Griechen (Leipzig 1868; reprint Hildesheim 1959)
ParPass	*La Parola del Passato*
Picard, *Manuel*	Picard, Charles, *Manuel d'archéologie grecque: La sculpture* (Paris 1935–64)
Pollitt, *AHA*	Pollitt, J. J., *Art in the Hellenistic Age* (Cambridge 1986)
Pollitt, *Ancient View*	Pollitt, J. J., *The Ancient View of Greek Art* (New Haven 1974)
RA	*Revue archéologique*
Raubitschek, *Dedications*	Raubitschek, A. E., *Dedications from the Athenian Akropolis* (Cambridge, Mass. 1949)
RE	Pauly–Wissowa, *Real-Encyclopädie der klassischen Altertumswissenschaft*
REG	*Revue des études grecques*
RendLinc	*Atti dell'Accademia Nazionale dei Lincei. Rendiconti*
RendNap	*Rendiconti dell'Accademia di Archeologia, Lettere e Belle Arti, Napoli*
RendPontAcc	*Atti della Pontificia Accademia Romana di Archeologia. Rendiconti*
RhM	*Rheinisches Museum für Philologie*
Richter, *Korai*	Richter, Gisela M. A., *Korai, Archaic Greek Maidens* (London 1968)
Richter, *Kouroi*	Richter, Gisela M. A., *Kouroi, Archaic Greek Youths* (2nd edition, New York 1960)
Richter, *Portraits*	Richter, Gisela M. A., *The Portraits of the Greeks* (London 1965)
Richter, *SSG*	Richter, Gisela M. A., *The Sculpture and Sculptors of the Greeks* (4th edition, New Haven 1970)
Richter–Smith	Richter, Gisela M. A., *The Portraits of the Greeks* (abridged and revised by R. R. R. Smith, Ithaca 1984)
Ridgway, *Archaic Style*	Ridgway, B. S., *The Archaic Style in Greek Sculpture* (Princeton 1977)
Ridgway, *Fifth Century*	Ridgway, B. S., *Fifth Century Styles in Greek Sculpture* (Princeton 1981)
Ridgway, *Severe Style*	Ridgway, B. S., *The Severe Style in Greek Sculpture* (Princeton 1970)
RivIstArch	*Rivista dell'Istituto Nazionale d'Archeologia e Storia dell'Arte*
Robertson, *HGA*	Robertson, Martin, *A History of Greek Art* (Cambridge 1975)
RömMitt	*Mitteilungen des Deutschen Archäologischen Instituts.*

	Römische Abteilung
Schweitzer, *Xenokrates*	Schweitzer, Bernhard, *Xenokrates von Athen, Schriften der Königsberger Gelehrten Gesellschaft, Geistwissenschaftliche Klasse* 9 (1932) 1–52
Sellers–Jex-Blake, *Chapters*	Sellers, E. and K. Jex-Blake, *The Elder Pliny's Chapters on the History of Art* (London 1896; reprint Chicago 1976)
STELE	*STELE. Volume in Memory of Nicholas Kontoleon* (Athens 1980) [title in Greek; articles in various languages]
Stuart Jones, *Ancient Writers*	Stuart Jones, Henry, *Select Passages from Ancient Writers Illustrative of the History of Greek Sculpture* (London 1895; reprint Chicago 1966)
SymbOslo	*Symbolae osloenses*
Ventris–Chadwick, *DMG*	Ventris, M., and J. Chadwick, *Documents in Mycenaean Greek* (Cambridge 1956; 2nd edition, ed. J. Chadwick 1973)

Introduction

THE NATURE OF THE SOURCES

The study of Greek art through ancient literary sources is complicated by a number of factors which cannot be said to apply to the study of any other period. First there is the fact that most of the authors who provide significant information lived *much later than the artists about whom they wrote*. The Elder Pliny, for example, who is our most comprehensive source for the history of Greek painting and sculpture of the Classical period (the fifth and fourth centuries B.C.), wrote in the second half of the first century A.C. Not only is the distance between Pliny and Pheidias about 500 years, but, as a Roman, Pliny spoke a different language and belonged to a society that was different in many ways from that of the artists who were his subject. The fact is that there are scarcely any "contemporary sources" in the extant literature on ancient art; there is no ancient writer who wrote on Pheidias or Zeuxis, as Vasari wrote on Michelangelo, through a direct knowledge of the artist's personality, aims, and products. The only contemporary references of any length that exist today for the art of the Classical period are inscriptions, some of which are presented in this volume, but these, it will be seen, are the most impersonal documents imaginable.

Another factor complicating the study of the literary sources for ancient art is that, with the exception of Vitruvius's *de Architectura* and the rhetorical descriptions of works of art that became fashionable in late Antiquity, there are *no writings which deal intentionally, directly and exclusively with art as such*. Many of the passages in this volume are in the nature of parenthetical remarks made by writers like Herodotos or Aristotle, who, in pursuing another subject, found their attention momentarily arrested by the example of a particular monument or a particular artist. Even the all-important sections on art given in books 33–36 of Pliny's *Natural History* are really digressions from more basic subjects. (The basic subject of books 33 and 34, for example, is metals; sculpture in metal is

I

treated as a special aspect of this general subject. The ostensible subject of book 35 is types of earth and minerals, but since painters used these materials as pigments, much of the book deals with painting. Book 36 deals with different types of stone.) Nor can Pausanias's meticulous and invaluable description of Greece in the second century A.C., any more than a modern guidebook to Greece, be said to deal primarily with art. In every case the information is there, but the modern scholar is required to select and arrange it in order to achieve a cohesive picture of ancient art. Hence in the present volume the reader will often find himself confronted with a series of relatively short passages extracted from larger works and juxtaposed for the purpose of unifying our knowledge of a particular artist or monument. It is well to point out that the nature of our sources makes this arrangement necessary. There is no ancient document which, like Baldinucci's *Life of Bernini*, can profitably be quoted without interruption and *in toto*. An average beginning student in the history of art who attempted to read through Pausanias without special instruction would probably get little out of it.

Granting all these qualifying factors, however, there are certain reasons why the writings of late authors like Pliny and Pausanias have a better claim to be considered "sources and documents" for the art of their early predecessors than does, say, a modern Englishman's critical evaluation of Masaccio. One reason is the *continuity of tradition* in ancient writings on art and the other is the relatively *objective, unoriginal nature* of many of our sources. Pausanias, for example, carefully describes the art which he saw and sometimes shows that he had an "eye" for style, but he almost never ventures any farther into the field of subjective evaluation than to say that a particular work is "worth seeing." Whatever historical information Pausanias gives about the works of art that he encountered is derived from inscriptions he had seen, earlier writers he had read, or word of mouth information given to him by his guides and informants. It was never his intention to be "original" or to provide for his own age a new assessment of the art that he described.

The traditional and unoriginal nature of Pliny's chapters on art is even more marked. As Pliny himself boasts at the beginning of the *Natural History*, the information in his work had been culled from 2,000 earlier sources. The picture of Greek art which Pliny presents is consequently an elaborate *mélange* of biographical, historical, and critical information derived from earlier sources which had diverse aims and interests. Fortunately we know what some of these sources were, since Pliny mentions them both in the text of the *Natural History* and in a book-by-book bibliographical index. These indices are especially important because they indicate that most of his sources for the history of art were Greek writers and that some of these writers were also practicing artists. Among the sources listed in the index to book 34 who are said to have written on sculpture, for example, we meet the following names: "Menaichmos, who

wrote on sculpture in metal [*toreutike*];[1] Xenokrates, who wrote on the same subject; Antigonos, who wrote on the same subject; Douris, who wrote on the same subject; Heliodoros, who wrote on Athenian dedications; Pasiteles, who wrote on marvellous works . . ." Of the writers mentioned, Menaichmos, Xenokrates, Antigonos, and Pasiteles are known to have been practicing sculptors. The date of Menaichmos and the nature of his writings are uncertain (see p. 42), but in the case of the other three writers there is enough information preserved to enable us to formulate some idea of their contribution to Pliny.

Xenokrates was active in the early third century B.C.[2] Although he may have been an Athenian by birth, he belonged to the sculptural school of Sikyon, and was a pupil of Euthykrates, the son of Lysippos, or of Teisikrates, a pupil of Euthykrates. In either case, he was a direct artistic descendant of Lysippos, the guiding genius of the Sikyonian school. Pliny not only tells us that Xenokrates wrote *volumina* on sculpture, but also refers to a statement made by Xenokrates (and Antigonos) in praise of the painter Parrhasios's ability as a draughtsman; hence it is clear that he wrote about painting as well as sculpture. Many modern scholars have concluded that Xenokrates must have been the source of an evolutionary system of art history, characterized by a distinct Sikyonian bias, which is imbedded in both Pliny's history of sculpture and his history of painting (see Bibliography 2). In this evolutionary system both painting and sculpture, after an early period of *rudis antiquitas*, gradually progressed toward a stage of perfection which was reached in the early Hellenistic period. Significant contributions or inventions that are ascribed respectively to five famous sculptors and five famous painters are thought to have marked distinct stages in this progression. In the history of sculpture that appears in book 34.54–65 of the *Natural History*, for example, the art is said to have been "opened up" (*aperuisse*) by Pheidias and to have been "refined" (*erudisse*) by Polykleitos. Myron is then said to have been "more precise in the application of *symmetria*" (*et in symmetria diligentior*) and to have made other improvements in the art. In the next stage the sculptor Pythagoras is credited with surpassing Myron (*vicit eum*) in the rendering of naturalistic details such as veins, hair, etc.; and finally Lysippos is said to have made the greatest contribution to the art (*statuariae arte plurimum traditur contulisse*) by improving on the achievements of all his predecessors. A similar evolutionary scheme, though perhaps less clearly presented, appears in the history of painting given in book 35 of the *Natural History*. Apollodoros is said to have begun the great era of Greek painting by developing the technique of "shading" or what the Greeks called *skiagraphia*. These innovations in the use

[1] *Toreutike* is the Greek term for "chasing" or "engraving" with a punch, burin, etc. It is applied to sculpture in gold and ivory as well as in bronze, and it is also used in connection with the decorative arts. On the background of the term see p. 206.

[2] For the literary testimonia on Xenokrates see p. 109 and 153. Three statue-bases signed by a sculptor named Xenokrates and dating to the early third century B.C. have survived (see Loewy, *IgB*, nos. 135a–c). On one of these (135a) the sculptor is identified as an Athenian.

of light and shade were further developed by Zeuxis. Parrhasios was then the first to introduce *symmetria* into painting, to perfect the rendering of the hair, the details of the face, etc., and to insist on clarity in draughtsmanship. In the next stage Euphranor "made symmetry his own" (*usurpasse symmetrian*), and finally Apelles brought all these qualities together (*picturae plura solis prope quam ceteri omnes contulit*). In each case, it will be noted, the sequence culminates with a great master of the Sikyonian school who was an immediate predecessor of Xenokrates. The criteria used to evaluate the artists in question are in many cases technical achievements – the use of proportion, control of detail, mastery of draughtsmanship and shading – which would be better understood by professional painters and sculptors than by laymen. The subject-matter of their statues and paintings seems, on the other hand, not to have been a primary concern. Basically what was handed down to Pliny from Xenokrates was the outlook of a practicing artist in the late fourth and early third centuries B.C. It is by preserving such material that Pliny's chapters can have some claim to being a significant document for the history of Greek art.

Of Antigonos, another of the sculptor–authors mentioned by Pliny, less is known. He is said by Pliny to have worked on the monuments set up by the Attalid kings of Pergamon after their victory over the Gauls in the latter part of the third century B.C. (see pp. 112–13) and is probably identical with Antigonos of Karystos, a versatile writer of the period who dabbled in biography, philosophy, and epigraphy as well as art history.[3] Since Pliny attributes the opinion that the painter Parrhasios was a draughtsman to Xenokrates and Antigonos jointly, it is usually assumed that Antigonos must have undertaken to expand and elaborate upon Xenokrates' treatise. Possibly he added certain new standards of judgment to Xenokrates' system, such as the representation of character and emotion – *ethos* and *pathos* – which is ascribed, in particular, to the fourth-century painter Aristeides (on Aristeides see p. 168; on *ethos* in general see pp. 230–1).

Pasiteles, another of Pliny's sources, was a native of one of the Greek cities of south Italy and obtained Roman citizenship in 89/88 B.C. He wrote five volumes on art, the subject of which is variously given by Pliny as *Marvellous Works* (*Mirabilia Opera*) or *Famous Works Throughout the World* (*Nobilia Opera in Toto Orbe*). Although we have no extant works of art that can positively be said to represent Pasiteles' own style, statues executed by members of his school are known, and these suggest that Pasiteles was one of the guiding spirits of the neoclassical movement in late Hellenistic art (see p. 120).

In the case of Xenokrates, Antigonos, and Pasiteles, then, we see that Pliny derived information from sources which were not only close to but in fact part of the history of Greek art.

[3] The evidence is summarized in Sellers–Jex-Blake, *Chapters*, pp. xxxvi–xlv, which is based on H. Wilamowitz-Moellendorff, *Antigonos von Karystos* (Philologische Untersuchungen, IV, Berlin 1881).

The same conditions also apply, at least in part, to the two other brief histories of Greek art that are preserved in Roman literature – those given by Quintilian, *Institutio Oratoria* 12.10.3–9, and by Cicero, *Brutus* 70 (see p. 223). The purpose of both these histories is to provide a series of stylistic comparisons between important rhetoricians and important artists. Quintilian's history, which is the more extensive of the two, clearly amalgamates several critical attitudes. Part of what he says about painting – as, for example, when he praises Zeuxis for his mastery of light and shade and Parrhasios for his draughtsmanship – seems to be derived from Xenokrates. His praise of Apelles' *ingenium et gratia*, on the other hand, may be derived from the painter's own writings (see p. 159); while the other *diversae virtutes* which he ascribes to various painters seem to stress qualities that would have been emphasized in treatises on rhetorical style.[4] Quintilian's history of sculpture, however, seems to follow a unified scheme of development which is derived neither from Xenokrates, nor from rhetorical criticism. In this scheme sculpture initially evolves from a state of "hardness" which characterizes the early fifth century toward a state of "softness" which is reached in the statues of Myron around the middle of the fifth century B.C. This development is followed by a stage in which Polykleitos is said to have attained perfection in representing human beauty and Pheidias is credited with having given form to the sublime qualities of the gods. In doing so, Quintilian says, Pheidias "added something to traditional religion." After Pheidias a decline sets in. Praxiteles and Lysippos mastered realism in sculpture, but Demetrios is blamed for having carried realism so far that he was "fonder of similitude than of beauty." Thus the high point of Greek sculpture comes, not, as in Xenokrates' system, with Lysippos in the late fourth century, but rather with Pheidias in the Classical period. And the characteristic feature of this high point is not the mastery of different technical aspects of sculpture but rather the possession of a kind of "spiritual intuition" – which the Greeks came to call *phantasia* – through which the sublime qualities of the gods could be perceived. (For a selection of the important passages documenting this theory see pp. 223–4.)

The origin of this *phantasia* theory is not certain, but it has been ascribed to the philosophical school which is usually called the "Middle Stoa." The thought of the chief figures of this school, Panaitios (*c.* 185–109 B.C.) and Poseidonios (*c.* 135–50 B.C.), was characterized by a fusion of Platonic idealism and Stoic psychology, both of which seem to have played a role in the formulation of the *phantasia* theory.[5] It was also characterized by a respect, even nostalgia, for the civilization of Greece in the fifth century B.C., i.e. the age of Pheidias and Polykleitos, and thus in many ways provided an intellectual background for the

[4] The concept of a *virtus*, or in Greek *arete*, of rhetorical style, i.e. an "essential excellence," seems to have originated in the literary criticism of the Peripatetic School, perhaps with Theophrastos. See Pollitt, *Ancient View*, pp. 60–1, 144–50.

[5] On this question see the second appendix to Schweitzer, *Xenokrates*; also Pollitt, *Ancient View*, pp. 52–5, with further references.

classicism that pervaded the late Hellenistic period. It is at least possible that this classicistic view of the history of sculpture was promulgated in the *quinque volumina* of the sculptor Pasiteles, since the date of his career and artistic predilections seem to have been in harmony with it.

VARIETIES OF ART CRITICISM IN ANTIQUITY

The different types of writers on Greek art and the critical attitudes which they expressed have already been touched upon in the preceding discussions. They may be summarized in four basic categories. The best preserved and hence most prominent group might be called *compilers of tradition*; it consists of writers who collected from disparate sources biographical, technical, and anecdotal information about art and artists. Sometimes these collections were supplemented by a certain amount of first-hand observation, as was the case with Pausanias, while at other times, they were almost wholly traditional, as is the case with Pliny. Such compilations can be traced back at least as far as the early Hellenistic period. Perhaps the earliest was the treatise on painting by Douris of Samos (*c.* 340–260 B.C.), who, as already mentioned, was one of the sources cited by Pliny in his index to book 34 of the *Natural History*. Douris' life and writings had many facets.[6] We know that he was at one time the tyrant of Samos, that he won a prize as a boxer in the Olympic games, and that he was a pupil of Theophrastos, Aristotle's successor as head of the Peripatetic school. His writings included historical chronicles, literary criticism, essays and biographies, and seem to have been characterized by an interest in unusual personalities and sensational anecdotes. In view of his background Douris is thought to be responsible for much of the anecdotal detail about the lives of artists that appears in Pliny. Pliny directly cites him as the source for the story that Lysippos had no teacher, but entered upon a career as a sculptor after having heard the painter Eupompos declare that nature itself, rather than any human teacher, was his model (*N.H.* 34.61; see p. 98). Other anecdotes in Pliny such as the story of the painting contest between Zeuxis and Parrhasios or the story of how Protogenes finally perfected one of his paintings by throwing a wet sponge at it seem to bear Douris' stamp (see pp. 150, 172). The critical attitude which lies behind these stories is one which might be called *popular criticism*, since it is characterized by ideas about art which are more typical of the layman than of either the practicing artist or the experienced connoisseur. The most abiding ideas of this popular criticism are an unquestioning acceptance of naturalism as the goal of art – i.e., the purpose of art is to imitate the external world and the best work of art is that which imitates it most convincingly – and an interest in the role of chance and the miraculous in art.

Another group of ancient writers on art might be called the *literary analogists*;

[6] See Sellers–Jex-Blake, pp. xlvi–lxvii and A. Kalkmann, *Die Quellen der Kunstgeschichte des Plinius* (Berlin 1898), pp. 144–71.

to it belong the rhetoricians and poets who looked to the visual arts as a source for stylistic analogies with literature or sometimes even as a direct source for literary inspiration. The short histories of art given by Quintilian and Cicero, for example, are primarily intended to serve as analogies to the stylistic development of Greek and Roman rhetoric. Dionysios of Halikarnassos (late first century B.C.), in writing on the different styles of Greek rhetoric, likewise draws analogies between the style of particular rhetoricians on the one hand and particular painters or sculptors on the other (see pp. 224–6). It has been suggested that these analogies may be traced back to a comparative canon of artists and rhetoricians formulated in the second century B.C.[7] The works of painters and sculptors also served as the subject-matter for short poems and rhetorical descriptive exercises, and in this sense they may be said to have had an influence on the actual content of ancient poetry and rhetoric. The tradition of writing short poems about works of art originated in the custom of inscribing metrical epigrams on the bases of statues. Many of the poems from the *Greek Anthology* that are included in this volume were presumably written for such a purpose. In time, however, epigrams became a formal literary genre, and many were written without any intention of ever having them inscribed on a stone base. There are, for example, over thirty epigrams extant about the famous Heifer by the sculptor Myron (see p. 50). Rhetorical descriptions of works of art, which in Greek were called *ekphraseis* (singular *ekphrasis*) appear to have come into vogue during the Roman period. A well-known example is Lucian's description of Zeuxis' *Centaur Family* (see pp. 151–3).

While it is clear that the literary analogists were primarily interested in their own disciplines rather than in the visual arts, they must be given credit for recognizing the importance of "personal styles" in the history of ancient art. They were aware that great artists, like great rhetoricians, had certain *virtutes* which distinguished them from other artists. The primary interest of the literary analogists was not so much in the ethical value of art nor in the evolution of artistic technique as in those obvious but sometimes difficult to define personal mannerisms that made each artist unique.

The third significant group of writers on ancient art might be called the *moral aestheticians*, and would include Plato, Aristotle, and the other Greek philosophers who judged art chiefly by its capacity to influence human behavior and moral awareness. Plato's condemnation of painting in the tenth book of the *Republic* (see pp. 231–3) is based on the belief that art encouraged men to indulge their natural tendency to be deceived and hence made it more difficult for them to perceive a higher, undistorted reality. Aristotle, unlike Plato, does not reject the value of all painting, but he does recommend in the *Politics* that the youth of a city be allowed to see only those paintings which are likely to have an ennobling effect (see p. 231). The authors of the late Hellenistic *phantasia* theory

[7] See Pollitt, *Ancient View*, pp. 60–1, 81–4.

discussed above generally had a more sympathetic and positive attitude toward the overall value of art and artists than did Plato or Aristotle, but they too seem to have believed that the greatest artistic creations were those which conveyed spiritually uplifting qualities. The ultimate artistic experience in this view was a kind of mystical communion; it is best expressed by Dio Chrysostom when he says that even the most wretched man upon viewing Pheidias's Zeus at Olympia forgot his worldly afflictions and found peace (see p. 62).

The fourth and final important group of ancient writers on art consisted of the artists themselves. Treatises by practicing architects go at least as far back as the middle of the sixth century B.C. when Theodoros and Rhoikos wrote on the Heraion at Samos and Chersiphron and Metagenes wrote on the temple of Artemis at Ephesos (see pp. 181–3, 233). Technical manuals on sculpture were written at least as early as the second half of the fifth century B.C. when Polykleitos wrote his famous *Canon* (see pp. 75–7), and in the fourth century there was apparently a rash of treatises by well-known painters. In the index to book 35 of the *Natural History*, for example, Pliny mentions writings by Apelles, Melanthios, Asklepiodoros, Euphranor, and Parrhasios, and the names of other painters who wrote about their art are known. The common element in all such writings seems to have been a preoccupation with problems of form and the technical procedures by which form is produced. Polykleitos's *Canon*, judging by what evidence is available, was essentially a highly technical manual of proportions. Its ultimate purpose was, in all probability, to define what perfect beauty in the human figure was, but it proceeded toward this goal not by analyzing and praising known works of sculpture but rather by presenting a complex series of measurements through which the commensurability (*symmetria*) of all the parts of a statue was to be achieved. The *Canon* was perhaps only an unusually complex and philosophical representative of a tradition of sculptors' workshop manuals which dated back (like architectural manuals) to the sixth century B.C. We know that at least one of his prominent predecessors, Pythagoras of Rhegion, "aimed at *rhythmos* and *symmetria*" (see p. 44). The preservation of such workshop manuals throughout the fifth and fourth centuries B.C. would account for the relatively unified and steady development of Greek sculpture during this period. Each new generation of sculptors began with a clear conception of the standards of the preceding one, and made innovations on the basis of its own taste and convictions. According to Cicero (*Brutus* 296), Lysippos used to say that the *Doryphoros* of Polykleitos was his model; Pliny, on the other hand, notes that Lysippos modified the "square quality" which was a characteristic of statues by his predecessors by using a new and hitherto untried system of proportions (*N.H.* 34.65). This "square quality," moreover, is specifically ascribed to Polykleitos. These two passages are not necessarily contradictory; rather, when taken together they suggest what the effect of the theoretical treatises of one generation may have been on the art of the next. Lysippos was familiar with the theoretical principles of Polykleitos and

admired them enough to make them a point of departure for the development of his own system of proportions. In spite of his respect for the work of the earlier sculptor, however, he clearly viewed his own innovations as improvements.

The interests and aims of the *professional critics*, as we might call Polykleitos and the other artists who wrote on art, seem to have been summed up in Xenokrates' history of sculpture and painting, in which, it will be remembered, the artists in question were evaluated on the basis of their formal and technical achievements. As a practicing artist Xenokrates must have been familiar with the technical treatises of his predecessors, and it is not unlikely that he used them in formulating the critical bases of his history.

The existence of these professional treatises is of paramount importance in the study of the sources and documents for the history of Greek art, since they form the earliest link in the chain of tradition by which our extant sources are connected with the original spirit that characterized the art of the Classical period.

Chapter 1

Ancient memories and primitive beginnings

THE EARLIEST RECORDS

The earliest documents that preserve a record of the Greek language are the "Linear B Tablets." These unbaked clay tablets were used by scribes in the great palaces of Bronze Age Greece to keep an inventory of property – equipment, livestock, land, etc. – that belonged to the rulers of the Mycenaean period. A substantial number of them were accidentally baked, and thus preserved, in the conflagrations that destroyed the Mycenaean palaces around 1200 B.C. (The exact dates of the destructions at the different sites, such as Knossos, Pylos, and Mycenae are disputed.) These tablets were, of course, practical, impersonal documents that were never intended to record the aesthetic sensibilities of artists or their patrons in the Mycenaean world. Nevertheless, a number of them, of which two examples are given here, do preserve detailed descriptions of vessels, furniture, and other objects that both call to mind surviving works of Mycenaean decorative art and seem to have echoes in the Homeric epics (see below). Readers should note that the exact meanings of certain words in these texts are matters of speculation and dispute.

Linear B Tablet from Pylos, no. Ta 642 (*DMG* 239): One stone table, of spring type, inlaid with aquamarines and *kyanos* and silver and gold, a nine-footer. One crescent-shaped stone table, inlaid with ivory and carved in the form of pomegranates and helmets. One stone table of the encircled type, a nine-footer, with feet and strutting of ivory and a carved running spiral.

Linear B Tablet from Pylos, no. Ta 707 (*DMG* 242): One ebony chair with golden back decorated with birds; and a footstool decorated with ivory pomegranates. One ebony chair with ivory back carved with a pair of finials and with a man's figure and heifers; one footstool, ebony inlaid with ivory and pomegranates.

THE MEMORY OF MYCENAEAN GREECE

While the myths and sagas of Classical Greece preserved a substantial amount of information about personalities and events of the Mycenaean age, the art of this period

was largely forgotten. A few of the major Bronze Age sites were visited in the second century A.C. by the traveller Pausanias, who was impressed with the scale of their surviving fortifications and tholos tombs.

Pausanias 2.16.5–7 (on the ruins of Mycenae): Parts of the fortification wall, however, still remain, and also the gate, on which lions stand. They say that these are the works of the Cyclopes, who made the wall for Proitos in Tiryns. Among the ruins of Mycenae there is a fountain called the *Perseia* and also the underground chambers of the children of Atreus, where their treasured possessions were stored. There is a tomb of Atreus, and also the graves of those whom Aigisthos entertained and slew upon their return from Troy with Agamemnon . . . Another tomb is that of Agamemnon, another that of Eurymedon the charioteer, another that of Pelops and Teledamos (the twin sons whom they say Kassandra bore and whom Aigisthos slew, while still babies, along with their parents), and still another is that of Elektra . . . Klytemnestra and Aigisthos were buried a short distance from the wall. They were not deemed worthy to rest within the wall, where Agamemnon lay along with those who were murdered with him.

Pausanias had a similar impression of the ruins of Tiryns, another great Bronze Age citadel south of Mycenae.

Pausanias 2.25.8: The wall, the sole part of the ruins which still remains, is a work of the Cyclopes and is made of unwrought stones, each stone being so huge that the smallest of them could not be moved even in the slightest degree by a pair of mules. Smaller stones were inserted long ago, in such a way that there is a tight fit between each of them and the larger stones.

Pausanias saw and admired a number of the famous corbel-vaulted tholos tombs of the Mycenaean period. An example at Orchomenos in Boeotia particularly impressed him.

Pausanias 9.36.5 and 9.38.2: The Greeks, quite remarkably, are liable to hold foreign monuments in greater wonder than local ones; for while the pyramids of Egypt have been described in writing in the most exact detail by distinguished authors, the Treasury of Minyas [at Orchomenos] and the walls of Tiryns have not received even the briefest mention, even though they are no less marvelous . . . (9.38.2) The treasury of Minyas, which is a marvel second to none, either in Greece or elsewhere, was made in the following manner. It is made of stone, its ground plan is circular, and its vault rises to a gently sloping peak. The uppermost of the stones, they say, is the stabilizing element for the entire structure.

A surviving tholos tomb at Orchomenos may be identical with the one described above. On this and other Mycenaean monuments mentioned in the preceding texts, see Bibliography 5.

THE ORIGIN OF THE ARTS

The legends among the Classical Greeks about the origin of the arts were naturally connected with those areas where Bronze Age craftsmanship had reached a high level. One such area was the island of Rhodes.

Diodoros 5.55.1–3: A people known as the Telchines was the first to settle the island called Rhodes . . . [Tradition records] that they were the inventors of some of the arts and the introducers of other things that were useful for the life of men. They are said to have been the first to make images of gods, and some of the ancient images are named after them. Among the Lindians, for example, there is a statue referred to as the Telchinian Apollo; among the Ialysians there is a Telchinian Hera and the Nymphs, and among the Kameirians a Telchinian Hera. These men were also wizards and could summon clouds, storms, and hail whenever they wished, and in a like manner they could even bring forth snow . . . It is also said that they could change their own shapes, and that they were jealous about giving instruction in their arts.

Strabo 14.2.7: Rhodes was earlier called Ophioussa and Stadia, and then Telchinis, from the fact that the Telchines settled on the island. Some say that they were sorcerers and magicians . . . others that they were maligned by rival workmen because they so excelled in the arts, and that thus they got their bad reputation. It is said that they came first to Cyprus from Crete, and thence to Rhodes, that they were the first to work iron and bronze, and that, in fact, they made the scythe for Cronos.

Tradition held that there was also an early school of Cretan artisans, known as the Idaian Daktyls, who were eventually apotheosized. The following passage may reflect a distant memory of the Bronze Age civilization of Crete, which we now call "Minoan."

Diodoros 5.64.3–5: The present settlers of Crete say that the earliest inhabitants to dwell there were those who are called the Eteocretans, an indigenous people, whose king, named Kres, was responsible for the discovery on this island of a great number of important skills which benefit the common life of men. Likewise a great number of the gods are reported by tradition to have come into being in this land, gods who because of their benefactions directed to the common good, won the rank of the immortals . . . The first of such gods, about whom there is a record preserved for posterity, dwelt around Mt Ida in Crete and were called the "Idaian Daktyls" . . . The Idaian Daktyls are said by tradition to have discovered the use of fire and also the nature of bronze and iron . . . and the technique by which they are worked.

As these stories about the Telchines, and the Idaian Daktyls make clear, an aura of magic and wizardry surrounded the careers of the earliest artists and their creations. This was particularly true of the colorful but puzzling artist called Daidalos.

DAIDALOS

The Greeks attributed many of the first great achievements in sculpture and architecture to a legendary artist named Daidalos (Latin "Daedalus"). The legends about Daidalos fall into two principal categories: those connecting him with Bronze Age Crete, and those connecting him with the earliest phases of "Archaic" sculpture in post-Bronze Age Greece.

The name Daidalos in Greek means something like "the cunning worker" or perhaps simply "the skillful one." The later Greeks were apt to ascribe to Daidalos almost any work of great merit that was produced in an early period for which there were no historical records. Thus, the name Daidalos is probably a personification of the artistic skill that was evident in many ancient images, especially wooden images, made in the period before the Greeks developed the technique of working stone. Pausanias, although he believed that an actual Daidalos once existed, recognized the symbolic quality of the name.

Pausanias 9.3.2: . . . men of old used to refer to wooden images as *daidala*. It seems to me that they gave them this name even before Daidalos, the son of Palamaon, was born in Athens; I suspect that he received this surname later on from these *daidala* and was not given the name at birth.

Whether Daidalos was only a personification or whether he was an actual person, stories of his career were already common in the earliest recorded stage of Greek literature, as is attested by Homer.

Homer, *Iliad* **18.590–3:** Thereon the renowned mighty-armed god contrived a dance floor like that which Daidalos once fashioned in wide Knossos for the fair-haired Ariadne.

The Cretan tradition is most completely preserved by Diodoros.

Diodoros 4.76.1–6: Daidalos was an Athenian by birth, his name indicating that he was one of the Erechtheids, for he was the son of Metion, who was the son of Eupalamos, who was the son of Erechtheus. Surpassing all others in natural ability, he pursued with zeal the art of building and also of fashioning statues and carving stone. He was the discoverer of many devices that contributed to the development of art, and he produced marvellous works in many parts of the inhabited world. In the production of statues he so excelled all other men that later generations preserved a story to the effect that the statues which he created were exactly like living beings; for they say that they could see, and walk, and preserved so completely the disposition of the entire body that the statue produced by art seemed to be a living being. Because he was the first to represent the eyes open and the legs separated as they are in walking, and also to render the arms and hands as if stretched out, he was marvelled at, quite naturally, by other men. For the artists who preceded him used to make their statues with the eyes closed, and with the arms hanging straight down and attached to the ribs.

However, even though Daidalos was widely admired for his skill in the arts, he none the less fled his homeland, having been convicted of murder for the following reason. Talos, a son of Daidalos's sister, was given his education by Daidalos when he was still a boy. The pupil, who turned out to be more gifted than his teacher, invented the potter's wheel and, when he happened to find the jawbone of a snake and managed to saw through a small piece of wood with it, set about to imitate the sharp edges of its teeth. With this as his model he devised an iron saw and by means of it sawed the wood that he used in his work. Thus he became known as the inventor of a tool that was of great use in the art of building. Likewise he invented the builder's compass and other devices prized by artisans, and as a consequence he gained a great reputation. Daidalos, however, became very jealous of the boy, and anticipating that he would become much more famous than his teacher, he murdered him . . .

After being condemned for the murder of Talos (who is called Kalos or Perdix in other sources) Daidalos fled to Crete, where he became a close friend of King Minos. Here Daidalos's skill as an artist resulted in further achievements and also further difficulties.

Diodoros 4.77.1–4: According to a tradition that has been handed down, Pasiphaë, the wife of Minos, conceived a passion for a bull, and Daidalos, having made a structure in the shape of a cow, made it possible for Pasiphaë to gratify her desire. The story goes that before this time it had been the custom of Minos to dedicate each year the most beautiful of the newly born bulls to Poseidon and then to sacrifice it to the god. But at this time, a bull of surpassing beauty was born, and he sacrificed in its stead another victim from among the inferior bulls. Poseidon, being angry with Minos, forced his wife Pasiphaë to conceive a passion for the bull. By means of the ingenuity of Daidalos Pasiphaë had intercourse with the bull and gave birth to the creature known in myth as the Minotaur. This creature, they say, was a hybrid form, the upper part of its body as far as the shoulders being like a bull, and the remaining parts like a man. As a place in which this monster could subsist, it is said that Daidalos built the Labyrinth, with winding passageways that were very difficult to follow for those unacquainted with them . . .

After the Pasiphaë incident, Daidalos fell out of favor with King Minos and was forced to flee from Crete. He did so by inventing sets of wings for himself and for his son Ikaros, with which they could fly to Sicily. Once again his ingenious device was successful, although during the flight Ikaros flew too near to the sun, which melted the wax which held the wings to his body, and plunged into the sea. Daidalos, however, reached Sicily, where, while in the service of King Kokalos, he was responsible for several remarkable feats of engineering, including a reservoir and an underground steam bath. See Diodoros 4.78.1–5.

Another legendary cycle, also preserved by Diodoros, connects the artistic activity of

Daidalos, both as a sculptor and architect, with Egypt. Diodoros records that Daidalos modelled his Labyrinth in Crete on the tomb of an Egyptian king named Mendes or Marros, and then comments on the general connections between the art of Daidalos and that of Egypt.

Diodoros 1.97.5–6: They say that Daidalos copied the maze-like plan of the labyrinth [in Egypt] which remains up to the present day and was built, as some say, either by Mendes, or, as others say, by King Marros, many years prior to the time of King Minos. It is also a fact that the *rhythmos* [patterns of composition; see pp. 44, 49] of the ancient statues of Egypt is the same as that of the statues made by Daidalos among the Greeks. The extremely beautiful propylon of the Hephaisteion in Memphis was also built by Daidalos, and having become an object of admiration, he won the right to set up a wooden statue of himself, which he wrought with his own hands, in the aforementioned sanctuary; at length, because of his genius, he was honored with great fame, and after having made many discoveries, he attained honors equal to those of the gods. For on one of the islands off Memphis there exists even today a sanctuary of Daidalos, which is honored by the local inhabitants.

The labyrinth is also mentioned by Diodoros 1.61.1–4 where he adds that it was no longer visible in his day.

During his travels in Greece, Pausanias saw a number of ancient images which he ascribed to Daidalos. The following passage is a typical example.

Pausanias 9.40.3: Of the works of Daidalos, there are two in Boeotia – the Herakles in Thebes and the Trophonios in Lebadeia. There are two other wooden images in Crete, that of Britomartis in Olous and the Athena at Knossos. The Knossians also have the "Dance of Ariadne," of which Homer made mention in the *Iliad*, a relief executed in white stone [the phrase usually signifies marble]. And the Delians possess an image [*xoanon*] of Aphrodite, not very large, which over the years has lost its right hand. It is finished at the bottom with a square base instead of feet. I believe that this is the statue which Ariadne received from Daidalos, and that, when she followed Theseus, she carried away the image from her home. The Delians relate that, when Theseus was deprived of her, he set up the image of the goddess to Apollo at Delos . . .

HOMER

Up to this point we have been looking at myths and traditions about early Greek art preserved in the writing of authors who wrote long after the periods that they were describing. The earliest sources containing descriptions of Greek art are, of course, the Iliad *and the* Odyssey *of Homer. While the date of these epics is still subject to some debate, most scholars now feel that they were composed sometime in the latter half of the eighth century* B.C. *Homer's descriptions of art are thought to reflect partly the art of his*

own time and partly, through the conservative medium of the oral tradition, the art of
the Mycenaean period. A famous example of the latter type of description is that of the
wine cup used by Nestor in his tent on the shore of Ilium.

Iliad 11.632–7: . . . an exceedingly beautiful cup, which the old man had
brought from home, studded with golden rivets. There were four handles on it,
and around each two golden doves were represented as if feeding, while below
there were two supports. Another man would have been hard pressed to lift the
cup from the table when it was full, but old Nestor raised it without any trouble.

In the early excavations of Mycenae, Schliemann found a gold cup which bears a
general similarity to the one described by Homer (see Marinatos–Hirmer, pl. 188).

Elsewhere the specific connections of Homer's descriptions of art are more difficult to
establish. His various descriptions of houses and palaces, for example, combined
memories of Mycenaean palaces (with their great central hearths), suggestions of
architectural decoration in the Orient, and elements of the houses of his own time,
especially those in Ionia. Some typical examples follow.

Odyssey 4.71–4 (Telemachos's exclamation to Peisistratos on seeing the palace
of Menelaos): Take a look, son of Nestor, delight of my heart, at the gleam of
bronze in the echoing halls, and of gold and electrum, of silver and ivory; the
court of Zeus the Olympian must be like this inside . . .

Odyssey 7.81–102 (The palace of Alkinoös in Phaiakia): . . . But Odysseus came
to the renowned palace of Alkinoös. And his heart was stirred with many
thoughts as he stood there, before crossing the bronze threshold. For a shimmer
as if of the sun or the moon played through the high-roofed palace of great-
hearted Alkinoös. Bronze walls ran around at every point, from the threshold to
the innermost recess, and there was also a cornice of dark enamel all around.
Golden doors closed in the sturdy palace, and silver door-posts stood on the
bronze threshold, with a silver lintel overhead, and a gold ring-handle. There
were gold and silver dogs on either side, which Hephaistos had wrought with
knowing ingenuity, serving as guards of the palace of great-hearted Alkinoös,
immortals, and unaging all their days. Within there were arm chairs placed
along the whole extent of the wall, from the threshold to the innermost recess,
and on these were thrown light, finely woven covers, the work of women.
There the leaders of the Phaiakians used to sit as they drank and ate, for they had
unending abundance. Golden youths stood on solidly-built bases, holding
gleaming torches in their hands, illuminating the palace at night for the
banqueters.

Homer seems most interested in and makes most frequent reference to the art which
the later Greeks were to call toreutike, *the art of chasing metal, and inlaying precious*
metals with one another and with gems. His descriptions of gems and the like often
suggest connections with the Near East, but whether these connections were Mycenaean
or later is difficult to say.

Odyssey 19.226–30 (Odysseus, disguised, describes to Penelope the brooch which he wore to Troy): . . . his brooch was of gold and had twin sockets for pins. It was skillfully worked on the front: a dog held a spotted fawn in his forepaws, clutching it as it gasped. And everyone marvelled at how, though being of gold, the dog clutched the fawn and throttled it.

On the archaeological parallels to this brooch see Nilsson (1933) p. 123 and Lorimer (1950) pp. 511–12 (Bibliography 8).

Iliad 23.740–4 (One of the prizes which Achilles offers at the funeral games of Patroklos): The son of Peleus immediately set out other prizes for speed of foot, a silver krater, finely wrought. It held just six measures, but in beauty it surpassed all others on earth by far, since highly skilled Sidonians had wrought it well, and Phoenicians had carried it over the misty sea.

The most elaborate description of an object in Homer is the famous description of Achilles' shield, Iliad 18.478–608. Although some have seen in this description a reflection of the psychology of Greek art in the Geometric period, the description itself is part of a formal literary genre and does not describe a real object. The description of Agamemnon's armor in the eleventh book of the Iliad, however, may reflect objects that Homer had actually seen.

Iliad 11.15–42: The son of Atreus shouted aloud and commanded the Argives to arm for battle. And he himself put on the gleaming bronze. First he fastened the greaves on his ankles, beautiful greaves, fitted with silver clasps. After that he put on a breast plate over his chest, the one which Kinyras once gave him as a guest's gift; for the great rumor had reached Cyprus that the Achaeans were about to sail forth in ships to Troy. It was on account of this that he gave it to him, wishing the king well. On it there were ten bands of dark enamel, and twelve of gold and twenty of tin. And serpents of dark enamel stretched up toward the neck, three on each side, like the rainbows which the son of Kronos fixes into a cloud, a portent to mortal men. Then he threw his sword over his shoulders. The golden nails upon it glittered, while the scabbard around it was of silver and was equipped with golden swordstraps. After that he took up his shield, big enough to hide a man, intricately worked, mighty, a beautiful shield; around it there were ten circles of bronze, and on it were twenty raised bosses of white tin, in the middle of which was one of dark enamel. And wreathed around in the very center was the grim face of the Gorgon, glaring terribly, and around it were Terror and Fear. On the shield was a strap decorated with silver, and on this writhed a serpent wrought of dark enamel with three heads, each turned in a different direction, growing from one neck. And on his head he set a helmet with two horns and four bosses and a crest of horsehair. Terrifying was the crest as it nodded from above.

The patron deities of the men who produced such objects were Hephaistos and Athena. The picture which Homer gives us of Hephaistos at work probably reflects,

with epic exaggeration, the appearance of a successful artist's workshop in Homer's own day.

Iliad 18.369–79: Silver-footed Thetis came to the house of Hephaistos, an imperishable starry house, outstanding among the immortal houses, wrought all of bronze, which the lame-footed god had made himself. She found him there sweating as he hovered busily around the bellows. He was engaged in making tripods, twenty in all, which were to stand along the wall of his well-constructed hall, and he set gold wheels beneath the stand of each, so that they might, moving by themselves, enter the divine assembly and again come back to the house – a marvellous thing to see. They were complete up to a point, but the skillfully wrought handles had not yet been placed upon them. These he was preparing, and he was also cutting the attaching bands.

The role of Athena and Hephaistos as the inspirational force behind the Homeric artist is reflected in the following passage.

Odyssey 6.232–4 (Athena sheds grace on Odysseus in Phaiakia): . . . just as when a man inlays silver with gold, a craftsman, whom Hephaistos and Pallas Athena have taught all manner of skills, and he fashions pleasing works of art.

Chapter 2

Sculpture: early developments and the Archaic period (*c.* 650–510 B.C.)

THE DAIDALIDAI

Whether Daidalos as a person existed or not, a group of sculptors from various parts of Greece, all of whom were apparently active in the sixth century B.C., were regarded as his disciples.

Dipoinos and Skyllis

Pliny, N.H. 36.9: The first to win fame in the carving of marble were Dipoinos and Skyllis, who were born on the island of Crete while the empire of the Medes still existed and before Cyrus began to rule as king in Persia, that is, in about the 50th Olympiad.[1] They betook themselves to Sikyon which was for a long period the home of all arts of this sort. The Sikyonians contracted with them to make images of the gods for the benefit of the city, but before the statues were finished the artists complained of unjust treatment and went off to Aitolia. Thereupon a famine invaded Sikyon and with it barrenness and dire mourning. To those who were seeking the remedy Pythian Apollo replied, "if Dipoinos and Skyllis finish the images of the gods," a prophecy which was brought to fulfillment at great expense and with much obsequious behavior. These images were of Apollo, Artemis, Herakles, and Athena, the last of which was later struck by lightning.

Works by Dipoinos and Skyllis were still visible in the second century A.C. when Pausanias travelled through Greece.

Pausanias 2.15.1 (At Kleonai): There is a sanctuary of Athena in which the image is the work of Skyllis and Dipoinos. Some say that they were pupils of Daidalos, while others maintain that Daidalos took a woman from Gortyna, and that Dipoinos and Skyllis were born to him by this woman.

[1] The 50th Olympiad, that is the 50th celebration of the quadrennial athletic festival held at Olympia, occurred in 580 B.C. Cyrus's rule as king of Persia began in 559 B.C.

Pausanias 2.22.5 (At Argos): After these things there is a temple of the Dıoskouroi. There are images of them and their children, Anaxis and Mnasinous, and along with them their mothers, Hilaeira and Phoibe, all of which are the work of Dipoinos and Skyllis, made of ebony. Likewise most of the parts of their horses are made of ebony, although a few are made from ivory.

Clement of Alexandria, *Protrepticus* 4.42: There were two other sculptors, Cretans, I believe, Dipoinos and Skyllis by name. These men made the images of the Dioskouroi in Argos, the statue of Herakles in Tiryns, and the wooden image (*xoanon*) of Artemis *Mounychia* in Sikyon.

Endoios

Pausanias 1.26.4 (on the Acropolis at Athens): Endoios was an Athenian by birth and a pupil of Daidalos, who followed Daidalos to Crete when the latter was exiled because of the death of Talos. By him there is a seated image of Athena, which has an inscription to the effect that Kallias dedicated it, and Endoios made it.[2]

Pausanias 7.5.9: There is at Erythrai a temple of Athena *Polias* with a wooden image of great size seated on a throne and holding a distaff in each hand, and also having a *polos*[3] on its head. That this is a work of Endoios we surmised from having observed,[4] among other things, the quality of its workmanship and also its similarity to the figures of the Graces and the Seasons, which stand in the open air before the entrance and are of white marble.

Smilis of Aegina

Pausanias 7.4.4 (on the cult image of Hera of Samos): Not the least significant among the points of evidence which one might cite for the fact that this is a very ancient sanctuary is to be found in the cult statue. For it is the work of an Aeginetan, Smilis, the son of Eukleides. This Smilis was of the same period as Daidalos, but he never achieved an equal reputation.

[2] An Archaic seated statue of Athena found on the Acropolis is frequently associated with the work of Endoios; see Richter, *SSG*, fig. 64; Boardman, *Archaic Period*, fig. 135. The inscribed signatures of this sculptor which have been found in Athens appear to date from around the third quarter of the sixth century B.C. The Kallias mentioned in the passage cited above may be Kallias the son of Phainippos, an Olympic victor in 564 B.C. and one of the major political opponents of the tyrant Peisistratos in the 540s and 530s B.C. A survey of the complex archaeological evidence connected with this sculptor suggests that his career spanned the period between *c.* 550 and 500 B.C., and that he was hence a generation or so younger than Dipoinos and Skyllis. For an excellent summary, see Raubitschek, *Dedications*, pp. 491–5.

[3] *Polos*: a cylindrical shaped headdress resembling a round basket. It acquired ritual significance in the cults of several goddesses.

[4] Reading *eidontes* for *endon*. The text of this sentence is defective, and I give an approximate rendering.

Pausanias 5.17.1: In the temple of Hera in Olympia there is a statue of Zeus, as well as the image of Hera seated on a throne. It [the Zeus statue] stands alongside and is bearded and equipped with a helmet on the head; these are simple[5] works. Next to them are statues of the Seasons seated on thrones made by Smilis the Aeginetan.

Klearchos of Rhegion

Pausanias 3.17.6 (monuments in Sparta): On the right of the Brazen House [see p. 26] there is an image of Zeus the Highest, the oldest of all those works which are in bronze. For it is not made of one piece [that is, cast], but after each of the parts was hammered individually, the parts were then fitted together with one another, and rivets hold them so that they do not come apart. They say that Klearchos, who was a citizen of Rhegion, made this image; some say that he was a pupil of Dipoinos and Skyllis and others that he was a pupil of Daidalos himself.

The technique of making statues by fastening together hammered sheets of metal around a core was known as sphyrelaton. *Some examples of this technique have been found at Dreros in Crete and are to be dated to c. 650 B.C. (see Richter, SSG, fig. 14; Boardman, Archaic Period, fig. 16). This style went out of fashion after the technique of casting large-scale bronze statues was perfected, presumably by Theodoros of Samos [see p. 27] around the middle of the sixth century B.C. This would suggest a rather early date for Klearchos, perhaps late seventh or early sixth century B.C. In another passage, however, Pausanias himself mentions a Klearchos of Rhegion as the teacher of Pythagoras of Rhegion (6.4.4), a sculptor who worked during the first half of the fifth century B.C. (see pp. 43–6). The chronological difficulty may be resolved by the assumption that there was an elder and a younger Klearchos, or that Klearchos simply made repairs on the venerable statue of Zeus.*

The Pupils of Dipoinos and Skyllis

Pausanias 5.17.1–2: By these [the statues of the Seasons by Smilis] stands an image of Themis, who was the mother of the Seasons, the work of Dorykleides, a Lakedaimonian by birth and a pupil of Dipoinos and Skyllis. The statues of the Hesperidai, five in number, were made by Theokles, also a Lakedaimonian, whose father was Hegylos. He too is reputed to have been a pupil of Dipoinos and Skyllis. They say that the image of Athena, wearing a helmet and holding a spear and a shield, is the work of the Lakedaimonian Medon, and that this man was the brother of Dorykleides and was taught by the same teachers.

[5] Greek *hapla*; perhaps also "primitive, undeveloped."

Pausanias 6.19.8 (about Olympia): The third of the treasuries, and also the fourth, are votive monuments of the Epidamnians[6] . . . It shows the celestial vault held by Atlas, and it shows Herakles and the tree which was to be found among the Hesperidai, the apple tree, as well as the snake coiled around the apple tree. These are also of cedar wood, and are the works of Theokles, the son of Hegylos. The writing on the celestial vault says that he made it along with his son.

Pausanias 2.32.5: Kallon [see p. 34] was a pupil of Tektaios and Angelion; these latter made the image of Apollo for the Delians. Angelion and Tektaios were taught by Dipoinos and Skyllis.

This image of Apollo is described by Plutarch.

Plutarch, On Music 14 (Moralia 1136A): The arrangement of the image of him in Delos has a bow in his right hand, and in his left hand the Graces, each of whom holds some musical instrument; one holds a lyre, another holds flutes, while the one who is placed in the middle holds a reed-pipe to her mouth.[7]

The Sculptor of the Megarian Treasury of Olympia

The name of the artist associated with this treasury is preserved in the manuscripts of Pausanias as "Dontas." Because this name is so unusual some modern scholars have felt that "Dontas" is a corruption of "Medon," a Spartan sculptor (mentioned above, p. 21) who appears to have been active toward the end of the sixth century B.C.[8]

Pausanias 6.19.12–14: The Megarians, who lived on the border of Attica, constructed a treasury, and in this treasury they set up offerings, small figures of cedarwood adorned with gold, representing the battle of Herakles with Acheloös. Zeus is depicted there, and Deianeira, as well as Acheloös and Herakles, and also Ares who is giving aid to Acheloös; likewise an image of Athena, who was Herakles' ally, once stood there. But this is now set up next to the Hesperidai in the temple of Hera. In the pediment of the treasury the battle of the gods and giants is represented, and a shield is placed above the pediment, [with an inscription] stating that the Megarians set up the treasury [with the spoils taken] from the Corinthians . . . The Megarians built the treasury in Olympia some years after the battle [with the Corinthians]. But it seems likely that they had offerings there dating from an earlier time which the Lakedaimonian Dontas, a pupil of Dipoinos and Skyllis, made.

[6] There is a lacuna in the text, and it is hence not clear to which treasury or to what part of it the wooden sculptures which are described belonged. Presumably they were reliefs.

[7] Representations of what appears to be this statue are preserved on Athenian coinage. See Lacroix, *Reproductions*, p. 201; pl. XVII, nos. 1 and 2.

[8] For example, Stuart Jones, *Ancient Writers*, p. 12.

The pedimental sculptures representing the battle of gods and giants from the treasury of the Megarians, dating from c. 510–500 B.C., are preserved in the Archaeological Museum at Olympia (see Boardman, Archaic Period, fig. 215; Richter, SSG, fig. 410).

EARLY SCULPTURE IN SPARTA

Bathykles of Magnesia

The passage which follows is Pausanias's description of the throne of "the Amyklaian god," later identified with Apollo, at Amyklai near Sparta. Fragments of the throne, constructed in about the middle of the sixth century B.C. are preserved in the Museum in modern Sparta.[9] It combined elements of both the Ionic order (extremely rare in the Peloponnesos in the Archaic period) and the Doric order. Along with the description of the chest of Kypselos (see pp. 210–15), it is one of the most informative pieces of literary evidence for the type of narrative subjects that were favored in Archaic art.

Pausanias 3.18.9–3.19.5: By Bathykles the Magnesian, who made the throne of the god of Amyklai, there are Graces, set up as votives upon the completion of the throne, and a statue of Artemis *Leukophryene*. Whose pupil this Bathykles was, and in the reign of what Lakedaimonian [Spartan] king he made the throne, these questions I pass over; but I saw the throne itself, and I will describe what sort of things there are upon it. Two Graces and two Seasons hold it up in front, and, in the same manner, in the back. On the left stand Echidna and Typhos, on the right Tritons. To go through the reliefs one by one in detail would only be a bore to my readers. But, to give a brief description (since many of them are not unfamiliar), Poseidon and Zeus are shown carrying Taÿgete, the daughter of Atlas, and her sister Alkyone. Also represented on it are Atlas, the single combat of Herakles with Kyknos, and the battle of the centaurs at the dwelling of Pholos. With regard to the creature called the "bull of Minos," I do not know why Bathykles represented it as being bound and led away alive by Theseus.[10] The dance of the Phaiakians is also represented on the throne and likewise Demodokos singing.[11] The exploit of Perseus against Medusa is also depicted. Passing over the battle of Herakles against Thourios, one of the giants, and the battle of Tyndareus against Eurytos, one comes to the rape of the daughters of Leukippos. He has also represented Dionysos and Herakles; Hermes is there carrying the former, still a child, to heaven; while Athena is leading Herakles to live from that time forth among the gods. Peleus is shown handing over Achilles to be brought up by Cheiron, who is said to have been his

[9] Several reconstructions of the throne, based on extant fragments and Pausanias's description, have been proposed. See Bibliography 10.
[10] The most common tradition was that Theseus killed the Minotaur. [11] *Odyssey* 8.471ff.

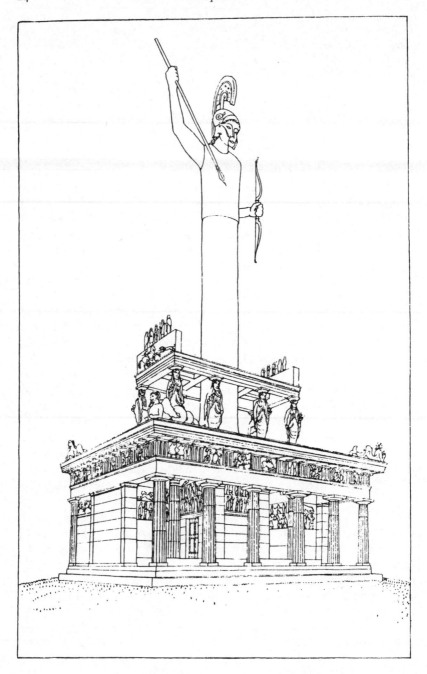

Fig. 1. The Throne of Bathykles at Amyklai; restoration by E. Fiechter.

teacher. Kephalos is there too, who on account of his beauty was abducted by Hemera, and also there are the gods who bring gifts to the marriage of Harmonia. The single combat of Achilles against Memnon is represented, and so is Herakles taking revenge upon Dionysios the Thracian and upon Nessos by the river Euenos. Hermes leads the goddesses to be judged by Paris, and Adrastos and Tydeus restrain Amphiaraos and Lykourgos the son of Pronax from fighting. Hera gazes at Io, the daughter of Inachos, who is already a cow, and Athena is shown fleeing Hephaistos who pursues her. After these there are depicted, from the labors of Herakles, the slaying of the Hydra and how he led up the dog from Hades. Then there are Anaxias and Mnasinous, each of them seated on horseback, but there is just one horse carrying Megapenthes, the son of Menelaos, and Nikostratos. Bellerophon is killing the beast in Lycia, and Herakles drives the cattle of Geryones. At the upper edges of the throne are placed the sons of Tyndareus, one on each side, on horseback. There are sphinxes beneath the horses and wild beasts higher up,[12] a leopard on one side and a lioness on the side by Pollux. On the highest spot on the throne a group of dancers has been made, representing the Magnesians who worked on the throne along with Bathykles. Running beneath the throne and, on the inside, away from the Tritons, is the hunt for the Kalydonian boar and Herakles killing the children of Aktor; and also Kalaïs and Zetes, who are driving the harpies away from Phineas. Peirithoös and Theseus are there, having just seized Helen. Herakles is strangling the lion, and Apollo and Artemis are shooting Tityos. Also represented there is the combat of Herakles with the centaur Oreios and of Theseus with the bull of Minos. In addition there is represented the wrestling match of Herakles with Acheloös and the story which is told about Hera, that is, how she was bound by Hephaistos; also the agonistic festival which Akastos held in honor of his father and the story of Menelaos and the Egyptian Proteus, as told in the *Odyssey*. And finally there is Admetos yoking a boar and lion to his chariot and the Trojans bringing the libations to Hector.

The part of the throne where the god would sit is not a single continuous plane, but rather it is furnished with several chairs, and by each chair there is left a wide space; the space left in the middle is the widest, and it is there that the image stands. I know of no one who has ascertained the height of the image by actual measurement, but, to give a rough estimate, it must be about 30 cubits high. It is not the work of Bathykles, but rather it is primitive and not made with much art, for although it has a face, and feet, and hands, it looks, for the most part, like a bronze column. It has a helmet on its head, and in the hands, a spear and a bow. The base of the image is made in the form of an altar, and they say that Hyakinthos is buried in it and that at the Hyakinthia festival, before they make offerings to Apollo, they make sacrificial offerings to the dead Hyakinthos at this altar through bronze doors. The doorway is on the left side of the altar.

[12] Or "running upwards." The text is ambiguous. The top of the throne may have had steps.

Worked [in relief] on the altar [that is, the base of the image] are in one place an image of Biris, and in another place Amphitrite and Poseidon. Zeus and Hermes are shown conversing with one another while nearby stand Dionysos and Semele and, with the latter, Ino. Demeter and Kore and Ploutos are also depicted on the altar, and after them the Fates [Moirai] and the Seasons [Horai], and, with them, Aphrodite and Athena and Artemis. They are carrying up to heaven Hyakinthos and Polyboia (who, they say, was the sister of Hyakinthos and died while she was still a virgin). Now this image of Hyakinthos shows him as already having a beard, but Nikias the son of Nikomedes [see pp. 169–71] painted him in the fairest bloom of youth, thus alluding subtly to the reputed love of Apollo for Hyakinthos. Also shown on the altar is Herakles being led to heaven by Athena and the other gods. Also on the altar are the daughters of Thestios and the Muses and the Seasons. As for the story of the [west] wind, Zephyros, and of how Apollo unintentionally killed Hyakinthos, and the tale about the flower, let them remain as they are told, even if one has doubts about them.

Gitiadas of Sparta

Pausanias 3.17.1–3: Among the Lakedaimonians there is no acropolis rising to a conspicuous height, like the Kadmeia at Thebes or the Larisa at Argos. But there are hills in the city, and to the one that projects higher into the air than the others they give the name "acropolis." In this place there is built a sanctuary of Athena, called both "Protectress of the city" and "the Lady of the Brazen House." The construction of the sanctuary was begun, they say, by Tyndareus. When he died his children wanted to make a second attempt to carry out this building project, and it was intended that the spoils from Aphidna would provide them with the means for beginning the work. But they too left it unfinished, and it was many years later that the Spartans made both the temple and the image of Athena of bronze.[13] The builder was Gitiadas, a local man. This Gitiadas also composed Doric lyric odes and other works, including a hymn to the goddess. There are reliefs wrought into the bronze showing many of the labors of Herakles, as well as many of the deeds that he performed of his own free will; and there are other reliefs showing exploits of the sons of Tyndareus, including the rape of the daughters of Leukippos. Also there is Hephaistos releasing his mother from fetters . . . There too are the Nymphs giving gifts to Perseus as he is about to set out on his expedition against Medusa in Libya – a helmet and the shoes by which he was to be carried through the air. Also wrought there are figures illustrating the birth of Athena and also Amphitrite and Poseidon; these are the largest figures and, in my opinion, those which are most worth seeing.

[13] For the representation of this statue on coins see Lacroix, *Reproductions*, pp. 217–18, pl. xviii, nos. 1 and 2.

THE SCULPTORS OF THE AEGEAN ISLANDS

Theodoros and Rhoikos

Theodoros of Samos, sculptor, architect, and master of the minor arts, was the most famous artist of the sixth century B.C. The literary sources for his career and lineage come from authors who, with the exception of Herodotos, lived at least 500 years after the artist's own time, and there are understandably some contradictions in the evidence that they preserve. Some, including Herodotos, refer to Theodoros as the son of Telekles and colleague of Rhoikos; others (Diodoros, Diogenes Laertios) refer to him as the son of Rhoikos. Some scholars in the nineteenth century (for example, Brunn, GgK 23–9) sought to resolve the contradictory points within the literary sources by postulating the existence of an elder Theodoros, the architect of the Heraion of Samos, and a younger Theodoros, who made the famous ring of Polykrates (see pp. 215–16). It is more likely, however, that only one artist existed, who, toward the beginning of his career, worked with Rhoikos in the temple of Hera at Samos (c. 560 B.C.) and who, toward the end of his career, made the ring of Polykrates (in the 520s B.C.). Rhoikos was perhaps an older relative of Theodoros.

One of the innovations of the school of Theodoros and Rhoikos appears to have been that of casting hollow bronze statues (as distinct from the earlier sphyrelata *of hammered metal sheets; see p. 21).*

Pausanias 8.14.8: The first men who made use of molten bronze for casting images in moulds were the Samians Rhoikos, the son of Phileas, and Theodoros, the son of Telekles.

Pausanias later says, however:

Pausanias 10.38.6: I have pointed out in the earlier sections of my work that the Samians Rhoikos, son of Phileas, and Theodoros, son of Telekles, were the discoverers of how to melt down bronze with controlled precision. These men were also the first to cast bronze. Of Theodoros I have not been able to discover any work still extant, at least among works made of bronze. But in the sanctuary of Ephesian Artemis, as you come to the building which has the paintings, there is an entablature above the altar of "Artemis of the First Throne," as she is called. There are a number of images set up on the entablature and among them is the figure of a woman which stands near the end; this is the work of Rhoikos, and the Ephesians call it "Night."

Another tradition states that Theodoros made the first self-portrait. Pliny's remark about the exactitude of the likeness is undoubtedly exaggerated.

Pliny, N.H. 34.83: Theodoros, who made the labyrinth, cast a bronze portrait of himself in Samos, which, besides its reputation as a marvellous likeness, was celebrated for its great subtlety of detail. The right hand holds a file, and the left

held a little *quadriga* (now removed to Praeneste) in three fingers – this latter is on such a small scale that, marvellous to say, were it to be made into a drawing, the fly, another work which Theodorus made at the same time, would cover both the chariot and the charioteer with its wings.[14]

The following anecdote, although probably not literally true, may suggest that Theodoros was one of the earliest sculptors to be interested in the problem of proportions.

Diodoros 1.98.5–9: Among the old sculptors who are particularly mentioned as having spent time among them [the Egyptians] are Theodoros and Telekles, the sons of Rhoikos, who made the statue of Pythian Apollo for the Samians. Of this image it is related that half of it was made by Telekles in Samos, while, at Ephesos, the other half was finished by his brother Theodoros, and that when the parts were fitted together with one another, they corresponded so well that they appeared to have been made by one person. This type of workmanship is not practiced at all among the Greeks, but among the Egyptians it is especially common. For among them the *symmetria* [commensurability of parts] of statues is not calculated according to the appearances that are presented to the eyes, as they are among the Greeks; but rather, when they have laid out the stones, and, after dividing them up, have begun to work on them, at this point they select a module from the smallest parts which can be applied to the largest. Then dividing up the lay-out of the body into twenty-one parts, plus an additional one-quarter, they produce all the proportions of the living figure. Therefore, when the artists agree with one another about the size of a statue, they part company, and execute the parts of the work for which the size has been agreed upon with such precision that their particular way of working is a cause for astonishment. The statue in Samos, in accordance with the technique of the Egyptians, is divided into two parts by a line which runs from the top of the head, through the middle of the figure to the groin, thus dividing the figure into two equal parts. They say that this statue is, for the most part, quite like those of the Egyptians, because it has the hands suspended at its sides, and the legs parted as if in walking.

The School of Chios

Pliny, *N.H.* 36.11–13: [Before the time of Dipoinos and Skyllis] the sculptor Melas already lived in Chios, and after him his son Mikkiades, and still later his grandson Archermos, whose sons Bupalos and Athenis were the most famous men in this craft in the time of the poet Hipponax; the last named can be dated with certainty in the 60th Olympiad [540 B.C.]. If one were to trace the lineage of their family all the way back to their grandfather, one would find that the

[14] The manuscripts offer several variations for the second sentence in this text, but the general idea is clear enough.

beginning of their art coincided with the beginning of the Olympiads [traditionally 776 B.C.]. Hipponax's face was notorious for its ugliness. Consequently they exhibited a portrait of him, for the purpose of making fun of it, to circles of laughter-loving companions; whereupon the indignant Hipponax unleashed the bitterness of his satire to such a degree that, as some believe, he drove them to hang themselves. But this is false; for they made a number of works later on in the neighboring islands, as for example those in Delos; on the bases of these, moreover, they have added the following epigram: "Chios is valued not only for its vines but also for the works of the sons of Archermos." And the people of Iasos [in Asia Minor] show an Artemis which is the work of their hand. In Chios itself there is reported to be a face of Artemis which is their work; it is set on high and those entering the building find its expression sad, while those who are leaving find it cheerful. In Rome there are statues by them in the pediment[15] of the temple of Apollo on the Palatine and in almost all the other structures which the deified Augustus built. Works by their father also exist both in Delos and on the island of Lesbos.

The names of Archermos, Mikkiades, and Melas appear on a dedicatory inscription found on Delos that may belong to the well-known Archaic figure of a flying Nike dating from c. 550 B.C. See Boardman, Archaic Period, fig. 103 and Bibliography 12.

EARLY SCULPTURE IN TERRACOTTA

Pliny, N.H. 35.151-2: . . . The modelling of portraits from clay was first invented at Corinth by Butades, a potter from Sikyon; it was really the achievement of his daughter, who was in love with a young man and, when that young man was leaving for a trip abroad, drew an outline of the shadow of his face which was cast from a lamp onto the wall. From this her father made a relief by impressing the outline in clay and fired it along with his other clay products so that it became hard. This relief, they say, was preserved in the sanctuary of the Nymphs, up until the time when [the Roman general] Mummius sacked Corinth. There are those who hold that the art of modelling was first invented in Samos by Theodoros and Rhoikos, well before the Bacchiadai were expelled from Corinth, but in fact Demaratus (who in Etruria begat Tarquinius, the king of the Roman people), when he was exiled from the same city, took with him Eucheir, Diopos, and Eugrammos, who were modellers in clay; from these men the art of modelling was imported into Italy.[16] It was Butades' invention either to add red earth or to model from red chalk, and he also first placed masks by the

[15] In the pediment – *in fastigio*; the phrase could also refer to the *akroteria* on the top of the gable of the temple.

[16] The archaeological record supports the tradition of a strong influence from Corinth on the early ceramic art of the Etruscans, especially in the seventh century B.C.; the date usually accepted for the rule of the Roman king Tarquinius Priscus is 616–579 B.C. The expulsion of the Bacchiadai occurred *c.* 657 B.C.

outermost tiles of tile-roofs;[17] at first he called these masks *prostypa*, but later he also made *ectypa*.[18] It was from these also that the pediments[19] of temples originated. It was on account of this artist that the *plastae* [modellers] got their name.

EARLY TRADITIONS ABOUT PORTRAIT SCULPTURE

The following passages supplement those already cited in connection with Theodoros's self-portrait (pp. 27, 181) and the portrait of Hipponax by the sons of Archermos (p. 29).

Pliny, N.H. 34.16–17: It was not customary to make effigies of men unless, through some illustrious cause, they were worthy of having their memory perpetuated; the first example was a victory in the sacred contests, especially at Olympia, where it was the custom to dedicate statues of all who had been victorious; and in the case of those who had been winners there three times they moulded a likeness from the actual features[20] of the person, which they call "icons."[21] The Athenians, I am inclined to believe, set up statues in public for the first time in honor of the tyrant-slayers, Harmodios and Aristogeiton [see pp. 41, 43].

Pausanias 6.18.7: The first portraits of athletes set up in Olympia were those of Praxidamas the Aeginetan, who was the victor in boxing in the 59th Olympiad [544 B.C.] and Rhexibios the Opuntian, who prevailed as a pankratiast[22] in the 61st Olympiad [536 B.C.]. These statues stand not far from the column of Oinomaos and are made of wood, that of Rhexibios of fig-wood and that of the Aeginetan, which is less weathered than the other, of cypress.

Pausanias 8.40.1: In the assembly-place in Phigalia there is a statue of Arrhachion the pankratiast, which is archaic in several ways and not the least of all in its format. The feet are not separated by very much and the arms hang down by the sides as far as the buttocks. The portrait is made of stone, and they say that an epigram was inscribed upon it, but this has disappeared with time. Two Olympic victories went to Arrhachion in the Olympiads which preceded the 54th [564 B.C.] . . .

An archaic statue of the kouros *type, found in Phigalia and now in Olympia, has sometimes been identified as the statue of Arrhachion, but the identification is doubtful (see Richter,* Kouroi, *no. 41).*

[17] That is, he made ornamental antefixes.
[18] The Greek words *ectypa* and *prostypa* are usually taken as "high relief" and "low relief" respectively. The most common meaning of *typos* is "relief." See Pollitt, *Ancient View*, pp. 272–93.
[19] That is, the ornamentation of pediments with terracotta reliefs.
[20] The Latin reads *ex membris* and appears to refer to the whole body.
[21] Latin *iconica* from the Greek *eikon*, a "likeness." Pliny's contention that portraits of this sort were made in Archaic Greece is doubtful.
[22] The *pankration* was an unusually rough event in the Olympic games which combined boxing and wrestling simultaneously. It continued until one of the contestants either gave in or was unable to continue.

Pausanias 6.15.8: Two victories went to the Spartan Eutelidas in the boys' contests of the 38th Olympiad [628 B.C.],[23] one for wrestling and one for the pentathlon. For this was the first and last time that boys were called to be contestants in the pentathlon. There is an ancient image of this Eutelidas, and on its base are letters which have been worn dim with time.

Herodotos 1.31: (An illustration given by Solon to Croesus of what sort of men could be considered truly happy): Kleobis and Biton. For the wealth which belonged to them (they were Argives by birth) was sufficient for their needs, and in addition to that they had great strength of body, as is shown by the fact that they were both prize-winning athletes. The following story is also told about them. There was a festival in honor of Hera at Argos, and their mother had to be transported to the sanctuary in an ox-cart; but the oxen did not arrive from the fields in time. Unable to wait because time was growing short, the young men put on the yoke themselves and drew the cart, with their mother riding along in it; after transporting her over a distance of forty-five stades, they arrived at the sanctuary. Having performed this feat, which was witnessed by everyone at the festival, their lives came to the best possible end, and in their case again the god showed how much better a thing it is to die than to live. For the Argive men, standing around the cart, commended the strength of the young men, and the Argive women congratulated the mother for being fortunate enough to have such sons. Then the mother, being overwhelmed both by the feat and the praises which it brought, stood before the image and prayed to the goddess to give Kleobis and Biton, her own children who had honored her so greatly, the best thing that can befall a man. Following her prayer they performed sacrifice and enjoyed the feast; afterwards the young men lay down to sleep in the sanctuary and never rose again – it was in this way that they met their death. The Argives made statues of them and set them up in Delphi because they were among the most virtuous of men.

A pair of statues of the kouros *type, found in Delphi in 1893–4 have been widely and frequently identified as the statues mentioned by Herodotos, although the identification is not completely certain and has been disputed. See Richter,* Kouroi, *nos. 12A and B and* Bibliography 14.

[23] Assuming that the statue of Eutelidas was contemporary with his victory, Pausanias seems to contradict his own statement, quoted above, that the earliest athlete portrait at Olympia was set up in 544 B.C.'

Chapter 3

Sculpture: the Late Archaic phase
(*c.* 510–480 B.C.)

The sculptors treated under this heading were primarily active during the last decade of the sixth century B.C. and the first two decades of the fifth. Several of them lived through the Persian Wars, overlapped into the Early Classical period, and played a role in forming the new Classical style. They were also the teachers of the great sculptors of the Classical period, such as Myron, Polykleitos, and Pheidias.

Ageladas of Argos

Ageladas (the Latin version of the name is "Hagelades"; see Pliny, N.H. 34.49, 55, and 57) was probably the oldest of the sculptors in this group. His earliest known work, the statue of the Olympian victor Anochos of Tarentum, dated from around 520 B.C. Later tradition held that he was the teacher of three great sculptors of the Classical period – Myron, Pheidias, and Polykleitos. The last of these was also from Argos and may have received his early training from the disciples of Ageladas; otherwise there is probably no truth in the tradition. The ancient sources give us no idea of the quality of his works, but they do give some conception of their variety.

STATUES OF ATHLETES

Pausanias 6.14.11 (at Olympia): there is also a statue of Anochos of Tarentum, the son of Adamatas, who was victorious in the single-course and double-course foot race; it is the work of Ageladas of Argos.

Pausanias 6.10.6 (at Olympia): Next to [the chariot of] Pantarkes is the chariot of Kleosthenes, a man of Epidamnos. This is the work of Ageladas; it stands behind the Zeus which was set up by the Greeks from the spoils of the battle of Plataea. Kleosthenes was victorious in the 66th Olympiad [516 B.C.], and he set up a statue of himself and his charioteer along with the horses.

Pausanias 6.8.6 (at Olympia): Not far from the statue of Promachos a statue of Timasitheos, a Delphian by birth, is set up; it is the work of Ageladas of Argos;

32

this man (Timasitheos) won victories in the *pankration*, twice at Olympia and three times at Pytho.[1]

STATUES OF GODS

Pausanias 4.33.1–2: Every day they carry water from the spring to the sanctuary of Zeus on Mt Ithome. The image of Zeus is the work of Ageladas and was originally made for the Messenian settlers in Naupaktos.[2] The priest, who is chosen each year, keeps the image in his house.

Pausanias 7.24.4: There are other statues at Aigion made of bronze, Zeus as a child and Herakles, who also has as yet no beard; these are the work of Ageladas of Argos.

Scholiast on Aristophanes, *Frogs,* **line 504:** Melite is a deme in Attica, in which Herakles celebrated the Lesser Mysteries. There is also a notable sanctuary of Herakles *Alexikakos* ["Averter of Evil"]. The image of Herakles is the work of Ageladas of Argos, who was the teacher of Pheidias.

A STATUE OF THE MUSES

Anthologia Graeca **16.220,** by Antipater of Sidon:

> Muses three entwined here we stand,
> One holds a flute,
> Another in her hands the barbiton,
> The third a lyre;
> The one by Aristokles holds the lyre;
> By Ageladas
> The barbiton, and she of Kanachos
> The hymning reeds . . .

A MILITARY VOTIVE

Pausanias 10.10.6 (at Delphi): The bronze horse of the Tarentines and the captive women are from the spoils taken from the Messapians, the barbarian neighbors of the Tarentines; these are the works of Ageladas of Argos.

Kanachos of Sikyon

(In addition to the passages cited below, see Cicero's critical analysis of the style of Kanachos, p. 223.)

[1] Herodotos 5.72, relates that a Delphian named Timasitheos was executed in Athens in 507 B.C. after participating with the Spartan king Kleomenes in an abortive *coup d'état.*

[2] In 456 B.C. the Athenians enabled Messenian refugees, who were fleeing Spartan domination, to settle in Naupaktos. If Ageladas began his career around 520 B.C., it is unlikely, although not impossible, that he was active at this time. On the other hand, if the Zeus shown on the coins of Messenia (see Richter, *SSG,* fig. 599; Lacroix, *Reproductions,* pl. XIX. 1–6) is that of Ageladas, he may have been active as late as the second quarter of the fifth century, since the style of the statue represented on the coins seems to be Early Classical.

Pliny, N.H. 34.75 (the statue of Apollo at Didyma): Kanachos [was the sculptor of] a nude Apollo, which bears the cognomen Philesios, in the sanctuary at Didyma, made from bronze of the Aeginetan formula;[3] and with it a stag, which is suspended in its tracks in such a way that a string can be drawn underneath its feet, with the heel and toe alternately retaining their grip, for a "tooth" on each part is so geared that when one is dislodged by pressure the other in its turn springs into place.[4]

Pausanias 9.10.2 (the statue of Ismenian Apollo at Thebes): . . . there is a hill to the right of the gates which is sacred to Apollo. Both the hill and the god as well are called "Ismenian," since the river Ismenos flows right by it . . . The image is equal in size to the one at Branchidai [another name for Didyma] and not very different in form. Whoever has seen one of these images and has learned who the artist was, requires no great skill to recognize, on beholding the other, that it is a work of Kanachos. They differ only in this way: the one at Branchidai is of bronze, while the Ismenian statue is of cedar-wood.

Pausanias 2.10.4 (a cult statue of Aphrodite at Sikyon): Immediately after this there is a sanctuary of Aphrodite. The only people authorized to enter it are a priestess (for whom it is no longer legal to have intercourse with a man) and a virgin, who has charge of the sacrificial rites for a year and is given the name *Loutrophoros* ["the bath-bearer"]. The rest of the people are required to watch from the entrance and to make their prayers from there. The image, which is seated, was made by Kanachos of Sikyon, who made the statue of Apollo for the Milesians at Didyma and the Ismenian Apollo for the Thebans. It is made of gold and ivory and has a *polos* on its head; in one of the hands it holds a poppy and in the other an apple.

Kallon of Aegina

(See also Quintilian's criticism of the style of Kallon, p. 222; for Kallon's teachers see p. 22.)

Pausanias 2.32.5 (at Troizen): . . . on the Acropolis there is a temple of Athena, called *Sthenias*. The *xoanon* of the goddess was made by Kallon the Aeginetan.[5] Kallon was the pupil of Tektaios and Angelion.

[3] *Aeginetica aeris temperatura.* The Aeginetan workshops had a special formula for compounding bronze which was famous in antiquity; see Pliny, *N.H.* 34.10.

[4] Reproductions of this statue on coins and in small bronzes and terracottas suggest that this stag was a small object placed in the Apollo's outstretched hand. See *EAA*, s.v. "Kanachos," and Lacroix, *Reproductions*, pp. 221–6. and pl. XVIII. 8–13. The statue was taken away to Ecbatana by the Persian king Darius (Herodotos 6.19 and Pausanias 1.16.3) but was later restored by the Hellenistic king Seleukos Nikator (312–281 B.C.).

[5] Pausanias frequently uses this term to denote a primitive wooden image belonging to an earlier stage in the development of Greek sculpture. Other authors, however, use the term to refer to images of all styles and periods, and it seems that Pausanias's use of the word is influenced by the antiquarian taste and theories of his own time. For a thorough review of the meaning of the term see

Kallon of Elis

(Possibly identical with Kallon of Aegina. Greek artists were itinerant.)

Pausanias 5.25.2–4: It once happened that when the Messenians on the strait [between Italy and Sicily] in accordance with an old custom sent a chorus of thirty-five boys, and with them a trainer and a flute-player, to some local festival of the Rhegians, a disaster overtook them. Not one of those who were sent off returned again safely; but the ship that was carrying the boys vanished into the deep along with them ... At that time the Messenians mourned over the loss of the children, and in addition to the other ways that were devised to honor them, they set up bronze statues at Olympia, which included along with the children, the trainer and the flute-player. The ancient inscription made it clear that they were votives of the Messenians on the strait. At a later time, Hippias,[6] who is called the "wise man" by the Greeks, composed elegiac verses in honor of them. They are the works of Kallon of Elis.

Pausanias 5.27.8 (a Hermes at Olympia): Not far from the offering of the people of Pheneos [i.e., the Hermes of Onatas; see p. 38], there is another image of Hermes, this one holding the *kerykeion* [herald's wand]. The inscription[7] says that it was set up by Glaukias, who was a Rhegian by descent, and that Kallon of Elis made it.

Hegias and/or Hegesias

The two names given separately by Pliny are usually thought to refer to the same artist. The rhetoricians of the Roman Empire looked upon the art of Hegesias and Kallon as a paradigm of a hard, linear style (see p. 222). Thus, although the literary sources give us little specific information about Hegias/Hegesias, he must have been one of the best known of the Late Archaic sculptors. "Hegias" (if a very probable emendation of the text of Dio Chrysostom, Or. 55.1 is correct) was apparently the teacher of Pheidias.

An inscribed statue base dating from around the second decade of the fifth century B.C. and bearing the signature of Hegias, has been found on the Athenian Acropolis [see Raubitschek, Dedications, no. 94].

Pliny, N.H. 34.78: The Athena and King Pyrrhos [son of Achilles] of Hegias are praised, as are his boys, called *keletizontes* [acrobatic jockeys], and his Castor and Pollux, which stand before the temple of Jupiter the Thunderer [in Rome]; by Hegesias there is a Herakles in the [Roman] colony of Parium [in Asia Minor].

A. Donohue, *Xoana and the Origins of Greek Sculpture* (Atlanta 1988). Like most of the Aeginetan sculptors Kallon probably worked primarily in bronze. Pausanias (3.18.8) saw a bronze tripod made by him set up at Amyklai.

[6] The Sophist Hippias of Elis, active in the second half of the fifth century B.C.

[7] This inscription has been found at Olympia. See Loewy, *IgB*, no. 33.

Onatas of Aegina

The sculptural school of Aegina was one of the most active and prosperous of the Late Archaic period, and its products were apparently so distinctive in style that Pausanias was able to recognize them centuries afterwards (for the texts see Chapter 13, p. 227). Onatas would appear to have been the foremost sculptor in the school. The pedimental sculptures from the temple of Aphaia at Aegina were made at the time when Onatas's influence must have been at its high-point, and we may reasonably assume that they provide us with a fair idea of what his style was like.

Pausanias 8.42.1–13 (the "Black Demeter" of the Phigalians and other works): The other of the mountains, Mt Elaion, is about thirty stades from Phigalia, and there is a cave there sacred to Demeter, whom they call "the black." Now what the people of Thelpousa say about the mating of Poseidon and Demeter, that much the Phigalians tend to believe; but the Phigalians maintain that what was given birth to by Demeter was not a horse, but rather the deity who is given the name "Despoina" ["the Mistress"] by the Arcadians. They say that afterwards, feeling simultaneously anger against Poseidon and anguish over the rape of Persephone, she put on black raiment, and entering into this cave, remained hidden for a long time. During this time it is said that all the things which the earth nourishes were dying, and that the race of men was being destroyed even more so by hunger, but none of the other gods knew where Demeter was hidden, until Pan went to Arcadia, and in pursuing the hunt from one mountain to another, arrived at Mt Elaion and spied on Demeter, noting what her bearing[8] was and what sort of raiment she was clothed in. It is said that Zeus learned of these things from Pan, and consequently the Fates were sent by him to Demeter, who, in turn, was persuaded by the Fates, put aside her anger, and gave up grieving. As a result of these things, the Phigalians say, they declared this cave sacred to Demeter and set up a wooden image in it. The image, they say, was fashioned by them in the following way: it was seated on a rock, and was like a woman in all parts except the head; she had the head and hair of a horse, and images of serpents and other beasts grew out of the head; she was dressed in a tunic which reached to her feet; there was a dolphin in one of her hands and a dove in the other. Why they made the wooden image in this way should be clear to any man who is intelligent and capable of assessing traditions. They say that they named her "black" because the goddess wore black raiment. However, they neither remember who was responsible for fashioning the image nor what was the manner in which it caught fire. But when the ancient image was destroyed, the Phigalians not only did not provide the goddess with another image but they neglected her many festivals and sacrifices, until finally barrenness fell upon the land.

[8] Bearing – Greek *schema*, possibly referring to the format which was later reproduced in Onatas's statue.

[*The Phigalians consulted the oracle at Delphi about the cause of the blight, and were told that it would be alleviated if they restored to Demeter her former honors*].

When the Phigalians heard the oracular response that was brought back, they made the other offerings in such a way as to give Demeter even greater honor than she had had before, and they also persuaded Onatas the Aeginetan, the son of Mikon, to make the image of Demeter for them at as great a price as he asked. The people of Pergamon have a bronze Apollo by Onatas, and it is a great marvel among them both because of its size and its art. This artist then, discovering a picture or a copy of the ancient wooden image – but guided even more, as it is said, by visions he had in dreams – made the image for the Phigalians in the generation after the invasion of Greece by the Medes. For this reckoning my evidence is as follows: at the time when Xerxes made his crossing into Europe, Gelon the son of Deinomenes was reigning as tyrant over the Syracusans and over the rest of the Sicilians as well. When Gelon died [478 B.C.], the rule passed on to Hieron, the brother of Gelon. When Hieron died [467/6 B.C.] before he could set up the offerings to Olympian Zeus which he had vowed for his victories in the horse races, Deinomenes the son of Hieron set them up on behalf of his father. These too are works of Onatas, and there are inscriptions at Olympia, one of which, the one above the offering, reads:

> In your holy games, Olympian Zeus, having been victorious
> Once in the four horse chariot, twice with a single horse,
> Hieron offered these gifts to you. His son set them up,
> Deinomenes, as a memorial to his Syracusan father.

The other inscription reads:

> The son of Mikon, Onatas fashioned me,
> Who has his home on the island of Aegina.

Thus the age of Onatas coincides with that of Hegias the Athenian and Ageladas the Argive.

It was mainly on account of this Demeter that I came to Phigalia . . . But this image which was made by Onatas no longer existed in my time, and most of the Phigalians were not aware that it had ever existed at all. The oldest man of those with whom I happened to converse said that in the third generation prior to his own, rocks from the roof had fallen on the image; it was smashed by these, he said, and completely destroyed. And in fact, I could still see clearly the place in the roof where the rock had broken away.

***Anthologia Graeca* 9.238** (epigram by Antipater of Thessalonike, perhaps connected with the statue of Apollo at Pergamon mentioned in the previous passage):

> Apollo is a hulking youth in this bronze by Onatas,
> A testimony of beauty for Leto and Zeus,

Proclaiming that Zeus did not love her in vain, and
 that, as the saying goes,
The eyes and head of the son of Kronos are glorious;
Not even to Hera is it hateful, this bronze which Onatas
 cast and
Which he modelled in this way with the help of Eileithyia.

Pausanias 5.25.12 (a statue of Herakles at Olympia): The Thasians . . . set up a statue of Herakles at Olympia, the base as well as the image being of bronze. The height of the image is ten cubits; it has a club in the right hand and a bow in the left . . . On the image of the Thasians at Olympia there is the following elegiac couplet:

The son of Mikon, Onatas, fashioned me,
 The one who has his home in Aegina.

This Onatas, though the style of his statues is that of Aegina, I will class as inferior to none of the sculptors who are descendants of Daidalos and belong to the Attic school.[9]

Pausanias 5.27.8 (a statue of Hermes at Olympia): The Hermes who carries a ram under his arm and has a leather cap perched on his head, and is also clad in a tunic and travelling cloak . . . has been given to the god by the Arcadians of Pheneos. Onatas the Aeginetan, and along with him Kalliteles, made it, according to the inscription. I assume that Kalliteles was either a pupil or a son of Onatas.

Pausanias 10.13.10: The Tarentines sent another tithe to Delphi from the spoils of their war with the barbarian Peuktians. The offerings were the work of Onatas the Aeginetan . . .[10] The statues represent foot-soldiers and horsemen, and also King Opis of the Iapygians who came as an ally of the Peuktians. This man is represented as having perished in battle, and over his prostrate body stand the hero Taras and also Phalanthos, the Lakedaimonian, not far from whom is a dolphin. For they say that before he reached Italy, Phalanthos was shipwrecked in the Krisaian sea and was carried to shore by a dolphin.

Pausanias 5.25.8 (at Olympia): There are also offerings made by the whole Achaean race in common: [these are statues of] those who, after Hector offered to fight a Greek champion in single combat, awaited the outcome of the lot for

[9] "School" – *ergasterion*, literally "workshop." Daidalos was an Athenian, and in this passage the "Daidalidai" and the sculptors of Attica are apparently synonymous. But elsewhere, as we have seen, Pausanias classifies non-Attic sculptors, such as Dipoinos and Skyllis, among the Daidalidai.

[10] Omitted here is a phrase in the text which is problematic. As it stands it apparently refers to a co-worker named Kalynthos. No artist by that name is known, although an offering from the Athenian Acropolis was dedicated (not made) by a man named Kalynthos. See Raubitschek, *Dedications*, no. 279, pp. 299–301, 509. Others have emended the text to read Kalliteles; or possibly Ageladas, who also worked on a Tarentine votive at Delphi.

the contest [*Iliad* 7.170–200]. They stand near the great temple armed with spears and shields. Opposite them on another base Nestor is represented, casting the lot of each into the helmet. Those who are drawing lots for the combat with Hector are eight in number – for the ninth, the one of Odysseus, was carried off to Rome, they say, by Nero – and of the eight, the only one with the name inscribed on it is that of Agamemnon. The inscription runs, moreover, from right to left. The figure whose shield-device is a rooster is Idomeneus, the descendant of Minos. Idomeneus' lineage stems from Helios the father of Pasiphaë, and they say that the rooster is sacred to Helios and announces when Helios is about to rise ... As to who the sculptor was, this is written on the shield:

> Many other works, and this one too, are by skillful Onatas,
> The Aeginetan, the son whom Mikon bore.

Glaukias of Aegina

Pausanias 6.9.4–9 (statues of victorious athletes at Olympia): ... They say that the chariot was an offering of Gelon who was the tyrant in Sicily. The inscription on it says that Gelon, the son of Deinomenes, of Gela, set it up, and the time of this victory by Gelon was the 73rd Olympiad. [488 B.C.; Pausanias proceeds to offer reasons for his belief that the Gelon who dedicated the chariot was not the Syracusan tyrant] ... Glaukias the Aeginetan made the chariot and the statue of Gelon himself ... Next to the chariot of Gelon is a statue of Philon, a work of the Aeginetan Glaukias. For this Philon, Simonides the son of Leoprepes composed a skillful elegiac couplet:

> My fatherland is Corcyra, Philon is my name.
> Of Glaukos I am
> The son and I won two Olympic victories in boxing.

Pausanias 6.10.1–3: ... After those that I have enumerated stands Glaukos of Karystos. They say that he was originally from Anthedon in Boeotia and was descended from the line of Glaukos, the sea-deity. This Karystian was descended from Demylos, and they say that he started out as a farmer. When one day the ploughshare fell off the plough, he proceeded to fit it back on the plough using his fist instead of a hammer. Demylos happened to witness the feat performed by his son and as a result took him to Olympia to fight in the boxing matches. There Glaukos, having no experience in the fine points of boxing, was being wounded by his antagonists, and when he was boxing with the last of them, it was expected that he would give in owing to the number of his injuries. His father, they say, then shouted, "Son, the plough-punch!" Then he dealt his antagonist an even more violent blow and immediately won the victory. He is said to have won other victory wreaths as well, twice at the Pythian games, and eight times at both the Nemean and Isthmian games. The son of Glaukos set up

this statue of him, and Glaukias the Aeginetan made it. The statue represented him as if he were shadow-boxing, because Glaukos was one of the smoothest boxers of his time.

Another work by Glaukias is an image at Olympia of the athlete and hero Theagenes of Thasos. Exactly when Theagenes lived is not clear, and Glaukias's image may have been made long after the death and heroization of the athlete. If that was the case, it may have been more in the nature of a cult image than a votive portrait. Pausanias's story of Theagenes' life and death is included here because it tells us something about the popular reaction to the power of images in the Archaic period.

Pausanias 6.11.2–9: Not far from the kings just discussed stands Theagenes the Thasian, son of Timosthenes. The Thasians say that Theagenes was not really the son of Timosthenes, but that Timosthenes was a priest of the Thasian Herakles and that an apparition of Herakles had intercourse with the mother of Theagenes, coming to her in the likeness of Timosthenes. They say that at the age of nine, as he was on his way home from school, he came upon a bronze image of some god or other set up in the agora and took such delight in the image that he pulled it off its base, put it on one of his shoulders, and took it with him. The citizens were angry at him for what he had done, but one man among them, who was advanced in years and wise, counseled them not to kill the boy and ordered him to bring the image back from his home and to reinstall it in the agora. He brought it back as bidden; the fame of the boy for his strength quickly became widespread, for the deed was proclaimed all over Greece. [A list of Theagenes' athletic victories follows] . . . When he died, a man who had been one of his enemies while he was alive came to the image of Theagenes every night and flogged the bronze as though he were causing pain to Theagenes himself. The statue finally put an end to this hybris by falling on the man and killing him, but subsequently his children proceeded to prosecute the image for murder. So the Thasians dumped the statue into the sea, following the judgment of Drakon, who, when he wrote laws dealing with homicide for the Athenians, banished even non-living things if any of them, in falling, happened to kill a man. After a time, however, when the earth yielded no crops to the Thasians, they sent envoys to Delphi, and the god responded by telling them that they should receive back their exiles. But although in obedience to this advice they received them back, they obtained no relief from the famine. Therefore they went for a second time to the Pythian priestess, saying that, although they had done what was commanded of them, the wrath of the gods was still upon them. Thereupon the Pythia answered them:

"You leave unremembered your great Theagenes."

And they say that when they were at their wits' end as to a means by which they could rescue the statue of Theagenes, some fishermen, after putting out to sea in search of fish, caught the statue in their net and brought it back to the land. The

Thasians set the statue up where it originally stood, and they now have the custom of worshipping him as if he were a god. I know of many places, both among the Greeks and among the barbarians, where they have installed images of Theagenes and where he cures plagues and receives honors from the local inhabitants. The statue of Theagenes in the *Altis* is the work of Glaukias the Aeginetan.

Anaxagoras of Aegina

Pausanias 5.23.1–3 (a statue of Zeus at Olympia): As you go by the entrance to the *Bouleuterion* there stands a statue of Zeus which has no inscription, and again, turning to the north, there is another image of Zeus. This one faces the rising sun; the Greeks who fought against Mardonios and the Medes at Plataea set it up. On the right side of the base, the names of the cities which took part in the action are inscribed. [A list of these cities follows] . . . This image which was set up at Olympia by the Greeks was the work of Anaxagoras of Aegina. Those who have written about Plataea have neglected to make mention of this artist in their accounts.

Pausanias's last remark may refer to Herodotos 9.81, who, in discussing the spoils from the battle of Plataea, notes:

. . . a tithe was taken for the god at Olympia . . . from which a bronze statue of Zeus, ten cubits high, was set up . . .

Antenor of Athens

Antenor and Hegias seem to have been the foremost Athenian sculptors of the Late Archaic period. One of Antenor's works, a kore *from the Acropolis of Athens, survives[11] and is usually dated to around 530–520 B.C. His most famous works were statues of the Tyrannicides, Harmodios and Aristogeiton, who slew Hipparchos, the brother of the tyrant Hippias, in 514 B.C. Antenor's group was presumably set up after 509 B.C., when the democratic government designed by Kleisthenes replaced the tyranny of the Peisistratids.*

Pausanias 1.8.5 (part of his description of the Athenian agora): Not far away stand figures of Harmodios and Aristogeiton who slew Hipparchos . . . Of these statues, one group is the work of Kritios [see p. 43], while Antenor made the older group. Xerxes, when he took Athens after the Athenians had evacuated it, carried off the latter group as spoils, but Antiochos later sent it back to the Athenians.[12]

[11] Richter, *Korai*, no. 110; Boardman, *Archaic Period*, fig. 141.
[12] Pliny, *N.H.* 34.70, and Arrian 3.16.7, 7.19.2, say that Alexander restored the statues to Athens. Valerius Maximus 2.10, ext. 1, says it was Seleukos. None of these writers mentions Antenor by name.

Menaichmos and Soidas of Naupaktos

Pausanias 7.18.8–10: On the acropolis at Patras there is a sanctuary of Artemis *Laphria*. The name of the goddess is foreign, and the image too was brought in from the outside. For Kalydon as well as the rest of Aitolia was desolated and evacuated by the Emperor Augustus in order that the Aitolian population could be incorporated into Nikopolis above Actium, and, as a result, the people of Patras got possession of the image of Artemis *Laphria*. As was the case with the population, so too most of the statues from Aitolia and Akarnania were taken to Nikopolis, but to the people of Patras, along with the other spoils from Kalydon, Augustus gave the image of *Laphria*, which was still receiving honors on the acropolis of Patras in my own day . . . The image represents her as a huntress, and it is made of ivory and gold. It is the work of the Naupaktian sculptors, Menaichmos[13] and Soidas. The evidence indicates that these men were active not much later than the time of Kanachos of Sikyon and Kallon the Aeginetan.

[13] Pliny, *N.H.* 34.80, and in his index to book 34 mentions a sculptor named Menaichmos who *scripsit de sua arte*. If this Menaichmos is the same as the one referred to by Pausanias, he would be the earliest sculptor known to have written about his art.

Chapter 4

Sculpture: the Early Classical period
(*c.* 480–450 B.C.)

Kritios and Nesiotes

Although literary sources give little information about them, Kritios and Nesiotes were among the most influential pioneers of the Early Classical style in sculpture. Their most famous work, a bronze group representing the Athenian tyrannicides Harmodios and Aristogeiton, stood in the Agora of ancient Athens. The Marmor Parium, *an ancient chronological inscription probably dating from the third century B.C., assigns its dedication to the year 477 B.C. The group was frequently copied in the Roman period, and the appearance of the original can be reconstructed with reasonable certainty from the surviving fragments of copies. On the copies and their attendant problems, see Bibliography 24.*

Pausanias 1.8.5: Not far off are the figures of Harmodios and Aristogeiton who slew Hipparchos. The reason for this deed and the way it was done have been told by others.[1] Of these statues one group is the work of Kritios, while Antenor made the older group [see p. 41].

Lucian, *Philopseudes* 18: As you are entering, pass by the statues on the right, among which stand the Tyrannicides, the figures by Kritios and Nesiotes.

Pausanias 1.23.9 also mentions a statue on the Acropolis in Athens of an Athenian named Epicharinos, who had won a victory in the foot races for armed warriors. Pausanias mentions only Kritios, but the inscribed base of the work survives and bears the signatures of both Kritios and Nesiotes. See Raubitschek, Dedications, pp. 124–5, 513–17.

Pythagoras of Rhegion

Pythagoras was apparently one of the Samians who migrated in 496 B.C. to Zankle (modern Messina) and came under the sway of the tyrant Anaxilas of Rhegion

[1] Thucydides 1.20; 6.54–8.

(Herodotos 6.23–5). It was probably this change of residence that gave rise to the tradition that there were two sculptors named Pythagoras, one from Samos and one from Rhegion. Pythagoras is cited by Pausanias as the sculptor of a statue at Olympia representing a boxer named Euthymos (Pausanias 6.6.6). Although Pausanias does not call the sculptor "Pythagoras of Rhegion" in this passage, he does seem to be referring to the same artist whose work he describes and praises in 6.4.3 (see below). The base of the statue of Euthymos has been found at Olympia, however, and on it Pythagoras signs himself as "the Samian" (see Loewy, IgB, no. 23).

Many of the works of Pythagoras seem to have represented athletes from the Greek cities of Italy and Sicily who had been victors in various athletic festivals.

On his role as a theorist about proportions and composition, his place in ancient art criticism, and the attribution of surviving works to him or to his influence, see the Introduction, p. 8 and Bibliography 25.

Pliny, N.H. 34.59: Pythagoras from Rhegion, in Italy, surpassed him [Myron] with his pankratiast, which was set up in Delphi . . . and his Leontiskos.[2] He also made a statue of the runner Astylos, which is on display at Olympia, and also in that place a Libyan [and] a boy holding a whip,[3] and a nude figure bearing apples; likewise at Syracuse there is the figure of a lame man which makes people who look at it actually feel the pain of its sore; also an Apollo transfixing the serpent with his arrows, and a man playing the *kithara*, a work which is called "the just," because, when Alexander captured Thebes, a sum of gold that was hidden in a fold in its garment by a fugitive remained undisturbed. Pythagoras was the first to represent sinews and veins, and he was more exact in his representation of the hair.

There was another Pythagoras, a Samian, who was initially a painter. His statues of seven nude figures and an old man which stand by the temple of Today's Fortune [in Rome] are much praised. It is recorded that he resembled the above-mentioned Pythagoras in appearance to the point of being indistinguishable . . .

Diogenes Laertios 8.46: Some say that there was another Pythagoras, a Rhegian sculptor, who seems to have been the first to aim at *rhythmos* and *symmetria*, and that there was yet another sculptor [of that name], a Samian.

Some of the statues referred to by Pliny in the first passage were also seen by Pausanias.

Pausanias 6.13.1 (the statue of the runner Astylos at Olympia): The statue of Astylos of Kroton is the work of Pythagoras. He won victories in three successive Olympiads in the one-stade dash and in the double-length race. Because however, on the occasion of the latter two victories, he proclaimed

[2] As the text stands Pliny says at this point "with the same work he also surpassed Leontiskos." Leontiskos was actually an athlete whose statue was made by Pythagoras (see Pausanias's reference to the work, below), not an artist. Either the text is faulty or Pliny misinterpreted his sources.

[3] Reading *et puerum tenentem flagellum*, as suggested by Stuart Jones.

himself a Syracusan in order to win the favor of Hieron the son of Deinomenes, the people of Kroton condemned his house to be a prison and pulled down his statue, which stood by the temple of Hera *Lakinia*.

Pausanias 6.4.3–4 (the wrestler Leontiskos): . . . there is a statue of Leontiskos, a wrestler in the men's competition, who was a Sicilian by birth and came from Messene on the Strait. It is said that he was crowned by the Amphiktyones and twice by the people of Elis, and that his style of wrestling was like that of Sostratos of Sikyon in the *pankration*. For it is said that Leontiskos did not know how to throw his opponents in wrestling but that he won by bending their fingers. The statue is by Pythagoras of Rhegion (and if ever there was an artist gifted in the art of modelling, it was he). They say that he was pupil of Klearchos [see p. 21], who was also from Rhegion and was a pupil of Eucheiros. Eucheiros is said to have been a Corinthian and to have learned at the school of the Spartans Syadras and Chartas.

One or both of the following are presumably connected with the Libyan mentioned by Pliny.

Pausanias 6.13.7: By the side of Bykelos stands a statue of a man in armor, Mnaseas, called "the Libyan," from Cyrene. Pythagoras of Rhegion made the statue.

Pausanias 6.18.1: There is also a bronze chariot of Kratisthenes of Cyrene, and mounted on the chariot are a figure of victory and Kratisthenes himself. Obviously his victory occurred in the chariot races. It is said that Kratisthenes was the son of Mnaseas the runner, who was called "the Libyan" by the Greeks. His votive offerings at Olympia are the work of Pythagoras of Rhegion.

Other statues of athletes at Olympia by Pythagoras represented a boxer in the boys' competition named Protolaos (Pausanias 6.6.1), a runner named Dromeus (6.7.10), and, as already noted, a boxer named Euthymos who was victorious in the 74th Olympiad, i.e., 484 B.C. (6.6.4–6).

It has been suggested by Urlichs (1857) (Bibliography 3A) that the "seven nude figures" mentioned by Pliny were part of a group representing the Seven against Thebes and that the figures of Eteokles and Polyneikes mentioned by Tatian were part of that group.

Tatian, *Oratio ad Graecos* 34.1 (ed. Whittaker): Is it not a disgrace that you have honored fratricide among yourselves, you who look at the representations of Polyneikes and Eteokles, and that you have not destroyed these memorials of evil by burying them along with their maker, Pythagoras?

Another suggestion[4] is that the "lame man" mentioned by Pliny was a statue of Philoktetes and that the following epigram from the Greek Anthology, which describes a bronze statue of Philoktetes, refers to the statue by Pythagoras.

[4] Elaborated in detail by Lechat in *Pythagoras de Rhégion*. See Bibliography 25.

Anthologia Graeca 16.112:

My enemy above all the Danaans is the sculptor who made me,
 another Odysseus,
who reminds me of my trouble and baneful sickness.
Not sufficient were the rocks, the tattered garment, the gore, the
sorrow,
but he has also worked even the pain into the bronze.

Varro, de Lingua Latina 5.31: The word "Europe" comes from Europa the
daughter of Agenor, whom as Mallius writes, the bull carried off from
Phoenicia; Pythagoras made a remarkable image in bronze of this scene in
Tarentum.

Dio Chrysostom, Or. 37.10 (comparing later statues to those of Daidalos): All
these [statues] remain in their position and place unless someone moves them;
the bronze of which they are constituted is incapable of movement, even though
possessed of wings, as in the case of the Perseus of Pythagoras.

√ Kalamis

*Kalamis, apparently an Athenian, was given an important place in the late Hellenistic
comparative canon of sculptors (see pp. 222–23).*

*A number of scholars believe that there were two artists named Kalamis, one a
sculptor active in the second quarter of the fifth century B.C. and the other a silversmith
and sculptor who was active in the fourth century B.C. and who may have been the
grandson of the Elder Kalamis. On Kalamis the silversmith, see below, p. 234; for
passages which may reasonably be said to refer to the younger Kalamis, see p. 94 and
footnote 32). See also the views of Reisch, Studniczka, Thompson, Raubitschek, and
Hedrick in the Bibliography 26.*

*The following passages clearly or probably refer to the sculptor of the Early Classical
period:*

Pausanias 6.12.1 (another votive at Olympia): Nearby is a bronze chariot and a
man mounted on it; race-horses stand by the chariot, one on each side, and there
are children seated on the horses. These are memorials to the Olympic victories
of Hieron the son of Deinomenes, who ruled as tyrant over the Syracusans after
his brother Gelon. But Hieron did not send these offerings: rather it was
Deinomenes, the son of Hieron, who gave them to the god. The chariot was the
work of Onatas of Aegina, while the horses on either side of it and the children
upon them are the work of Kalamis.[5]

[5] Although we have classed Onatas among the Late Archaic sculptors, his career lasted into the
Early Classical period. Kalamis was clearly a younger contemporary of Onatas, perhaps even a
pupil.

Pausanias 5.25.5 (a votive at Olympia set up by the city of Akragas [modern Agrigento]): On the cape in Sicily which is turned toward Libya and the south, the cape called Pachynos, is the city of Motye. The people who dwell in it are Libyans and Phoenicians. It was against these foreigners in Motye that the people of Akragas waged war, and, when they took booty and spoils from them, set up at Olympia bronze statues of boys, who hold out their right hands and are hence depicted as if they were praying to the god. These figures are placed on the wall of the *Altis*. I supposed that they were the works of Kalamis, and the tradition about them supports my suppositions.

Lucian, in his Imagines, *envisions a woman of perfect beauty, whom he calls "Panthea." He derives the features that he would attribute to her from famous statues, among them the "Sosandra" ("Savior of Men") of Kalamis. This figure, as Lucian tells us (Imag. 4), stood on the Acropolis of Athens and may be identical with the figure of Aphrodite by Kalamis that Pausanias saw on the Acropolis. The Aphrodite in question was dedicated by Kallias, a wealthy Athenian citizen who married Elpinike, the sister of the Athenian political leader Kimon, and paid off a substantial fine that had been incurred by Kimon's father, Miltiades, the hero of Marathon. (See Herodotos 6.136; Plutarch, Life of Kimon 4.) By paying this fine, Kallias was perhaps viewed as the saviour of the family of Kimon, and the statue of Aphrodite may have been set up to commemorate this fact.*

Pausanias 1.23.2: When Hipparchos [the son of Peisistratos] died – and what I am saying has never before come to be written down but is generally believed by many Athenians – Hippias tortured and killed [an Athenian woman named] Leaiana ["Lioness"], knowing that she was the mistress of Aristogeiton and believing that there was no way in which she could have been ignorant of the plot. In reaction to this, when the tyranny of the Peisistratids came to an end, the Athenians set up a bronze lioness as a memorial to the woman, next to the image of Aphrodite, which, they say, was a dedication of Kallias and a work of Kalamis.

Lucian, *Imagines* 6: The Sosandra and Kalamis shall adorn her with modesty, and the holy and inscrutable smile will also be like hers, and the simplicity and orderliness of her dress shall also come from the Sosandra, except that her head shall be left uncovered.

Lucian, *Dialogi Meretricii* 3.2 (one courtesan criticizes a young man's admiration of another courtesan): Diphilos praised lavishly her rhythmic movements and the way she led the dance, and how well her step followed the *kithara*, how fair her ankle was, and ten thousand other things, as if he were praising the Sosandra of Kalamis, and not Thaïs.

The following passages could conceivably refer to either the older or the younger Kalamis. The most controversial of them is Pausanias's reference to a statue of Apollo Alexikakos in the Athenian Agora.

Pausanias 1.3.4: In front of the temple [of Apollo *Patroös*] there is a statue of Apollo . . . which they call *Alexikakos* ["the Averter of Evil"], made by Kalamis. They say that this name became associated with the god because, by means of an oracle from Delphi, he stayed the plague which afflicted them during the Peloponnesian War.

The plague referred to by Pausanias occurred in the early 420s B.C., a date which would seem to be too late for a sculptor who was mainly active in the Early Classical period. Some assume that Pausanias is mistaken in this passage and that the Apollo Alexikakos *was set up in the wake of some earlier plague (e.g., Thompson (1937), Bibliography 26); others argue that the statue was made in the fourth century B.C., when a major temple to Apollo* Patroös *was constructed in the Agora of Athens (e.g., Hedrick (1988), Bibliography 26).*

Strabo 7.6.1 (a colossal Apollo in Apollonia on the Black Sea): Apollonia, a colony of the Milesians . . . has on a certain island a sanctuary of Apollo, from which Marcus Lucullus took away the colossal statue of Apollo, a work of Kalamis, and set it up on the Capitol.

The Apollo from Apollonia also seems to be referred to by Pliny, N.H. 34.39 and by Appian, Illyrica *30 and to be pictured on the coinage of Apollonia (Lacroix,* Reproductions, *pl. 20.6–9).*

Pausanias 2.10.3 (an image of Asklepios at Sikyon): As you enter you see the god, who is beardless, a work executed in gold and ivory by Kalamis. He holds a scepter in one hand and the cone of the cultivated pine tree in the other.

Pausanias 5.26.6 (a statue of Nike [Victory] at Olympia): Beside the Athena there is a statue of Nike. The Mantineans set it up, but they do not make clear in the inscription what war it commemorates. Kalamis is said to have made it without wings, in imitation of the wooden statue in Athens called "the wingless."

Pausanias 9.22.1 (a statue of Hermes in Tanagra): There are also sanctuaries of Hermes the "Ram-bearer" and of Hermes whom they call the "Vanguard." With regard to the former name, they relate that Hermes warded off a plague from them by carrying a ram around the city wall; to commemorate this event Kalamis made an image of Hermes carrying a ram on his shoulders.

(For representations on coinage, Lacroix, Reproductions, *pl. 20.4.)*

Myron of Eleutherai

Pliny, N.H. 34.57–8: Myron, who was born at Eleutherai, and was a pupil of Ageladas, was most renowned for his statue of a heifer, a work which is praised in well-known verses – for many people gain their reputations through someone else's inventiveness rather than their own. He also made a dog, a

Discus-thrower, a Perseus and the sea-monsters,[6] a Satyr marvelling at the flutes, and an Athena,[7] contestants in the *pentathlon* at Delphi, pankratiasts, and a Herakles which is now in the round temple of Pompey the Great[8] in the Circus Maximus. He also made a monument to a cicada and a locust, as Erinna indicates in her poem.[9] He also made an Apollo which was carried off by the Triumvir Antony but restored again by the deified Augustus after he was warned in a dream. Myron seems to have been the first to extend the representation of reality;[10] he used more compositional patterns in his art than Polykleitos[11] and had a more complex system of symmetry;[12] he too, however, though very attentive as far as the bodies were concerned, failed to express a sense of inner animation; moreover he did not render the hair and the pubes any more perfectly than the rude art of an earlier period had.

Of the various works of Myron mentioned by Pliny, the "Discus-thrower" (Diskobolos), *which has been reconstructed with considerable accuracy from a series of Roman copies, is the best known today. Lucian's brief but valuable description of its composition helps to confirm the attribution of the copies.*

Lucian, *Philopseudes* 18: Surely, I said, you do not speak of the discus-thrower, who is bent over into the throwing position, is turned toward the hand that holds the discus, and has the opposite knee gently flexed, like one who will straighten up again after the throw? Not that one, he said, for the *Diskobolos* of which you speak is one of the works of Myron.

Quintilian, *Institutio Oratoria* 2.13.8–10: It is often expedient to make variations in some established, traditional order and it is occasionally fitting to do so, as, for example, when we see the dress, face, and pose varied in statues and

[6] Latin *pristes*; another reading is *pristas*, "sawyers." If sea monsters is correct, the reference may be to the story of Perseus and Andromeda. It is possible that the *pristes* or *pristas* refer to a separate work, not connected with the Perseus and Medusa of Myron seen by Pausanias (1.23.7) on the Athenian Acropolis.

[7] Many scholars have assumed that the Satyr marvelling at the flutes and the Athena were a group, i.e. Athena and Marsyas, and that the group is preserved in Roman copies, primarily in a satyr type in the Vatican and an Athena type of which one of the best replicas is in Frankfurt. For a composite reconstruction see Richter, *SSG*, figs. 621–31. Others dispute the validity of this reconstruction. See Bibliography 28c.

[8] This temple was dedicated to Herakles and was built by Pompey the Great.

[9] Pliny probably presents garbled information here derived from a poem in the *Greek Anthology* (7.190) which refers to a tomb for a pet locust and a pet cicada set up by a girl named Myro.

[10] Latin *multiplicasse veritatem*; *veritas* translates the Greek *aletheia*, which referred to a physical reality the nature of which was confirmed by objective measurement rather than simply by appearance.

[11] Latin *numerosior in arte quam Polyclitus*. Latin *numerus* translates the Greek *rhythmos*, "shape, pattern"; *ars* may translate *techne* and refer to the theoretical precepts which Myron applied to his art and by which he explained it.

[12] Latin *diligentior in symmetria*; *diligens* translates the Greek *akribeia* which refers to precision or exactness in the handling of minute details. The meaning of Pliny's phrase may be not that Myron's system of *symmetria* was superior to that of Polykleitos but that it involved more proportional measurements and fewer common denominators.

paintings. For indeed there is very little grace in a body which stands upright; the face, for example, looks straight ahead, the arms are allowed to hang down, the feet are joined, and the work as a whole is rigid from head to toe. But the familiar relaxed curvature and, as I might even call it, movement, provides a kind of liveliness and emotion. Therefore, the hands are not arranged in one manner alone, and there are a thousand varieties of expression in the face. Some figures have a sort of running or charging format, while others sit or recline. Some are nude, some are dressed, while others offer a mixture of both. What work is there which is as distorted and elaborate as that *Diskobolos* of Myron? But if anyone should criticize this work because it was not sufficiently upright, would he not reveal a lack of understanding of the art, in which the most praiseworthy quality is this very novelty and difficulty?

In Antiquity, however, the most famous work of Myron was the cow (or heifer), about which the verses mentioned by Pliny were written. The fame of this work is attested by the fact that there are, in addition to other references, thirty epigrams about it preserved in the Greek Anthology *(9.713–42). A selection of them is given here. Most of them, as will be seen, praise the statue's realism.*

Anthologia Graeca 9.717, by Euenos:

> Either a hide completely of bronze provides the covering for
> a real cow, or the bronze has a soul within it.

Anthologia Graeca 9.734, by Dioskorides:

> O bull, in vain do you nudge this heifer. For it is lifeless;
> Myron, the cow-sculptor, has deceived you.

Anthologia Graeca 9.731, by Demetrios:

> It was Myron who thus set me up – a young cow,
> and the shepherds throw stones at me, as if I were left behind.

Anthologia Graeca 9.737, by Julianus of Egypt:

> It is a bronze heifer that you strike. Greatly has art tricked you,
> O shepherd – Myron did not put the soul within it.

Anthologia Graeca 9.793, by Julianus of Egypt:

> Seeing the heifer of Myron you would quickly cry out:
> Nature is lifeless but art is alive.

Anthologia Graeca 9.738, by Julianus of Egypt:

> In this cow Nature and Lady Art waged a battle.
> And Myron bestowed the prize on both equally,
> For to those who behold it, Art has stolen the power of Nature,
> But to those who touch it, Nature is Nature.

Myron's fame as a sculptor of animals is also reflected in the following passages:

Propertius 2.31.7–8:

> And around the altar stood the herd of Myron,
> Four cows, made by art, statues full of life.

Petronius, *Satyricon* 88: Myron, who could almost capture the spirits of men and animals in bronze, found no heir.

As the two preceding passages indicate, Myron's sculpture was exceptionally popular with the Romans, and a number of his works were carried off to Rome and given prominent places there.

Strabo 14.1.4 (in the temple of Hera on Samos): Three colossal structures by Myron were set on a single base; these were carried off by Antony, but Augustus Caesar set two of them up again on the same base, the Athena and the Herakles. The Zeus, however, he transferred to the Capitoline and made a shrine for it there.

Cicero, *in Verrem* 2.4.3.5–7 (concerning a shrine belonging to Heius Mamertinus, which was plundered by Verres): Indeed, to get back to the shrine, there was a statue there, of which I speak, a Cupid made of marble, and in the opposite part there was a Herakles, an outstanding work, made of bronze. This was said to be a work of Myron . . . [Sec. 7] All these statues that I have mentioned, Verres carried off from the shrine of Heius.

Cicero, *in Verrem* 2.4.43.93: Did you not carry off from the very holy shrine of Aesculapius in Agrigentum a monument of the same Publius Scipio, a beautiful statue of Apollo, on the upper leg of which the name of Myron was inscribed in small silver letters?

Pausanias 9.30.1 (on Mt Helikon): Sulla set up the standing image of Dionysos, which, among the works of Myron, is the most worthy of note after the Erechtheus in Athens; the statue which he [Sulla] set up was not from his own resources; he took it from the Minyai of Orchomenos. This is an example of the saying among the Greeks: "to worship the divine with other people's incense."

Myron also did a number of victorious athletes, which were seen by Pausanias. Since little information, other than the names of the athletes, is given, we omit the text of these references.[13] *One statue, however, that of an athlete named Ladas, was the subject of an interesting anonymous elegiac poem (here translated in prose) in the* Greek Anthology.

***Anthologia Graeca* 16.54:** As you once were, O Ladas, full of life, when you left behind wind-swift Thymos, straining your sinews as you ran on the tip of your

[13] Pausanias 6.2.2 (Lykinos of Sparta, winner in the horse races); Paus. 6.8.4 (Timanthes of Kleonai in the *pankration*); Paus. 6.8.5 (Philippos of Pellana in the boys' boxing); Paus. 6.13.2 (Chionis the Lakedaimonian).

toes; so did Myron cast you in bronze, and stamp everywhere on your body your anticipation of the crown of Pisa.

He is full of hope; and on the edge of his lips the breath from his hollow flanks is visible; soon the bronze will leap for the crown, nor will the base be able to hold it back. Oh, art is swifter than a breath of wind.

On Myron's place in ancient art criticism see also pp. 3, 222, 228.

Telephanes

Nothing is known about the sculptor Telephanes other than what Pliny tells us; but, if his information is accurate, Telephanes may have been one of the outstanding sculptors of the Early Classical period.

Pliny, N.H. 34.68: Artists who have written composite volumes on this subject [sculpture and/or *toreutike*] extol with the highest praises one Telephanes of Phokis [or Phokaia],[14] who is otherwise unknown, because . . . [lacuna in text] he lived in Thessaly, and his works remained in obscurity there; nevertheless, by the testimony of these writers, he should be placed on an equal level with Polykleitos, Myron, and Pythagoras. They praise his Larisa, and his Spintharos, who was a victor in the *pentathlon*, and his Apollo. Others speculate that the cause of his lack of reputation is not this [that he lived in a remote area], but rather it is that he offered his services to the workshops of Kings Xerxes and Darius.

[14] The text says *Phocaeum* rather than *Phoceum*, which should mean that Telephanes was from Phokaia in Asia Minor rather than Phokis, but the text suggests that he was from central Greece.

Chapter 5

Sculpture: the High Classical period
(c. 450–400 B.C.)

In the second half of the fifth century B.C., Athens began to wield the same influence in the arts that she was beginning to wield in literature, philosophy, and politics. Under the political hegemony of Pericles (c. 461–429 B.C.), a grand rebuilding program was undertaken to replace the monuments of Athens that had been destroyed in the war with the Persians. The overseer of Pericles' building program was the sculptor Pheidias (on the Periclean building program see also under architecture, pp. 187–93).

Pheidias

Pheidias's personal contribution, other than being general overseer, to the Periclean building program, was to make the great gold and ivory cult statue of Athena for the Parthenon. *In doing so, he ran into opposition from Pericles' political enemies.*

Plutarch, *Life of Pericles* **13.4–9 (excerpts):** The man who directed all the projects and was the overseer for him [Pericles] was Pheidias, although individual works were executed by other great architects and artists . . . Pheidias himself worked on the golden image of the goddess, and his name is inscribed as the artist on the stele.[1] Almost everything was under his supervision, and, as we have said, he was in charge, owing to his friendship with Pericles, of all the other artists. This brought envy against the one and, against the other, slander to the effect that Pheidias was in the habit of procuring for Pericles free-born women who visited the building site.

Plutarch, *Life of Pericles* **31.2–5:** Pheidias the sculptor was commissioned to make the cult statue, as we have already said. Because he was a friend of Pericles and had considerable influence with him, he made a number of jealous enemies. These enemies decided to test the populace by bringing a charge against Pheidias, in order to find out what the popular judgment would be against Pericles. Accordingly they persuaded a certain Menon, one of Pheidias's co-

[1] Just what stele is not clear. The reference may be to the base of the statue.

workers, to sit down in the Agora as a suppliant and beg for immunity in return for giving information and making a charge against Pheidias. The man was received as a witness by the people, and an inquiry was held in the assembly, but acts of theft were not proven. For right from the very beginning and on the advice of Pericles, Pheidias had so worked and put in place the gold for the image that it was quite possible to remove it and test its weight. And this is what Pericles challenged his accusers to do.

But it was the reputation of his works that aroused jealousy against Pheidias, and particularly the fact that, in making a relief of the battle of the Amazons on the shield [of the Athena *Parthenos*], he included a figure of himself as a bald old man lifting up a stone with both hands and a very handsome portrait of Pericles fighting against an Amazon. The position of Pericles' arm, however, which holds up a spear in front of his eye, is ingeniously contrived for the purpose, it would appear, of concealing the likeness which is only visible on either side.[2]

Pheidias was ultimately led away to prison and died of a disease, or, as some say, by poison, which had been prepared by the enemies of Pericles in order to bring a false accusation against him. As for the informer, Menon, on the motion of Glykon the populace gave him immunity and ordered the generals to guarantee the man's safety.

A different version of the trial and death of Pheidias is told by scholiasts writing on lines 605–9 of the Peace *of Aristophanes, which read:*

> First Pheidias began it all by acting ill
> and Pericles dreaded that he might be involved;
> He feared your tempers and the way you grind your teeth;
> So before the worst could come, he set ablaze a town,
> By throwing in the little spark, the Megarian decrees.[3]

Scholiast on Aristophanes' *Peace* 605: (First Scholiast) Philochoros[4] writing of the archonship of Theodoros[5] says as follows:[6] The gold image of Athena was set up in the great temple and had a weight of forty-four talents;

[2] Some of the free Roman copies of the shield do contain figures which fit this description. That the figures were really portraits of Pericles and Pheidias has been doubted, probably rightly, by a number of scholars (see Bibliography 29E, 2). The story may be a popular tradition of the Roman period, when portraits, of course, were commonplace. The tradition about the portraits is also recorded by Dio Chrysostom, *Or.* 12.6; Pseudo-Aristotle, *de Mundo* 399B; Valerius Maximus 8.14.6; and Apuleius, *de Mundo* 32.

[3] In 432 B.C. Pericles was responsible for a decree which forbade the Megarians access to any port allied to Athens. The decree had the effect of crippling Megara economically and was one of the contributing causes of the Peloponnesian War.

[4] Philochoros: an Athenian historian of the third century B.C. who specialized in Athenian history and politics. His work survives only in small fragments.

[5] The name given in the text is Skythodoros, but Theodoros is known to have been archon in 438 B.C.

[6] Just how much, if any, of what follows is a direct quotation from Philochoros is difficult to say. For a discussion of the question, see Jacoby, *Fragmente der griechischen Historiker* 3b (suppl.), Vol. 2 (Leiden 1954), pp. 391–401 (commentary on Philochoros, frag. 121).

Pericles was in charge, and Pheidias made it. And Pheidias, after he had made it, was tried for having embezzled some of the ivory which was used for the scales [of the snake represented with Athena]. Having gone into exile in Elis, he is said to have undertaken to make the image of Zeus at Olympia, and, after making it, to have been put to death by the Eleans in the archonship of Pythodoros,[7] who came seven years later. (**Second Scholiast**) Some say that when Pheidias the sculptor was convicted of having defrauded the city and was banished, Pericles, in fear because he had overseen the preparation of the statue and had known about the theft, proposed the Megarian decrees and brought on the war, in order that, with the Athenians concentrating their attention on the war, he would not have to submit his accounts to them for scrutiny . . . But the suspicion against Pericles seems groundless, since the affair about Pheidias occurred seven years prior to the beginning of the war. Pheidias, as Philochoros says, worked on the statue of Athena during the archonship of Pythodoros[8] and stole the gold from the snakes of the chryselephantine statue of Athena, an act for which he was condemned and punished by exile. He happened to be in Elis where he had taken on the commission to do the statue of Zeus at Olympia for the Eleans, and having been thus condemned by them,[9] he was put to death while in exile.

Pliny, *N.H.* 34.54: Pheidias, besides his Olympian Zeus, which no one can rival, also made an Athena of gold and ivory in Athens, the one which is in the *Parthenon* and is represented as standing; and, in bronze, besides the Amazon mentioned earlier [see p. 226] he made another Athena of such outstanding beauty that it has received the surname "the beautiful." He also made a "key-bearer"[10] and another Athena, which Aemilius Paullus dedicated in Rome in the temple of Today's Fortune, and also two statues in Greek dress which Catulus dedicated in the same temple, and another colossal nude figure; Pheidias is rightly judged to have opened up the art of *toreutike* and to have demonstrated it.[11]

[7] The text says "Skyphodoros," but no archon by that name is known. Pythodoros was archon in 432 B.C.

[8] The text says Pythodoros (432 B.C.), but the correct reading is perhaps Theodoros, whose archonship (438 B.C.) seems to coincide with the time when Pheidias finished the Athena *Parthenos* and went to Olympia.

[9] The "them" here is ambiguous but most likely refers to the Athenians, not the Eleans. The first scholiast's story to the effect that Pheidias swindled the Eleans as well as the Athenians seems unlikely. It probably reflects either the scholiast's misunderstanding of Philochoros or Philochoros's misunderstanding of the facts. The truth may be that Pheidias died in Elis while in exile, or that he subsequently returned from Elis to Athens to stand trial and died there.

[10] "Key-bearer" – Greek *kleidouchos*, possibly a priest or priestess (the key symbolized the control of a sanctuary) or a deity of whom the keys were an attribute, conceivably the Athena *Promachos* (see *infra*).

[11] *Toreutike*, as already noted, is the Greek term for the art of "chasing." It would seem, however, that Pliny uses the term in the broader sense of "sculpture" or at least "chryselephantine and metal sculpture." Since all Greek sculpture received a fine surface finish which necessitated the use of at least certain aspects of the technique of chasing, it may be that, in referring to the part, Pliny is thinking of the whole. For bibliography on this question and also for a dissenting opinion, see G. M. A. Richter, *AJA* 45 (1941) 375–83, and M. J. Milne, *ibid.* 390–8.

The Works of Pheidias

In the preceding passages mention has already been made of the most famous works of Pheidias – the gold and ivory statue of Athena Parthenos at Athens and the Zeus at Olympia. The question as to whether Pheidias executed the Zeus before or after the Athena was debated for many years, with cogent reasons being offered for both points of view. In the excavations of the workshop of Pheidias at Olympia in the 1950s, however, a number of molds on which some of the gold sheets of the statue were hammered were discovered and also fragments of pottery (including a black-glaze cup with what is held by some to be Pheidias's signature incised on the bottom). The style of these objects seems to prove once and for all that the Zeus was made after the Athena. On these finds, which have not yet been fully published, see Kunze (1959) and Mallwitz (1972) (Bibliography 29D). Both the Athena and the Zeus are mentioned many times in ancient literature. Some of the more informative passages follow.

THE ATHENA *PARTHENOS*

Pausanias 1.24.5–7 (in his description of the Athenian Acropolis): In the temple which they call the *Parthenon* . . . the cult image itself is made of ivory and gold. In the middle of her helmet there is placed an image of a sphinx . . . and on each side of the helmet griffins are represented . . . griffins are beasts which look like lions but have the wings and the beak of an eagle . . . The statue of Athena stands upright and wears a tunic that reaches to the feet, and on her breast the head of Medusa [i.e., the aegis], made of ivory, is represented. In one hand she holds a figure of Victory about four cubits high and in the other she holds a spear; at her feet is placed a shield, and near the shield is a serpent. This serpent would be Erichthonios. On the base the birth of Pandora is represented in relief. The poems of Hesiod and others tell how Pandora was the first woman. Before this Pandora the race of women had not yet come into being.

Pliny, *N.H.* 36.18–19: That Pheidias is extremely famous among all people who appreciate the reputation of his Zeus at Olympia, nobody doubts, but in order that those who have not seen his works may know that he is justly praised, I will offer some small points of evidence to prove how great his inventiveness was. To do this, I shall use as proof neither the beauty of the Zeus at Olympia nor the size of the Athena which he made at Athens (since she is 26 cubits high and is made of ivory and gold), but rather I shall use the battle of the Amazons which is carved in a circular pattern on the convex side of her shield; likewise on the concave side of it he represented the struggle of the gods and giants, and on her sandals that of the Lapiths and Centaurs, so fully did every part offer the opportunity for the application of his art. On the base is carved the scene which they call "the Birth of Pandora," with twenty gods present at the birth.[12] The

[12] Reading *dii adsunt nascenti* (Urlichs).

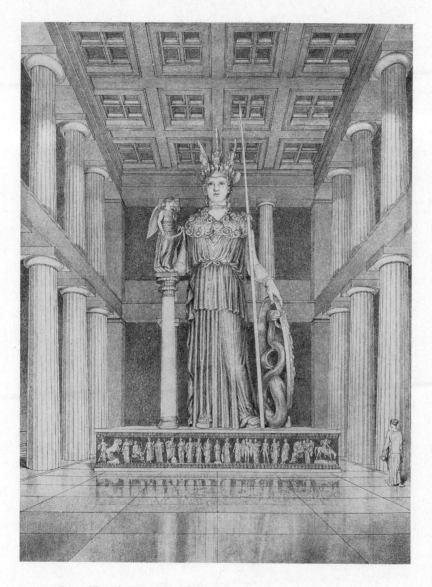

Fig. 2. The Athena *Parthenos* of Pheidias; restoration by Camillo Praschniker.

Victory is especially marvellous, but experts admire the serpent and also the bronze sphinx which is placed below the point of her spear.[13] Let these details, mentioned in passing, suffice concerning an artist who cannot be praised enough, and at the same time let them serve to indicate that his sense of grandeur was equal to the challenge even in small details.

The foregoing descriptions have made it possible to recognize small-scale versions of the Parthenos *in various media. In general, and for extensive illustrations, see Leipen,* Athena Parthenos *(Bibliography 29E).*

Thucydides 2.13.5 (part of Pericles' enumeration of the Athenian financial resources at the beginning of the Peloponnesian War): And he added still further the money from the other sanctuaries, no small sum, which they could use, and, if they should be completely cut off from all other resources, they could use the gold plates which were placed on the goddess herself. For the statue, he pointed out, had forty talents of pure gold, and it was all removable. This, he said, they could use for their own salvation, but afterwards they must not put back less than they took away.[14]

THE ZEUS AT OLYMPIA

The Zeus was perhaps the most highly venerated statue in the ancient world.

Pausanias 5.10.2: The temple and the image were offerings to Zeus from the spoils that the Eleans seized when they conquered Pisa and as many of the surrounding peoples as sided with the Pisans in the war.[15] Pheidias is reputed to have been the sculptor of the image, and as evidence of this, there is an inscription beneath the feet of Zeus which reads: "Pheidias, the son of Charmides, the Athenian, made me."

Pausanias 5.11.1–11: The god is seated on a throne made of gold and ivory. A garland, which is made to look like olive shoots, is placed on his head. In his right hand he holds a figure of Victory, also made of ivory and gold, who holds a fillet and has a garland on her head. In the god's left hand there is a scepter, which is inlaid with many kinds of metal; the bird which is seated on the top of the scepter is the eagle. The shoes of the god are of gold and so also is his robe. On the robe there are animate figures and also lily flowers represented. The throne is variegated with gold and stones, and still further with ebony and ivory. Upon it, moreover, there are painted figures and sculptured images. There are four

[13] Presumably a reference to the sphinx on the helmet.

[14] The gold was actually removed (and apparently never replaced) c. 297 B.C. by the Athenian tyrant Lachares, see Pausanias 1.25.7, Athenaios 11.405F.

[15] The particulars about this war are not known, but it is usually thought to have taken place not long before the construction of the temple. The Eleans conquered Pisa in c. 570 B.C., but this seems much too early for the war which led to the building of the temple. Perhaps the Elean campaigns against neighboring towns mentioned by Herodotos (4.148) are referred to here.

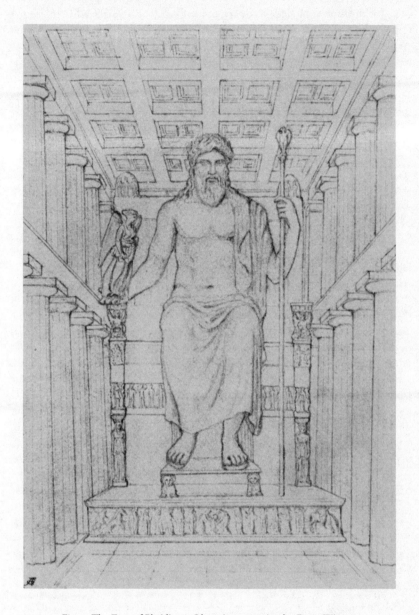

Fig. 3. The Zeus of Pheidias at Olympia; restoration by Franz Winter.

Victories, represented in the pose of dancers, on each leg of the throne, and two others at the foot of each leg. On each of the front feet are placed the children of the Thebans who are seized by sphinxes, and under the sphinxes Apollo and Artemis are shooting down the children of Niobe with arrows. Between the legs of the throne there are four bars, each one extending from one foot to the next. On the bar which directly faces the entrance there are seven sculptured images; the eighth of them has disappeared, but they do not know how. These must be representations of ancient contests, for the contests for boys[16] had not yet been instituted in the time of Pheidias. They say that the figure of a youth binding a fillet on his head resembles Pantarkes in appearance, the Elean youth who was the object of Pheidias's love. Pantarkes won a victory in the boys' wrestling contest in the 86th Olympiad [436 B.C.]. On the other bars there is a company of warriors which, along with Herakles, fights against the Amazons. The number of figures, taking both sides together, is twenty-nine, including Theseus, who is lined up among the allies of Herakles. There are not only legs supporting the throne, but also columns which stand between the legs and are equal [in size and number] to them. It is not possible to go underneath the throne [and enter it] in the same way that one enters the interior of the throne at Amyklai.

At Olympia there are fences constructed like walls which serve as barriers. Of these fences the section which is opposite the door is painted with a glaze of blue enamel; the rest of them have paintings by Panainos. Among them is Atlas holding up heaven and earth; Herakles stands by ready to take the burden from Atlas. Further along are Theseus and Peirithoös and also Hellas and Salamis, who has in her hand the ornament which goes on the ships' prows; from the ·labors of Herakles there is the battle with the Nemean lion, which is followed by the outrage against Kassandra committed by Ajax, Hippodameia the daughter of Oinomaos with her mother, and Prometheus, who is still bound in chains, although Herakles has climbed up to him. For this story is told about Herakles, namely, that he killed the eagle which was causing Prometheus agony in the Caucasus and that he freed Prometheus from his bonds. Finally there is a picture of Penthesileia giving up the ghost with Achilles there holding her up. There are also two Hesperidai who carry the apples which are said to have been turned over to their care. This Panainos [see p. 143] was the brother of Pheidias, and the *Battle of Marathon* in the Stoa *Poikile* in Athens was also painted by him. On the highest part of the throne, above the head of the image, Pheidias has made Graces on one side and Seasons on the other, three of each. In the epics these are

[16] Pausanias does not say to what contests he is referring. Elsewhere he notes that the boys' contests in running and wrestling were instituted in the 37th Olympiad (632 B.C.; see Pausanias 5.8.9). For this reason some editors have felt that Pausanias makes an error here or that the text is corrupt. Changes in the rules and in the types of contests offered, however, were frequently made in the Olympic games. It is quite possible that boys were excluded from certain games in Pheidias's day which were open to them in the time of Pausanias (for example, the *pankration* which was not open to boys until the 145th Olympiad (200 B.C.)).

said to be the daughters of Zeus. Homer, for example, in the *Iliad* [5.749–51] says that they were entrusted with the sky, just like the guards of a king's court.

The stool beneath the feet of Zeus, which in the Attic dialect is called a *thranion*, has golden lions and also, in relief, the battle of Theseus against the Amazons, the first heroic deed of the Athenians against people of a different race. On the base which supports the throne and all the other ornamentation which surrounds Zeus, there are works of gold: Helios mounted on his chariot, Zeus and Hera, [Hephaistos],[17] and, next to him, Charis. After her comes Hermes, and, after Hermes, Hestia. After Hestia is Eros receiving Aphrodite as she rises from the sea; Peitho [Persuasion] is crowning Aphrodite. Also represented are Apollo, with Artemis, and Athena and Herakles; finally, toward the end of the base are Amphitrite and Poseidon, and also Selene, who appears to me to be riding a horse. It is said by some that the goddess is borne by a mule, not a horse, and there is a certain simple-minded story which they tell about the mule.

The measurements of the Zeus at Olympia, both its height and breadth, have been written down and are known to me, but I will not bestow praise upon those who did the measuring, because the measurements that have been recorded by them are far less impressive than the effect that the statue makes on those who see it. In fact they say that the god himself bore witness to Pheidias's artistic skill. For when the image had just been completed, Pheidias prayed to the god to send him a sign if the work was pleasing to him, and at that very moment, they say, a lightning bolt struck the floor at a spot which in my day was covered with a bronze hydria.

The section of the floor in front of the image is fitted out, not with white, but with black tiles. A raised rim of Parian marble runs around the border of the black stone, and serves to hold in the olive oil that is poured out. For olive oil is beneficial to the image at Olympia, and it is olive oil which prevents any injury from occurring to the ivory due to the marshiness of the *Altis*. On the Acropolis in Athens it is water, and not olive oil, that benefits the ivory on the image called the *Parthenos*. For the Acropolis is extremely dry owing to its excessive height, and the image, being made of ivory, yearns for water and the moisture that comes from water. When I asked at Epidauros the reason why neither water nor olive oil is poured on the image of Asklepios [see p. 105], those in charge of the sanctuary told me that both the image of the god and his throne were built over a well.

Strabo 8.3.30: The greatest [of the offerings in the temple of Zeus at Olympia] was the image of Zeus, which Pheidias, the son of Charmides, made of ivory, and which is of such great size that, though the temple is indeed one of the largest, the artist seems to have failed to take into account the question of

[17] "Hephaistos" was added to the text by H. Brunn. Some antecedent is needed for the phrase "next to him"; Charis, "Grace," was, according to Homer (*Iliad* 18.382), the wife of Hephaistos.

proportion; for although he represented the god as seated, he almost touches the peak of the roof, and thus gives the impression that, if he were to stand up straight, he would take the roof off the temple. Some authors have written down the measurements of the statue, and Kallimachos mentioned it in one of his iambic poems. Panainos the painter, Pheidias's own brother and his co-worker, was a great help to him in the decoration of the statue, especially the drapery, with colors. There are a good number of quite marvellous paintings on display around the sanctuary which are the work of that artist. And they recount this tradition about Pheidias: when Panainos asked him what model he intended to employ in making the image of Zeus, he replied that it was the model provided by Homer in the following lines:

> Thus spoke the son of Kronos and nodded his dark brow and the ambrosial locks flowed down from the lord's immortal head, and he made great Olympos quake. [*Iliad* 1.528–30]

In his Olympian Oration *Dio Chrysostom puts into the mouth of Pheidias a long disquisition on the capabilities and limitations of the plastic arts; prior to that disquisition, Dio and his audience express to an imaginary Pheidias their impression of his Zeus.*

Dio Chrysostom, *Or.* 12.50–2: O best and noblest of artists, that you have created a sweet and engaging sight, an inescapable delight for the vision, for all those Greeks and non-Greeks who have come here on many different occasions – this nobody will deny. For it would even overwhelm those beings in creation that have an irrational nature – the animals – if they could once see this work. It would overwhelm creatures like the bulls, for example, which are always being led to this altar, so that they would willingly submit to those who prepare them for sacrifice, if they could do it as a kind of favor to the god. It would also affect the nature of eagles and horses and lions, so that they, quelling their savage and wild side, would feel great peace of spirit as they were charmed by the sight [of the statue]. And among men, whoever might be burdened with pain in his soul, having borne many misfortunes and pains in his life and never being able to attain sweet sleep, even that man, I believe, standing before this image, would forget all the terrible and harsh things which one must suffer in human life. Such is the vision which you have conceived and rendered into art, a vision which is really: "An assuager of sorrow, gentle, an obscurer of the memory of all evils" [*Odyssey* 4.221]. Such is the light and such is the grace that comes from your art. For not even Hephaistos himself would find fault with the work, if he judged it by the pleasure and delight it gives to mortal eyes.

THE ATHENA *PROMACHOS*

Pausanias 1.28.2 (on the Acropolis in Athens): [Among the monuments on the Acropolis] is a bronze image of Athena, [made from] a tithe [from the spoils] taken from the Persians who landed at Marathon, a work of Pheidias; they say,

however, that the battle of Lapiths and Centaurs on her shield, as well as the other scenes wrought upon it, were engraved by Mys, and that these and the rest of the works of Mys were drawn for him by Parrhasios the son of Euenor. The point of the spear of this Athena and the crest of the helmet become visible to approaching sailors as soon as they round Cape Sounion.

Scholiast on Demosthenes, *Against Androtion* **13:** . . . for there are three images of Athena on the Acropolis in different places, one which has existed from the beginning, made of olive wood, which they call Athena *Polias*, since the city is hers; a second, exclusively of bronze, which they made when they were victorious at Marathon and is called the Athena *Promachos*; and a third which they made from gold and ivory . . . [the Athena *Parthenos*].

The Athena Promachos *is depicted on Athenian coins of the Roman period, but these images are too small to be of much help in reconstructing the details and style of the statue (see Lacroix,* Reproductions, *pls. 24.6–10 and 25). Epigraphical evidence suggests that the statue was made between 465 and 456 B.C. It was thus one of the earlier works of Pheidias.*

THE ATHENA *LEMNIA*

Pausanias I.28.2: . . . the most worth seeing of the works of Pheidias, the image of Athena which is called "the Lemnian," after those who dedicated it.

Lucian, *Imagines* **4–6** (a dialogue dealing again with the ideal characteristics to be embodied in Panthea, cf. pp. 46–7, 65, 86): LYKINOS: Of the works of Pheidias which one do you praise most highly? POLYSTRATOS: Which if not the *Lemnia*, on which he thought it fit to inscribe his name . . . The *Lemnia* and Pheidias shall furnish the outline of her [Panthea's] whole face, the softness of the sides of her face, and the well-proportioned nose.

Furtwängler's identification of the Athena Lemnia *with a type reconstructed from a head in Bologna and a torso in Dresden has often been accepted and has been widely illustrated. It remains controversial, however. For varying views of the problems involved see Bibliography 291.*

Other Works of Pheidias

THE ATHENA *AREIA* AT PLATAEA

Pausanias 9.4.1: the Plataeans have a sanctuary of Athena surnamed *Areia* ["the warlike"]; it was built from the spoils which the Athenians apportioned out to them from Marathon. The image is a *xoanon* overlaid with gold, except for the face, the hands and the feet which are of Pentelic marble.[18] In size it is only a little smaller than the bronze [the Athena *Promachos*] on the Acropolis, which

[18] Wooden statues of which the extremities were done in stone were called "acrolithic."

the Athenians also set up as first fruits from [the spoils of] the battle of Marathon, and here too it was Pheidias who made the image for the Plataeans.

AN ATHENA AT PELLENE IN ACHAEA

Pausanias 7.27.2: Along the roadside as you come to the city is a temple of Athena, built of local stone, but the image is of ivory and gold. They say that it was made by Pheidias before he made the images on the Acropolis in Athens and in Plataea. The people of Pellene say that there is also an underground shrine of Athena and that this shrine is directly under the base of the image; and further that the air from the shrine is damp and for that reason beneficial to ivory.

AN ATHENA IN ELIS

Pausanias 6.26.3: On the acropolis in Elis there is a sanctuary of Athena, with an image of ivory and gold. They say that it is by Pheidias. A cock is represented on the helmet, because cocks are birds of the sort that are very ready to fight. This bird could also be thought of as being sacred to Athena *Ergane* ["the worker"].

THE APHRODITE *OURANIA* IN ELIS

Pausanias 6.25.1 (in the town of Elis): Behind the stoa built from the spoils taken from Corcyra is a temple of Aphrodite; the precinct is in the open air not very far from the temple. In the temple is the image of the goddess whom they call *Ourania* ["Celestial']; it is made of ivory and gold and is the work of Pheidias; it stands with one foot upon a tortoise.

Plutarch, *Coniugalia Praecepta* 32 (*Moralia* 142D): Pheidias represented the Aphrodite of the Eleans as stepping on a tortoise, a symbol of good housekeeping and silence, for women.

THE ATHENIAN TRIBAL HEROES IN DELPHI

Pausanias 10.10.1–2: On the base . . . there is an inscription which says that the statues were set up from a tithe of the spoils from the battle of Marathon. They represent Athena, Apollo, and a man who was one of the generals, Miltiades. Of those who are called heroes there are Erechtheus, Kekrops, Pandion, Leos, Antiochos (the son of Herakles and Meda, the daughter of Phylas), and also Aegeus and Akamas, one of the children of Theseus. These heroes gave their names to the Athenian tribes in accordance with a response from the Delphic oracle. As for Kodros, the son of Melanthos, and Theseus and Neleus, however, they are no longer among the Eponymous heroes. Pheidias made the statues that I have catalogued, and it is quite true that these are a tithe from the battle.

The preceding passages show clearly that almost all of Pheidias's artistic effort was applied to making images of gods and heroes, most of them cult images. One obscure reference by Pausanias, however, does seem to refer to a portrait statue of a human being.

Pausanias 6.4.5 (at Olympia): As for the boy binding his hair with a fillet, let him too be brought into my account of Pheidias because of Pheidias's skill as a sculptor; we have no idea, however, as to whose image it was that Pheidias made.

Alkamenes

Alkamenes was a pupil of Pheidias and second in reputation only to his teacher. He may have inherited the job of supervising the Periclean building program after the death of Pheidias. His best known work was the Aphrodite in the Gardens *in Athens.*

Pliny, *N.H.* 36.15–16: I must not omit pointing out that this art [sculpture in marble] is much older than painting or sculpture in bronze, both of which began with Pheidias in the 83rd Olympiad [488 B.C.] . . . There is a tradition that Pheidias himself did sculpture in marble, and that the extremely beautiful Venus in the buildings of Octavia in Rome is his. It is certain at least that he was the teacher of Alkamenes the Athenian, a sculptor of the first rank, by whom there are a number of works in the temples in Athens, and also a particularly famous statue of Venus outside the walls which is called the *Aphrodite in the Gardens*. It is said that Pheidias himself put the finishing touches on this work.

Pausanias 1.19.2: As to the area which they call "the Gardens" [in Athens], and the temple of Aphrodite, there is no story told by them. Nor is there any story about the Aphrodite that stands near the temple. And yet the format of that statue is quadrangular, like that of herms, and the inscription indicates that Aphrodite *Ourania* is the eldest of those who are called the Moirai [Fates]. The image of Aphrodite in the Gardens is the work of Alkamenes and is one of the things most worth seeing in Athens.

Although the language of Pausanias in the above passage is ambiguous, it is probable that the image by Alkamenes was the cult image within the temple of Aphrodite, not the herm-like image that stood near the temple. On the many speculations about the appearance and significance of these images, see Bibliography 30A and C.

Lucian, *Imagines* 6 (further features of the Panthea): The cheeks and the front part of the face he will take from the *Aphrodite in the Gardens* of Alkamenes, and as for the hands, the shapeliness of the wrists, and the subtle taper of the fingers, these too he will take from the statue *in the Gardens*.

Pausanias 2.30.2: Alkamenes, it seems to me, was the first to represent Hekate by three images joined together,[19] a figure which the Athenians call Hekate *Epipyrgidia* ["on the tower"]. It stands by the temple of [Athena] Nike *Apteros* [on the Athenian Acropolis].

[19] Hekate was, among other things, a goddess of the crossroads; hence she had to look in many directions at once and a three-headed image was appropriate.

*A number of small votive images of a three-bodied Hekate have been found in Athens,
and they may reflect the appearance of Alkamenes' statue. See Bibliography 30F. The
Hekate, like the Hermes Propylaios (see below), may have been one of the works in
which Alkamenes experimented with an archaistic style.*

Pausanias 1.20.3 (an image of Dionysos in Athens): The most ancient sanctuary
of Dionysos is right by the theater. There are two temples within the precinct
and also two statues of Dionysos, the *Eleuthereus* ["the Liberator"] and the one
which Alkamenes made of ivory and gold.[20]

Cicero, *de Natura Deorum* 1.83: At Athens we praised that statue of
Hephaistos which Alkamenes made, a figure standing upright and draped, in
which there is visible a slight but not ugly lameness.

*The same description of the Hephaistos is given by Valerius Maximus 8.11, ext. 3.
The statue in question was perhaps the cult image of the Hephaisteion in the Agora in
Athens. See Harrison (1977) (Bibliography 30B) with further references.*

Pausanias 9.11.6 (in Thebes): Thrasyboulos, the son of Lykos, and those
Athenians who, along with him, overthrew the tyranny of "the Thirty" (for it
was from Thebes that they set out when they made their descent upon Athens)
[403 B.C.], set up colossal statues of Athena and Herakles in Pentelic marble,
works by Alkamenes, in the sanctuary of Herakles.

*Other figures of deities by Alkamenes, seen by Pausanias, were an Ares in Athens
(1.8.4); an image of Hera in a temple situated between Athens and Phaleron (1.1.5); and
an Asklepios in Mantineia (8.9.1). Right at the entrance to the Athenian Acropolis
Pausanias saw a statue of Hermes which, he noted, "they call the Propylaios."
Pausanias does not say that the Hermes was a work of Alkamenes, but what seem to be
copies of the work have been found at Pergamon and Ephesos, and these bear inscriptions
identifying Alkamenes as the sculptor. The god was represented in the form of a herm
with stylistic features that derive from the Archaic style of Greek sculpture. The fact that
a number of uninscribed versions of the type have been found in Athens seems to confirm a
link between the statue on the Acropolis and the herms found in Asia Minor. The
inscription (see Altertümer von Pergamon (Berlin 1907) 7.1 p. 48 (Bibliography
30E)) on the herm from Pergamon (now in Istanbul) reads as follows:*

*"You will recognize the extremely beautiful image by Alkamenes, the Hermes before
the Gates [Greek: pro pylōn]. Pergamios set it up."*

Alkamenes seems to have made at least one portrait statue of an athlete:

Pliny, N.H. 34.72: Alkamenes, the disciple of Pheidias, made marble statues
and also a bronze statue of a winner in the *pentathlon*, known as the
enkrinomenos.[21]

[20] For the representation of this figure on Athenian coins, see Lacroix, *Reproductions*, pl. XXXVI, 3.
[21] *Enkrinomenos* – either "he who is approved" or "he who had been admitted to the games."

Agorakritos of Paros

Agorakritos, another pupil of Pheidias, seems to have been very closely associated with this teacher. There is some confusion in the sources, in fact, as to whether certain sculptures were done by the teacher or the pupil. This is true, for example, in the case of the most famous statue ascribed to Agorakritos, the Nemesis of Rhamnous. In such cases it is probably best to look for the truth in the lectio difficilior; *that is to say, if a well-known work is ascribed both to a very famous artist and to a more obscure one, the latter is probably the correct attribution.*

Pliny, *N.H.* 36.17: Another disciple of his [Pheidias's] was Agorakritos of Paros, who was pleasing to him because of his youth and beauty; as a result, it is said that Pheidias allowed Agorakritos's name to be put on a number of his [Pheidias's] own works. In any case, the two disciples [Alkamenes and Agorakritos] competed with one another in the making of an Aphrodite, and Alkamenes was the victor, not because of the quality of his work but through the votes of the citizenry who favored one of their own people against a foreigner;[22] whereupon Agorakritos, according to tradition, sold his statue with the proviso that it should not remain in Athens and that it should be called "Nemesis."[23] It was set up in Rhamnous, a deme of Attica, and is a work which Marcus Varro[24] preferred to all other statues. There is also a work of Agorakritos in the same town in the shrine of the Great Mother.

It is not completely clear whether "the same town" means Athens or Rhamnous. Arrian (Peripl. Pont. Euxin. 9) describes a statue of the "Mother of the Gods" in the Metroön in the Agora at Athens. The image held a cymbal in one hand and was flanked by lions. A number of stone statuettes reproducing this image have been found in the Agora excavations. (See Bibliography 31C.) Both Arrian and Pausanias (1.3.5), who also saw it, ascribe the statue to Pheidias, but Pliny's reference suggests that it may have been by Agorakritos.

Pausanias 1.33.2–8: About sixty stades from Marathon as you go along the seacoast toward Oropos is Rhamnous. The houses where the people live are on the sea, and inland a little, away from the sea, is the sanctuary of Nemesis, who is the most inexorable of the gods toward men of sinful violence. It would seem that the wrath of this goddess also fell upon those of the barbarians who landed at Marathon. For thinking that no obstacle stood in the way of their taking Athens, they were bringing with them some Parian marble to use for a trophy, just as if the whole thing were over and done with. It was this stone that Pheidias made into a statue of Nemesis; on the head of the goddess is a crown on which are represented deer and some images of Victory which are not very big. In her

[22] Agorakritos, being from the island of Paros, was considered a foreigner.
[23] Nemesis was the goddess of retribution for unjust acts.
[24] Marcus Terentius Varro (116–27 B.C.). See Appendix.

left hand she holds the branch of an apple tree, and in her right hand she holds a *phiale* [offering bowl], on which Ethiopians are represented. [At this point Pausanias examines inconclusively the question of why the Ethiopians are represented on the bowl, and is led into a digression on the geography of Ethiopia.] . . . This statue does not have wings nor is any other of the ancient statues of Nemesis represented with them, since not even the extremely holy ancient images [*xoana*] which belong to the people of Smyrna have wings. But later artists, maintaining that the goddess makes her epiphany most of all after a love affair, represent Nemesis with wings just as they do Eros. I now go on to the images represented on the base; what I have indicated up to this point was for the sake of clarity. The Greeks say that Nemesis was the mother of Helen, but that Leda suckled her and brought her up. As to Helen's father, the Greeks as well as everyone else think that it was Zeus and not Tyndareus. Having heard these stories Pheidias represented Helen as being brought before Nemesis by Leda; likewise he represented the children of Tyndareus and a man named Hippeus who stands by with a horse. Also there are Agamemnon, Menelaos, and Pyrrhos the son of Achilles; it was he who first took Hermione, the daughter of Helen, as his wife. Orestes was left out on account of the daring act against his mother, yet Hermione remained by him through everything and even bore him a child. Next on the base is someone called Epochos and another youth. With regard to them, the only thing I heard was that they were brothers of Oinoë, from whom the name of the deme comes.

Substantial fragments of the image of Nemesis survive in Athens and the British Museum and from them Despinis has been able to make a convincing reconstruction of the entire image (see Bibliography 31B).

Pausanias 9.34.1 (in Boeotia): Before you reach Koroneia as you come from Alalkomenai, there is a sanctuary of Athena *Itonia* . . . In the temple there are bronze images of Athena *Itonia* and Zeus. They are the works of Agorakritos, the pupil and loved one of Pheidias.

Kolotes

Pliny, N.H. 35.54: . . . Panainos [the brother of Pheidias] who painted the inside of the shield of an Athena in Elis,[25] which Kolotes made, the disciple of Pheidias and his assistant in the making of the Zeus at Olympia.

Strabo 8.3.4: It is a moderate-sized village [Kyllene, the port of Elis], which has an image of Asklepios by Kolotes, an ivory statue which is a marvel to look upon.

Pliny, N.H. 34.87: Kolotes, who worked with Pheidias on the Zeus at Olympia, made statues of philosophers.

[25] Probably the Athena of Pheidias on the acropolis in Elis; see above.

For Pausanias's description of a gold and ivory table at Olympia ascribed to an artist named Kolotes, see p. 220.

Kresilas of Kydonia (Crete)

Although a native of Crete, Kresilas seems to have worked mainly in Athens in the time of Pericles. Probably, like Agorakritos, he was a metoikos *(resident foreigner).*

Pliny, N.H. 34.74–5: Kresilas made a man wounded and expiring, in which one can sense how little life remains; he also made the "Olympian Pericles," a work worthy of the title; it is a marvellous thing about this art that it can make famous men even more famous . . . Kresilas[26] also made a *Doryphoros* ["spear-bearer"] and a wounded Amazon.

The "wounded man" is thought to be identical with the statue of the Athenian Dieitrephes, seen by Pausanias on the Athenian Acropolis and described (1.23.3) as being "wounded with arrows." The evidence for this conclusion is a base found on the Acropolis in Athens that bears the name of Hermolykos, son of Dieitrephes, as the dedicator and the signature of Kresilas as sculptor. See Raubitschek, Dedications, no. 132, pp. 141–4, 510–13 and the useful summary in Richter, SSG, pp. 179–80. For attempts to identify the "wounded man" in Roman copies see Bibliography 32C. Replicas survive of a portrait type of Pericles (Richter, Portraits, figs. 432–47), and it is generally assumed that these derive from the original by Kresilas. On the wounded Amazon see also p. 226.

Other works by Kresilas were votive offerings to Demeter, in Hermione (Loewy, IgB, no. 45), and to Pallas (Athena) Tritogeneia (Anthologia Graeca 13.13). Whether these offerings were images of the respective goddesses or votives of some other form is not known.

Styppax of Cyprus

Pliny, N.H. 34.81: Styppax the Cypriote is famed for one statue, the *splanchnoptes*; the subject of this statue was a slave of the Olympian Pericles roasting entrails and kindling a fire with the breath from his puffed-out cheeks.[27]

Lykios the Son of Myron

Athenaios 11.486D: [Lykios] was a Boeotian by birth from Eleutherai, and was the son of Myron the sculptor . . .

[26] The text reads "Ctesilas."

[27] *Splanchnoptes*: "the roaster of *splanchnia*," which were the inner parts of a sacrificial animal such as the heart, kidneys, and the like. Further anecdotes about this slave are given by Pliny in *N.H.* 22.44.

Pliny, *N.H.* 34.79: Lykios was a disciple of Myron, who made a figure of a boy blowing on dying embers, a work worthy of his preceptor, and also figures of Argonauts . . .[28] Lykios also made a figure of a boy burning incense.

Pausanias 1.23.7: I remember having seen other works on the Acropolis of Athens, including a bronze by Lykios, the son of Myron, of a boy who has a *perirrhanterion* [a vessel for lustral water] and Myron's Perseus, depicted after he had carried out the deed against Medusa.

Pausanias 5.22.2–3 (at Olympia): Alongside what is called the Hippodamion there is a semi-circular base of stone, and the image that stands on it represents Zeus along with Thetis and Hemera ["Day"], who are praying for their children. These stand in the middle of the base, while Achilles and Memnon, arranged as if they were ready for combat, are present, one at each edge of the base. Other groups also oppose one another in man-to-man combat in the same manner, that is, barbarian against Greek: Odysseus against Helenos (for these two had the greatest reputation for wisdom in the respective armies), Alexander [that is, Paris] against Menelaos (because of their long-standing hatred), Aeneas against Diomedes, and Deiphobos against Ajax the son of Telamon. These were the works of Lykios the son of Myron, and they were set up by the people of Apollonia on the Ionian sea . . .[29]

Three inscriptions found on the Athenian Acropolis (for the text see Raubitschek, *Dedications*, nos. 135, 135a, 135b): The knights [dedicated this] from the [spoils of] the enemy. The cavalry commanders were Lakedaimonios, Xenophon, and Pronapos. Lykios of Eleutherai, the son of Myron, made them.

> *The three Athenian cavalry commanders are known to have been active around the middle of the fifth century B.C. (see Raubitschek, Dedications, pp. 150–1). The statue may have been set up sometime after the Athenian victory at Oinophyta (457 B.C.) or after the suppression of the Euboean revolt (466/5 B.C.).*
>
> *Of the three inscriptions, no. 135 is the original and the other two are copies executed in the Roman period. The inscriptions may be connected with a sculptural group that Pausanias saw near the entrance to the Acropolis and that he identified as the "sons of Xenophon," or, if not them, then "figures simply made for decoration" (Pausanias 1.22.4). It has been suggested that the original group represented the Dioskouroi. Pausanias, knowing that the sons of the writer Xenophon were sometimes called "the Dioskouroi" (see Diogenes Laertios 2.52), may have misinterpreted the inscription. The*

[28] In the section omitted Pliny mentions several works by other artists, including one of the pankratiast Autolykos which is ascribed to the fourth-century sculptor Leochares. Since Autolykos was the victor in the *pankration* in 421 B.C. (see Xenophon, *Symposium* 2), well before the time when Leochares was active, some scholars (for example, Overbeck and Stuart Jones) ascribe the Autolykos to Lykios.

[29] The dedicatory inscription which follows indicates that the Apollonians set up this group after a victory over the Abantes of Euboea.

statues which he saw were, in any case, probably Roman copies. (See Raubitschek, Dedications, pp. 518–19.)

Paionios of Mende (Thrace)

Paionios is one sculptor who may be even better known today than he was in Antiquity. His "Flying Nike," now in the Archaeological Museum in Olympia, is one of the rare examples of an original Greek statue from the hand of a known master. The statue was seen, when it stood in its original position in Olympia, by Pausanias.

Pausanias 5.26.1: The Dorian Messenians who at one time received Naupaktos from the Athenians set up at Olympia an image of Nike on a column. This image is the work of Paionios of Mende, and was made from the spoils taken from the enemy, when they waged war against the people of Akarnania and Oiniadai; at least so it seems to me. The Messenians themselves say that the offering resulted from their exploit on the island of Sphakteria along with the Athenians but that they did not inscribe the name of their enemy through fear of the Lakedaimonians, whereas they had no fear at all of the people of Oiniadai and Akarnania.[30]

The base of the statue which Pausanias mentioned has been found at Olympia (Loewy, IgB, no. 49). It reads:

The Messenians and the Naupaktians set up [this statue] to Olympian Zeus as a tithe from the spoils taken from the enemy. Paionios of Mende made it, and he also won the commission to make the *akroteria* for the temple.

It should also be noted that Pausanias ascribes the pedimental sculptures of the temple of Zeus at Olympia (p. 186), which were made c. 460 B.C., to Paionios and Alkamenes. While it is not impossible that Paionios could have worked on the pediments, and then, forty years later, having undergone a radical change of style, made the Flying Nike, it does seem unlikely, and most modern scholars reject Pausanias's attribution. The same may be said about Alkamenes, who may have been active as late as 403 B.C. The akroteria of the temple, as the inscription on the base of the Flying Nike shows, were made by Paionios, and it may be that Pausanias confused them with the pedimental sculptures.

Strongylion

Pliny, N.H. 34.82: Strongylion made an Amazon, which they call *euknemon* on account of the excellence of its legs; it was also on account of this that the

[30] The Messenian campaign against Oiniadai, which took place in 452 B.C., was not notably successful (Pausanias 4.25.9–10). The Athenian victory over the Spartans at Sphakteria took place in 424 B.C. (Thucydides 4.8–41). Since Paionios's statue seems to date from *c.* 420, it is probable that the Messenians were right and Pausanias was wrong about the occasion of the battle.

statue was carried around in the retinue of the emperor Nero. The same sculptor also made a statue of a youth; this work became well known through its association with the name of Brutus of Philippi, who was fond of it.

The last mentioned work is also referred to in the epigrams of the Roman poet Martial.

Martial 14.171:

> The glory of so small a statue is not obscure.
> Of this very boy Brutus was the lover.

(See also Martial 2.77; 9.51.)

Strongylion also seems to have made a latter-day version of the Trojan horse in bronze on the Acropolis of Athens. The work is referred to in the Birds *of Aristophanes line 1128, and a scholiast on that line notes that the dedicator was one Chairedemos, son of Euangellos, from the deme of Koile. The base of the statue, from which the scholiast probably derived his information, has been found in the sanctuary of Brauronian Artemis on the Acropolis of Athens, and it bears the signature of Strongylion as sculptor. (See Raubitschek,* Dedications, *no. 176. The base is dated in the last quarter of the fifth century B.C.). The horse was also seen by Pausanias, who does not mention the sculptor's name.*

Pausanias 1.23.7–8: There is also a sanctuary of Brauronian Artemis . . . A horse is set up there called "the Wooden" but made of bronze. That the horse made by Epeios[31] was a siege machine for breaching the wall [of Troy] is known to everyone who does not ascribe absolute simple-mindedness to the Phrygians. It is said, of course, of that horse that it held within it the best of the Greeks, and the design of this bronze one has been made to illustrate that story. Both Menestheus and Teukros are peeking out of it and so too are the children of Theseus.

Pausanias 9.30.1 (on Mt Helikon): The first images of the Muses are the work of Kephisodotos, all of them; a little farther on there are three more, again by Kephisodotos, and then three others by Strongylion, an artist responsible for excellent [images of] cattle and horses.[32]

Pausanias 1.40.2–3 (in Megara): Not far from the fountain is an ancient sanctuary; portraits of Roman emperors, from our own time, stand in it and also located there is a bronze image of Artemis called the "Savior." They say that a detachment from the army of [the Persian general] Mardonios, having overrun the Megarid [479 B.C.], wished to pull back to Mardonios at Thebes, but by the will of Artemis night came on them as they were on the road and, losing their

[31] Epeios was the legendary builder of the original Trojan horse; see *Odyssey* 8.492.

[32] Kephisodotos (see pp. 83–4) was mainly active in the early fourth century B.C. Strongylion's career probably belonged to the late fifth and early fourth centuries.

way, they turned into the hilly region of the country. In an attempt to find out if there was an enemy detachment nearby, they hurled some missiles, and the rock, which was near them, groaned as it was hit; after that they shot their arrows with even greater zeal. Eventually they used up all their arrows, thinking that they were shooting at the enemy. At daybreak the Megarians attacked, and, it being a case of armed men fighting unarmed men who no longer even had missiles, they killed most of them. It was for this reason that they made an image of Artemis the Savior . . . The image of Artemis herself was made by Strongylion.

Strongylion's statue in Megara was presumably made several decades after the battle. Another image of Artemis the Savior seen by Pausanias was perhaps also by this sculptor.

Pausanias 1.44.4: The hilly region of the Megarid is on the border of Boeotia, and in it the city of Pagai has been built by the Megarians . . . In Pagai there remains something well worth seeing – a bronze image of Artemis called *Soteira* (the "Savior"). It is equal in size to the one in Megara and no different from it in design.

The Artemis Soteira *is represented on late coins of Megara and Pagai; see Lacroix,* Reproductions, *pl. XXVI, nos. 4, 5 and 6.*

Kallimachos

Pliny, *N.H.* 34.92: Of all [sculptors], however, Kallimachos is most remarkable for his surname: he was a perpetual deprecator of his own work, nor was there ever an end to his attention to minutiae; for this reason he was called the *katatexitechnos*, a memorable example of the need for establishing a limit to meticulousness. Also by him are the "Lakonian Dancers," a technically flawless work, but one in which meticulousness has taken away all charm.

Attempts have been made to identify echoes of the Lakonian Dancers in reliefs of the Roman period. See Bibliography 37.

Pausanias 1.26.6–7 (in the *Erechtheion* on the Acropolis in Athens): . . . the most holy object, and one which by common agreement was held to be so many years before the people from the demes united [into a city] is the image of Athena, on what is now the Acropolis but was then simply called the *polis* ["city"]. There is a tradition that this image fell from heaven, but I will not go into whether this is true or not. Kallimachos made a gold lamp for the goddess. When they have filled the lamp with oil, they wait [before refilling it] until the same day of the following year, and the oil which is in the lamp suffices for the intervening time, even though it remains lighted both day and night alike. Its wick is of Karpasian flax, which is the only type of flax that is not consumed by fire. Above the lamp

is a bronze palm tree, which reaches to the roof and draws up the smoke. Kallimachos who made the lamp, although inferior to the foremost practitioners of this art, was so much superior to all of them in inventiveness that he became the first sculptor to drill through stones, and he took the name *katatexitechnos*;[33] or possibly, when others called him by that name, he adopted it himself.

Tradition also attributed to Kallimachos the invention of the Corinthian column. See pp. 193–4.

Deinomenes

According to Pliny, N.H. 34.50, Deinomenes was active in the 95th Olympiad (400 B.C.).

Pausanias 1.25.1 (on the Acropolis in Athens): Deinomenes made the [two] statues of women that stand nearby, Io the daughter of Inachos and Kallisto the daughter of Lykaon; the events in the stories about both of these women are exactly alike – that is, the love of Zeus, and anger of Hera, and the transformation which, in the case of Io, was into a cow; in the case of Kallisto, into a bear.

Tatian, *Oratio ad Graecos* 53 (ed. Whittaker): Deinomenes, by means of his art, made a work which perpetuated the memory of Besantis, the queen of the Paionians, because she carried in her womb a child who was black.

Other works by Deinomenes were statues of Protesilaos and of a wrestler named Pythodemos (Pliny, N.H. 34.76).

Socrates

Pausanias 1.22.8: Right at the entrance to the Acropolis there is a Hermes which they call *Propylaios* [see above, under Alkamenes], and statues of "the Graces" which, they say, were made by Socrates the son of Sophroniskos, to whose reputation as the wisest of men the Delphic oracle was a witness.

Pausanias 9.35.3–7: And in front of the entrance to the Acropolis there are Graces, three in number, beside which they perform mystic rites that must not be spoken of to the many . . . (**Sec. 6**) Who the man was who first represented the Graces naked in sculpture or painting I was not able to find out, since, in the earlier periods, the sculptors represented them as draped, and the painters made them the same way . . . (**Sec. 7**) Socrates the son of Sophroniskos made images of

[33] *Katatexitechnos* would literally mean the "one who melts down his art" or "one who dissolves his art." The manuscripts of Pausanias read *kakizotechnos*, "the spoiler of art," a title which would fit Pliny's discussion of Kallimachos (where it does not occur) better than Pausanias's. Vitruvius uses the name *katatechnos*, which could mean "the artificial one" but is probably an error; see p. 194 below.

the Graces for the Athenians in front of the entrance to the Acropolis. And these too are all draped.

Pliny, N.H. 36.32: Nor are the Graces in the *propylaia* of the Athenians less esteemed, the ones which Socrates made; this is another man, not the painter, though some think he is the same.

On the painter Socrates see p. 166.

The tradition that the philosopher Socrates was also a sculptor was apparently taken for granted in the Roman period,[34] although some degree of uncertainty is indicated in the passage from Pliny and in Pausanias's use of the phrase "they say." A number of modern scholars,[35] however, have doubted that there is any truth in the tradition and perhaps with good reason. The earliest sources for it are the sensational chronicler Douris of Samos (c. 340–260 B.C.) and the Skeptic philosopher Timon of Phlious (c. 320–230 B.C.).[36] Undoubtedly there was a group of the Graces carved by a sculptor named Socrates, but the name was not uncommon, and the attribution to the sculptor may be a later tradition that developed from Socrates' playful reference to himself as a descendant of Daidalos (Plato, Euthyphro 10c).

The sculptors of the High Classical period treated up to this point have been those whose artistic fortunes were bound up in some way with Athens, either because they were citizens or because their patrons were Athenians (or Athenian allies).

The other great center for the production of sculpture in this period was Argos.

Polykleitos of Argos

See also pp. 222–3.

Pliny, N.H. 34.55: Polykleitos of Sikyon, a disciple of Ageladas,[37] made a *Diadoumenos* [one who binds a fillet on his head], a soft-looking youth which is famous for having cost one hundred talents; and a *Doryphoros* [spear-bearer], a virile-looking boy. He also made a statue which artists call the "Canon" and from which they derive the basic forms of their art, as if from some kind of law; thus he alone of men is deemed to have rendered art itself in a work of art.[38] He also made a man scraping himself with a strigil and a nude figure attacking with a javelin,[39] and two boys, also nude, playing with knucklebones, who are called

[34] See Diogenes Laertios 2.18; Lucian, *Somnium* 12; Valerius Maximus 3.4.ext. 1.

[35] See J. Burnet's edition of the *Euthyphro, Apology and Crito* (Oxford 1924), notes p. 51; A. E. Taylor, *Socrates, the Man and his Thought* (1933; reprint New York 1956), pp. 40–2.

[36] Both cited by Diogenes Laertios 2.19. Douris apparently said that Socrates was a slave as well as a stone-cutter, another reason to question his reliability.

[37] Plato and Pausanias, as well as Polykleitos's own signatures (Loewy, *IgB*, no. 91), indicate that he was an Argive; Sikyon succeeded Argos as the leading artistic center of the Peloponnesos; Pliny here may be under the influence of Xenokrates (see Introduction, p. 3) who was a member of that school. On Ageladas see above, pp. 32–3.

[38] *Artem ipsam fecisse artis opere indicatur. Ars* (Greek *techne*) in the first instance probably refers to artistic theory; compare Pliny's comments on Myron, p. 49, n. 11. [39] Reading *telo incessentem*.

the *astragalizontes* [dice players] and are now in the Emperor Titus's atrium – a work than which, some claim, there is none more perfect. He also made a Hermes, which was once in Lysimacheia,[40] a Herakles, which is in Rome, a military commander[41] putting on his armor, and a statue of Artemon, who was called the *periphoretos*.[42] Polykleitos is deemed to have perfected this science and to have explained the art of *toreutike*, just as Pheidias had opened up its possibilities. It was strictly his invention to have his statues throw their weight on one leg; Varro says, however, that they are "square" and almost all composed after the same pattern.[43]

Of the works of Polykleitos mentioned by Pliny, at least two, the Doryphoros *and the* Diadoumenos, *have been identified with confidence in Roman copies. Other identifications are more speculative. See Bibliography 39.*

The Canon of Polykleitos mentioned by Pliny was the name of a theoretical treatise as well as of a statue. Galen and other writers give some idea of the contents of the treatise.

Galen, *de Placitis Hippocratis et Platonis* 5 (ed. Müller, p. 425): Beauty, he [Chrysippos] believes, arises not in the commensurability of the constituent elements [of the body], but in the commensurability [*symmetria*] of the parts, such as that of finger to finger, and of all the fingers to the palm and the wrist, and of these to the forearm, and of the forearm to the upper arm, and, in fact, of everything to everything else, just as it is written in the *Canon* of Polykleitos. For having taught us in that work all the proportions of the body, Polykleitos supported his treatise with a work of art; that is, he made a statue according to the tenets of his treatise, and called the statue, like the work, the "Canon."

Galen, *de Temperamentis* 1.9: Modellers and sculptors and painters, and in fact image-makers in general, paint or model beautiful figures by observing an ideal form in each case, that is, whatever form is most beautiful in man or in the horse or in the cow or in the lion, always looking for the mean within each genus. And

[40] Lysimacheia, a city on the Hellespont built by the Hellenistic monarch Lysimachos (*c.* 360–281 B.C.).

[41] Some editors interpret "military commander" (Latin *Hageter*) to be another name for the Herakles rather than a separate work.

[42] *Periphoretos* can mean either "the infamous" or "he who is carried around." If the second meaning is intended, the reference may be to an engineer named Artemon who worked under Pericles (Plutarch, *Pericles* 27.3–4). Artemon was lame and had to be carried around in a litter.

[43] The phrase "this science" (*hanc scientiam*) seems to refer in the text to the art of metal sculpture as a whole; perhaps in Pliny's original source the reference was to Polykleitos's theories of proportion and design. "Square-like" here translates the Latin *quadrata* (Greek *tetragonos* in Pliny's source) which has been interpreted in several ways. Some have interpreted it in a metaphorical way as "four-square"; others view it as a reference to the carefully balanced and essentially torsionless composition of Polykleitos's figures and translate it with phrases like "squarely built." Silvio Ferri interprets the terms *quadratus* and *tetragonos* by analogy to their use in rhetoric; where they refer to the balancing of four cola in a sentence through either a paratactic or chiastic scheme. Elements in the statues of Polykleitos are similarly balanced. See Bibliography 39A and B.

a certain statue might perhaps also be commended, the one called the "Canon" of Polykleitos; it got such a name from having precise commensurability of all the parts to one another.

Quintilian implies that the Doryphoros *and the* Canon *were the same work, and the fact that the fourth-century sculptor Lysippos (see pp. 98–104) claimed to have used the* Doryphoros *as his model (Cicero,* Brutus *296) seems to confirm this.*

Quintilian, *Institutio Oratoria* **5.12.21:** And indeed the outstanding sculptors and painters, when they wish to represent bodily forms which are as beautiful as possible, have never fallen into this error – namely that they use some Bogoas or Megabyzus[44] as the model for their work – but rather they use the *Doryphoros,* a work suitable both for the military and for the wrestling-court . . .

Plutarch and Philo Mechanicus preserve what appear to be two direct quotations from Polykleitos's treatise.

Plutarch, *Quaestionum Convivalium Libri VI* **2.3.2 (***Moralia* **636C):** The artists first of all model their figures so as to be without surface detail and shapeless, and then later distinguish the individual forms. For this reason, Polykleitos the sculptor said "the work is hardest when the clay is on the nail."[45]

Philo Mechanicus, *Syntaxis* **4.1** (ed. Schöne (Berlin 1893) p. 49.20; Diels, *Fragmente der Vorsokratiker*[7] 40B2): . . . thus the statement made by the sculptor Polykleitos may be suitably repeated for the future. For "perfection," he says, "arises *para mikron*[46] through many numbers." Indeed, it happens in the same manner in that art [sculpture] that, in finishing off works through many numbers [measurements], they make a slight deviation in each part and in the end these add up to a large error.

Polykleitos also made many statues of victorious athletes. The Doryphoros *and* Diadoumenos, *in fact, may have been originally in this category, although no specific name is connected with them. Pausanias also mentions a number of these athlete statues without describing them: Thersilochos of Corcyra and Aristion of Epidauros*

[44] The names are perhaps intended to suggest an oriental eunuch.

[45] Also quoted in Plutarch, *Quomodo quis suos in virtute sentiat profectus* 17 (*Moralia* 86A). "On the nail" was a proverbial phrase meaning something like "in the fine points." The reference was perhaps originally to the fact that the artist put the finishing touches on his clay model with his fingernails.

[46] *Para mikron* – the meaning of this Greek phrase is debated. Philo's interpretation seems to be that it means "from a minute calculation," that is, a very slight difference in measurements can make the difference between a work which is successful and one that is not. (This meaning is accepted in Diels (and Kranz), *Fragmente der Vorsokratiker,*[7] 40B2.) Another interpretation is that the phrase means something like "except for a little" or "almost," implying that, when all the correct measurements are made, there is still something else needed (for example, alterations based on the artist's subjective preferences) before a work can achieve beauty. Others take the phrase to mean "from a small unit," that is, a module; still another meaning might be "gradually," "little by little." A useful summary of the interpretations is given by Schulz (1955). See Bibliography 39B.

(6.13.6),[47] *Xenokles of Mainalos (6.9.2), Antipater of Miletos (6.2.6), and Kyniskos*[48] *of Mantinea (6.4.11) – all at Olympia.*

In addition to works that reflected his interest in systems of proportion and to statues of victorious athletes, Polykleitos also made images of deities. Most of these receive only scant mention in the sources, but one of them, a colossal gold and ivory image of Hera in the Argive Heraion, is described in some detail by Pausanias.

Pausanias 2.17.4–5: The image of Hera is seated on a throne; it is very large, made of gold and ivory, and is the work of Polykleitos. On her head is a crown which has the Graces and the Seasons worked upon it; in one of her hands she holds a pomegranate and in the other a scepter. As for the details about the pomegranate[49] – since it is a teaching which must not be talked about – I will pass over it. They say it is a cuckoo that is perched on the scepter and explain it by the story that Zeus, when he was in love with the virgin Hera, changed himself into this bird, and that she caught it to have as a pet. This story and others like it that are told about the gods I record without believing them; nevertheless I do record them. It is said that the image of Hebe, which stands next to the Hera, is the work of Naukydes [see pp. 79–80]; it too is of ivory and gold. By it there is an ancient image of Hera on a column. This most ancient image is made of wild pear wood; it was set up in Tiryns by Peirasos the son of Argos, and when the Argives sacked Tiryns they carried it off to the *Heraion.*

Strabo 8.6.10: . . . the *Heraion* near Mycenae was the common property of both [Argos and Mycenae]; in the temple there are statues by Polykleitos, which in artistic quality are the most beautiful of all works, but in value and grandeur they are inferior to those of Pheidias.[50]

Other images of deities simply mentioned by Pausanias: a Zeus Meilichios in Argos (2.20.1) and a group of Apollo, Leto, and Artemis on Mt Lykone between Argos and Tegea (2.24.5). There was also a statue of Aphrodite at Amyklai set up after the battle of Aigospotamoi (405 B.C.), which Pausanias (3.18.7–8) says was "by Polykleitos," but this may have been the work of the younger Polykleitos (see pp. 106, 195).

Another work of Polykleitos was a pair of statues called the Kanephoroi *("basket bearers"). The exact nature of the subject and the purpose of the statues is obscure, but they probably represented women or girls who took part in a religious procession.*

Cicero, in Verrem 2.4.3.5 (discussing the art collection of Heius in Sicily, which was plundered by Verres): In addition there were two bronze statues, not

[47] Aristion's victory was in 452 B.C. This was probably one of the earliest works of Polykleitos.

[48] The base of this statue with its accompanying inscription has been found at Olympia. See Loewy, *IgB,* no. 50. The "Westmacott Athlete," a Roman copy in the British Museum, has sometimes been connected with the Kyniskos. See Richter, *SSG,* fig. 703.

[49] The pomegranate was sacred to Demeter and Persephone and was connected with the symbolism of death and resurrection in some of the Greek mystery cults.

[50] "Value" and "grandeur" here translate, with intentional ambiguity, the Greek words *polyteleia* and *megethos.* The words may literally mean "cost" and "size," or they may have a metaphorical meaning, as for example, "richness" and "grandeur of conception."

large, but of truly outstanding beauty, clothed in garments such as virgins wear, who, with their hands raised, were carrying certain sacred objects on their heads in the manner of the Athenian virgins. These are called the *Kanephoroi*. Who is the artist who made them? Who indeed? You admonish rightly; they were said to be by Polykleitos.

Finally we may add an anecdote from Aelian which, though of doubtful historical veracity, may perhaps be a true reflection of Polykleitos's attitude as an artist.

Aelian, *Varia Historia* 14.8: Polykleitos made two statues at the same time, one which would be pleasing to the crowd and the other according to the principles of his art. In accordance with the opinion of each person who came into his workshop, he altered something and changed its form, submitting to the advice of each. Then he put both statues on display. The one was marvelled at by everyone, and the other was laughed at. Thereupon Polykleitos said, "But the one that you find fault with, you made yourselves; while the one that you marvel at, I made."

Naukydes of Argos

Naukydes, who, as has already been noted, did the statue of Hebe which stood next to Polykleitos's Hera at Argos, was the son of the sculptor Patrokles (attested by an inscription, Loewy, IgB, no. 86). These two artists were apparently relatives of Polykleitos, although in exactly what relationship they stood to him is difficult to determine. Patrokles had another son named Daidalos (Loewy, no. 88). According to Pausanias (2.22.7) Naukydes was the brother of a sculptor named Polykleitos.[51] *This may have been the younger Polykleitos, whose existence is well attested (see pp. 106, 195). In that case, Naukydes, Daidalos, and Polykleitos the Younger may all have been sons of Patrokles, who in turn may have been a brother or cousin of the elder Polykleitos. Pliny (N.H. 34.50) dates Naukydes and Patrokles in the 95th Olympiad (400 B.C.). Daidalos and Polykleitos the Younger were presumably somewhat younger than Naukydes and were active mainly in the first quarter of the fourth century B.C.*

Of Patrokles we know only that he made figures of athletes, warriors, hunters, and men engaged in sacrifice (Pliny, N.H. 34.91), and that he worked on a large Spartan votive at Delphi (see p. 80).

Pliny, *N.H.* 34.80: Naukydes is valued for his Hermes and his discus-thrower and his figure of a man sacrificing a ram.[52]

The discus-thrower of Naukydes has sometimes been identified with a marble figure in the Vatican. See Bibliography 40.

[51] One manuscript reads "Perikleitos," however, and Naukydes is called the son of Mothon, not Patrokles.
[52] The last is sometimes associated with a group of Phrixos sacrificing a ram seen by Pausanias on the Athenian Acropolis (1.24.2).

Pausanias 6.9.3 (at Olympia): The portraits which are the most splendid works of Naukydes in my opinion are this one of Cheimon in Olympia and the one that was carried off from Argos to the temple of Peace in Rome.

Other works of Naukydes were his portrait of the athlete Eukles of Rhodes (Pausanias 6.6.2) and of Baukis of Troizen (Pausanias 6.8.4).

The Disciples of Polykleitos

Pliny, *N.H.* 34.50: . . . Polykleitos had as his disciples Argeios, Asopodoros, Alexis, Aristeides, Phrynon, Deinon, Athenodoros, and Dameas of Kleitor.

Some of these sculptors are otherwise completely unknown, but a number of them worked on a large votive monument set up by the Spartans at Delphi to commemorate their victory over the Athenians.

Pausanias 10.9.7–10: Opposite are offerings of the Lakedaimonians from the spoils of their victory over the Athenians: the Dioskouroi and Zeus, Apollo and Artemis, and, by them, Poseidon and Lysander,[53] the son of Aristokritos, who is being crowned by Poseidon; also there are Agias, who was the soothsayer for Lysander on that occasion, and Hermon, who piloted the flag-ship of Lysander. The statue of Hermon was made, as one might expect, by Theokosmas of Megara because he had been enrolled as a citizen by the Megarians. The Dioskouroi were by Antiphanes of Argos, and the soothsayer was the work of Pison of Kalaureia, which belongs to Troizen. As for Athenodoros and Dameas, the latter made the Poseidon and the Artemis, and also the Lysander, while Athenodoros made the Apollo and the Zeus. These last artists were Arcadians from Kleitor. Behind the works just described, figures have been set up of those who gave aid to Lysander at Aigospotamoi, both Spartan and allies. These were Arakos the Lakedaimonian [a list of ten names follows] . . . These were made by Tisandros, but the following ones were made by Alypos of Sikyon[54] [a list of seven names follows] . . . After these Axionikos, the Achaian, from Pellene [nine names follow] . . . They say that these are the works of Patrokles and Kanachos.

The Spartan dedication after Aigospotamoi clearly stood on one of the large bases just inside the entrance to the temenos of Apollo at Delphi, but on exactly which of the surviving bases it stood is a matter of dispute.

Pausanias 10.9.12 (following the above): Now as to the struggle between the Athenians and the Argives over the area called Thyrea[55] – this was prophesied

[53] Lysander: the Spartan admiral and director of military operations during the last years of the Peloponnesian War.

[54] Alypos of Sikyon was a pupil of Naukydes; see Pausanias 6.1.3.

[55] This battle at Thyrea (on the border between the Argolid and Lakonia) must be the one in 414 B.C. mentioned by Thucydides 6.95.

by the Sibyl, who said that the battle would come out evenly. But the Argives, feeling that they had gotten the upper hand in the battle, sent a bronze horse – representing the "Wooden Horse" [of Troy], I suppose – to Delphi. This was the work of Antiphanes of Argos.[56]

Other Sculptors of the High Classical Period

Theokosmas of Megara

Theokosmas was one of the artists who worked on the Spartan victory offering at Delphi (see above) and hence has some association with the school of Polykleitos; but, as the following passage shows, he also had connections with Athens.

Pausanias 1.40.4 (at Megara): After this, as you go into the sanctuary of Zeus called the *Olympieion* there is a temple which is well worth seeing. The image of Zeus, however, was not completed owing to the outbreak of the war of the Peloponnesians against the Athenians, in which every year the Athenians, by ravaging the country of the Megarians with their ships and their army, destroyed public property and brought private land-owners to the brink of ruin. The face of the image of Zeus is of ivory and gold, while the remaining parts are of clay and gypsum. They say that it was made by Theokosmas, a local artist, and that Pheidias collaborated with him. Above the head of Zeus are the Seasons and the Fates. This makes it clear to all that Fate is obedient to him alone and that he is the god who apportions the seasons as he sees fit. Behind the temple are some half-worked pieces of wood. These Theokosmas intended to adorn with ivory and gold and thus finish the image.[57]

Nikodamos of Mainalos (in Arcadia)

Pausanias 5.26.6 (at Olympia): . . . there stands an image of Athena with a helmet on her head and clad in an aegis. Nikodamos of Mainalos made it, and it is an offering of the Eleans.

Pausanias 5.25.7 (at Olympia): On the same wall with the offerings of the people of Akragas [see p. 46] there are also two nude statues of Herakles as a boy. One represents him in the act of shooting with his bow at the Nemean lion. This statue of Herakles and likewise the lion [which is pitted] against Herakles were offered by Hippotion of Taras [Tarentum], and are the works of Nikodamos of Mainalos. The other image is the offering of Anaxippos of Mende, and was transferred to this place by the Eleans.

[56] Antiphanes was the pupil of a sculptor named Periklytos, who was in turn a pupil of Polykleitos; see Pausanias 5.17.4.

[57] The image is possibly represented on the Megarian coinage of the time of the Roman empire. See Lacroix, *Reproductions*, p. 265, pl. XXII, 10.

Pausanias also saw statues at Olympia by Nikodamos of the athletes Antiochos of Lepreon (6.3.9), Damoxenidas of Mainalos (6.6.3), and Androsthenes of Mainalos (6.6.1). The last of these was a victor in the pankration *in 420 B.C. The base of the statue of Damoxenidas has been found at Olympia (Loewy, IgB, no. 98 and Marcadé, Recueil des signatures, I, 84) and seems to date from the fourth century. Hence Nikodamos's career can be placed in the late fifth and early fourth centuries.*

Chapter 6

Sculpture: the fourth century B.C.

This chapter deals with artists and works associated with the period up to and including the time of Alexander the Great.

Kephisodotos of Athens

Pliny (N.H. 34.50) dates Kephisodotos in the 102nd Olympiad (372 B.C.).

Pliny, N.H. 34.87: There were two sculptors named Kephisodotos. By the first there is a Hermes nursing the infant Dionysos; he also made a man declaiming in public with his hand upraised – whom it represents is not certain; the subsequent Kephisodotos did some philosophers.[1]

Pausanias 9.16.2 (at Thebes): . . . there is a sanctuary of Tyche [Fortune]. She [the statue of Tyche] carries the child Ploutos [Wealth]. The Thebans say that the hands and the face of the image were done by Xenophon and the rest by Kallistonikos, a local man. It was a clever design on the part of these artists – that is, putting Ploutos in the hands of Tyche as if she were his mother or nurse; but no less clever was the design of Kephisodotos. For he made the image for the Athenians of Eirene [Peace] holding Ploutos.[2]

Pliny, N.H. 34.74: Kephisodotos made the marvellous Athena in the port of Athens [Peiraeus] and an altar for the temple of Zeus the Savior in the same harbor, a work with which few may be compared.[3]

Pausanias 8.30.10: Quite near the stoa [of Aristander in Megalopolis] in the direction from which the sun rises is a sanctuary of Zeus surnamed the Savior. It

[1] The elder Kephisodotos and the younger Kephisodotos were respectively the father and son of Praxiteles.

[2] According to Pausanias 1.8.2, this figure stood on the Areopagos in Athens. Roman copies of it are preserved in Munich and New York. See Richter, *SSG*, figs. 704–8 and Bibliography 41; for the representations of it on the coins of several cities, Lacroix, *Reproductions*, pl. XXVI, nos. 8–10. The cult of Eirene was officially introduced into Athens in 375 B.C. (Cornelius Nepos, *Timotheus* 2.2), which provides an approximate date for the statue.

[3] Perhaps the same as the statues of Zeus and Athena in Peiraeus mentioned by Pausanias 1.1.3.

is ornamented with columns placed all around it. Next to Zeus, who is seated on a throne, stands, on the right, "Megalopolis," and, on the left, is an image of Artemis the Savior. These are of Pentelic marble, and the Athenians Kephisodotos and Xenophon made them.

For the images of the Muses on Mt Helikon by Kephisodotos see p. 72.

Praxiteles

Pliny (N.H. 34.50) dates Praxiteles in the 104th Olympiad (364 B.C.).

Pliny, N.H. 36.20: I have mentioned the date of Praxiteles in my discussion of the sculptors who worked in bronze; yet it was in his fame as a worker of marble that he surpassed even himself. There are works by him in Athens in the *Kerameikos*. But superior to all the works, not only of Praxiteles, but indeed in the whole world, is the Aphrodite which many people have sailed to Knidos in order to see. He made two statues and offered them for sale at the same time; one of them was represented with the body draped, for which reason the people of Kos, whose choice it was (since he had put the same price on both), preferred it, judging that this was the sober and proper thing to do. The people of Knidos bought the rejected one, the fame of which became immensely greater. Later King Nikomedes[4] wished to buy it from the Knidians, promising that he would cancel the city's whole debt, which was enormous. They preferred, however, to bear everything, and not without reason. For with that statue Praxiteles made Knidos famous. Its [that statue's] shrine is completely open, so that it is possible to observe the image of the goddess from every side; she herself, it is believed, favored its being made that way. Nor is one's admiration of the statue less from any side. They say that a certain man was once overcome with love for the statue and that, after he had hidden himself [in the shrine] during the nighttime, he embraced it and that it thus bears a stain, an indication of his lust. There are other statues in Knidos by illustrious artists, a Dionysos by Bryaxis and another Dionysos and an Athena by Skopas; and there is no greater testimonial to the quality of Praxiteles' Aphrodite than the fact that, among all these works, it alone receives mention. Also by him [Praxiteles] there is an Eros, which Cicero used in his charges against Verres, and for the sake of which people used to visit Thespiai; it is now placed in the lecture rooms of Octavia.[5] There is another Eros by him, this one nude, in Parium,[6] the colony on the Propontis, which is equal to the Aphrodite at Knidos both for its fame and for the injury it suffered; for

[4] Probably Nikomedes IV of Bithynia who ruled from *c.* 94 to 74 B.C.

[5] These were part of a large complex of buildings dedicated by Augustus to his sister Octavia. They consisted of a series of porticoes surrounding temples of Jupiter *Stator* and Juno *Regina*, a library and *curia* (hall for political assemblies), and the *scholae* mentioned here, which were rooms for philosophical disputation, lectures, and artistic exhibitions.

[6] Represented on the coins of Parion of the Roman Imperial period, see Lacroix, *Reproductions*, pl. XXVIII, nos. 1–4.

Alketas the Rhodian fell in love with it and also left upon it the same sort of trace of his love. At Rome, the works of Praxiteles are a Flora, a Triptolemos, and a Demeter in the gardens of Servilius, a "Success" and "Good Fortune"[7] on the Capitoline, and also Maenads, which they called Thyiads, and Caryatids, and Sileni, which are among the monuments belonging to Asinius Pollio,[8] and an Apollo and a Poseidon.

Pliny, *N.H.* 34.69–70: Praxiteles, who was more successful in marble [sculpture] and hence was more famous [in that medium] also made, however, very beautiful works in bronze: the Rape of Persephone, a *Katagousa*,[9] and a Dionysos with a figure of "Drunkenness" and the famous Satyr to which the Greeks attach the surname *periboëtos* ["the much talked of" or "the notorious"]; also the statues[10] which were once in front of the temple of Felicitas along with an Aphrodite and which were consumed in the fire which destroyed that temple during the principate of Claudius; the latter work was equal to her sister statue in marble, which is famed all over the world [that is, the Aphrodite of Knidos]; also a woman bestowing a garland, a woman putting on an armlet, "Autumn"[11] . . .[12] He also made a young Apollo who, close at hand, is lying in wait with an arrow for a lizard, which is creeping up, for which reason they call him the *Sauroktonos*.[13] Also well regarded are two of his statues that express diverse emotions, his "Matron Weeping" and his "Courtesan Smiling." This last they believe to have been Phryne [Praxiteles' mistress], and they detect in it the love of the artist and the reward revealed in the face of the courtesan. There is also a statue which reveals his kindly nature. For he placed a charioteer made by himself in a *quadriga* made by Kalamis [see p. 94, n. 32], lest the latter, who was better at representing horses, should be thought to have failed in representing men.

Of the many works of Praxiteles mentioned by Pliny in the preceding passages, the Aphrodite of Knidos was quite clearly the most famous. A number of copies of it exist (see Bibliography 42C), but the effect of the original is perhaps more truly reflected in the following passages.

[7] "Success" – Latin *Bonus Eventus*, probably Greek *Agathos Daimon*; "Good Fortune" – Latin *Bona Fortuna*, Greek *Agathe Tyche*.

[8] Gaius Asinius Pollio, 76 B.C.–4 A.C., a wealthy Roman politician, writer, literary critic, and patron of the arts.

[9] Meaning either "a woman spinning thread" or possibly a reference to a figure who is "bringing home" Persephone from the underworld. The Greek admits both meanings, but the first alternative seems more likely.

[10] The statues are apparently the "Thespiades," probably a group representing the Muses referred to by Pliny, *N.H.* 36.39, and by Cicero, *in Verrem* 2.4.2.4.

[11] Only one manuscript reads *Oporan*, "Autumn." The earliest edition of Pliny printed *oenophoram*, "wine-bearer." Urlichs suggested *Canephoram*, "Basket-bearer."

[12] At this point Pliny ascribes to Praxiteles the Tyrannicides group (by Antenor) that was carried off by Xerxes. His information is clearly erroneous; see p. 41.

[13] *Sauroktonos* – "Lizard Slayer;" Roman copies in bronze and marble and also on coins exist. Richter, *SSG*, figs. 720–3.

Lucian, *Imagines* 6 (once again selecting features for the "Panthea"): LYKIOS:
And now he will make it possible for you to see the statue coming into being as
he fits it together, taking only the head from the Knidian [Aphrodite]. For he
will not want to use the rest of the body, since it is nude. But the area around the
hair and the forehead and also the neat line of the eyebrows he shall let her have
just as Praxiteles made them; likewise the dewy quality of the eyes with their
joyous radiance and welcoming look, this too he shall preserve just as Praxiteles
conceived it . . . and as to how old she should be, let the measure of this follow
exactly that of the goddess in Knidos. Yes, this too shall be measured according
to Praxiteles' standard.

Lucian, *Amores* 13–14: When we had taken sufficient delight in the garden
plants, we passed on into the temple. The goddess is set there in the middle of it –
an exceedingly beautiful work of Parian marble – with a look of proud
contempt and a slight smile which just reveals her teeth. The full extent of her
beauty is unhidden by any clinging raiment, for her nudity is complete except
insofar as she holds one hand in front of her to hide her modesty. So strongly has
the artist's art prevailed, that the recalcitrant and solid nature of the stone has
become adapted to each limb . . . The temple has two entrances, [the second
being] for those who wish to see the goddess directly from the back, in order
that nothing about the goddess should fail to be marvelled at . . . (**Sec. 14**) To see
the goddess in her entire splendor, we went around to the back. As the doors
were opened by the woman who was entrusted with the keys unforeseen
amazement at the goddess's beauty seized us . . .

The Aphrodite of Knidos is also the subject of a number of poems in the Greek
Anthology. *The following is a typical example.*

Anthologia Graeca 16.160, by a poet named Plato:

> Paphian Cythera came through the sea to Knidos
> Wishing to see her own image.
> Having gazed from every angle in that conspicuous space
> She cried: "Where did Praxiteles see me naked?"
> Praxiteles did not see what was unlawful, but the iron
> Carved the Paphian just as Ares would have wanted her.

*Phryne, Praxiteles' notorious mistress, seems to have served as the model for a number
of his sculptures.*

Athenaios 13.590: [Phryne, Praxiteles' mistress] in the festival of the Eleusians
and in the festival of Poseidon took off her robes in view of all the Greeks,
unbound her hair and went into the sea. It was with her as a model that Apelles
painted his Aphrodite *Anadyomene* [rising from the sea]. And Praxiteles the
sculptor, falling in love with her, made his Knidian Aphrodite with her as the
model.

Athenaios 13.591B: The local people had a gold statue made of this Phryne and set it up in Delphi on a column of Pentelic marble. Praxiteles was the sculptor. Of this statue Krates the Cynic said, when he saw it, that it was an offering of the incontinence of the Greeks. The portrait stood between those of Archidamas the king of the Lakedaimonians and Philip, the son of Amyntas, and bore the inscription: "Phryne the Thespian, daughter of Epikles" . . .

Phryne is also reputed to have forced Praxiteles into a definitive judgment on his own work.

Pausanias 1.20.1–2 (in Athens): There is a road leading from the Prytaneion which is called [the street of the] "Tripods." They give the place that name because there are temples just big enough for this purpose [that is, of holding tripods], and in them stand tripods, made of bronze; they also contain works of art that are especially worth noting. For there is a Satyr there of which Praxiteles is said to have been very proud. When Phryne once asked him to give her whichever of his works he considered the most beautiful, they say that he agreed, as a lover would, but that he could not bring himself to confess which work appeared most beautiful to him. Consequently a slave of Phryne's was sent running to Praxiteles to tell him that the greater part of his work had been ruined when a fire broke out at his workshop but that not all his work had been destroyed. Praxiteles immediately began to rush through the doorway and said that all his work would have been for naught if the fire had caught his Satyr or his Eros. But Phryne told him to relax and to cheer up, for he had not really suffered anything grievous, but by a ruse she had tricked him and forced him to admit which of his works were the most beautiful. So it was that Phryne chose the Eros. In the temple of Dionysos nearby there is a Satyr, a boy who holds out a drinking cup.[14]

Tradition held that Phryne dedicated the Eros in the sanctuary of Eros at Thespiai in Boeotia.

Pausanias 9.27.3–5 (at Thespiai): Lysippos [see p. 104] later made an Eros in bronze for the Thespians, and prior to that Praxiteles had made one of Pentelic marble. As to the events concerning Phryne and the trick played by this woman on Praxiteles, I have already presented them in another place. They say it was Gaius [Caligula] who, when he became emperor, first moved the image of Eros to Rome; it is said that Claudius had it sent back to the Thespians and that Nero had it dragged back to Rome a second time. There a fire finally destroyed it . . . The statue of Eros that stands in Thespiai in our own time was made by the Athenian Menodoros, copying the work of Praxiteles. There is also an

[14] It is not clear whether Pausanias is referring to Praxiteles' Satyr in the last sentence or simply to another work in the area of the street of the tripods. A series of Roman copies representing a satyr pouring wine is frequently connected with a Praxitelean original; Richter, *SSG*, figs. 729–31; Rizzo, *Prassitele* (Bibliography 42A), pls. 19–26.

Aphrodite and a portrait of Phryne by Praxiteles himself; both Phryne and the goddess are of stone.

Strabo 9.2.25: The Thespians formerly were famous for the Eros of Praxiteles, which he himself carved and the courtesan Glykera[15] set up in Thespiai; she was a native of that place by birth and received the statue from the artist as a gift. Therefore, some people formerly used to go up to Thespiai in order to see the Eros, there being otherwise not much worth seeing . . .

Athenaios 13.591A: And Praxiteles the sculptor, being in love with her [Phryne], modelled his Knidian Aphrodite after her, and on the base of the Eros beneath the stage building of the theater he had inscribed:

> Praxiteles rendered precisely the love he suffered,
> Drawing the archetype from his own heart.
> Phryne received me as a gift; love philtres no longer
> Do I shoot with any bow, but love is stirred by looking at me.

Many other less well-known figures of gods and goddesses by Praxiteles were seen by Pausanias in his travels. The passages that follow describe works for which there is some sort of corroborating archaeological evidence.

Pausanias 8.9.1 (in Mantineia): The Mantineians have a two-part temple which is divided right down the middle by a wall. In one section of the temple there is an image of Asklepios, the work of Alkamenes; in the other there is a sanctuary of Leto and her children. Praxiteles made the images in the third generation after Alkamenes. On the base of these figures are [reliefs of] the Muses and Marsyas playing the flute.[16]

Pausanias 1.44.2 (at Megara): Going from the Agora on the road which is called "the Straight" there is on the right a sanctuary of Apollo called *Prostaterios* ["Standing before the doors" or "Protecting"]. This is found by turning just a little away from the road. In it there is an Apollo worth seeing, an Artemis, a Leto, and other images; the Leto and her children were made by Praxiteles.[17]

Pausanias 2.21.8–9 (in Argos): The sanctuary of Leto is not far from the trophy, and the image is the work of Praxiteles. The figure of the maiden who is next to the goddess they call Chloris, saying that she was a daughter of Niobe, and that she was originally called Meliboia.[18]

[15] Glykera is presumably the same as Phryne.

[16] This base still exists and is now in the National Museum in Athens; Richter, *SSG*, figs. 726–8; Rizzo, *Prassitele*, pls. 130–2.

[17] The group is represented on Roman coins from the time of Commodus and Septimius Severus; see Lacroix, *Reproductions*, pl. XXVII.1. Rizzo identified it with a marble figure of Artemis (a Roman copy) in Dresden, *Prassitele*, pls. 16–18.

[18] These images are represented on Argive coinage of the Roman Imperial period; see Lacroix, *Reproductions*, pl. XXVII.2–4.

Pausanias 10.37.1 (at Antikyra in Phokis): On the right about two stades from the city itself, there is a high rock – the rock is a spur of the mountains – and on it a sanctuary of Artemis has been established. The statue, which is one of the works of Praxiteles, holds a torch in the right hand and has a quiver over the shoulders. By her on the left is a dog. In size the image is taller than the tallest woman.[19]

The famous figure of Hermes holding the infant Dionysos, found in the temple of Hera at Olympia in 1877, was seen in situ *and briefly mentioned by Pausanias.*

Pausanias 5.17.3 (at Olympia): . . . at a later time still other works were set up in the temple of Hera, among them a Hermes of stone, who carries the infant Dionysos, the work of Praxiteles . . .

Whether the Hermes is an original, a copy, or the work of a later Praxiteles is a long-disputed question. See Bibliography 42B.

Pausanias (1.3.4) ascribes to Praxiteles a group in Athens representing Demeter, Persephone, and Iacchos and notes that his group had an inscription in Attic letters. Since Attic letters went out of common use in Athens in 403 B.C., some have ascribed the statues to an elder Praxiteles. As Frazer, Stuart Jones, and others have pointed out, however, the inscription seen by Pausanias might have been a Hadrianic restoration intentionally carved in the old-fashioned manner.

Pausanias (9.11.6) also ascribes the pedimental sculptures of the temple of Herakles at Thebes to Praxiteles. Here again it is possible that we deal with an elder Praxiteles, since such a commission would be unique among the works of the younger sculptor.

Demetrios of Alopeke (in Attica)

Although our information about Demetrios is limited to a few brief references, and no known Roman copy of any of his works exists, he must have been one of the most distinctive of the fourth-century sculptors. In the late Hellenistic canon of sculptors preserved by Quintilian (see pp. 222–3) he is classified as the arch-realist of Greek sculpture and ranks with Praxiteles and Lysippos as one of the three most important artists of the fourth century.[20] For speculative, inconclusive attempts to identify his style and influence, see Bibliography 43.

Pliny, N.H. 34.76: . . . Demetrios made a statue of Lysimache,[21] who was a priestess of Athena for sixty-four years, and also an Athena, which is called "the Musical"[22] – the serpents on its Gorgon echo with a tinkling sound at the stroke

[19] A figure fitting this description is found on the coins of Antikyra, Richter, *SSG*, fig. 724. Rizzo, *Prassitele*, p. 13, however, doubts that this Artemis was actually a work of Praxiteles.

[20] Four signed bases from statues by Demetrios are known: *I.G.* II² 3828, 4321, 4322, and 4895. These appear to date from the early fourth century.

[21] D. M. Lewis (see Bibliography 43) has suggested that this Lysimache was the inspiration for Aristophanes' *Lysistrata* (produced in 411 B.C.). If true, the association would suggest a date for Demetrios early in the fourth century.

[22] *Musica* is the reading of most of the manuscripts. Another suggested reading is *mycetica*, "bellowing."

of a *kithara*. He also made a statue of the cavalryman Simon, who wrote the first treatise on horsemanship.

Lucian, *Philopseudes* 18: "Did you not notice," he said, "upon coming into the courtyard the beautiful statue standing there, a work of Demetrios *Anthropopoios* ['Maker of Men']?" "Surely you don't mean the one throwing the discus?" I said . . . "Not that one," he said, "since that is one of the works of Myron, the *Diskobolos*, of which you speak. Nor do I mean the one next to it, the one binding his head with a fillet, a beautiful statue, for this is a work of Polykleitos . . . Perhaps you saw a certain figure which was beside the running water, the one with a pot-belly, a bald head, half exposed by the hang of his garment, with some of the hairs of his beard blown by the wind, and with his veins showing clearly, just like the man himself – that is the one I mean; it is reputed to be Pellichos, the Corinthian general."

Leochares of Athens

For Leochares' work on the Mausoleum at Halikarnassos, see pp. 196–8.

Pliny, *N.H.* 34.79: Leochares made an eagle, which is aware of just what it is abducting in Ganymede and for whom it carries him, and which therefore refrains from injuring the boy with its claws, even through his clothing; [he also made] an Autolykos who was a victor in the *pankration*, in honor of whom Xenophon wrote his *Symposium*, and the Zeus the Thunderer, praised before all others, on the Capitoline; also an Apollo wearing a diadem, and Lykiskos,[23] the slave dealer, and a boy who is endowed with a crafty and deceitful servility.

The Zeus and Ganymede, also mentioned by Tatian, Oratio ad Graecos 34.3 (ed. Whittaker), has sometimes been associated with a small Roman version in the Vatican (Richter, SSG, fig. 786). The Apollo mentioned by Pliny is sometimes associated with the "Apollo Belvedere" in the Vatican (Richter, SSG, fig. 784). On the attribution of these and other works to Leochares, see Bibliography 44.

Pausanias 5.20.9 (at Olympia): Within the *Altis* is a *Metroön* and a round building called the *Philippeion*. On the peak of the roof of the *Philippeion* is a bronze poppy, which serves as a binding point for the beams . . . The building is made of burnt brick, and is circled by columns. It was made by Philip after the fall of Greece at Chaironeia (388 B.C.). There stand statues of Philip and Alexander, and with them Amyntas the father of Philip. These works are by Leochares and are of ivory and gold, as are the portraits of Olympias and Eurydike.

Vitruvius 2.8.11 (at Halikarnassos): At the highest point of the citadel there is, in the middle, a sanctuary of Ares with a colossal acrolithic [see p. 63] statue by

[23] It is not clear from the text whether this Lykiskos is a work of Leochares or the name of another sculptor.

the hand of the noted artist Leochares. At least some think that this statue is by Leochares; others think it is by Timotheos [see pp. 104–5].

Plutarch, *Lives of Ten Orators: Isocrates* 27: There is a bronze portrait of him [Isocrates] set up in Eleusis before the first colonnade, dedicated by Timotheos, the son of Konon, which bears the inscription: "Timotheos for the sake of friendship, and respecting hospitality, set up this portrait of Isocrates to the goddesses. A work of Leochares."

Pseudo-Plato, *Epistle* 13.361A (a letter purporting to be from Plato to Dionysos II of Syracuse): Concerning the things about which you wrote asking me to send you, I bought the Apollo, and Leptines is bringing it to you; it is by a young and noble artist named Leochares; there was another work there by him that was very elegant, I thought. Therefore I bought it with the intention of giving it to your wife . . .

Other works by Leochares included: a Zeus and Demos in Peiraeus (Pausanias 1.1.3); a Zeus on the Acropolis in Athens (Pausanias 1.24.4); an Apollo near the temple of Apollo Patroös *in Athens (Pausanias 1.3.4; see pp. 47, 168). See also Loewy,* IgB *77–83, for the signed statue bases by Leochares.*

Bryaxis

Bryaxis was also one of the sculptors who worked on the Mausoleum at Halikarnassos (see pp. 196–8).

Pliny, *N.H.* 34.73: Bryaxis made an Asklepios[24] and a Seleukos.[25]

Pliny, *N.H.* 34.42 (in Rhodes): There are other colossal statues in the same city, one hundred in number, smaller than this one [the colossus of Rhodes, see p. 110], but each one of which, had it stood alone somewhere, would have made that place famous; and besides these there were five [colossal statues] of gods, which Bryaxis made.

Pliny, *N.H.* 36.22: In Knidos there are other marble statues by illustrious artists, a Dionysos by Bryaxis . . .

Georgios Kedrenos, *Synopsis of Histories*, ed. Niebuhr 536B (Overbeck, SQ 1321): Julian, crossing over into Antioch and continuing up to Daphne and worshipping the idol of Apollo – for in that place there stood a marvellous work by the sculptor Bryaxis, which no one else was capable of imitating – sought an oracular response from it, but no answer was forthcoming.

This statue is further described by the rhetorician Libanios of Antioch.

Libanios, *Orat.* 61: And a mental effort makes the apparition [of the Apollo] stand before my eyes – the gentleness of its form . . . the offering bowl, the

[24] Pliny probably refers to the Asklepios (with Hygieia) by Bryaxis seen by Pausanias (1.40.6) at Megara. [25] King Seleukos I of Syria ruled from 312 to 280 B.C.

kithara, the tunic reaching to the feet, the softness in the stone at the neck, the belt around the chest keeping in place the gold tunic[26] in such a way that some of it is held in tight and some of it billows out . . . he seemed like one who was singing a melody.[27]

Another statue ascribed to a sculptor named Bryaxis was the great cult statue of Serapis at Alexandria.

Clement of Alexandria, *Protrepticus* 4.48 (after discussing several versions of the origin of the cult and where the statue came from): . . . the sculptor Bryaxis made it, not the Athenian, but another sculptor with the same name as that Bryaxis. He made use of mixed and varied materials for the work. There were filings of gold on it and of silver; also of bronze, iron, and lead, and in addition to that, tin; nor did it lack any of the Egyptian gems – fragments of sapphire, haematite, and emerald, and others of topaz. Having ground all these to a powder and mixed them together, he colored the mixture to a dark blue shade (and owing to this, the color of the image is rather dark) and, blending all these things in with the dye left over from the worship of Osiris and Apis, he modelled the Serapis.[28]

Other works by Bryaxis were a Pasiphaë (Tatian, Oratio ad Graecos 33) and perhaps also a Zeus and Apollo with lions at Patara in Lycia (Clement of Alexandria, Protrepticus 4.47). A base in Athens with reliefs representing horsemen and tripods is signed by Bryaxis.[29]

Silanion of Athens

Pliny, *N.H.* 34.51: In the 113th Olympiad [327 B.C.] . . . was Silanion; in connection with whom there is the remarkable fact that he became famous without the benefit of a teacher.

Pliny, *N.H.* 34.81–2: Silanion cast a [portrait of] Apollodoros, who was a modeller himself, but who was among all artists the most meticulous in his art and also a harsh critic of himself, frequently smashing his finished statues as long as he was unable, owing to his zeal for his art, to be satisfied and was therefore given the surname "the Madman." This quality Silanion expressed in his portrait and made out of bronze not a man but anger itself. He also made a famous Achilles and a trainer exercising athletes.

[26] From Theodoretus, *Historia Ecclesiastica* 3.10, we learn that the statue was made of wood and gold.

[27] The statue was probably the prototype for the Apollo represented on a Seleukid tetradrachm. See Lacroix, *Reproductions*, pl. XXVIII.7.

[28] All of the many surviving images of Serapis may be variants of the type created by Bryaxis. On the complicated question of which artist made the image at Alexandria, and when it was made, see the summary in Pollitt, *AHA*, pp. 279–80 and Bibliography 45.

[29] Picard, *Manuel* IV, pp. 858–63; Richter, *SSG*, figs. 771–2.

Diogenes Laertios 3.25: In the first chapter of the *Records* of Favorinus it is said that Mithridates the Persian set up a statue of Plato in the Academy and inscribed on it: "Mithridates, son of Rhodobates, dedicated to the Muses this portrait of Plato, which Silanion made."

The surviving portrait type of Plato, of which there are numerous replicas, is generally thought to derive from the original by Silanion. See Richter, Portraits, pp. 164–70, figs. 915–75.

Plutarch, *de Recta Ratione Audiendi* **3.30 (Moralia 18c):** We are delighted when we see the Philoktetes of Aristophon and the Jokasta of Silanion represented as both wasting away and dying.

Plutarch, *Quaestionum Convivalium Libri VI* **5.1.2 (Moralia 674A):** We find pleasure in and we marvel at the modelled statue of Jokasta, in whose face, they say, the artist mixed silver, so that the bronze might take on the surface color of a human being whose life is slowly being snuffed out.

Cicero, *in Verrem* **2.4.57.125–6:** For the Sappho, which was carried off from the *Prytaneion* [in Syracuse], gives you such a just excuse that it is almost to be viewed as something which can be conceded and ignored. For this work of Silanion is so perfect, so elegant, so elaborate, that I ask if it would not be better off in the hands of a private citizen or even a whole people, rather than in the hands of that most refined and elegant man Verres?

Other works by Silanion include: a Theseus in Athens (Plutarch, Life of Theseus 4); the Boxers Satyros of Elis (Pausanias 6.4.5), Telestas of Messenia (Pausanias 6.14.4), and Demaretas of Messenia (Pausanias 6.14.11).

Silanion was also the author of a treatise on symmetria (see p. 233).

Euphranor

Euphranor worked primarily in Athens[30] and was both a sculptor and a painter (see pp. 167–8). He also wrote on art theory (see pp. 8, 233). Pliny (N.H. 34.50) dates Euphranor in the 104th Olympiad (364 B.C.).

Pliny, N.H. 34.77: The Alexander Paris is a work of Euphranor praised because it conveys all these [aspects of his personality] simultaneously – the judge of the goddesses, the lover of Helen, but also the killer of Achilles. His also was an Athena, which at Rome was called the *Catuliana*, and was dedicated below the Capitoline by Q. Lutatius Catulus, and also a statue of "Bonus Eventus," holding an offering-bowl in the right hand and an ear of corn and some poppies in the left; also a Leto after childbirth, holding up the infants

[30] Pliny refers to him as *Isthmius* (*N.H.* 35.128) which would seem to mean that the sculptor was a native of the small town near the sanctuary of Poseidon at Isthmia. On the problems that this information raises see Palagia, *Euphranor* (Bibliography 47), p. 6.

Apollo and Artemis, [a group which is] in the temple of Concord. He also made four-horse chariots, two-horse chariots, a very beautiful *Kleidouchos* ["Key-bearer"],[31] a "Virtue" and a "Greece," both colossal figures, a woman represented as wondering and worshipping, and also [portraits of] Alexander and Philip in four-horse chariots.

Euphranor also did the cult image of Apollo for the temple of Apollo Patroös in the Agora at Athens (Pausanias 1.3.4, see pp. 47, 168). A partially preserved torso found in the Athenian Agora in 1907, now in the Stoa of Attalos, is accepted by most scholars as a fragment of this statue. A statue of Hephaistos by Euphranor is mentioned by Dio Chrysostom (Or. 37.43). On the many problems involved in attributing surviving sculptures, especially the bronze Athena from Peiraeus, to Euphranor, see Palagia, Euphranor and Bibliography 47.

The Younger Kalamis,[32] Praxias, and Androsthenes

Pausanias 10.19.4 (the temple of Apollo at Delphi): The figures in the pediments are Artemis, Leto, Apollo, the Muses, the setting sun, and Dionysos with the Thyiad women. The artist who executed the first of them was the Athenian Praxias, a pupil of Kalamis. But since the temple was under construction for some time, fate, as was inevitable, carried off Praxias, and the remainder of the decoration of the pediments was done by Androsthenes, who was also an Athenian by birth and a pupil of Eukadmos.

A few fragments of these sculptures survive. On their style and meaning see Bibliography 48.

Up to this point we have dealt with sculptors who were either Athenians or who were closely associated with Athens. A number of the most influential sculptors of the century, however, were unconnected with the Athenian school and developed styles uniquely their own. The two most important of these were Skopas and Lysippos.

Skopas of Paros

Skopas was one of the sculptors who worked on the Mausoleum of Halikarnassos (see pp. 196–8), and he was also a distinguished architect. On the style of Skopas and the

[31] This term is also used in connection with a work of Pheidias, see p. 55. It probably represented a priestess, although other interpretations have been suggested. See Palagia, *Euphranor*, pp. 40–1.

[32] On the younger Kalamis, see also p. 85. The temple of Apollo at Delphi referred to in this passage was built *c.* 360–330 (this was the sixth and last temple). Overbeck and, following him, Stuart Jones associated Pausanias's description of the pediments with the description of architectural (metope?) sculptures in Euripides' *Ion*, lines 190ff., but the two passages are surely unconnected. Euripides would have known the fifth (or "Alkmaionid") temple; Pausanias would have seen the sixth one. If Praxias was active *c.* 360, the younger Kalamis can be placed in the early and mid-fourth century. He is probably the same as Kalamis the silversmith (see p. 234). The story that Praxiteles made the charioteer for a chariot group by Kalamis may also refer to the younger sculptor. Perhaps too the Apollo in the Gardens of Servilius in Rome which Pliny (*N.H.* 36.36) ascribes to Kalamis the *caelator* was by him.

complicated problems involved in attributing surviving sculptures to him, see Stewart,
Skopas of Paros *and Bibliography 49.*

Pliny, N.H. 36.25–6: The fame of Skopas rivals that of these [Praxiteles and his relatives]. He made an Aphrodite and a *Pothos* ["Desire" or "Yearning"], which are worshipped with extremely sacred ceremonies at Samothrace; also an Apollo which is on the Palatine,[33] and in the gardens of Servilius a much-praised seated Hestia with two pillars[34] flanking her, pillars for which there are duplicates among the monuments collected by Asinius, where there is also a *Kanephoros* ["Basket-bearer"] by him. But the greatest value is attached to those works in the shrine built by Cn. Domitius in the Flaminian Circus – Poseidon[35] himself and Thetis and Achilles, along with Nereids riding dolphins, huge fish and sea-horses, and also Tritons, the chorus of Phorkys, sea-monsters and many other creatures of the sea, all by his hand; a distinguished achievement, even if it had occupied his whole life. But the truth is that there also exists at present, in addition to the works mentioned above and those that we do not know about, a colossal seated Ares executed by his hand in the temple of Brutus Callaecus[36] also in the Circus, and in addition to this a nude Aphrodite, in the same place, a work that takes precedence over the one by Praxiteles and would make any other place [but Rome] famous . . .

Pliny, N.H. 36.28: There is equal doubt as to whether the "Dying Children of Niobe" in the temple of Apollo *Sosianus* [in Rome] were made by Skopas or Praxiteles; and likewise there is doubt as to which of the two did the father Janus,[37] which was dedicated by Augustus in its [or his?] own temple after being brought from Egypt; and now its identity is further concealed by a gilt covering.

Pausanias 8.45.4–7 (at Tegea in Arcadia): Aleos made the ancient sanctuary of Athena *Alea* for the Tegeans. At a later time the Tegeans built for the goddess a great temple, well worth seeing. A fire, which broke out suddenly and spread quickly, destroyed the temple when Diophantos was the Archon at Athens in

[33] This statue was originally in Rhamnous. It was brought to Rome to be used as a cult statue in a new temple of Apollo on the Palatine, which commemorated the battle of Actium and was dedicated in 28 B.C. It is represented on Roman coins; see Picard, *Manuel* III.2, pp. 640–1.

[34] Pillars – *kampteras*, a Greek word for the pillars at the turning point of an ancient "hair-pin" shaped race course.

[35] It has been suggested that Cn. Domitius Ahenobarbus brought these figures from Bithynia where he was governor *c.* 40–35 B.C. and where there was a famous temple of Poseidon at Astakos Olbia. Domitius probably completed a restoration of the temple of Neptune in Rome in 32 B.C. when he was consul. For a useful summary of other interpretations and for a review of surviving works that may be associated with this group, see Lattimore, *The Marine Thiasos in Greek Sculpture*, chapter 2 and, more generally, Bibliography 49. Some scholars attribute the group to a later artist named Skopas, who is thought to have been active in the first century B.C. See Mingazzini (1971) (Bibliography 49). [36] This temple, dedicated to Mars, was built in 138 B.C.

[37] Janus was a Roman deity with no precise Greek equivalent, and it is unlikely that Skopas or Praxiteles made an image of him. The monument to which Pliny refers may have been a double herm.

the second year of the 96th Olympiad, the same year in which Eupolemos of Elis was the victor in the one-stade foot race [395 B.C.].[38] The temple which stands in our own time is superior to all the other temples in the Peloponnesos in, among other things, its artistic adornment and in its size. The first ornamental colonnade in it is Doric, and the one after that is Corinthian. Also, outside the temple, stand columns in the Ionic order.[39] The architect of it, I learned, was Skopas the Parian, who made images in many places in ancient Greece and also made some in Ionia and Karia. The figures in the pediment on the front represent the hunt for the Kalydonian boar. The boar is placed exactly in the middle of it and to the side of it are Atalanta, Meleager, Theseus, Telamon, Peleus, Polydeukes [Pollux], Iolaos (who undertook most of the labors with Herakles), the children of Thestios, and the brothers of Althaia, Prothoüs and Kometes. Beside the boar on the other side is Epochos holding up Ankaios who already has wounds and has dropped his axe; by him are Kastor and Amphiar-aos, the son of Oikles; after them is Hippothoös, the son of Kerkyon, the son of Agamedes, the son of Stymphalos. The last figure represented is Peirithoös. Represented in the pediment on the back of the temple is the battle of Telephos against Achilles on the plain of the river Kaïkos.

Fragments of these pedimental figures have been found and are now in Athens and Tegea. They may not be by the hand of Skopas, but they are thought by most scholars to reflect his artistic influence. See Bibliography 49, especially Dugas, Le sanctuaire d'Aléa Athéna à Tégée, *pls. XCVI–CX.*

Pausanias 8.47.1 (in the sanctuary of Athena *Alea* at Tegea): Beside the image of Athena on one side stands a statue of Asklepios and, on the other side, one of Hygieia, both of Pentelic marble, works of Skopas the Parian.

Pausanias 6.25.1 (in Elis): The precinct of Aphrodite is enclosed by a fence; inside the precinct a base has been made and on the base is a bronze image of Aphrodite seated upon a goat, also of bronze. This is a work of Skopas and they call it Aphrodite *Pandemos*.[40] The significance . . . of the goat I leave to those who wish to guess.

Scholiast on Aeschines, *Against Timarchos,* **p. 747** (ed. Reiske): There were three female deities called the "Holy Goddesses" or the "Eumenides" or the "Erinyes" ["Furies"]. Of them the two on each side were made by Skopas of Paros from *lychnites*;[41] the one in the center was by Kalamis.[42]

[38] Although the old temple was burned in 395 B.C., the new one seems not to have been built until about 360 B.C. or possibly even later (see the view of Stewart, *Skopas of Paros,* pp. 67–9). The main period of Skopas's artistic activity must be placed around the middle of the fourth century.

[39] On the architectural remains of the temple and their arrangement see the study of N. Norman (1984) (Bibliography 49).

[40] *Pandemos* means "common," "for everybody." The statue forms a contrast with the Aphrodite *Ourania* of Pheidias (see p. 64) which Pausanias describes immediately before this.

[41] *Lychnites* – a term for Parian marble (Pliny, *N.H.* 36.14).

[42] Presumably the younger Kalamis. See p. 94.

Pausanias is probably describing the same works in the following passage.

Pausanias 1.28.6 (in Athens): Nearby is the sanctuary of those gods whom the Athenians called the *Semnai* ["the Holy Ones"] but whom Hesiod in the *Theogony* calls the "Erinyes." Aeschylus first represented them as having snakes on their head along with their hair. But there is nothing fearful in these images ...

Strabo 13.1.48: In this town of Chryse [in Asia Minor near Troy] there is a sanctuary of Apollo *Smintheus*, and the symbol which preserves the etymology of the name, the mouse, is placed at the foot of the statue. These are works of Skopas the Parian.[43]

Of particular interest to ancient writers was the Bacchante or Maenad of Skopas.

***Anthologia Graeca* 9.774**, by Glaukos the Athenian:

> This is a Parian Bacchante; the sculptor breathed life
> Into the stone; she leaps up as if in frenzied revel.
> O Skopas, the god-creating art of your hand has wrought
> A goat-slaying wonder, a raving Thyiad.

Kallistratos, *Eikones* 2 (excerpts): ... For Skopas, as if moved by some inspired conception, instilled into the creation of this image a state of divine possession ... The image of a Bacchante made of Parian marble has been transformed into a real Bacchante. For the stone, while retaining its natural form, seems to escape from the normal law that governs stones. What appeared was in actuality an image, but art had transformed the imitation into reality ... The hair was stirred by the wind and was separated to show the quality of each strand ... not only that, but it also showed the hands in action – for she did not brandish the *thyrsos*, but she bore a sacrificial victim and seemed to shout the Bacchic cry, a more piercing symbol of her madness ... Thus Skopas, while making images of beings that were not really alive, was an artisan of truth and impressed miraculous qualities on the surface of bodies made of inert matter.

Some of the qualities in the Maenad that impressed ancient authors can be appreciated in the figure of a raving Maenad in Dresden which is generally accepted as a copy, or at least a version, of Skopas's original (see Stewart, Skopas, pl. 32 (Bibliography 49)).

Pausanias 2.10.1 (in Sikyon): In the gymnasium, not far from the agora, there stands a Herakles made of stone, a work of Skopas.

The Herakles may be depicted on Sikyonian coins (see Stewart, Skopas, pl. 31). Attempts to identify copies or echoes of it in surviving works, such as the "Hope Herakles," are controversial. See Palagia (1984), Bibliography 49.

[43] Perhaps represented on the coins of Kyzikos and Alexandreia in the Troad; see Arias, *Scopas*, pl. VI, nos. 19, 20 (Bibliography 49); Picard, *Manuel* III, pp. 690–1. Lacroix (*Reproductions*, p. 318), however, doubts the identification.

*On Skopas's architectural sculptures other than those mentioned above, see pp. 196–8
(Mausoleum) and p. 182 (Artemision at Ephesos).*

Lysippos of Sikyon

Pliny, N.H. 34.61–5: Douris[44] says that Lysippos of Sikyon was not a disciple
of any other artist, but that he was at first a bronze-worker and undertook a
career in the fine arts[45] upon hearing a response of the painter Eupompos. For
when that man [Eupompos] was asked which of his predecessors he followed, he
pointed to a crowd of men and said that one ought to imitate nature itself, and
not another artist. Lysippos made more statues than any other artist, being, as we
said, very prolific in the art; among them was a youth scraping himself with a
strigil [*Apoxyomenos*], which Marcus Agrippa dedicated in front of his baths, a
work amazingly pleasing to the Emperor Tiberius. He [Tiberius] was, in fact,
unable to restrain himself in its case (although at the beginning of his principate
he had been master of himself) and had it moved to his own bedroom,
substituting another statue in its place. When, however, the indignation of the
Roman people became so great that they demanded, by an uproar in the theater,
that the *Apoxyomenos* be replaced, the Emperor, even though he had fallen in
love with it, put it back. Lysippos is also famed for his "Tipsy Flute-girl" and his
"Hunt with Dogs," but most especially for his "*Quadriga* with the Sun" [that is,
the god Helios] belonging to the Rhodians. He also made many portraits of
Alexander the Great, beginning from his boyhood, one of which so delighted
the Emperor Nero that he ordered that it be gilded. Afterwards however, when
the artistic value of the statue was superseded by its monetary value, the gold
was taken off, and yet it was considered more precious in that state, even though
the scars from the work done on it and the cuttings into which the gold had been
fastened remained. He also made a portrait of Hephaistion, the friend of
Alexander the Great, which some ascribe to Polykleitos, although he lived
about a hundred years earlier. He also made "Alexander's Hunt" which was
consecrated at Delphi, a Satyr at Athens, and "Alexander's Squadron," in which
he executed portraits of all Alexander's friends with the utmost exactitude.
Metellus, after subduing Macedonia, transferred this work to Rome [148 B.C.].
He also made *quadrigas* of various types. He is said to have contributed much to
the art of casting statues by representing the hair in detail, by making the head
smaller than earlier sculptors had, and by making the bodies slenderer and more
tightly knit, as a result of which the height of his statues seems greater. There is

[44] See Introduction, p. 6.
[45] "Undertook a career in the fine arts" – *rationem cepisse*. The Latin term *ratio* frequently refers to
the theoretical principles that underlie an art. Lysippos, it will be seen, was an important innovator
in the theory of sculptural proportions. The fact that he developed his own principles of proportion
of design rather than adopting those of another artist or school may have given rise to the tradition
that he had no teacher.

no Latin term for [the Greek word] *symmetria* which he observed with the utmost precision by a new and previously unattempted system which involved altering the "square"[46] figures of the older sculptors; and he used commonly to say that by them [that is, the earlier sculptors] men were represented as they really were, but by him they were represented as they appeared. What seem to be especially characteristic of his art are the subtle fluctuations of surface that are apparent even in the smallest details.

On the relationship of the well-known Apoxyomenos *in the Vatican and other surviving sculptures to the works mentioned by Pliny, see Bibliography 50.*

Pliny, N.H. 34.37: . . . Lysippos is related to have made 1,500 works, all of them of such artistic quality that any single one could have given him fame; this number came to light upon his death, when his heir broke open his strong-box. For it was his custom to put in it one gold coin, worth a denarius, from the fee which he received for each statue.

Pliny's discussion of Lysippos makes it clear that his career was closely associated with the Macedonian royal family. He was perhaps originally employed by Philip II (ruled 359–336 B.C.) and later served Alexander (ruled 336–323 B.C.) as his court sculptor. His portraits of Alexander established a type of heroic portrait that was often imitated throughout the rest of Classical Antiquity. On the various surviving portraits of Alexander and their relationship to the originals by Lysippos, see Bibliography 50A and D.

Plutarch, *de Alexandri Fortitudine seu Virtute* **2.2.3 (*Moralia* 335A–B):** When Lysippos first modelled a portrait of Alexander with his face turned upward toward the sky, just as Alexander himself was accustomed to gaze, turning his neck gently to one side, someone inscribed, not inappropriately, the following epigram:

> The bronze statue seems to proclaim, as it looks at
> Zeus: I place the earth under my sway; you,
> O Zeus, keep Olympos.

As a result, Alexander decreed that only Lysippos should make his portrait. For only Lysippos, it seems, brought out his real character in the bronze and gave form to his essential excellence. Others, in their eagerness to imitate the turn of his neck and the expressive, liquid glance of his eyes, failed to preserve his manly and leonine quality.

Plutarch, *Life of Alexander* **4.1:** The statues of Lysippos best embody Alexander's physical appearance, and in fact Alexander himself deemed that only Lysippos was worthy of modelling his portrait. For it was this artist who

[46] "Square figures" – *quadratas staturas*. It will be remembered that Polykleitos's statues were *quadrata*; on the meaning of the term see p. 76, n. 43.

captured with precision those features which Alexander's followers and friends
later imitated, namely, the tension expressed in his neck as it was bent slightly to
the left and the glistening quality of his eyes.

Plutarch, *de Iside et Osiride* **24 (***Moralia* **360D):** Lysippos the modeller did
well to find fault with the painter Apelles because the latter, in painting a
portrait of Alexander, put a thunderbolt in his hand. He himself represented
Alexander with a spear, which time would never rob of its glory, being a true
and proper attribute.

The ideas contained in these two passages from Plutarch are repeated in passages
from many other writers.[47] *In addition to single portraits of Alexander, Lysippos also*
represented him in two large monumental groups. One of these, the "Granikos
Monument," was set up to commemorate Alexander's victory at the river Granikos in
334 B.C. It is probably identical with the "Squadron of Alexander" mentioned by
Pliny.

Arrian, *Anabasis* **1.16.4:** Of the Macedonians, twenty-five of the "Com-
panions" died in the first assault, and bronze portraits of them stood in Dion [in
Macedonia], made by Lysippos at the command of Alexander . . .

The Granikos Monument was carried off from Dion to Rome by the Roman general
Metellus after he subdued Macedonia in 148 B.C. Velleius Paterculus 1.2.2–5 records
that the group included a portrait of Alexander. For this passage see The Art of Rome,
p. 45.
The group mentioned by Pliny representing "Alexander's Hunt" at Delphi is further
described by Plutarch.

Plutarch, *Life of Alexander* **40.4:** Krateros[48] set up a memorial of this hunt at
Delphi and had bronze statues made of the lion and the dogs, and also of the king
engaged in combat with the lion, and of himself coming to give aid; some of
these were made by Lysippos, others by Leochares.

Another interesting aspect of Lysippos's artistic production was the apparently
playful use that he made of the effects of scale in sculpture. A number of his famous statues
were colossal and at least one was a miniature. The impressions produced in both cases
seem to have been surprising.

Pliny, *N.H.* **34.40:** Of such a sort [that is, colossal] also is the statue in Tarentum
made by Lysippos, forty cubits high. A remarkable fact about this statue is that,
although it can be moved, as they say, by hand, the system by which its weight is
distributed is such that it cannot be dislodged by storms. In fact the artist is said to
have provided against this possibility by a column which was placed opposite it

[47] Texts with translations are collected in Johnson, *Lysippos* (Bibliography 50A), pp. 299–307.
[48] Krateros (*c.* 370–321 B.C.) was one of Alexander's generals. The "Krateros Monument" at
Delphi was probably dedicated by his son. The dedicatory inscription for the group and the
foundations of the base on which it stood are preserved.

a short distance away in the direction from which it was most necessary to break the blast of the wind. Therefore, on account of its size and the difficulty of removing it, Fabius Verrucosus[49] did not touch it when he transferred from that place the Herakles which is now on the Capitoline.

Strabo makes it clear that the colossus referred to by Pliny represented Zeus and that the Herakles was also a colossal figure.

Strabo 6.3.1: Tarentum has a very beautiful and spacious agora in which there is installed a bronze colossus of Zeus, the largest in existence after the one in Rhodes [see p. 110]. Between the agora and the harbor is the acropolis which has few remains of the offerings that were part of its ornamentation in the old days. This is because the Carthaginians destroyed many of them when they took the city, and the Romans carried off others as booty when they conquered the city by force. One of the latter is the colossal bronze of Herakles now on the Capitoline, a work of Lysippos, an offering of Fabius Maximus after he took the city . . .

It was apparently this statue of Herakles that was subsequently transferred to Constantinople and destroyed by the Franks when they attacked the city in 1204 A.C.

Niketas Choniates, *de Signis Constantinopolitanis* **5:** The great Herakles, begotten in a triple night, is now cast down and stretches over a great space, he who was seated on a basket with a lion's skin stretched out over it . . . He sat there with no quiver slung upon him, neither bearing a bow in his hands, nor brandishing a club before him, but rather stretching out his right foot and also his right hand as much as was possible, while bending his left leg at the knee and leaning on the elbow of his left arm, with his forearm stretched upward, thus gently supporting his head in the palm of his hand, a figure full of despondency. His chest was wide, his shoulders broad, his hair thick, his buttocks ample, his arms strong, and in size he was as great as, I suppose, the actual Herakles was imagined to have been by Lysippos,[50] the artist who wrought this most excellent work of bronze, the foremost and ultimate creation of his own hands, and a work of such great size that a cord fitted around its thumb could be used as a man's belt, and the shin of its leg equalled the height of a man.

Commissions to create images of Herakles seem to have offered a challenge to Lysippos's powers of invention. One of them represented the muscle-bound hero leaning on his club in exhaustion. The original was apparently over life-sized and is known in a number of Roman copies, of which the most famous is the "Herakles Farnese" in Naples.[51] It formed the subject for a display of descriptive rhetoric by the rhetorician Libanios (fourth century A.C.).

[49] Fabius Verrucosus – Q. Fabius Maximus, a Roman consul, general, and elected dictator, who conquered Tarentum in 209 B.C.
[50] The text says "Lysimachos," which is almost certainly a corruption of "Lysippos."
[51] The type is associated with Lysippos through a small version in the Palazzo Pitti in Florence that bears the inscription: "The work of Lysippos." See Brunn-Bruckmann, *Denkmäler*, no. 284.

Libanios, *Ekphraseis* 15: It was not possible for Herakles, when he ceased from his labors, to stand without praise nor to avoid being an object of wonder as he took respite from his achievements, but rather, by being represented in sculpture, he was preserved so that people could see him both laboring and after a labor. It was with a form of this sort that the artist set him up in a conspicuous place. For Herakles rested there, not undergoing danger as he was when Nemea saw him, but rather as Argos received him after he destroyed the lion. Thus he stood there bearing the tokens of his exploits and yet, the tokens notwithstanding, with the high-point of his trials clearly behind him. To begin with his head bends toward the earth and he seems to me to be looking to see if he can kill another opponent. Then his neck is bent downward along with his head. And his whole body is bare of covering, for Herakles was not one to care about modesty when his attention was directed toward excellence. Of his arms, the right one is taut and is bent behind his back, while the left is relaxed and stretches toward the earth. He is supported under the arm-pit by his club which rests on the earth, experiencing the same leisure [as he]. And so the club supports him while he rests, just as it saved him when he fought. The artist has done well, it seems to me, in arranging the disposition of the club. For while laboring he [Herakles] uses his right hand, while in pausing for a moment of peace he uses his left. And he has also given him an idle hand. The lion skin is draped upon the club, and this covers both the lion and that by which it was destroyed. Of Herakles' two legs the right one is beginning to make a movement, while the left is placed beneath and fitted firmly on the base, and this arrangement makes it possible for the onlookers to learn just what sort of man Herakles is, even though he has ceased from his labors.

By contrast to these colossal works, another of Lysippos's most famous representations of Herakles was a miniature table-piece. This Herakles Epitrapezios ("On the table") is also known in a number of Roman copies. See Bibliography 50A, B. Martial traces here some of the owners of the statue from Alexander the Great down to Novius Vindex in his own day.

Martial 9.44: He who, being seated, mitigates the hardness of the stone with a stretched out lion's skin, a great god [compressed] in a small bronze, and who, with his face turned upward, beholds the stars which he once bore; whose left hand glows with the strength of oak, his right with unmixed wine – his fame is not something recent, nor is his glory from our [Roman] chisel. It is the well-known gift and work of Lysippos that you see. This divine power was once held by the table of the tyrant of Pella [Alexander], the victor who now lies in the earth that he had quickly tamed; by this [statue] Hannibal, as a boy, took an oath at the Libyan altars; it was this god who commanded savage Sulla to give up his rule; offended by the tumid terrors of various rulers' courts, he rejoices now to dwell at private hearths, and as he was once the convivial guest of placid Molorchus, so now he has decided to be the god of learned Vindex.

Vindex's art collection and especially the Herakles Epitrapezios *are also described at length by Statius. The following passage is an excerpt from that description.*

Statius, *Silvae* 4.6, lines 32–47: Among these [Vindex's treasures] was the genius and tutelary deity of his pure table, the son of Amphitryon [Herakles], who greatly captured my heart; nor was my eye satiated by looking at him long. So great was the dignity enclosed within the narrow borders of the work; so great its majesty. A god he was, a god! He granted, Lysippos, that the impression of himself produced by your art should be this – to be seen as small but to be thought of as enormous. And although this marvellous work is contained within the measure of a foot, nevertheless there will be an urge to cry out, as you cast your glance over his body: "On this chest the Nemean ravager was throttled; those the arms that bore the deadly oak-club and broke the Argo's oars!" And its size! How great is the deception in that small form! What controlled skill! How great was the experience of that learned artist in the details of his art, endowing him with the ingenuity to fashion a table ornament but at the same time to conceive a colossus.

Another work by Lysippos illustrating his characteristic inventiveness was his allegorical statue of Kairos *("Opportunity").*

***Anthologia Graeca* 16.275** (an epigram by Poseidippos):

Questioner – "Who was the sculptor and where was he from?"
Statue – "He was a Sikyonian."
Q – "And what was his name?"
S – "Lysippos."
Q – "And who are you?"
S – "Opportunity, the all conqueror."
Q – "Why do you stride on the tips of your toes?"
S – "I am always running."
Q – "Why do you have pairs of wings on your feet?"
S – "I fly like the wind."
Q – "Why do you carry a razor in your right hand?"
S – "As a sign to men that my appearance is more abrupt than any blade [is sharp]."
Q – "And your hair, why does it hang down over your face?"
S – "So that he who encounters me may grab it."
Q – "By Zeus,[52] and why is the back of your head bald?"
S – "Because nobody, once I have run past him with my winged feet, can ever catch me from behind, even though he yearns to."
Q – "For what reason did the artist fashion you?"
S – "For your sake, stranger. And he placed me before the doors as a lesson."

[52] This oath could belong either to this question, or with the preceding answer. The punctuation of the original text is uncertain.

The Kairos, with its obvious "content" or "message," became a common subject for the ancient art of ekphrasis, the rhetorical description of works of art. Two late antique descriptions of the statue, those of Himerios (Eclogae 14.1) and Kallistratos (Eikones 6), are also extant. Himerios recounts that the statue had a scale in its left hand; Kallistratos says that it stood in Sikyon and that its feet rested on a globe. In these late antique writings one must allow for a certain exaggeration. That the Kairos stood in Sikyon, however, seems likely, and the scale in the left hand seems to be justified by the representations of Kairos on late gems and reliefs. On the meaning and form of Lysippos's Kairos see Bibliography 50E.

Other works by Lysippos receiving brief mentions that are probably or possibly preserved in Roman copies are: an Eros in Thespiai (Pausanias 9.27.3, cited earlier in connection with the Eros of Praxiteles; see p. 87); a bronze Poseidon in Corinth (Lucian, Juppiter Tragoedus 9); and a portrait of Socrates (Diogenes Laertios 2.43).

Lysistratos, Brother of Lysippos

Pliny, N.H. 35.153: The first of all artists to mold an image of a man in plaster taken from the surface [of the body] itself,[53] and the first to institute the method of making corrections on that work after pouring wax into the resulting mold, was Lysistratos of Sikyon, the brother of Lysippos, of whom we have spoken. It was this man who introduced the method of making realistic likenesses; before him they sought to make statues as beautiful as possible.[54] He also invented the technique of taking casts from statues, and this practice increased to such an extent that no figures or statues were made without clay [that is, a clay model].

Timotheos

Since he was one of the sculptors hired to do a major portion of the sculptures on the Mausoleum, Timotheos was apparently one of the more successful sculptors of the fourth century (see p. 196). He also worked on sculptures connected with the temple of Asklepios at Epidauros (c. 380–370 B.C.) as is attested by an inscription that records the expenses for the temple.

I.G. IV², 102, lines 34–5 and lines 88–90: Timotheos contracted to make and to furnish typous[55] for 900 drachmas. Pythokles was his guarantor . . . [line 88]

[53] "Surface of the body itself" – e facie ipsa. The Latin facies refers to the whole surface of the body, not simply to the face. Thus the passage does not necessarily refer to the rise of "veristic" portraiture. See Rhys Carpenter, "Observations on familiar statuary in Rome," Memoirs of the American Academy in Rome 18 (1941) 74–6.

[54] The contrast is perhaps between the newer statues made from casts and the earlier tradition, apparently beginning to die out at this time, of making them according to a canon of symmetria.

[55] The term typos (accusative plural typous) most commonly means "relief" or "mold-made figure." In spite of this, some scholars still take the term to refer to "models" for pedimental sculptures. On the meaning of typos see Pollitt, Ancient View, pp. 272–92.

Timotheos contracted [to make] *akroteria*[56] over the other pediment for 2,240 drachmas. Pythokles and Hagemon were his guarantors.

This inscription is also of considerable interest for the study of Greek architecture. See pp. 195–6.

Pausanias 2.32.4 (at Troizen): The image of Asklepios was made by Timotheos. The people of Troizen say, however, that it is not Asklepios but rather a representation of Hippolytos.

On the statue of Artemis by Timotheos on the Palatine in Rome, restored by Avianius Evander, see The Art of Rome, *p. 89.*

Pliny 34.91 also identifies Timotheos as one of several sculptors who made figures of "armed men, hunters, and people making sacrificial offerings."

On the problems involved in attributing surviving sculptures, especially sculptures from the temple at Epidauros, to Timotheos, see Bibliography 52.

Thrasymedes of Paros

Thrasymedes was both an architect and a sculptor and applied these skills on the temple of Asklepios at Epidauros. (See also under architecture, p. 195.)

Pausanias 2.27.2: The image of Asklepios [in the temple at Epidauros] is half the size of that of Olympian Zeus in Athens[57] and is made of ivory and gold. An inscription indicates that it was fashioned by Thrasymedes the son of Arignotos, a Parian. He [Asklepios] is seated on a throne and holds a staff in one hand; his other hand is placed over the head of the snake, and a dog is also represented lying beside him. On the throne there are wrought the exploits of the Argive heroes – Bellerophon against the Chimaira and Perseus carrying off the head of Medusa.

The Later Followers of Polykleitos

Passages relating to the immediate disciples of Polykleitos have already been cited, pp. 80–1.

Daidalos of Sikyon

Pliny, *N.H.* 34.76: Daidalos, who is also mentioned with praise among the sculptors in marble, made [statues in bronze of] two boys scraping themselves with strigils . . .

[56] Substantial portions of the *akroteria* and fragments of the pedimental sculptures from the temple of Asklepios are extant. See Richter, *SSG*, figs. 758–60; J. Crome, *Die Skulpturen des Asklepios-Tempels von Epidauros* (Berlin 1951).

[57] Presumably the image in the *Olympieion* in Athens; on this temple see pp. 204–5.

Pausanias 6.2.8 (at Olympia): In the *Altis* . . . are statues of Timon and of Aisypos, the son of Timon, who is represented as a boy mounted on a horse. For the fact is that the boy's victory was in the horse race, while Timon claimed victory in the chariot race. The artist who fashioned the portraits for Timon and for his son was Daidalos of Sikyon, who also made the trophy in the *Altis* for the Eleans, commemorating their victory[58] over the Spartans.

Daidalos was also one of several sculptors who worked on a monument set up by the Tegeans at Delphi to commemorate a victory over the Spartans in 369 B.C. (Pausanias 10.9.5–6).

Polykleitos the Younger

Pausanias 6.6.2 (at Olympia): Polykleitos the Argive, not the artist who made the image of Hera [see p. 78], but rather the pupil of Naukydes, made a statue of the boy wrestler, Agenor the Theban.

Pausanias 8.31.4 (in the sanctuary of Demeter and Kore at Megalopolis):[59] Within the sanctuary there is a temple of Zeus *Philios* ["of Friendship"]; the image is by Polykleitos the Argive and resembles [an image of] Dionysos. For as footwear it has high boots, and it holds a drinking cup in one hand and a *thyrsos* in the other; an eagle, however, is seated on the *thyrsos*, and this, to be sure, is not in agreement with the things recorded about Dionysos.

Polykleitos the Younger was also an architect. See p. 195.

Alypos of Sikyon

Alypos was a pupil of Naukydes (see pp. 79–80) and was one of the sculptors who worked on the great Spartan victory monument at Delphi (see p. 80). He also made statues of victorious athletes at Olympia (Pausanias 6.1.3; 6.8.5).

Sthennis of Olynthos

Pliny (N.H. 34.51) dates Sthennis in the 113th Olympiad (328 B.C.). Olynthos, which (according to Pausanias) was his native city, was destroyed in 348 B.C. by Philip of Macedon. An inscribed statue base (Loewy, IgB, no. 103a) indicates that Sthennis subsequently obtained Athenian citizenship.

Pliny, N.H. 34.90: Sthennis made the Demeter, Zeus, and Athena, which are in the temple of Concord in Rome; and also the "Weeping Matrons" and figures of worshippers and sacrificers.

[58] The victory took place *c.* 400 B.C. (Pausanias 5.4.8).
[59] Megalopolis was founded in 370 B.C. Assuming that the statue was made expressly for the sanctuary, it would have to be the work of the Younger Polykleitos.

Plutarch, *Life of Lucullus* **23.3–4:** It seemed that some person stood by him [Lucullus] in his sleep and said: "Go forward a little, Lucullus. For Autolykos has come and wishes to meet you." Waking up at that moment he was not able to figure out what the vision meant, but he took the city [Sinope] on that very day, and as he was pursuing those of the Cilicians who were sailing away, he saw lying on the shore a statue that the Cilicians had been carrying off but had not had time to put on board. This was one of the most beautiful works of Sthennis. Someone informed him thereupon that it was a statue of Autolykos, the founder of Sinope.[60]

The other known works by Sthennis were portraits of victorious athletes at Olympia (Pausanias 6.16.8; 6.17.5).

[60] Lucullus captured Sinope *c*. 70 B.C.

Chapter 7

Sculpture: the Hellenistic period

THE EARLY HELLENISTIC PHASE (*c.* 323–250 B.C.)

The School of Lysippos

Among the most active artists of the early Hellenistic period were the sons, pupils, and followers of Lysippos. Like Lysippos himself, the school was characterized by an interest in portraiture, commemorative monuments with historical subjects, personifications, and colossal figures. The principal period of the school's influence seems to have been in the late fourth century B.C. and in the first half of the third.

Pliny, N.H. 34.66: Lysippos left behind sons and pupils who were renowned artists – Daippos, Boedas, and above all Euthykrates, although the last-mentioned, having imitated the *constantia* of his father rather than his elegance, chose to find favor through the austere genre [of sculpture] rather than the pleasant.[1] Thus he portrayed best a Herakles, at Delphi, an *Alexander Hunting* at Thespiai,[2] and a *Cavalry Battle*; likewise his image of Trophonios at the oracle [in Lebadeia], several *quadrigas*, a horse with baskets,[3] and a pack of hunting dogs. Teisikrates, also from Sikyon, was in turn his disciple, but was closer to the school of Lysippos – to the extent, in fact, that several of his statues can scarcely be distinguished [from those of Lysippos] as, for example, his *Aged Theban*, his *King Demetrios*, and his *Peukestes*, the man who saved Alexander's life and was hence worthy of such an honor.

[1] The language of this passage seems to reflect the critical terminology of rhetoric, which included an "austere genre" of rhetorical style and an "elegant [Greek *glaphyros*] genre." See Dionysos of Halikarnassos, *de Compositione Verborum* 22; Demetrios, *de Elocut.* 128. *Constantia* is probably an aspect of the austere style. It is usually taken to mean "conscientiousness" or "harmoniousness" in the general sense, although S. Ferri (1940) has suggested that it refers to Lysippos's formulas for proportion and composition (Bibliography 39B). Pliny seems to suggest, however, that Euthykrates' *austeritas* lay in the choice of masculine, martial subjects.

[2] Some of the manuscripts read "Thespiades" here, that is, "the Muses," but this is probably a distortion in the manuscript tradition.

[3] Baskets – *fiscinis*; some manuscripts read *fascinis*, "forked poles."

Pliny, N.H. 34.81: Phanis, the disciple of Lysippos, made a figure of a woman assisting at a sacrifice [*Epithyousa*].[4]

Pliny makes several other brief references to some of these artists.

Pliny, N.H. 34.73: Boedas made a figure who is worshipping.

N.H. 34.87: Daippos made a *Perixyomenon* ["Man scraping himself all around with a strigil"].

N.H. 34.89: Teisikrates made a two-horse chariot in which [the artist] Piston placed a woman.

On Daippos see also Pausanias 6.12.6; 6.16.5.

Xenokrates, the sculptor and writer on art (see Introduction, pp. 3–4, 9) was a pupil of either Teisikrates or Euthykrates.

Pliny, N.H. 34.83: Xenokrates, the disciple of Teisikrates, or according to others of Euthykrates, surpassed both of them in the number of his statues, and wrote volumes about his art.

Another of the outstanding pupils of Lysippos was Eutychides of Sikyon, known especially for his statue of the Tyche *(Fortune) of Antioch on the Orontes, which survives in a number of Roman copies and variants (see Bibliography 56). Antioch was founded in 300 B.C., and the statue must have been made in that year or shortly thereafter.*

Pausanias 6.2.6–7 (at Olympia): By the portrait of Thrasyboulos stands one of Timosthenes the Elean, who won a victory in the foot-race for boys . . . The statue of Timosthenes was made by Eutychides of Sikyon, who was taught by Lysippos. This Eutychides made the image of Tyche for the Syrians, a work which is held in great honor by the local people.

In the following passage the Byzantine chronicler John Malalas (sixth century A.C.), who was a native of Antioch, maintains that the statue stood in the theater of Antioch and represented a girl whom the Emperor Trajan had sacrificed in connection with his building projects in Antioch (c. 115 A.C.). The reliability of Malalas as an historian is open to doubt, but he does add some important information about the form of the statue that is confirmed by Roman versions of the type and by representations of it on coins.

John Malalas, *Chronicle* 9.276.4–9, ed. Stauffenberg, Stuttgart 1931 (Overbeck, *SQ* 1531): He [Trajan] completed the theater of Antioch, which was

[4] Furtwängler proposed in 1907 that the well-known "Girl of Anzio" in the Museo Nazionale delle Terme in Rome was the *Epithyousa* mentioned by Pliny, and the idea, although doubtful, has often been repeated. See Bibliography 56.

unfinished, and he set up in it, within the *Nymphaion* of the *proskenion* in a tetrastyle shrine, a gilded statue of the girl whom he had sacrificed, giving her the form of the Tyche of the city seated on a figure of the river Orontes and crowned by Kings Seleukos and Antiochos.

Personifications seem to have been one of Eutychides' specialties.

Pliny, N.H. 34.78: Eutychides made a river Eurotas in which many have said that the art is more liquid than the water.

Pliny's description of the Eurotas apparently derives its phraseology from a poem by Philippos in the Greek Anthology.

Anthologia Graeca 9.709 (by Philippos of Thessalonike, 1st cent. A.C.): The artist brought forth Eurotas, after his bath in the fire, as if still dripping wet from immersion in his stream. He quivers in a watery way throughout all his limbs, seeming to flow from the top of his head to the tips of his toes. Art was in competition with the river. Who was it that persuaded the bronze to go revelling along more liquidly than water?

Eutychides also did a statue of Dionysos, which was in the collection of Asinius Pollio at Rome (Pliny, N.H. 36.34).

The most famous statue executed by a follower of Lysippos was the "Colossus of Rhodes," a statue of Helios, the god of the sun, by the sculptor Chares of Lindos.

Pliny, N.H. 34.41: But the work that surpassed all in admiration was the colossal statue of the Sun of Rhodes, which was made by Chares of Lindos, a disciple of Lysippos, who was mentioned above. This statue was 70 cubits high [*c.* 32 m]; after standing 56 years[5] it was thrown down by an earthquake, but even as it lies on the ground it is a marvel. Few people can get their arms around its thumb, and the fingers are larger than most statues. Vast caves yawn within the limbs that have been broken off, and in them are seen great masses of rock, with the weight of which he [Chares] stabilized it as he was setting it up. According to tradition, the work on it took twelve years and cost 300 talents, which they raised from [the sale of] the siege machinery left behind by King Demetrios when he gave up the long siege of Rhodes in disgust [305 B.C.].

Many other references are made to the Colossus in ancient literature, but these add little to the information given by Pliny. According to Strabo (14.2.5) the Rhodians were forbidden by an oracle to set the statue up again. Sextus Empiricus (Against the Logicians 1.107) tells the unlikely story that Chares committed suicide because the expenses for the statue turned out to be greater than his fee.

The only other known work by Chares was a colossal head dedicated on the Capitoline in Rome by the consul P. Lentulus in 57 B.C. (Pliny, N.H. 34.44).

[5] The earthquake is thought to have occurred in 224 B.C. The colossus was thus made *c.* 280 B.C.

Another sculptor sometimes associated with the school of Lysippos was "Doidalsas of Bithynia," an artist who may have existed or may be a product of modern scholarship. Pliny (N.H. 36.35) mentions a statue of Aphrodite bathing herself in the Portico of Octavia in Rome by an artist whose name was probably Doidalsas, although the reading of the text is problematical.[6] This work has often been associated with the "Crouching Aphrodite," a statue type known in a number of Roman copies and variants.

It has also been suggested that the name "Daedalus," given to the sculptor who made the statue of Zeus Stratios *for King Nikomedes I of Bithynia when the cult was instituted in Nikomedea c. 264 B.C. (Eustathius, Comm. ad Dionys. Perieg. 793 = Overbeck, SQ 2045) should be read as "Doidalsas." Doidalsas appears to be a Bithynian name (Strabo 12.4.2). See Bibliography 56.*

Attic Sculpture

The Sons of Praxiteles: Kephisodotos and Timarchos

Pliny dates these two sculptors in the 121st Olympiad (292 B.C.).

Pliny, N.H. 36.24: Kephisodotos was the son of Praxiteles and was his artistic heir. Much praised is his *Symplegma*[7] at Pergamon, a work distinguished for the way the fingers seem to press on flesh rather than marble. Works by him at Rome are a Leto in the temple [of Apollo] on the Palatine, an Aphrodite in the collection of Asinius Pollio, and, in the temple of Juno within the Portico of Octavia, an Asklepios and Artemis.

Pliny also notes that Kephisodotos made portraits of "philosophers" (N.H. 34.87).

Plutarch, *Lives of the Ten Orators: Lykourgos* (Moralia 843E–F): There are wooden portraits of Lykourgos and his sons, Habron, Lykourgos, and Lykophron, which were made by Timarchos and Kephisodotos, the sons of Praxiteles.

Other works by the sons of Praxiteles were an image of Enyo in the temple of Ares in Athens (Pausanias 1.8.4) and a portrait of Menander from which the identifying inscription is preserved (Loewy, IgB, no. 108). This portrait of Menander is usually thought to be the one that Pausanias (1.21.1) saw in the theater of Dionysos in Athens and is associated with a well-known but highly controversial portrait type of which there are many, widely-varying, Roman copies. See Richter, Portraits, figs. 1514– 1643 and Richter–Smith, Portraits, pp. 159–64. For other portrait signatures and literary references involving one or both of the sons of Praxiteles, see Loewy, IgB, nos. 109–12; Tatian, Oratio ad Graecos 33; and Pausanias 9.12.4.

[6] Only one manuscript, the Bamberg Codex, reads "Daedalsas," and many editors have expressed doubt as to whether the name of a sculptor can really be identified in this text. See the useful note in the edition of J. André (Budé, Paris 1981) p. 162.

[7] *Symplegma* – a group of intertwined figures.

In addition to his sons, Praxiteles had a pupil named Papylos who made a statue of Zeus Xenios (Jupiter Hospitalis), which was in the collection of Asinius Pollio in Rome (Pliny, N.H. 36.33–4).

Polyeuktos

This artist is known only for his great portrait of Demosthenes which survives in good Roman copies (see Richter, Portraits, figs. 1397–1513).

Plutarch, *Lives of the Ten Orators: Demosthenes* (*Moralia* 847A): [Demosthenes himself] wrote . . . the elegiac couplet which was later inscribed on his portrait statue by the Athenians:

> If you had strength equal to your conviction, Demosthenes,
> The Macedonian Ares never would have ruled the Greeks.

This portrait stands near the roped-off area and the Altar of the Twelve Gods [in the Agora in Athens] and was made by Polyeuktos.

Plutarch, Life of Demosthenes 31.1, also mentions this statue and observes that: "It stood there with the fingers interlaced . . ."

THE MIDDLE HELLENISTIC PHASE (*c.* 250–150 B.C.)

The School of Pergamon

The kingdom of Pergamon came into political and artistic prominence under King Attalos I (ruled 241–197 B.C.). In a series of battles between 236 and 228 B.C. Attalos's armies defeated a coalition of Seleukid armies and tribes of Galatians or "Gauls" that had settled in Asia Minor and had been exacting tribute from Greek cities in the region. To commemorate these successes Attalos subsidized a number of victory monuments that represented the Pergamenes as standard-bearers of Greek culture, defeating the Gauls and other opponents. At least three of these were set up in Pergamon in the sanctuary of Athena, and a number of surviving sculptures are thought to be copies from them (most notably the famous group of a "Dying Gaul and his Wife" in the Terme in Rome and the "Dying Trumpeter" in the Capitoline Museum). Later, apparently in 201 B.C., Attalos set up another group on the south slope of the Acropolis in Athens. The figures in this group – Gauls, Persians, Amazons, and even giants – were on a smaller scale and are thought to be reflected by copies in Naples, Venice, and elsewhere.[8]

Under Attalos's successor Eumenes II (197–159 B.C.) the great Altar of Zeus at Pergamon was built. The well-known gigantomachy frieze of this altar marks the culmination of the dramatic, "baroque" style that had been developing for a century in the Pergamene school, but little is recorded about the artists who executed it.

On these monuments and the artists associated with them see Bibliography 59.

[8] Some scholars (e.g. Schober) associate this monument with Attalos II and thus date it toward the middle of the second century B.C. See Bibliography 59.

Pliny, *N.H.* 34.84: A number of artists have represented the battles of Attalos and Eumenes against the Gauls – Isogonos, Pyromachos, Stratonikos, and Antigonos, who wrote volumes about his art.

These artists probably worked on the group set up by Attalos I in Pergamon itself. Stratonikos is probably the same as the renowned silversmith to whom Pliny attributes portraits of philosophers (N.H. 33.156 and 34.90) and whose work is referred to on inscriptions found at Delos. On Antigonos of Karystos, see Introduction, p. 4.

"Pyromachos" is probably identical with Phyromachos, who made the image of Asklepios which was in the sanctuary known as the Nikephorion *outside Pergamon.*

Diodoros 31.35: . . . Prousias the Bithynian king [Prousias I], when his attack on Attalos [Attalos II] was unsuccessful [156 B.C.], sacked the sanctuary called *Nikephorion*, which was outside the city, and plundered the temple. He took as booty both the votive statues and also the cult images of the gods including the famous image of Asklepios, which, they think, was the work of Phyromachos, an example of extraordinary workmanship.

The signature of Phyromachos appears on several statue bases associated with Attalid monuments, and he appears to have been the creator of a posthumous portrait type of the philosopher Antisthenes (see Bibliography 59). Pliny also attributes a quadriga group to him (N.H. 34.80).

The Pergamene sculptor Isogonos mentioned by Pliny is not otherwise known, and it has been suggested that this name may be a corruption of "Epigonos" whom Pliny mentions in the following passage. The signature of Epigonos son of Charios occurs on two of the bases from the Attalid monuments on the acropolis of Pergamon as well as on several other Pergamene inscriptions. He may have been the foremost Attalid sculptor.

Pliny, *N.H.* 34.88: Epigonos, who imitated almost all the subjects thus far mentioned, surpassed others with his Trumpeter and with his Infant pitiably caressing its slain mother.

The "Dying Trumpeter" in the Capitoline is represented with a trumpet lying on the ground beside him and may be a copy of this work.

Although he is not named in Pliny's list of artists who worked at Pergamon, the sculptor Nikeratos is known to have worked for the Attalids and seems to have been a close associate of Phyromachos. The names of both sculptors appear on a dedication to Athena at Pergamon dating from the time of Attalos I, and Nikeratos was also the sculptor of an Attalid monument dedicated on Delos to commemorate one of the victories over the Gauls (for references see Pollitt, AHA, p. 84). Some or all of the works mentioned by Pliny in the passages below may have been dedicated at Pergamon.

Pliny, *N.H.* 34.80: Nikeratos made an Asklepios and a Hygieia, which are [now] in the temple of Concord in Rome.

Pliny, N.H. 34.88: Likewise Nikeratos, having attempted everything that other sculptors had done, represented Alcibiades and his mother Demarate performing a sacrifice by the light of torches.

Tatian, *Oratio ad Graecos* 33 (ed. Whittaker) (Tatian, a Christian apologist, is ridiculing the statues admired by his contemporaries): Why do you feel that Glaukippe gave birth to a holy child? Well, suppose someone did give birth to a portentous child, as is shown in her statue by Nikeratos the bronze-worker, son of Euktemon and an Athenian by birth; even if she did carry an elephant in her womb, is that any reason why Glaukippe should enjoy public honors?

Pausanias's description of the Attalid dedication on the Acropolis in Athens is brief but informative. His reference to the scale of the figures has made it possible to identify them in copies, and his itemization of the subjects of the group suggests that the Attalids sought to link his victory over the Gauls with all the great victories of "civilization over barbarism" in the Greek historical and mythical past.

Pausanias 1.25.2: By the south wall [of the Athenian Acropolis] Attalos dedicated [figures representing] the legendary war of the giants who lived in the area of Thrace and the isthmus of Pallene, the battle of the Athenians against the Amazons and their exploit against the Persians at Marathon, and the destruction of the Gauls in Mysia, each figure being about two cubits [in height].

The great Pergamene altar is mentioned in only one[9] brief reference.

Ampelius, *Liber Memorialis* 8.14: At Pergamon there is a great marble altar, 40 feet high, and with extremely large sculptures; it [the sculptural decoration] consists of the battle of the giants.

The School of Rhodes

The Sculptors of the Laokoön

Pliny, N.H. 36.37: Furthermore the fame of many is not great, for in certain instances the number of artists involved stands in the way of their achieving individual renown even in the case of outstanding works, since no single person received the glory and since many names cannot all be recognized equally. Thus it is with the Laokoön in the palace of the Emperor Titus, a work that must be considered superior to all other products of the arts of painting and sculpture. From one stone the eminent artists Hagesandros, Polydoros, and Athenodoros of Rhodes, following an agreed-upon plan, made him [Laokoön], his sons, and the marvellous intertwining of the snakes.

The famous Laokoön in the Vatican Museum seems to be identical with the group seen by Pliny, although the Vatican group is admittedly made of seven blocks, not one.

[9] Unless the mention of a "throne of Satan" at Pergamon in the Bible (*Revelation* 2.12) also refers to the altar.

The signatures of Hagesandros, Athenodoros, and Polydoros also occur on the Shipwreck Group from Sperlonga, and it is now generally thought that the Laokoön and the Sperlonga sculptures date from the same time (probably the first century A.C., although earlier dates are conceivable and have been proposed). See Bibliography 60C.

Apollonios and Tauriskos of Tralles (in Karia)

Pliny, *N.H.* 36.33-4: Asinius Pollio, being a man of great enthusiasm, naturally wanted his art collection to be seen. In it are . . . the *Hermerotes*[10] of Tauriskos (not the engraver [*caelator*], but rather an artist from Tralles) . . . and a Zethos and Amphion along with Dirke, the bull and the rope – all carved from the same piece of stone – a work by Apollonios and Tauriskos brought from Rhodes. These men caused a controversy about their parents,[11] professing that, although Menekrates[12] appeared to be their father, their actual father was Artemidoros.

The famous "Farnese Bull"[13] in Naples is probably a late variant of the group of Zethos, Amphion, and Dirke.

Aristonidas and Mnasitimos

An inscription from Rhodes dating c. 200 B.C. (Loewy, IgB, no. 197) records the signature of Mnasitimos the son of Aristonidas. We are also told by Pliny (N.H. 35.146) that Mnasitimos, the "son and disciple" of Aristonidas, was a painter (as well as a sculptor). One work by Aristonidas is described by Pliny.

Pliny, *N.H.* 34.140: The artist Aristonidas, when he wanted to represent the madness of Athamas subsiding into remorse after he had thrown his son Learchos over the precipice, made a mixture of bronze and iron, so that, when the rust shone through the sleek beauty of the bronze, a blush of shame would be expressed. This statue still exists today in Rhodes.

Other Artists of the Mid-Hellenistic Period

Boethos of Kalchedon (on the Bosporos)

An original bronze group representing a winged boy leaning on a herm (perhaps Agon, the personification of athletic contests) and signed by "Boethos of Kalchedon" has been found in the sea off the coast of Tunisia and is now in the Bardo Museum in Tunis. The wreck of the ship on which this group was carried seems to have taken place c. 100 B.C. (see Bibliography 63). Signatures on bases of lost works by Boethos confirm

[10] *Hermerotes* – double busts with Hermes and Eros back to back.

[11] *Parentum . . . certamen* might also be translated as a "competition of parents."

[12] Menekrates occurs among the names of artists inscribed on the Altar of Zeus at Pergamon, and if he is identical with the architect whose fame was recorded by Ausonius as late as the fourth century A.C. (*Mosella* 307), he may have been the principal designer of the altar.

[13] Bieber, *SHA*, fig. 529; Richter, *SSG*, fig. 849.

that he was active in the mid-second century B.C., and the bronze in Tunis probably dates from this time.

Pliny, N.H. 34.84: By Boethos, who was better known for working in silver, there is a child . . . strangling a goose.[14]

A group representing a boy strangling a goose is also mentioned, along with other works, in the Fourth Mime *of Herondas. In this mime two women, Kynno and Kokkale, have entered the sanctuary of Asklepios at Kos and are admiring some of the statues set up there.*

Herondas 4.20–34:

> KOKKALE: "Oh my, Kynno dear, what beautiful statues. Who was the artist who made this stone and who set it up?"
> KYNNO: "The children of Praxiteles! Don't you see those letters on the base? And Euthies and Prexon set it up."
> KOKKALE: "May Paion be gracious to such people and to Euthies for these beautiful works. Look, dearie, look at that child gazing upward toward the apple. Wouldn't you say that if she doesn't get the apple she might expire on the spot? And look at that old man, Kynno – and by the Fates, look how that child strangles the Egyptian goose. If the stone weren't right in front of us, this work, you might say, would start talking. My, my! The time will come when men will put real life into these stones!"

Among Roman copies of Hellenistic sculptures there are two types of a boy throttling a goose. On the vexed question of which of these, if either, belongs to Boethos of Kalchedon, see Pollitt, AHA, and Bibliography 63. Herondas was active in the third century B.C., and if the group that he describes is identical with the one mentioned by Pliny, it must have been by an earlier sculptor named Boethos. But the two references may be unrelated.

Pausanias 5.17.4 (at Olympia): There is a gilt, nude child seated before Aphrodite [in the *Heraion* at Olympia]; this was wrought by Boethos of Kalchedon [or Carthage].[15]

THE RISE OF CLASSICISM AND THE LATE HELLENISTIC PERIOD (c. 175–31 B.C.)

As the great art of the Classical period receded farther into the Greek past, it began to take on an aura of sanctity in the minds of both the later Hellenistic artists and their

[14] The translation omits a distorted word in the text. The manuscripts read *sex anno, sex annis, eximiae,* and *eximie,* and various editors have proposed reconstructions not preserved in the manuscripts, e.g. *amplexando.*

[15] The majority of manuscripts read "Karchedon," i.e. "Carthage," and it may be that the work at Olympia was by an entirely different sculptor, Boethos of Carthage, from the one who made the Bronze group in Tunis and the boy strangling a goose. Most editors have assumed, however, that "Karchedon" is simply a copying error and that Pausanias's text originally read "Kalchedon."

patrons (especially the Romans). A desire to imitate the masterpieces of the Classical period, and, subsequently through the use of newly invented machines, to copy it mechanically, characterizes much of the art of the late Hellenistic period; nevertheless, a few powerful artistic personalities continued to make their marks as individuals within the classicistic movement.

Damophon of Messene

Damophon was one of the earliest classicists. A group of original cult statues, which he made for the sanctuary of Despoina ("the Mistress") at Lykosoura, in Arcadia, were found in 1889. Fragments of the group are in the small museum in Lykosoura, while others are in the National Museum in Athens (see Bibliography 64). They are described by Pausanias.

Pausanias 8.37.3–5 (in the temple of Despoina): The images of Despoina and Demeter themselves, the throne on which they sit, and the stool beneath their feet are all of one stone. No part of the drapery, nor any of the parts carved around the throne, is clamped to another stone by iron or cement; rather, everything is made from one piece of stone. This stone was not brought [to the sanctuary] by them, but they say that, following a vision in a dream, they dug into the earth within the sanctuary and found it. The size of both of the images is about like that of the Mother in Athens. These are also works of Damophon. Demeter carries a torch in her right hand, while the other hand rests upon Despoina. Despoina holds a scepter and has what is called "the *cista*" on her knees. Beside the throne by Demeter stands Artemis, who is wrapped in the skin of a deer and has a quiver slung over her shoulders; in one of her hands she holds a torch and in the other two serpents. Alongside Artemis, a dog of the type suitable for hunting is reclining. Near Despoina stands Anytos, who is represented in the form of an armed warrior. Those around the sanctuary say that Despoina was brought up by Anytos, and that Anytos was one of those who are called Titans.

In the course of describing other works by Damophon at Messene, Pausanias mentions that the sculptor did an admirable job of repairing Pheidias's Zeus at Olympia. This assignment may have been the cause of or the result of his affinity for the Classical style. Pausanias also visited other sanctuaries with images by Damophon.

Pausanias 4.31.6–10 (in the town of Messene): A statue most worthy of mention is the image of the Mother of the Gods in Parian marble, a work of Damophon, who made refittings of the utmost precision on the Zeus at Olympia when the ivory on it cracked. For this service, honors have been bestowed on him by the Eleans. Also by Damophon is [the statue of the goddess] called *Laphria* in Messene [a discussion of the cult of Artemis *Laphria* intervenes] . . . The greatest number of images and those most worth seeing are in the sanctuary of Asklepios. In one separate group there are images of the god and his

Fig. 4. The Group by Damophon at Lykosoura; restoration by Guy Dickins.

children and in another are images of Apollo, the Muses and Herakles. Also represented are the city of Thebes, Epaminondas the son of Kleommis, Tyche, and Artemis *Phosphoros* ["Light-bringer"]; Damophon made those of the statues which are made of stone (I know of no Messenian other than him who achieved importance as a maker of images); the portrait of Epaminondas is of iron and is the work of some other artist, not him.

Pausanias 7.23.5–7: At Aigion [in Achaia] there is an ancient sanctuary of Eileithyia, and [the image of] Eileithyia is covered from head to foot with a fine woven garment; it is a wooden image except for the face, hands, and feet – these are made of Pentelic marble. One of her hands is stretched out straight; the other holds a torch. One might conjecture that torches are an attribute of Eileithyia because the birth-pains of women are like fire.[16] The torches might also be explained by the fact that it is Eileithyia who brings children to the light. The image is the work of Damophon of Messene.

Not far from the sanctuary of Eileithyia is one of Asklepios with images of Hygieia and Asklepios. The iambic inscription on the base says that they were made by Damophon of Messene.

Pausanias 8.31.1–6 (at Megalopolis in Arcadia): At the other end of the stoa [of Aristander] toward the west there is a sanctuary of the Great Goddesses. The Great Goddesses are Demeter and Kore, as I have made clear in my chapter on Messenia. The Arcadians call Kore *Soteira* ["Savior"]. Carved in relief before the entrance are Artemis on one side and Asklepios and Hygieia on the other. Of the Great Goddesses Demeter is made completely of stone, while *Soteira* has drapery made of wood. The height of each is about fifteen feet. [Damophon of Messene[17]] made these images and also the rather small maidens in front of them, who are dressed in tunics reaching to the ankles and each of whom carries on her head a basket filled with flowers. These are said to be the daughters of Damophon, but by those who incline to a more religious interpretation they are thought to be Athena and Artemis collecting flowers with Persephone. Next to Demeter there is a Herakles, about a cubit tall. Onomakritos says in his epic verses that this Herakles is one of those who are called "Idaian Daktyls." [Pausanias then mentions a table carved with reliefs of Apollo, Pan, and the Nymphs, but it is not clear whether this is a work of Damophon] . . . Within the sanctuary of the Great Goddesses there is also a shrine of Aphrodite. Before the entrance are ancient wooden images of Hera, Apollo, and the Muses (these, they say, were brought from Trapezos) while in the temple are images made by Damophon – a wooden Hermes and an Aphrodite made of wood except for her hands, face, and feet, which are of stone. They ascribe the title *Machanitis* ["the

[16] Eileithyia was the goddess of childbirth.
[17] The name is missing in the text, but the reference to Damophon which follows makes the restoration of it certain.

Contriver"] to this goddess, with considerable justification it seems to me, for on account of the works of Aphrodite there has been much devising and all sorts of discourses have been invented by men.

Pasiteles

Pasiteles, a Greek from south Italy, was renowned as a sculptor, silversmith, and writer (see Introduction, p. 4). According to Pliny (N.H. 36.156) he lived "around the time of Pompey the Great," that is, c. 108–48 B.C. No work by Pasiteles himself has been positively identified, but the works of his school are known. A statue of a youth signed by "Stephanos the pupil of Pasiteles" is in the Villa Albani, and a group signed by "Menelaos the pupil of Stephanos," apparently representing Orestes and Elektra, is in the Museo Nazionale delle Terme in Rome. On these statues and their variants, see Pollitt, AHA, pp. 175 and figs. 183–6, with further references.

Pliny, N.H. 35.156: [Varro] also praised Pasiteles who said that modelling was the mother both of working sculpture in metal [*caelaturae*] and of carving statues [*statuariae scalpturaeque*] and who, although he was outstanding in all these arts, never made anything unless he made a model[18] beforehand.

Pliny, N.H. 36.39: Varro . . . is also an admirer of Pasiteles, who wrote five volumes on famous works throughout the world. He was born on the Greek coast of Italy and was given Roman citizenship along with the towns there [89/ 88 B.C.]; it was he who made the ivory statue of Jupiter in the temple of Metellus at the approach to the Campus Martius. It once happened that when he was in the dockyards where there were some wild African animals and was looking into a cage at a lion of which he was making an engraving, a panther broke out of another cage and posed no slight danger to this most attentive artist. He is said to have made many works, but those that he made are not enumerated by name.

Cicero, *de Divinatione* **1.36.79** (in the course of describing omens at the birth of famous men, Cicero refers to Roscius, a famous actor): . . . when he [Roscius] was in the cradle and was being brought up in Solonium, which is a piece of land in the territory of Lanuvium, his nurse once woke up suddenly and perceived in the night by the light of a lamp the sleeping boy entwined in the embrace of a serpent . . . Pasiteles engraved this scene on silver, and our own Archias expressed it in verse.

Neo-Attic Sculptors

In the wake of the growing political domination of Greece by Rome, wealthy Romans became both patrons of Greek artists and collectors of Greek art. Roman collectors tended to favor the works and the style of the "old masters" of Greek sculpture, that is,

[18] "Made a model" – *antequam finxit.* Richter has suggested, however, that the phrase may refer to the taking of plaster models as part of a copying technique; see *Ancient Italy* (Ann Arbor 1955), pp. 112–16.

the artists of the Classical period like Pheidias and Polykleitos. To meet the demands of the new art market, many Greek sculptural workshops turned to making copies of earlier works of Greek art and also to creating new works in old styles. Eventually some Greek sculptors migrated to Italy in order to be nearer to the source of important commissions.

Euboulides and Eucheiros

Pausanias 1.2.5 (in the "House of Poulytion" within the gymnasium of Hermes near the gates leading into the Kerameikos in Athens): Here there are images of Athena *Paionia*, of Zeus, of Memory and the Muses; also an Apollo, the offering of and the work of Euboulides, and the *daimon* Akratos, from the retinue of Dionysos.

Pausanias 8.14.10 (at Pheneos in Arcadia): Among the gods, the people of Pheneos give the most honor to Hermes and celebrate an athletic festival called the *Hermaia*; they have a temple of Hermes and in it a stone image. This was made by an Athenian, Eucheiros, son of Euboulides.

What seem to be fragments of the sculptures mentioned by Pausanias in the "House of Poulytion" in Athens, most notably a colossal head of Athena, survive, along with an inscription bearing the name of Eucheiros. (See Pollitt, AHA, fig. 169 and Bibliography 66.) They date from the mid- or late second century B.C. Euboulides and Eucheiros must have worked on the monument together.[19] A colossal female head in a similar style, signed by a sculptor named Attalos, has also been discovered at Pheneos and may be associated in some way with the workshop of Euboulides and Eucheiros (see Bibliography 66).

Pliny (N.H. 34.88) mentions a statue representing a figure "counting on its fingers" by Euboulides. It has been conjectured that this might have been a portrait of the Stoic philosopher Chrysippos, whose statue is described by other writers as having one hand extended, as if he were counting the points in an argument on his fingers.[20] Chrysippos died c. 204 B.C. If a sculptor named Euboulides did indeed make a portrait of Chrysippos, and that portrait was made during the philosopher's lifetime, it is likely that the work was by an older Euboulides, perhaps the grandfather of the neo-Attic sculptor.

Eukleides of Athens

Closely related to the work of Euboulides was that of another Athenian, Eukleides. A colossal head of Zeus from Aigeira in Achaia and now in Athens (see Pollitt, AHA, fig. 170) is a fragment from one of several images by Eukleides seen by Pausanias.

[19] G. Despinis has recently expressed doubts as to whether the head of Athena in the National Archaeological Museum in Athens really belongs to the group mentioned by Pausanias (see Bibliography 66).

[20] See Sidonius Apollinaris, *Epistulae* 9.9.14 and Cicero, *de Finibus*, 1.11.39.

Pausanias 7.25.9: There is a temple here [Aigeira] of Demeter, another of Aphrodite and Dionysos, and still another of Eileithyia. The images are of Pentelic marble, works of the Athenian Eukleides. There is also drapery for the Demeter.[21]

Pausanias 7.26.4: Aigeira offers, as a monument worthy of being recorded, a temple of Zeus with a seated image made of Pentelic marble, a work of the Athenian Eukleides. In this sanctuary there also stands an image of Athena. The face, the hands, and the feet are of ivory, while the rest is of wood decorated with gold leaf and paint.

Polykles, Timokles, Timarchides, Dionysios

These four names occur in the form of inscribed signatures as well as in literary sources and seem to refer to fathers, sons, and grandsons, with the same name sometimes being repeated in alternate generations, within a family of sculptors. Some members of the family may have migrated from Athens to Rome after receiving commissions from Metellus to make cult images for the temples within the Porticus Metelli *(see* The Art of Rome, *pp. 45–6).*

According to Pliny (N.H. 34.52) Polykles and Timokles were among the sculptors who were active in the 156th Olympiad (156 B.C.). On the complicated and controversial genealogy of these sculptors see Bibliography 67.

Pliny, *N.H.* 36.35: . . . Timarchides made the Apollo who holds a *kithara* in the same temple [the temple of Apollo near the Portico of Octavia], and in the temple of Juno within the Portico of Octavia the image of the goddess herself is by Dionysios; Polykles did still another one[22] . . . Polykles and Dionysios, the sons of Timarchides, did the Jupiter in the adjacent temple . . .

The portions of the above passage that are omitted here are given in The Art of Rome, *p. 112.*

Pausanias 6.4.5 (at Olympia): Polykles, the other of the Attic sculptors and a pupil of Stadieus the Athenian, made a statue of the Ephesian boy pankratiast Amyntas, the son of Hellanikos.

Pausanias 6.12.8 (at Olympia): The portrait of [the boxer] Agesarchos [of Triteia] is the work of the sons of Polykles.

Pausanias 10.34.8 (in the sanctuary of Athena *Kranaia* at Elateia): The image [of Athena] was also made by the sons of Polykles. It is armed as if for battle, and

[21] What Pausanias means by this last sentence is uncertain. Possibly the temple contained special drapery with which the image was adorned as part of a particular ritual.

[22] The proper punctuation of the Latin is uncertain in this passage, and it could also be interpreted to mean that Timarchides made the image of Juno and that Dionysios and Polykles together did still another one.

worked upon its shield are reliefs which are a copy of those in Athens on the shield of the statue called the Athena *Parthenos*.

Pausanias 10.34.6 (also at Elateia): A temple is built here to Asklepios, and there is an image which has a beard. The names of those who made the image are Timokles and Timarchides, who are natives of Attica.

Pliny also mentions that Timarchides did statues of hunters, athletes, armed warriors, and the like (N.H. 34.91), and Cicero mentions a Herakles by Polykles that came into the possession of Scipio (Ep. ad Atticum 6.1.17). A statue of a Roman magistrate, found on Delos, is signed by Dionysios the son of Timarchides and Timarchides the son of Polykles.[23]

The classicistic strain ascribed to the work of these artists is supported not only by the fact that they made copies of famous works like the shield of the Athena Parthenos but also by the fact that the torso of the one extant statue seems to imitate the style of Praxiteles.

[23] Richter, *SSG*, fig. 829; Pollitt, *AHA*, fig. 78.

Chapter 8

Painting: earliest developments and the fifth century B.C.

Origins, Early Inventions, and the Archaic Period

Pliny, N.H. 35.15–16: The question of the origins of painting is uncertain, nor does it belong within the scope of this work. The Egyptians affirm that it was invented among themselves six thousand years ago and that it later passed over to Greece – an empty claim, as is quite obvious. As for the Greeks, however, some say that it was invented in Sikyon, and others say among the Corinthians, but all assert that the first sort of painting involved tracing the shadow of a man with lines and that later a second, more difficult method employing single colors, and called "monochrome," was invented; the latter method exists even now. They say that the linear method was invented by Philokles the Egyptian or by Kleanthes of Corinth but that the first to make extensive use of it were Aridikes the Corinthian and Telephanes the Sikyonian; these men were still working without any color but were already adding lines here and there within the outline. For this reason it became the custom to add identifying inscriptions to the figures that they painted. The inventor of filling in these lines with the color of ground clay was, they maintain, Ekphantos of Corinth.[1]

Kleanthes of Corinth, who is mentioned by Pliny in the preceding passage, and his contemporaries, also executed some paintings in a sanctuary of Artemis in the area of Pisa near Olympia.

Strabo 8.3.12: In the sanctuary of [Artemis] *Alpheionia* there are paintings by Kleanthes and Aregon, who were Corinthians; by the former is the *Sack of Troy* and the *Birth of Athena*; by the latter *Artemis carried aloft on a Griffin* . . .

Athenaios 8.346B–C: I am acquainted with the painting kept in the sanctuary of Artemis *Alpheiosa* in the area of Pisa. It is the work of Kleanthes the Corinthian. In it Poseidon is shown offering a tuna fish to Zeus, who is having birth pangs.[2]

[1] The manuscripts contain a number of variant readings for the last sentence of this passage.

[2] Probably from the birth of Dionysos, who, after Semele gave birth to him prematurely, was sewed up in the thigh of Zeus and later reborn.

Pliny, N.H. 35.55–6: It is generally acknowledged that a picture by the painter Boularchos, which represented the battle of the Magnetes,[3] was acquired in exchange for its weight in gold by Kandaules, also called Myrsilos, the king of Lydia and the last of the Herakleidai.[4] So great had the value of painting already become. This must have happened around the time of Romulus, for indeed Kandaules died in the 18th Olympiad, or, as some maintain, in the same year as Romulus, when, unless I am mistaken, painting was already remarkable for the brilliance of its technique; in fact, for the perfection of it.[5] And, if one is obliged to accept this conclusion, it becomes evident at the same time that the basic developments were *much* earlier and that those who painted in monochrome, the date of whom has not been handed down, came *somewhat* earlier – such as Hygiainon, Dinias, Charmadas, Eumaros of Athens, the artist who first distinguished the male sex from the female sex in painting,[6] and Kimon of Kleonai, who dared to represent all sorts of figures and further developed Eumaros's inventions. This Kimon invented *katagrapha*, that is to say three-quarter views;[7] he also disposed the countenances of his figures in various ways, showing them looking backward, upward, and downward; he made the distinction between the parts of the body more clear by articulating the joints; he emphasized the veins; and, beyond that, he depicted the creases and folds in the drapery.

The inventions which Pliny ascribes to Kimon in the preceding passage – foreshortening, experimentation with different bodily poses, articulation of naturalistic detail – are all features which developed in the "Pioneer period" of Athenian red-figure vase painting, c. 525–500 B.C. In spite of the fact that Pliny seems to have visualized Kimon as being much earlier, this date appears to be confirmed by an epigram of Simonides (c. 556–468 B.C.) preserved in the Greek Anthology.

Anthologia Graeca 9.758:

> Kimon painted the door on the right;
> The one on the right as you leave, Dionysios painted.

On Dionysios see p. 145.

On Dionysios see p. 145.

The painting referred to by Herodotos in the following passage was presumably by a Greek (rather than a Persian) painter of the Archaic period, since it was dedicated by a

[3] A tribe, possibly of Greeks, living in the mountains along the eastern border of Thessaly. The occasion of the battle is not known.

[4] The Classical Greeks believed that the rulers of western Asia Minor in the eighth and seventh centuries B.C. were descendants of Herakles.

[5] The 18th Olympiad – 708 B.C. The traditional date for the death of Romulus was 717 B.C. Kandaules, whose murder is described by Herodotos 1.8–12, is thought to have died in the 680s B.C.

[6] The convention of representing the skin of men as dark and that of women as light existed in the Near East long before the rise of Classical Greece, and it is found on Greek vase painting as early as the seventh century B.C.

[7] "Three-quarter views" – Latin *obliquae imagines*; the phrase could also mean "profile portraits," but "three-quarter views" seems more in keeping with the inventions ascribed to Kimon.

Greek architect. Darius's bridge over the Bosporos was constructed in 512 B.C. as part of the first Persian expedition into Europe.

Herodotos 4.88: Darius [the Persian king] was so pleased with the bridge [across the Bosporos] that he gave its architect, Mandrokles of Samos, ten of each of the usual types of gift. As an offering of first fruits from these gifts Mandrokles had a painting made that showed the whole extent of the bridge, and King Darius sitting on his throne, and the army passing over it. After seeing to the preparation of the painting, he dedicated it in the sanctuary of Hera [at Samos] with the following inscription:

> Having spanned the fish-filled Bosporos, Mandrokles offered this to Hera
> as a memorial of his bridge; he won a crown for himself, and brought
> glory to Samos, and fulfilled with his work the expectations of King
> Darius.

Polygnotos of Thasos

See also pp. 221–3, 230–1.

Polygnotos's association with the Athenian political leader Kimon (c. 512–449 B.C.), who perhaps brought him from Thasos to Athens and helped him to acquire Athenian citizenship, makes it clear that he was active c. 475–450 B.C. Pliny (N.H. 34.85) notes that Polygnotos was also a sculptor, although no specific statues by him are mentioned.

Pliny, N.H. 35.58–9: Others were famous . . . before the 90th Olympiad [420 B.C.], such as Polygnotos of Thasos, who first painted women in transparent drapery, and represented their heads in multi-colored headdresses; and he also made many innovations in painting, since it was he who introduced representing the mouth as open, showing the teeth, and varying the face from the rigidity that had existed previously. There is a picture by him in the Portico of Pompey (but which was formerly in front of his [Pompey's] Curia) in which there is some doubt as to whether he has depicted the figure with the shield as moving upward or moving downward. He painted a chamber in Delphi, and he also painted the portico in Athens which they called the *Poikile*, doing it for nothing, although Mikon painted a part of it for a fee. Actually the reputation of Polygnotos was greater, since the *Amphiktyones*, which is the common council of Greece, decreed free food and lodging for him.[8]

Plutarch, *Life of Kimon* 4.5–6: They accused him [Kimon] of having intercourse in his youth with his own sister Elpinike, and they say that Elpinike was not particularly well behaved in other respects, but that she lived in sin with Polygnotos the painter. And it was for this reason, they say, that, in painting the

[8] Presumably the *Amphiktyones* of Delphi, where Polygnotos did some of his best-known work.

Trojan women in the stoa which was then called the *Peisianakteion* but later the *Poikile*, he made the face of Laodike into a portrait of Elpinike. Polygnotos was not just one of the common workmen, and he did not paint the stoa for a profit, but rather he painted it free, thus showing his patriotic zeal for the city, as is related by the historians; the poet Melanthios expresses it in this manner:

> For at his own cost he decorated the temples of the gods
> And the Agora of Kekrops with the virtues of demi-gods.

Harpokration, *Lexicon*, s.v. "Polygnotos": ... concerning Polygnotos the painter, a Thasian by birth, the son and pupil of Aglaophon, and how he achieved Athenian citizenship when he painted without a fee the *Stoa Poikile*, or, according to others, the paintings in the treasury[9] and the *Anakeion*[10] – this history has been related by others including Artemon in his book *About Painters* and Juba in his book *On Painting.*[11]

The Works of Polygnotos

THE *SACK OF TROY (ILIOUPERSIS)* AND *UNDERWORLD (NEKYIA)* IN THE *LESCHE* OF THE KNIDIANS IN DELPHI.

The Lesche *("Clubhouse") dedicated by the people of Knidos was situated within the precinct of Apollo at Delphi. The famous paintings by Polygnotos were inside the building, either on its walls or on wooden plaques attached to the walls. Pausanias's description of them is long and elaborate and is presented here in abridged form (with omissions, except for minor discursive remarks, summarized in brackets).*

The language of the description – such phrases as "higher up," "above," and the like – makes it clear that Polygnotos placed his figures above and below one another as if they were disposed on a plane which could be seen receding toward the horizon. Polygnotos was probably the innovator of this type of spatial composition in Greek painting. It has frequently been suggested that his style of spatial and figural composition is reflected in the well-known "Niobid Krater" in the Louvre[12] and other vases of the Early Classical period. For attempts to reconstruct the general design of the paintings at Delphi, see Bibliography 68B.

Pausanias 10.25.1: Above the Kassotis[13] is the building which has the paintings by Polygnotos; it is an offering of the Knidians and is called the *Lesche* by the Delphians because when they got together here in the old days they used to

[9] Perhaps a reference to the sanctuary of Theseus in Athens (*Theseos hieroi* rather than *Thesauroi*).
[10] *Anakeion*: the sanctuary of the Dioskouroi in Athens, see below.
[11] Nothing more is known of Artemon. Juba (*c.* 50 B.C.–23 A.C.), besides being a prolific and versatile writer, was king of Mauretania. He was one of the sources used by Pliny in compiling his chapters on the history of art. [12] Arias–Hirmer, *Greek Vase Painting*, pls. 173–5.
[13] A spring within the sanctuary at Delphi.

Fig. 5a. Polygnotos's *Ilioupersis* at Delphi; restoration by Mark Stansbury-O'Donnell. North wall. Sea Scene. Lower level, left to right: Ship of Menelaos with men and boys, Phrontis (with hat), Ithaimenes (with bundle), and Echoiax (on gangplank); tents of Menelaos with Polites, Strophios, Alphios, boy, and Amphialos; Briseis, Diomedes (above), and Iphis; Panthalis, Helen, and Elektra; Eurybates, Aithra, and Demophon; Astyanax and Andromache; Medesikaste and Polyxena; Nestor. Upper level, left to right: Helenos; Meges, Lykomedes, and Euryalos; Klymene and three women; Deinome and three women.

Fig. 5b. Polygnotos's *Ilioupersis* at Delphi; restoration by Mark Stansbury-O'Donnell. East wall. Altar scene. Lower level, left to right: Horse; Elasos, Neoptolemos, and Astynoös; child and altar; Laodike; Medusa with fountain, Leokritos, old woman with child. Upper level, left to right: Wall of Troy, Epeios, and Trojan Horse; Polypoites and Akamas; [Diomedes?] and Odysseus; Ajax, altar, and Kassandra with statue of Athena; Agamemnon and Menelaos; [Palace of Priam?].

Fig. 5c. Polygnotos's *Ilioupersis* at Delphi; restoration by Mark Stansbury-O'Donnell. South wall. Land Scene. Lower level, left to right: Eioneus and Admetos, Eresos, Sinon, body of Laomedon, and Anchialos; house of Antenor; Theano, Glaukos, and Eurymachos; Antenor and Krino with child; servants, child and ass. Intermediate level, left to right: Pelis; Koroibos. Upper level, left to right: Priam; Axion; Agenor.

discuss weightier subjects, including everything connected with legends . . . As you go into the building the whole portion of the painting to your right represents Ilium captured and the Greeks sailing away. On the ship of Menelaos they are getting everything ready for the departure. The ship is depicted and among the sailors there are grown men and, mixed up with them, children; in the middle of the ship is the helmsman Phrontis, holding two poles. Homer represented Nestor as talking about Phrontis, among other things, with Telemachos. [Some remarks on the history of Phrontis intervene.] . . . This Phrontis, to continue, is in the painting of Polygnotos, and beneath him is a certain Ithaimenes carrying clothing, and Echoiax is seen going down the gangplank and holding a bronze *hydria* [water jar]. Polites, Strophios, and Alphios are striking the tent of Menelaos which is not far from the ship. Amphialos is taking down another tent, while at his feet a boy is seated. There is no inscription by the boy; Phrontis above is represented with a beard. His name is the only one Polygnotos learned from the *Odyssey*;[14] the names of the others, it seems to me, he invented himself.

Briseis stands there with Diomedes above her and Iphis in front of both of them; they seem to be scrutinizing Helen's beauty. Helen herself is seated, and Eurybates is near her. I supposed that he was the herald of Odysseus, although he did not yet have a beard. The handmaids Elektra and Panthalis are there; the latter stands next to Helen while Elektra is binding sandals on her mistress' feet. These names are also different from those that Homer gives in the *Iliad*,[15] where he represented Helen, and her servants along with her, going to the wall. Seated above Helen is a man shrouded in a purple cloak and looking extremely downcast. One might surmise that it was Helenos, the son of Priam, even before reading the inscription. Near Helenos is Meges; he is wounded in the arm, just as Lescheos of Pyrrha, the son of Aeschylinos, represented him in the *Sack of Troy*. For he says that he was wounded by Admetos the son of Augeias in the battle which the Trojans fought in the night. Lykomedes the son of Keraon is depicted next to Meges with a wound in his wrist. Lescheos says that he was wounded in this way by Agenos. It is quite obvious that Polygnotos would not have painted their wounds in this way if he had not read the poem by Lescheos. He has added, however, another wound on Lykomedes' ankle and a third on his head. Euryalos the son of Mekisteos is also wounded on the head and on the wrist. These figures are placed higher up than Helen in the picture. After Helen comes the mother of Theseus with her hair shorn and Demophon, one of the sons of Theseus, who, I gather from his attitude, is trying to determine whether it will be possible for him to save Aithra. [Details about his attempt to save Aithra, the mother of Theseus, who became Helen's slave, intervene.] . . .

The Trojan women seem to be captives already and are mourning their fate. Andromache is depicted, and her child stands by her clutching her breast – this child, Lescheos says, met his end by being hurled from the tower. He further

[14] *Odyssey* 3.282. [15] *Iliad* 3.144, where the maidens are Aithre and Klymene.

says that this was not a decree of the Greeks, but that Neoptolemos made a private decision to be the murderer. Also depicted is Medesikaste; she too is one of the illegitimate daughters of Priam . . . Andromache and Medesikaste are wearing hoods,[16] while Polyxena has her hair braided as is customary with virgins. Poets sing about how she died at the tomb of Achilles, and I know of paintings that I have seen both in Athens and at Pergamon above the river Kaïkos dealing with the sufferings of Polyxena. To continue, Nestor is also represented with a cap on his head and a spear held in his hand. There is also a horse whose position suggests that he is about to roll in the dust. Right up to the spot where the horse is, there is a beach and on it pebbles are just visible; thereafter the representation of the sea breaks off.

(10.26.1): Up above this group of women, at the point between Aithra and Nestor, there are these other captive women – Klymene, Kreousa, Aristomache, and Xenodike . . . [a discussion of the literary sources for these figures – Stesichoros and Lescheos – intervenes] . . . Represented on a couch above these are Deinome, Metioche, Peisis, and Kleodike. Of these, the name of Deinome alone occurs in the work called the *Little Iliad*. The names of the other women, I believe, were invented by Polygnotos. Epeios is represented as a nude figure who razes the wall of Troy to the ground. Above the wall rises the head, which is alone visible, of the Wooden Horse. There too is Polypoites the son of Peirithoös, who has his head bound with a fillet, and next to him Akamas the son of Theseus, who has a helmet on his head; a crest has been wrought on the helmet. Also there is Odysseus . . . and Odysseus has put on his cuirass. Ajax the son of Oileus stands by an altar holding a shield, swearing an oath about his shameless act against Kassandra. Kassandra is seated on the ground and holds the image of Athena, since she pulled the image down from its base when Ajax was dragging her away from her place as a suppliant. Depicted there also are the children of Atreus, who also wear helmets. Menelaos holds a shield on which a serpent has been wrought, a reference to the portent that appeared among the victims at Aulis. Below those who are making Ajax swear the oath, and parallel with the horse by Nestor, is Neoptolemos who has killed Elasos, whoever Elasos may be. He is represented with only a little life left in him. Astynoös, of whom Lescheos makes mention, has fallen on his knees and Neoptolemos strikes him with his sword. Polygnotos has represented Neoptolemos alone as still engaged in slaying Trojans, because it was his intention that the whole painting should be above the grave of Neoptolemos . . . Also depicted is an altar and a small boy who clings to it out of fear. On that altar is a bronze cuirass. [A discussion of the cuirass follows.] . . .

Beyond the altar he has painted Laodike who is standing. I have not found her listed among the captive Trojan women by any poet. [A discussion of the

[16] Hoods – Greek *kalymmata*. The word can also mean veil. The garment is probably intended to be a sign of mourning.

sources for the history of Laodike intervenes.] . . . Next to Laodike there is a
stand made of stone and on the stand is a bronze washing-basin. Medusa,
holding on to the stand with both hands, is seated on the ground. She too should
be counted among the daughters of Priam according to the Ode of the poet of
Himera [Stesichoros]. Beside Medusa is an old woman with her hair shorn, or a
man who is a eunuch, who holds a naked child on his knees. The child is
represented as holding its hand in front of its eyes out of fear. (**10.27.1**) There are
also corpses, including a naked man named Pelis who lies prostrate on his back;
below this Pelis lie Eioneus and Admetos, still dressed in their cuirasses . . . The
others above these are, beneath the wash-basin, Leokritos the son of Poulyda-
mas, killed by Odysseus, and, above Eioneus and Admetos, Koroibos the son of
Mygdon. [A digression on Mygdon and Koroibos intervenes.] . . . And higher
up than Koroibos are Priam, Axion, and Agenor. [A discussion of the literary
sources for the death of Priam and Hecuba intervenes.] . . . Sinon, the
companion of Odysseus, and Anchialos are carrying off the body of Laomedon;
and there is another corpse, the name of which is Eresos. No poet, as far as I
know, has sung this story about Laomedon and Eresos. Also represented is the
home of Antenor with a leopard skin hanging over the doorway, the sign of an
agreement among the Greeks to keep their hands off the house of Antenor.
Theano is also depicted along with her sons, Glaukos, who is seated on a corselet
consisting of two parts fitted together, and Eurymachos, who is seated on a rock.
By him stands Antenor and after that Krino, the daughter of Antenor. Krino
carries an infant child. The look on the faces of all of them is that of people who
have suffered a great disaster. Servants are loading a chest and other baggage on a
donkey. Also seated on the donkey is a small boy. Below this section of the
painting there is also the elegiac couplet of Simonides:

> Polygnotos, Thasian by birth, Aglaophon's son,
> Painted the sacking of Ilium's citadel.

THE UNDERWORLD (*NEKYIA*)

Pausanias 10.28.1: The other part of the painting, the part on the left-hand side,
represents Odysseus, who has gone down to the region called Hades in order to
ask the soul of Teiresias about how to achieve a safe homecoming. The details of
the painting are as follows. There is water that looks like a river, and is clearly
intended to be Acheron. Reeds have grown up in it and there are forms of fish so
faint that you might take them for shadows rather than fish. There is a ship on
the river and a ferryman at the oars. Polygnotos followed, it seems to me, the
poem called the *Minyad*. For in the *Minyad* are the following lines about Theseus
and Peirithoös.

> But at that spot they did not within the place of anchorage find the ship on
> which the dead embark, the one that the old ferryman, Charon, used to
> steer.

For this reason, Polygnotos painted Charon as a man already well on in years. Those who are on board are not all clearly distinguishable to those who have arrived.[17] Tellis appears to have reached the age of an ephebe,[18] and Kleoboia, who is still a virgin, holds a chest on her knees of the type they usually make for Demeter. With regard to Tellis all I heard was that the poet Archilochos was his grandson, while they say that Kleoboia first brought the rites of Demeter from Paros to Thasos.

On the bank of Acheron there is a group well worth seeing; it is placed below the boat of Charon and shows a man who has been unjust to his father being choked by the father. [Examples of how earlier generations were dutiful to their parents intervene.] . . . Near the man in Polygnotos's painting who maltreated his father and for that reason has a full measure of suffering in Hades, near him, I repeat, there is a man who is receiving his punishment for having robbed sanctuaries. The woman who is punishing him knows about drugs and such things as are for the torture of men. [Examples of piety among earlier generations are given.] . . . Thus it appears all men at that time held the divine in high honor, and for that reason Polygnotos painted the scene about a man who robbed sanctuaries.

Higher up than the figures I have thus far spoken of is Eurynomos. The Delphian guides say that this Eurynomos is one of the demons in Hades, and that he eats the flesh of corpses and leaves behind only the bones. But Homer, in the *Odyssey*, and the poems called the *Minyad* and the *Nostoi* ["Homecomings"] – for in these poems mention is made of Hades and of the terrors that are in it – do not know of this demon Eurynomos. Nevertheless I shall make clear what sort of creature this Eurynomos is and in what sort of format he has been depicted. The color of his skin is between blue and black like that of flies that are always hovering around meat; he is showing his teeth and is seated on a vulture's skin spread out beneath him. After Eurynomos come Auge and Iphimedeia from Arcadia. Auge turned up at the house of Teuthras in Mysia, and of all the women with whom they say Herakles had an affair, she was the one who bore a child most like its father.

(**10.29.1**): Still higher up than the figures which I have already spoken of are Perimedes and Eurylochos the companions of Odysseus who are carrying sacrificial victims. These victims are black rams. After them there is a man who is seated; the inscription says that he is "Oknos" ["Sloth"]. He is represented as plaiting a rope, while a female donkey stands by him continually eating up the plaited portion of the rope. They say that this Oknos was a man who loved work but that he had a spendthrift wife. And everything he earned by work was spent by his wife not much later. So, they maintain, Polygnotos has painted here an allusion to the wife of Oknos. [Other anecdotes about Oknos are given.] . . .

[17] "To those who have arrived" is omitted by some editors.
[18] Ephebe is the Greek term for a youth who had reached the age of 18 and was undergoing military training.

Fig. 6a. Polygnotos's *Nekyia* at Delphi, restoration by Mark Stansbury–O'Donnell. Reconstruction of the north wall of the *Nekyia*. Lower level, right to left: father throttling his son, woman giving poison to a man, Ariadne, Phaidra, Chloris, Thyia, Prokris, Klymene, Megara, Theseus, Peirithoös. Intermediate level, right to left: Tyro, Eriphyle. Upper level, right to left: boat of Charon with Kleoboia and Tellis, Eurynomos, Auge, Iphimedeia, Perimedeia, Eurylochos, Oknos, Ass, Tityos, Odysseus, Elpenor, Teiresias, Antikleia.

Fig. 6b. Polygnotos's *Nekyia* at Delphi, restoration by Mark Stansbury-O'Donnell. Reconstruction of the west wall of the *Nekyia*. Lower level, right to left: Kameiro, Klytie, Antilochos, Agamemnon, Protesilaos, Achilles, Orpheus, Promedon, Schedios, Pelias, Thamyris. Intermediate level, right to left: Patroklos. Upper level, right to left (from center): Phokos, Iaseus, Maira, Aktaion with mother, deer, and dog, Marsyas, Olympos.

Fig. 6c. Polygnotos's *Nekyia* at Delphi, restoration by Mark Stansbury-O'Donnell. Reconstruction of the south wall of the *Nekyia*. Lower level, right to left: Hector, Ethiopian boy, Memnon, Sarpedon, Tantalos (far left). Intermediate level, right to left: Paris, Penthesileia, young woman carrying water (far left), Sisyphos, three water carriers. Upper level, right to left: Ajax the Greater, Palamedes, Thersites, Ajax the Lesser, Meleager, women with broken pitchers, Kallisto, Nomia, Pero.

Tityos is also depicted, no longer being punished, but completely consumed by continual torture, a faint and decomposed image.

Going on to the next group of figures in the painting, nearest to the man who twists the rope, is Ariadne. She is seated on some rocks and looks at her sister Phaidra, who in turn is swinging herself on a loop-swing, holding the rope in her hands on each side. This position, even though it is represented rather prettily, suggests the story of the death of Phaidra. [Remarks on the story of Ariadne and Dionysos follow. Then Pausanias examines images of other women who, like Phaidra, had renowned marriages with gods or heroes.] . . . Below Phaidra is Chloris, leaning against the knees of Thyia . . . Next to Thyia stands Prokris, the daughter of Erechtheus, and, with her, Klymene . . . Farther back Megara from Thebes is shown; this is the Megara who married Herakles . .

Above the heads of the women just mentioned is the daughter of Salmoneus [Tyro] seated on some rocks and by her is Eriphyle, standing, who holds the ends of her fingers through her tunic by her neck; and you can imagine that in the folds of her tunic, in one or the other of her hands, she holds that well-known necklace.

Above Eriphyle he has painted Elpenor and Odysseus who is crouching on his feet, and holds his sword above the pit; and the prophet Teiresias is coming forward toward the pit. After Teiresias is Antikleia, the mother of Odysseus, seated on the rocks. Elpenor, instead of garments, wears a plaited mat as is customary for sailors. Lower down than Odysseus are Theseus and Peirithoös seated on chairs; the former holds both Peirithoös's sword and his own, while Peirithoös stares at the swords. And you would guess that he was angry with the swords because they were useless and of no avail in their adventures. [Details about the myth of Theseus and Peirithoös follow.] . . .

(10.30.1): Next Polygnotos has painted the daughters of Pandareos. [A summary of Homer's story about these daughters, *Odyssey* 20.66–78, follows.] . . . Polygnotos has painted them as maidens garlanded with flowers and playing with dice, and their names are given as Kameiro and Klytie . . . After the daughters of Pandareos is Antilochos, with one foot on a rock and with his face and his head resting in his two hands, while after Antilochos is Agamemnon, leaning on a scepter beneath his left armpit and holding up a staff in his hands. Protesilaos, who is seated, is looking at Achilles. Such is the position of Protesilaos, and above Achilles stands Patroklos. These figures, except for Agamemnon, do not have beards.

Beyond them is depicted Phokos, who is shown as a boy, and Iaseus, who has a full beard; the latter is taking a ring off Phokos's left hand, as is in accord with the following story. Phokos, the son of Aiakos, crossed over from Aegina into the territory now called Phokis with the intention of establishing rule over the men who lived in that part of the mainland and of settling there himself. When he arrived Iaseus conceived a deep friendship for him and, as is the custom, gave him gifts, among which was a seal stone set on a gold ring. When, however, after a not very great period of time, Phokos returned to Aegina, Peleus

immediately hatched a plot to take his life. It is for this reason, that is, as a reminder in the painting of their friendship, that Iaseus is eager to see the ring and Phokos is willing to let him take it.

Beyond them is Maira, seated on a rock. Concerning her it is recorded in the poem called the *Nostoi* that she departed from the world while still a virgin . . . Next to Maira is Aktaion, the son of Aristaios, and Aktaion's mother. They hold in their hands a fawn and are seated on a deerskin. A hunting dog lies stretched out before them, suggesting both the life of Aktaion and the manner of his death.

Looking at a still lower part of the painting, we come, after Patroklos, to Orpheus, seated on a sort of hill; in his left hand he has hold of a *kithara*, and with the other hand he touches a willow. There are branches which he touches, and he is leaning against the tree. The grove seems to be that of Persephone, where black poplars and willows grew according to Homer. The manner in which Orpheus is represented is Greek and neither his clothing nor his headdress are Thracian. Leaning against the other side of the willow tree is Promedon. There are those who think that the name was invented and introduced, just as if it were in a poem, by Polygnotos; it is said by others that the man was a Greek who was fond of listening to all kinds of music, but especially to the singing of Orpheus. In this area of the painting is Schedios who led the Phokians to Troy. With him is Pelias seated on a chair; his beard and his hair alike are grey, and he gazes at Orpheus. Schedios holds a dagger and has a garland of grass on his head. Seated near Pelias is Thamyris whose eyes have been blinded and is represented in the attitude of one who is completely humiliated; the hair on his head has grown long as has his beard. His lyre is thrown at his feet, with its horns broken and with strings which have snapped. Above him is Marsyas seated on the rocks and by him Olympos represented as a blooming boy who is learning how to play the flute. [Remarks on Marsyas and the flutes follow.] . . .

(**10.31.1**): If you look again at the upper part of the painting, there comes, after Aktaion, Ajax of Salamis, and also Palamedes and Thersites engaging in a game of dice, of which Palamedes was the inventor. The other Ajax looks at them as they play. The color of this Ajax might be likened to that of a man who has been in a shipwreck and whose skin is still caked with salt. Polygnotos has thus quite artfully brought together the enemies of Odysseus. [The background of Odysseus' enemies is then mentioned.] . . . Meleager, the son of Oineus, appears higher up in the painting than Ajax the son of Oileus, and seems to be looking at Ajax. [The story of Meleager's death follows.] . . .

In the lower part of the painting, after the Thracian Thamyris, Hector is seated, clasping his left knee with both hands, and represented in the attitude of one who grieves. After him comes Memnon, seated on a rock and right next to Memnon is Sarpedon. Sarpedon buries his face in both hands, while Memnon places one hand on Sarpedon's shoulder. They all have beards, and there are birds worked into the cloak of Memnon. [These birds, it is explained, attend upon the tomb of Memnon.] . . . By Memnon a naked Ethiopian boy is

represented, because Memnon was the king of the Ethiopian people. [A discussion of the route which Memnon took to Troy intervenes.] . . .

Above Sarpedon and Memnon is Paris, who does not yet have a beard. He is clapping his hands just the way some rude country fellow would clap them. You will say that Paris appears to be calling Penthesileia to him by the sound of his hands. Penthesileia is also there looking at Paris; she seems by the toss of her head to look on him with disdain and to treat him as of no account. The representation of Penthesileia is that of a virgin; she carries a bow that is like Scythian bows and wears a leopard skin on her shoulders. Above Penthesileia there are women who carry water in broken clay vessels. One is depicted as still possessing the beauty of youth, while the other is already advanced in age. There is no separate inscription for each of the women, but rather there is a common label for both, which identifies them as being among the women who were never initiated. Higher up than these is Kallisto, the daughter of Lykaon, and Nomia, and Pero, the daughter of Neleus. As her bride-price, Neleus asked for the cattle of Iphikles. As for Kallisto, instead of a mattress, she has a bearskin, and she has her feet resting on Nomia's lap. As I have pointed out earlier in this work [8.38.11], the Arcadians say that Nomia is a Nymph of that region. There is a tradition among the poets that Nymphs live for a great number of years but that they are not completely exempt from death.

After Kallisto and the women who are with her, there is the representation of a cliff, and Sisyphos, the son of Aiolos, is exerting himself to push the stone up the cliff. There are also in the painting a storage jar, an old man, and a boy and some women – a young woman below the stone and another who is beside the old man and of the same age as he. The others are carrying water, and you will no doubt guess that the old woman's water-jar is broken. And whatever water is left in the sherd, she is pouring back into the storage jar again. I surmised that these were people who attached no significance to the rites at Eleusis. For the earlier Greeks felt that the Eleusinian mysteries surpassed all others in holiness to the same extent that the gods were more worthy of honor than heroes.

Beneath this storage jar is Tantalos, who has all the pains that Homer depicted with regard to him, and in addition to these there is also the fear caused by the stone that hangs over him. It is clear that Polygnotos has followed the version of Archilochos here. I do not know, however, whether Archilochos borrowed the story about the stone from the others or whether he introduced it into the poem himself.

Such is the number and so great are the beauties that this painting of the Thasian possesses.

THE *ANAKEION* (SANCTUARY OF THE DIOSKOUROI) IN ATHENS

Pausanias 1.18.1: The sanctuary of the Dioskouroi is an ancient one . . . Here Polygnotos has painted an episode connected with them – the marriage of the daughters of Leukippos; Mikon [see p. 142] painted those who sailed with Jason against the Kolchians . . .

PAINTINGS AT PLATAEA

Pausanias 9.4.1–2: In Plataea there is a sanctuary of Athena called *Areia*. [The temple was built from the spoils of the battle of Marathon, and the image was made by Pheidias, see pp. 63–4] . . . There are paintings in the temple, one by Polygnotos, showing Odysseus, who has already finished off the suitors; the other, by Onasias, showing the earlier expedition of Adrastos and the Argives against Thebes.[19] These paintings are on the wall of the *pronaos* . . .

PAINTINGS IN THE *PROPYLAIA* OF THE ACROPOLIS IN ATHENS

Pausanias 1.22.6: The room on the left of the *Propylaia* contains some pictures.[20] Among those that time has not caused to grow faint, there are pictures of Diomedes and Odysseus, the latter in Lemnos taking away the bow of Philoktetes and the former stealing the image of Athena from Troy. Also there among the pictures is one of Orestes killing Aigisthos and Pylades killing the son of Nauplios, who had come to aid Aigisthos. And there is Polyxena about to have her throat cut near the tomb of Achilles. Homer did well to pass over this savage act; he likewise did well, it seems to me, in composing a poem about the sack of Skyros by Achilles, thus differing from those who say that Achilles dwelt among the virgins in Skyros, which is the story Polygnotos has painted. He also painted Odysseus by the river encountering the girls who were doing the washing along with Nausikaa – just as Homer has described it.

Whether the paintings not specifically ascribed to Polygnotos in the above passage were also by him is not clear.

Mikon of Athens

Mikon and Polygnotos collaborated on the paintings in the Stoa Poikile, *the* Anakeion, *and possibly, if the emendation of Harpokration given above (p. 127, n. 9) is correct, the sanctuary of Theseus in Athens. Mikon also resembled Polygnotos in being a sculptor as well as a painter (Pausanias 6.6.1; Pliny, N.H. 34.88).*

The Works of Mikon

THE *AMAZONOMACHY* AND THE *BATTLE OF MARATHON* IN THE *STOA POIKILE* IN ATHENS (SEE ALSO PP. 143–5)

Aristophanes, *Lysistrata* 678–9 and scholiast: . . . just contemplate those Amazons which Mikon has painted, mounted on horseback and fighting against men!

[19] This is the only known work by Onasias. The reading "Adrastos and" is based on a restoration of the text proposed by Dindorf.

[20] Much of this room is still intact in the north wing of the *Propylaia* (built 437–432 B.C.). If the room was originally designed for the function that it fulfilled in Pausanias's day, it perhaps should be recognized as the world's earliest public art gallery, but its function as a picture gallery may not have developed until the time of the Roman domination of Athens.

Scholiast: The *Stoa Poikile* in Athens is thus spoken of because of the paintings in it. Here Mikon made the battle of the Amazons. He was the son of Phanochos, an Athenian.

Aelian, *de Natura Animalium* **7.38:** A certain Athenian brought along a dog as an ally in the battle of Marathon, and each of them is represented in the painting in the *Poikile*; the dog was not dishonored; in fact, as its reward for having undergone the danger, it was shown with Kynaigeiros and Epizelos and Kallimachos [the Athenian generals]. These men and also the dog were painted by Mikon. At least some say by him, but others say by Polygnotos.

THE ARGONAUTS IN THE ANAKEION IN ATHENS

Pausanias 1.18.1 (see also under Polygnotos, pp. 127, 140): The sanctuary of the Dioskouroi is an ancient one. There . . . Mikon has painted those who sailed with Jason against the Kolchians. The intensity of his effort in this painting is particularly apparent in the figure of Akastos and the horses of Akastos.

Pausanias 8.11.3 (concerning the daughters of Pelias, who, at the instigation of Medea, killed their father): No poet has recorded their names, at least within the scope of my reading, but Mikon the painter wrote the names Asteropeia and Antinoë on his portraits of them.[21]

PAINTINGS IN THE THESEION IN ATHENS

Pausanias 1.17.2–3: By the gymnasium there is a sanctuary of Theseus. There are paintings here of the Athenians fighting the Amazons. This war has also been represented on the shield of the Athena [*Parthenos*] and on the base of the Olympian Zeus [by Pheidias, see pp. 58–62]. Also painted in the sanctuary of Theseus is the battle of the Lapiths and centaurs. Theseus is there and has already killed a centaur. Among the others the battle is still an equal match. The painting on the third wall is not very clear to those who have not heard what they tell about it, in part because of its age and in part because Mikon did not depict the whole story. [A section follows narrating some of the exploits of Theseus in Crete, in Western Greece, and in the underworld, and also his death on Skyros. Which of these stories Mikon did or did not represent is not clear.] . . .

The following anecdote is probably to be connected with one of the mural paintings described above.

Aelian, *de Natura Animalium* **4.50:** With regard to horses, they say that they have no lower eyelids. They maintain, moreover, that it was the fault of Apelles

[21] These figures presumably belonged to the painting of the Argonauts. Another figure which perhaps belonged to this painting was that of the Argonaut Boutes, hidden behind a rock so that only his helmet and one eye were visible. This figure gave rise to the proverb, "Quicker than Boutes," because it was felt that Mikon could have executed the figure in a very short time. For the texts (Zenobios and other collections of proverbs) see Overbeck, *SQ*, no. 1085.

of Ephesos that, when painting a certain horse, he did not take note of this peculiarity in the animal. Others say that this fault should not be ascribed to Apelles but to Mikon, who was very good at painting this animal and erred only in the way just mentioned.

Panainos the Brother of Pheidias

Panainos, as a passage cited earlier attests, collaborated with Pheidias on the ornamentation of the statue of Zeus at Olympia (see p. 62).

Pausanias 5.11.6: This Panainos was the brother of Pheidias, and the *Battle of Marathon* in the *Stoa Poikile* in Athens was also painted by him.

Pliny, N.H. 35.54–8 (in a discussion on the chronology of Greek painting): . . . there is a tradition that Pheidias himself was originally a painter and that the shield [of the Athena *Parthenos*] in Athens was painted by him; moreover there can be no doubt that his brother Panainos, who painted the inside of the shield of Athena in Elis which was made by Kolotes [see p. 68] . . . was active in the 83rd Olympiad [448 B.C.] . . . (**Sec. 57**) Indeed Panainos, the brother of Pheidias, even painted the battle of the Athenians against the Persians at Marathon. Now at this time the use of color had increased to such an extent and the art had become so highly perfected, that he is reputed to have painted portraits of the leaders in this battle – among the Athenians Miltiades, Kallimachos, and Kynaigeiros, and among the barbarians Datis and Artaphernes.[22] (**Sec. 58**) Not only that but during the time when he flourished competitions in painting were instituted at Corinth and Delphi, and in the first of these he [Panainos] competed with Timagoras of Chalkis, by whom he was defeated, which is clear from an old poem by Timagoras himself . . .

Pliny, N.H. 36.177: There is a temple of Athena in Elis in which Panainos the brother of Pheidias introduced the technique of working plaster with milk and saffron; as a result even today if saliva, applied to one's thumb, is rubbed into it, it gives off the odor and taste of saffron.

The Paintings in the *Stoa Poikile* in Athens

As the preceding passages in this section have indicated, Polygnotos, Mikon, and Panainos all contributed to the paintings of the Stoa Poikile *(the "Decorated Portico") in the Agora in Athens. The fullest description of the paintings is that of Pausanias.*

Pausanias 1.15.1: . . . the stoa, which is called *poikile* from its paintings . . . This stoa contains first a scene with the Athenians drawn up against the Lakedaimo-

[22] Whether Panainos and Mikon painted separate pictures of the battle of Marathon in the *Stoa Poikile*, or whether they collaborated on a single picture is uncertain.

nians at Oinoë in the territory of Argos. The painting does not show the high-point of the struggle, nor has the action reached the point where there is already a display of valorous deeds, but rather the battle is just beginning and they are still in the process of coming to grips with one another. On the middle wall the Athenians and Theseus are shown fighting the Amazons [painted by Mikon]. Among these women alone, it would seem, defeat did not rob them of their recklessness in the face of danger, since Themiskyras was seized by Herakles and later their army, which they sent to Athens, was destroyed, but in spite of all that they came to Troy to fight against the Athenians and all the other Greeks as well. After the Amazons come the Greeks who have taken Troy and also the kings who have gathered together on account of the outrageous act of Ajax against Kassandra [painted by Polygnotos]. The painting includes Ajax himself and also Kassandra and other captive women. The final part of the painting represents those who fought at Marathon [painted by Mikon and Panainos]. The Boeotians who inhabit Plataea and the Attic force are coming to grips with the barbarians. In this section the struggle is an equal match. In the center of the battle, however, the barbarians are fleeing and are pushing one another into the marsh, and at the borders of the painting there are Phoenician ships and Greeks slaying those of the barbarians who are climbing into them. Here too is a depiction of the hero Marathon, after whom the plain is named; Theseus is represented as rising out of the earth, and Athena and Herakles are here also. For Herakles was first decreed to be a god by the Marathonians, as they themselves say. Of the combatants the most conspicuous in the painting are Kallimachos, who was chosen by the Athenians to be the supreme commander, and, of the other generals, Miltiades, and also the hero who is named Echetlos.

The battle of Oinoë mentioned by Pausanias seems to have taken place sometime during the Athenian–Argive alliance of 461–452 B.C. It would be surprising to find a then quite recent, and now somewhat obscure, historical battle grouped with the other paintings in the stoa, which had epic or near-epic subjects. L. H. Jeffery, in an important study of the historical significance of the paintings, has suggested that the "Battle of Oinoë" may actually have represented the legendary campaign of the Athenians, led by Theseus, to retrieve the bodies of the Argive heroes who had fallen in the battle of the "Seven against Thebes." See Bibliography 71.

There is some evidence that paintings of other subjects – notably, the Herakleidai, and Sophokles playing the lyre – were included among the paintings in the Stoa Poikile, *but if they existed, nothing can be determined about their date and authorship.*[23]

A brief mention of the stoa by the neoplatonist Synesios of Cyrene (c. 370–413 A.C.) suggests that the paintings were executed on wooden boards attached to the walls rather than painted on plaster.

[23] See Wycherley's analysis of all the references to the *Stoa Poikile*, Bibliography 71.

Synesios, *Epistles* 54: [People who have visited Athens] dwell among us like demi-gods among demi-donkeys because they have seen the Academy and the Lyceum, and the *Poikile* in which Zeno philosophized. This is no longer *poikile*, however, because the Proconsul took away the boards.

In **Epistles 135** *Synesios once again speaks of the removal of boards "to which Polygnotos of Thasos had applied his art."*

Dionysios of Kolophon

Reference has already been made to an epigram of Simonides (p. 125) that mentions a painter named Dionysios who, along with Kimon of Kleonai, painted a certain set of doors. This epigram (a rare example of a contemporary reference to an artist) dates Dionysios in the first half of the fifth century B.C. Aelian also suggests that he was a contemporary of Polygnotos.

Aelian, *Varia Historia* 4.3: Polygnotos of Thasos and Dionysios of Kolophon were painters. Polygnotos painted large pictures . . . Those of Dionysios, except for the size, imitated the art of Polygnotos in its precision, its representation of emotion and character, its use of patterns of composition, the thinness of the drapery, and so on.[24]

Plutarch, *Life of Timoleon* 36.3: The poetry of Antimachos and the paintings of Dionysios, both from Kolophon, although they have vigor and tension,[25] seem forced and labored.

Pliny, *N.H.* 35.113: . . . Dionysios on the contrary painted nothing other than human beings, and on account of this he was given the name *anthropographos* ["painter of men"].

In the above passage it is not certain that the Dionysios referred to is Dionysios of Kolophon. The name anthropographos, *however, suggests that he may be the same as the Dionysios mentioned by Aristotle (see p. 230) who "painted men as they were."*

Agatharchos

Agatharchos, the son of Eudemos, was a Samian by birth. His great achievement was the invention of rules for the rendering of spatial perspective in painting. The representation of perspective was called skenographia *in Greek, a word that literally means "scene-painting." Vitruvius records a tradition that perspectival renderings were first employed*

[24] Aelian's information in this passage is of the sort which might have come from the history of Xenokrates (see Introduction, pp. 3–4, 9). On the "thinness of the drapery" compare Pliny's *tralucida veste pinxit* (*N.H.* 35.58), see p. 126.

[25] "Tension" here translates the Greek *tonos*, which possibly refers to the contrast of light and shade in a painting. See Pliny, *N.H.* 35.29.

*in the painted stage-settings designed for the Athenian dramas. The exact date of
Agatharchos is uncertain. His association with a drama of Aeschylus suggests a date in
the second quarter or middle of the fifth century B.C., but the drama in question could have
been a revival, and the painter's association with Alcibiades implies a date later in the
century.*

Vitruvius 7, praef. 11: For first of all Agatharchos, when a tragedy by
Aeschylus was being presented, made the stage-setting [*scaena*], and left behind a
commentary about it. Instructed by him, Demokritos and Anaxagoras wrote
on the same subject, demonstrating how it followed that, if a definite center is
constituted for the direction of the eyes and also the extension of the radii
[therefrom], the lines correspond to these according to a natural law, so that
from an uncertain object certain images may produce the appearance of
buildings in the paintings of the stage-setting, and things drawn on vertical flat
planes may seem in some cases to be receding and in other cases to be projecting
outward.

*The Latin text of the above passage is probably the most obscure and problematical of
all the ancient texts on art. For a discussion of the problems see Bibliography 72.*
The other literary testimonies about Agatharchos are anecdotal.

Plutarch, *Life of Pericles* 13: And indeed they say that when Agatharchos
the painter boasted that he could paint figures quickly and easily, Zeuxis [see
p. 188] overheard him and said, "It takes me a long time." For facility and speed
in making a thing do not give it lasting gravity or the sharpness of beauty.

Plutarch, *Life of Alcibiades* 16 (discussing the faults of Alcibiades): He made
the Athenians forgive all the other things and bear them with restraint, always
giving the mildest of names to his misdeeds, such as "youthful pranks" and
"good fellowship." A typical example was when he locked up the painter
Agatharchos, and then, when Agatharchos had painted his [Alcibiades'] house,
let him go again with a reward.

Pauson

*Pauson had a reputation for painting lowly or perhaps immoral subjects: see Aristotle's
evaluation of him, p. 231. His date is uncertain, but if he is the same as the indigent and
depraved Pauson at whom Aristophanes pokes fun (Acharnians 854; Thesmophoria-
zusai 948; Ploutos 602), he belongs to the second half of the fifth century B.C. One
amusing anecdote about him is preserved.*

Lucian, *Demosthenis Encomium* 24: They relate about the painter Pauson that
he was hired to paint a horse rolling on its back. But he painted it running, and
with a great cloud of dust around it. While he was still painting, the man who
hired him interfered and rebuked him for not executing the painting according
to instructions. Consequently Pauson ordered his assistant to exhibit the

painting upside down, and the horse was thus seen to be lying on its back and rolling around.

The Relatives of Polygnotos: Aristophon and Aglaophon

Plato (Gorgias 448 B and scholiast) records that a painter named Aristophon, the son of Aglaophon, was Polygnotos's brother. A few works by this painter are mentioned by Pliny.

Pliny, N.H. 35.138: Aristophon [is praised for] his Ankaios wounded by the boar, along with Astypale as his companion in the suffering, and also a detailed picture in which Priam, Helen, "Credulity," Odysseus, Deiphobos and "Deceit" are represented.[26]

Another painter named Aglaophon was active in the later fifth century (he was a contemporary of Alcibiades) and was probably a grandson of Aglaophon, the father of Polygnotos and Aristophon (since the custom of repeating names in every other generation was common among the Greeks). He may have been the son of Aristophon or even of Polygnotos. Pliny (N.H. 35.60) dates him in the 90th Olympiad (420 B.C.).

Athenaios 12.534D (concerning Alcibiades): When he arrived in Athens from Olympia, he set up two paintings by Aglaophon. One of these showed [figures representing] "the Olympic games" and "the Pythian games" placing a wreath on his [Alcibiades'] head; in the other "Nemea" was shown seated and on her lap was Alcibiades, whose face was more beautiful than those of the women.[27]

Apollodoros of Athens

Apollodoros, although little is known about him, was one of the most important Greek painters. It was he who first developed the technique of what the Greeks called skiagraphia, "shading," that is, the simulation of normal optical experience of figures in light and space by the modulation of light and shade in a painting.

Pliny, N.H. 35.60: . . . now all these [referring to Aglaophon and other painters active in the 90th Olympiad] are illustrious; however, our exposition must not linger over these while it is hastening to get on to the luminaries of the art, among whom Apollodoros the Athenian first shone brightly in the 93rd Olympiad [408 B.C.]. He first established the method for representing appearances[28] and first conferred glory upon the paintbrush by a law.[29] By him are a

[26] The names "Ankaios" and "Astypale" are reconstructed from a faulty text. Ankaios was involved in the Kalydonian boar hunt. For "Deceit" ("Dolus") some would read "Dolon."

[27] The same picture is mentioned by Plutarch, *Life of Alcibiades* 16.7, and may be identical with the portrait of Alcibiades seen by Pausanias in the picture gallery of the *Propylaia* in Athens; see Pausanias 1.22.6–7.

[28] "Established the method for representing appearances" – *hic primus species exprimere instituit.*

[29] "By a law" – *iure*. The reference is perhaps to the "laws" or "rules" of Apollodoros's technique of shading, although others would simply translate *iure* as "by right."

Priest Praying and *Ajax Burned by a Lightning Bolt*, a work which may be seen today at Pergamon. Nor is there a painting[30] on display by any artist before Apollodoros which holds the eyes.

Plutarch, *de Gloria Atheniensium* 2 (*Moralia* 346A): Apollodoros, the painter who first invented the fading out and the building up of shadow, was an Athenian, of whose works it is written:

Easier to criticize than to duplicate[31]

Scholiast on *Iliad* 10.265: . . . painters and sculptors represent Odysseus wearing a cap. Apollodoros the *skiagraphos* first painted a cap on Odysseus . . .

Scholiast on Aristophanes, *Ploutos* 385: There is a painting, moreover, of the Herakleidai and Alkmene and the daughter of Herakles, who, in fear of Eurystheus, are supplicating the Athenians – a painting which is not by Pamphilos, as some say, but by Apollodoros.

[30] "Painting" – *tabula*, which means an easel painting, probably done on wood. The meaning of the passage may be that all the great paintings prior to Apollodoros's were wall paintings, and that he was the first to win a reputation through easel paintings.

[31] Literally, "One will find fault better than one will imitate." This saying is elsewhere ascribed to Zeuxis. See p. 149.

Chapter 9

Painting: the fourth century B.C.

Judging by the literary sources the fourth century B.C. was the great age of Greek painting. The leading painters of this era seem to have been strong personalities; personal ambitions, rivalries, and eccentricities are more apparent here than in any other period.

Zeuxis of Herakleia

See also pp. 221–3.

Pliny, N.H. 35.61–6: After the portals of the art of painting were opened by him [Apollodoros], Zeuxis of Herakleia entered them in the fourth year of the 95th Olympiad [397 B.C.], and he led the paintbrush, which now would dare to undertake anything, onward to great glory. His prime is placed falsely by some writers in the 89th Olympiad [424 B.C.], since he was a disciple of either Demophilos of Himera or Neseus of Thasos (it is uncertain which) who, it is certain, flourished at that time.[1] Apollodoros, who was discussed above [see pp. 147–8], wrote this verse about him: "Zeuxis stole the art from his very teachers, and carried it off with him." He also acquired such great wealth that he showed it off at Olympia by exhibiting his name woven into the checks of his cloaks in gold letters. Afterwards he decided to give away his works as gifts, because he maintained that no price could be considered equal to their value – works such as the *Alkmene* [which he gave] to Akragas, and the *Pan* to Archelaos. He also did a *Penelope* in which he seems to have painted morality itself, and an athlete; in the case of the last mentioned work he was so pleased with himself that he wrote beneath it the verse which, as a result, became famous: "Easier to criticize than to imitate."[2] A magnificent work is his *Zeus on a Throne* with the gods standing by and also his *Herakles Strangling the Snakes* in

[1] This is a free translation of an enigmatic sentence. Pliny's meaning may also be that, since Zeuxis was a disciple of Demophilos and Neseus, his prime could not have come at the same time as theirs.

[2] Again a free translation of an epigram which is also preserved, in its Greek form, by Plutarch, who ascribes it to Apollodoros. See above, p. 148.

the presence of his mother Alkmene, who is quaking with fear, and Amphi-
tryon. He is criticized, however, for having made the head and the limbs too
large, although in other respects he was so attentive to precision of detail that,
when he was about to make a picture for the people of Akragas, which they
were going to dedicate in the temple of Hera *Lakinia* at public expense, he made
an inspection of the virgins of the city, who were nude, and selected five in order
that he might represent in the picture that which was the most laudable feature
of each. He also painted monochromes in white.[3] His contemporaries and rivals
were Timanthes, Androkydes, Eupompos, and Parrhasios. The last is reputed to
have entered into a contest with Zeuxis, and when the latter depicted some
grapes with such success that birds flew up to the scene,[4] he [Parrhasios] then
depicted a linen curtain with such verisimilitude that Zeuxis, puffed up with
pride by the verdict of the birds, eventually requested that the curtain be
removed and his picture shown; and, when he understood his error, he
conceded defeat with sincere modesty, because he himself had only deceived
birds, but Parrhasios had deceived him, an artist. It is said that afterwards Zeuxis
painted a picture of a boy carrying grapes, and when the birds flew up to them
[the grapes], he approached the work and, in irritation with it, said, "I have
painted the grapes better than the boy, for if I had rendered him perfectly, the
birds would have been afraid." He also made statues in clay, which were the
only works left behind in Ambrakia when Fulvius Nobilior transferred the
statues of the Muses from there to Rome [189 B.C.]. There is also in Rome a
Helen by the hand of Zeuxis, which is in the porticoes of Philippus, and a
Marsyas Tied Up in the temple of Concord.

*The picture of Helen mentioned by Pliny appears to have been the same as the picture
that he mentions in connection with the temple of Hera* Lakinia *at Akragas. According to
Cicero and Dionysios of Halikarnassos[5] this picture was actually at Kroton in south
Italy, where there was a famous temple of Hera* Lakinia. *Cicero provides the fullest
account of what seems to have been a popular story about his painting.*

Cicero, *de Inventione* 2.1.1: At one time, the people of Kroton, when they
were at the height of their resources and were counted among the first cities of
Italy in wealth, wanted to enrich the temple of Hera, which they cared for with
the utmost conscientiousness, with outstanding pictures. Therefore they hired
for a large fee Zeuxis of Herakleia, who at that time was thought to excel by far

[3] Perhaps line drawings on a white ground similar to the example from Herculaneum, now in
Naples. See A. Maiuri, *Roman Painting* (Geneva 1953), p. 104; or perhaps paintings done in white
paint on a dark ground; or possibly paintings in a grisaille technique similar to that of the painted
metopes on the façade of the Macedonian tomb at Lefkadia (see Pollitt, *AHA*, p. 190; P. Petsas,
Taphos ton Leukadion (Athens 1966), pl. 1, fig. 1, and pl. 31.
[4] "Up to the scene" – *in scaenam*, probably indicating that the paintings were part of the stage
setting, unless *scaenam* refers to the "scene" within the painting itself.
[5] Dionysios of Halikarnassos, *de Imitatione* 6 (ed. Usener, Radermacher, p. 203) (Overbeck, *SQ*
1669).

all other painters. He also painted many other pictures, of which a portion have been preserved from his time down to our own owing to the sanctity of the shrine, and in order that his mute image would contain within itself the preeminent beauty of the feminine form, he said that he also wanted to paint a Helen. This statement the people of Kroton, who had often been informed that he surpassed all others in painting the female body, heard with pleasure. For they thought that if he should apply his utmost efforts to the genre in which he was most capable, an outstanding work would be left behind for them in that sanctuary. Nor did their opinion prove to be a deception. For Zeuxis immediately questioned them as to whether they had beautiful virgins in the city. They immediately took him to a *palaestra* [wrestling court] and showed him many youths ... [when] he marvelled greatly at the forms and the bodies of these boys, they exclaimed: "Their sisters are our virgins; so you can guess just what their quality is from these youths." "I beg you to provide me" he said, "with the most beautiful of these virgins, while I paint the picture I promised you, in order that the truth may be transferred to the mute image from the physical model." Thereupon the citizens of Kroton, by a resolution of the public council, gathered the virgins into one place and gave the painter the power to choose whichever ones he wanted. And so he chose five, whose names many poets have handed down to posterity because they were approved by the judgment of him who is supposed to have had the most reliable judgment about beauty. For he did not believe that it was possible to find in one body all the things he looked for in beauty, since nature has not refined to perfection any single object in all its parts. [Consequently Zeuxis selected the best feature of each of the virgins whom he had chosen to serve as models for his painting.]

In connection with the Helen, Aelian preserves an interesting example of one painter's reaction to the work of a recent predecessor.

Aelian, *Varia Historia* 14.47: Zeuxis of Herakleia painted a picture of Helen. The painter Nikomachos was overcome with admiration for the image and was clearly amazed by the painting. Someone happened to come along and asked him how his emotions could be so stirred up by a work of art. The painter replied, "You would not have asked me if you possessed my eyes."

On Nikomachos see pp. 166–7.

The most clearly described painting by Zeuxis was his picture of a Centaur Family. *In an essay entitled* Zeuxis or Antiochos, *Lucian pretends to be worried about the fact that his speeches are being praised only for their novelty and not for their technique. He then draws a parallel to the* Centaur Family *of Zeuxis.*

Lucian, *Zeuxis or Antiochos* 3: Zeuxis, that best of painters, did not paint popular and common subjects, or at least as few as he could, that is, subjects such as heroes or gods or wars; but rather he always tried to do something new, and whenever he conceived of something unusual and strange, he demonstrated the

precision of his art in [representing] it. Among his other daring innovations Zeuxis represented a female centaur, who in turn was feeding twin centaur children, mere infants. A copy of this picture, which duplicates the original in precision of line, now exists in Athens. The Roman general Sulla is said to have sent off the original to Italy along with other things, but I think that everything, including the painting, was destroyed when the cargo-ship sank while rounding Cape Malea. Be that as it may, I have seen the "picture of the picture" and to the degree that I am capable, I will give you a verbal description of it, although, by Zeus, I am not a connoisseur of the graphic arts; however, I remember it quite well, since it was not long ago that I saw it in the house of one of the painters in Athens. And the great admiration that I felt for its artistry at the time may now be of help to me in describing it more clearly.

The centaur herself is represented as lying on rich grass with the horse part of her body on the ground, and her feet stretched out behind. The human womanly part of her is raised up slightly and is supported by her bent arm. Her fore-legs are not placed in front of her and stretched out at length, as would be normal with one lying on her side, but one foot is bent, like one who is kneeling, with the hoof tucked underneath, while the other foot, on the contrary, is stretched forward and takes hold of the ground, just as horses do when they are trying to get up. She holds up one of the two newborn children in her cradled arms and nurses it in the human manner by holding it up to her woman's breast; the other child she suckles from her horse's teat in the manner of a foal. In the upper part of the picture, as if placed on some kind of lookout post, is a male centaur, obviously the husband of her who is nursing the infants in two ways; he leans over, laughing, and is not completely visible but [can be seen only up to a point] in the middle of his horse body; he holds up in his right hand a lion's whelp and waves it above his head as if he were frightening the children with his joke.

As for the other aspects of the painting, those which are not wholly apparent to amateurs like us but which nevertheless contain the whole power of the art – such as drawing the lines with the utmost exactitude, making a precise mixture of the colors and an apt application of them, employing shading where necessary, a rationale for the size of figures [that is, perspective], and equality and harmony of the parts to the whole – let painters' pupils, whose job it is to know about such things, praise them. As for me, I particularly praised Zeuxis for this achievement, namely that in one and the same design he has demonstrated the greatness of his artistic skill in a variety of ways. For, on the one hand, he has made the husband completely terrifying and quite wild, with impressively frightful hair, and shaggy all over, not just in the horse part of his body but also on his human chest and most of all on his shoulders; and the look on his face, even though he is laughing, is thoroughly bestial, with a wildness belonging to the hills.

He, then, is as I have described. The horse part of the female, on the other

hand, is extremely beautiful, just like the Thessalian fillies, when they are as yet untamed and chaste; the upper part of her is that of a very beautiful woman except for the ears – these alone of her features are satyr-like. The combination and the junction of the bodies, by which the horse part is connected with and bound to the womanly part changes softly, without any harshness, and the transition is made so gradually that it escapes notice and deceives the eye as it goes from one part to another. As for the young ones, there is a certain wildness in them in spite of their infancy, and there is already something frightening even in their tenderness – yes, this too struck me as something marvellous – and also how, in their babyish way, they look up at the lion's whelp, while each of them clutches the nipple and presses close to the body of their mother.

Now when Zeuxis put these things on exhibition he thought that the viewers would be astounded at his artistry – and they, to be sure, shouted their approval – for what else could they say when they came upon so beautiful a sight? But they praised all the things that those people have lately praised in me, such as the strangeness of the conception, and how the subject of the painting was new and previously unknown to them. The result was that Zeuxis, when he perceived that the newness of the subject was preoccupying them and drawing their attention away from its artistic quality, and that the precision of its details was being treated as a by-product, said to his pupil: "Come, Mikion, cover up the picture, and the rest of you pick it up and take it home. For they are praising only the clay of my work, but as to the lighting effects, and whether these are beautifully executed and of artistic merit, these questions they treat as if they were not of much importance; rather, the new-fangled quality of the subject surpasses in renown the precision of its workmanship."

Parrhasios of Ephesos

Pliny, *N.H.* 35.67–72: Parrhasios, who was born in Ephesos, contributed much to the art. He first gave *symmetria* to painting, and was the first to give liveliness to the face, elegance to the hair, and beauty to the mouth; and it is acknowledged by artists that he was supreme in painting contour lines, which is the most subtle aspect of painting. For to paint corporeal forms and the mass of objects is no doubt a great achievement, but it is one in which many have achieved fame; but to make the contour lines of bodies and to include just the right amount when establishing the limits of a painted figure, is an artistic success rarely achieved. For the outline ought to round itself off and establish such limits that it suggests other things behind it and thus reveals even what it hides. This is the glory which Xenokrates and Antigonos, who wrote about painting, conceded to him,[6] proclaiming their opinion with pride rather than simply confiding it. And there are many remnants of his drawing among his tablets and parchments, from which, they say, artists derive great benefit in a

[6] On the background of this passage see Introduction, p. 3.

variety of ways. In conveying the spatial mass[7] of bodies, however, his success was inferior to his achievement elsewhere. He painted a picture of the *Demos* ["Populace"] of the Athenians, a work which is especially ingenious in its presentation of the subject-matter; for he represented it as changeable, irascible, unjust, and unstable, but also placable, clement, and full of pity; boastful and . . .[8] illustrious and humble, ferocious and fearful – all at the same time. He also painted a *Theseus*, which was on the Capitoline in Rome, a *Naval Commander* armed with a breastplate, and, in a single picture, which is in Rhodes, Meleager, Herakles, and Perseus; this last has there been scorched three times by lightning but not obliterated, a fact which adds to its miraculous quality. He also painted an *Archigallus*,[9] a picture which the Emperor Tiberius fell in love with and shut up in his bedroom; the value of the picture, according to Deculo, was estimated at 6,000,000[10] sesterces. He also painted a *Thracian Nurse* with an infant in her arms, a *Philiskos*, a *Dionysos with Virtue Standing by*, and two children in whom the carefree and uncomplicated quality of childhood is observable; and also a priest attended by a boy with an incense box and a wreath. There are two extremely well-known pictures by him, one representing a man engaged in the race in soldier's armor who is running so hard that he appears to be dripping with sweat, and another representing a man taking off his armor [and who is so exhausted] that he is perceived to be gasping for breath. Also praised are his *Aeneas and Kastor and Pollux*, all in the same picture, and likewise [in a single picture] his *Telephos, Achilles, Agamemnon, and Odysseus*. He was a prolific artist, but no one ever made use of the fame of his art more insolently than he, for he even adopted certain surnames, calling himself the *Habrodiaitos* ["He who lives in luxury"] and, in some other verses, the "Prince of Painting," claiming that the art had been brought to perfection by him; above all, he maintained that he was sprung from the lineage of Apollo and that his *Herakles*, which is in Lindos, was painted to make the hero look just as he did when Parrhasios often saw him in his dreams. And when, by a large majority of votes, he was defeated at Samos by Timanthes in a competition for a painting of *Ajax and the Award of the Armor*, he said in the name of his hero that it was a great vexation to him that he should have been defeated for a second time by an unworthy opponent. He also painted some small obscene pictures, apparently refreshing himself by a wanton joke of this sort.

The verses, mentioned by Pliny, that Parrhasios wrote about himself are preserved by Athenaios.

[7] Spatial mass – *in mediis corporibus*, which could simply refer to the linear details within an outline, but which more likely refers to the technique of conveying bodily mass through shading; in this regard Zeuxis perhaps surpassed Parrhasios.

[8] A lacuna is suggested here by Mayhoff. Perhaps a word like *modestum* was paired with *gloriosum* (boastful).

[9] *Archigallus* – the chief priest among the priests of the goddess Kybele, who were called *galli*.

[10] The manuscripts read 60 and 60,000; the present reading was suggested in the edition of Ian (1860) and is adopted in Mayhoff's basic edition of Pliny.

Athenaios 12.543D (translated in prose): A man who loves luxury but respects virtue painted this: Parrhasios, whose renowned fatherland was Ephesos, nor do I forget my father Euenor, who begat me, his legitimate child and the foremost practitioner of art among the Greeks.

12.543E: And if they harken to the unbelievable, I say this. I say that already, the clear limits of this art have been revealed, by my hand. A boundary not to be surpassed has been fixed; but there is nothing completely flawless among mortal men.

In the Memorabilia *Xenophon records what purports to be an actual discussion of painting between Socrates and Parrhasios. That such a conversation ever actually took place is doubtful, but the passage is nevertheless important as a reflection of the interest among the artists of the fourth century in representing* ethos *and* pathos, *"character" and "emotion."*

Xenophon, *Memorabilia* **3.10.1–5:** . . . Coming one day to the house of Parrhasios, he [Socrates] said, in the course of a discussion: "Well, Parrhasios, is painting the representation of visible things? Certainly by making likenesses with colors you imitate forms that are deep and high, shadowy and light, hard and soft, rough and smooth, and young and old."

"What you say is quite true," he [Parrhasios] said.

"Moreover, in making a likeness of beautiful forms, since it is not easy to find one man who is completely faultless in appearance, you take the most beautiful features from each of many models and thus make the whole body appear beautiful."

"That is just what we do," Parrhasios said.

"Well, what about this?" Socrates said, "Do you not imitate the character of the soul, the character that is the most persuasive, the sweetest, the most friendly, the most longed for, and the most beloved? Or are these things inimitable?"

"But how could that be imitated, O Socrates, which has neither proportions, nor color, nor any of the things you mentioned just now, and is, in fact, not even visible?"

"Well," Socrates said, "is it not natural for a man to look at certain things with either affection or hostility?"

"I suppose so," he said.

"Therefore this much must be imitable in the eyes?"

"Yes, certainly," he said.

"And does it seem to you that people keep the same expression on their faces when they behold the good and evil fortunes of their friends, so that people who are concerned behave just like those who are not?"

"No indeed," Parrhasios said, "for they beam with joy at their good fortune, and they display a sad countenance at their evil fortunes."

"And is it not possible," Socrates said, "to imitate these?"

"Yes, of course," he said.

"And likewise grandeur and liberality as well as lowliness and illiberality, moderation and thoughtfulness as well as insolence and vulgarity – these too are revealed through the expression of the face and through the attitudes of the body, both stationary and in movement."

"You are right," he said.

"Therefore these too can be imitated?"

"Yes, of course," he said.

"And which," Socrates said, "do you think it is more pleasant to look at, men in whom beautiful and noble and lovable natures are revealed or those in whom shameful, villainous, and hateful natures reveal themselves?"

"By Zeus, there is a great difference, Socrates," he said.

Timanthes[11]

Pliny, *N.H.* 35.73–4: As for Timanthes, he was an artist of great ingenuity. Particularly famous owing to the praise given to it by orators[12] is his *Iphigeneia*,[13] whom he depicted, as she was about to perish, standing at the altar with others looking on gloomily, especially her uncle [Menelaos]; he [Timanthes] has exhausted every expression of sadness and has veiled the face of her own father [Agamemnon], whom he could not represent adequately. And there are other examples of his ingenuity, such as the *Sleeping Cyclops* painted on a small panel, in which, in order to express the Cyclops' great size, he painted next to it some satyrs who are measuring its thumb with a *thyrsos*. Moreover, in the works of this artist alone, more is suggested than is actually painted, and, although the art is of the highest quality, nevertheless the ingenuity is greater than the art. He also painted a *Hero*, a work of the utmost perfection, in which he has included the art of painting men itself. This work is now in Rome in the temple of Peace.

Quintilian, *Institutio Oratoria* 2.13.12–13: In oratory there are things that ought not to be done, either because they should not to be shown or because they cannot be expressed in the way that they deserve to be. This is what Timanthes (who was, I believe, from Kythnos) did in the picture for which he was the victor over Kolotes of Teos. For when he painted the picture of the sacrifice of Iphigeneia, he made Kalchas look grief-stricken and Odysseus even more grief-stricken, and then he gave to Menelaos a look of sorrow that was the ultimate effect of this sort his art could achieve. After thus exhausting his

[11] Quintilian, *Inst. Or.* 2.13.12, says that Timanthes was from the island of Kythnos. Eustathius, *Comm. ad Il.* p. 1343.60 (Overbeck, *SQ* 1739), calls him a Sikyonian.

[12] These orators could be Cicero, *Orator* 74, and Quintilian, *Inst. Or.* 2.13.12, from whom we hear that Odysseus and the prophet Kalchas were also represented in the picture.

[13] Timanthes' *Iphigeneia* is perhaps freely copied in a wall painting representing the same scene from the house of the tragic poet in Pompeii, now in Naples. See A. Maiuri, *Pompeian Wall Paintings* (Bern 1960), no. vi, Curtius, Tafel v, and Bibliography 76.

capacity to convey such emotion and being at a loss as to how to express the face of the father in an adequate way, he covered his [Agamemnon's] head with a veil and left it to the imagination of the viewer to judge the extent of his pain.

Essentially the same anecdote is told by Cicero, Orator 74 and Valerius Maximus 8.11. ext. 6.

On the Ajax of Timanthes, mentioned by Pliny in connection with the work of Parrhasios, see p. 154.

Androkydes

One of this painter's works became a pawn in the political in-fighting among Theban political leaders in the late 370s B.C.

Plutarch, *Life of Pelopidas* 25.5: Androkydes of Kyzikos had a commission from the city [Thebes] to paint another battle and was in the process of finishing the work at Thebes. However, when the city revolted and the war broke out, and the painting was left not quite finished, the Thebans confiscated it for themselves. Menekleidas, then, persuaded the Thebans to dedicate this picture with the name of Charon inscribed on it, thus hoping to dim the renown of Pelopidas and Epaminondas.

Athenaios 341A: Androkydes of Kyzikos, the painter, being very fond of fish, as the historian Polemon relates, was so carried away by his gourmet taste that he painted fish surrounding a figure of Skylla with the greatest attention.

A similar anecdote about Androkydes' painting of Skylla is told by Plutarch, Quaestionum Convivalium Libri VI, 4.2 (Moralia 665D).

The Schools of Classical Painting: Eupompos of Sikyon and Pamphilos of Amphipolis

The painters mentioned up to this point were thought of as belonging to a mainland or "Helladic" school (Zeuxis, and before him, Aglaophon and Apollodoros) and an Asiatic school (Euenor, Parrhasios, and Timanthes). With Eupompos and the growing influence of the artists of Sikyon, a new division was made.

Pliny, *N.H.* 35.75–7: It was at this time[14] that Euxeinidas was the teacher of Aristeides, an outstanding artist, and Eupompos was the teacher of Pamphilos, who was in turn the preceptor of Apelles. One work by Eupompos represents a victor in a gymnastic contest holding a palm branch. His influence was so great that he effected a [new] division of the art of painting: the schools, which before him were counted as two – called the "Helladic" and "Asiatic" – were on account of this artist, who was a Sikyonian, made into three [new schools] by

[14] That is, early fourth century B.C., contemporary with Zeuxis, Parrhasios, and Timanthes.

subdividing the Helladic into the Ionic, the Sikyonian, and the Attic. By Pamphilos are a *Family Group*, a *Battle of Phlious*, and a *Victory of the Athenians*;[15] also an *Odysseus on his Raft*. He was himself a Macedonian by birth . . . and he was the first painter who was erudite in all branches of knowledge, especially arithmetic and geometry, without which, he held, an art could not be perfected; he taught no pupil for less than a talent, charging 500 drachmas a year,[16] a fee which both Apelles and Melanthios paid him. As a result of his prestige, it came about that, first in Sikyon and then in all Greece, free-born boys were given lessons in drawing on wooden tablets, although the subject had previously been omitted, and thus painting was received into the front rank of the liberal arts. And indeed it has always been an honorable feature of painting that it was practiced by free-born men, and subsequently by distinguished people, while there has been a standing prohibition against slaves being instructed in it. Hence neither in this art nor in the sculptural arts [*toreutike*] are there any renowned works done by someone who was a slave.

The Sikyonian School

Plutarch, *Life of Aratos* 12.5–13.1 (Plutarch describes the artistic interests of Aratos of Sikyon [271–213 B.C.], the leader of the Achaean League, and goes on to discuss the Sikyonian school in general): From Karia, Aratos came after a long time to Egypt and went to the king [Ptolemy III] who happened to be amicably disposed toward him, since his favor had been cultivated by drawings and paintings from Greece; for this was a subject in which Aratos was not without good taste, and, constantly collecting works that were of high artistic skill and great refinement, especially those of Pamphilos and Melanthios, he would send them [to the king]. For the fame of the Sikyonian school and the success of its painting was then still at its height, because this painting alone had a beauty that did not fade. As a result of this, Apelles, who was then already much admired, came there and became a member of the school for the fee of one talent, desiring to partake of its reputation rather than because he was lacking in artistic skill.

Apelles of Kos

Apelles seems to have been the most renowned of the Greek painters. Pliny's long and colorful account of his career is an amalgamation of information derived from every variety of ancient art criticism, including the writings of Apelles himself.

Pliny, *N.H.* 35.79–97: Nevertheless the painter who surpassed all those who were born before him and all those who came later was Apelles of Kos, who was

[15] The battles referred to may be the capture of Phlious by the Spartans in 379 B.C. and Athens' naval victory over Sparta at Naxos in 376 B.C.

[16] A talent was reckoned at 6,000 drachmas; hence Pamphilos's course took twelve years.

active in the 112th Olympiad [332 B.C.]. He alone contributed almost more to the art of painting than all other painters combined and also produced volumes, which contain his doctrine [concerning painting]. The "grace" [*venustas*] of his art was outstanding, even though other very great painters were active at that time. Apelles admired the work of these other artists, and bestowed praise on all, but held that they lacked his artistic grace [*venerem*], which the Greeks call *charis*; he felt that they had attained every other quality but that in this one alone nobody was his equal. And he made still another claim to fame, when he admired a work of Protogenes, which involved immense labor and an anguishing, unlimited attention to detail; for he said that by every standard Protogenes' achievements were either equal to his own or superior but that in one quality he [Apelles] was outstanding, and that was in knowing when to take his hand away from a painting, a memorable warning that too much detail can be harmful. His candor, however, was no less impressive than his art; for he used to admit his inferiority to Melanthios in *dispositio*, and to Asklepiodoros in *mensurae*, that is, how much distance should be left between one thing and another.[17]

An instructive incident occurred involving him and Protogenes. The latter lived in Rhodes, and Apelles at one time sailed there, eager to get to know at first hand the works of that artist who was known to him only by the extent of his reputation, and immediately sought him out in his studio. He was absent at the time, but a panel of considerable size was set up on the easel, and one old woman was the custodian of it. She informed him that Protogenes was out and asked by whom she should say he was being sought. "By this person," answered Apelles, and picking up the paintbrush he drew in color across the panel a line of the utmost fineness. When Protogenes returned, the old woman showed him what had been done. They say that the artist immediately contemplated the subtlety of the line and said that it was Apelles who had come, for such a perfect piece of work could not be fittingly ascribed to anyone else. Then he himself, with another color, drew an even finer line over the first one, and, absenting himself again, instructed the old woman that if the visitor returned she should show him the line and add that this was the person whom he was seeking. And this is just what occurred. For Apelles returned and, blushing with shame at the thought of being defeated, he split the [first two] lines with a third color, thus leaving no room for any further display of subtlety. At this Protogenes, admitting that he was defeated, flew down to the port in search of his guest. And he resolved that the panel should be handed down to posterity just as it was, a marvel to be admired, of course, by everyone, but above all by other artists. I am informed that it was consumed in the first conflagration of the house of Caesar on the Palatine;[18] prior to that it was much admired by us [that is, the Romans], since it

[17] *Dispositio* (Greek *diathesis*?) probably refers to the grouping of figures. *Mensurae* may refer to the distance between groups, or it may refer to measurements by which the illusion of perspective is achieved. [18] Caesar = Augustus. This fire occurred in 3 A.C.

contained on that extensive surface nothing other than those lines, which almost eluded one's vision; among the outstanding works of many artists it seemed to be a blank panel, and by that very fact it attracted attention and was better known than any other work there.

In general it was a standing practice with Apelles never to be so occupied with carrying out the day's business that he did not practice his art by drawing a line, and the example that he set has come down as a proverb.[19] He also used to place finished works in a shop in view of passers-by, and, hiding behind a panel, he would listen attentively to the faults that they pointed out, holding that the public was a more astute judge than himself. They say that he was criticized by a shoemaker because he had made one too few lace-holes in the sandals, and that on the following day, the same man, proud that a correction had been made on the basis of his previous criticism, made fun of the leg, whereupon the artist peered out and denounced him, saying a shoemaker should not presume to judge anything higher than a sandal; and this too has come to be a proverb. He was also gifted with a courteous nature and, on account of this, was on quite good terms with Alexander the Great, who frequently came to his studio – for, as we said, he forbade by an edict that his portrait should be made by any other artist – but when Alexander used to discourse upon many aspects of painting even though he was not well informed, Apelles would politely advise him to be quiet, saying that he was being laughed at by the boys who were grinding the colors. So confident was he in the power of his privileged position, even with a king who was otherwise of an irascible nature. And Alexander, notwithstanding, bestowed honor on him in one very conspicuous case. For when he gave orders that the woman named Pankaspe, who was his principal favorite among all his concubines, should, as a token of his admiration for her beauty, be painted in the nude by Apelles, and when he learned that Apelles, while working on the picture, had fallen in love with her, he gave her to him; for he [Alexander] was great in spirit and even greater in his power over himself; he made this into a victory no less great than his other victories, because he conquered himself and gave to the artist not only his bed but his affection; nor was he even moved by consideration of [the feelings of] his favorite, who had once belonged to a king, but now belonged to a painter. There are those who believe that she was the model from whom the Aphrodite *Anadyomene* ["Rising from the Sea"] was painted. It was also Apelles who, being kindly disposed toward his rivals, first established the reputation of Protogenes at Rhodes. Protogenes was treated with contempt by his own people, as is the case with many artists who are domestic products, and when Apelles inquired of him about what sort of prices he asked for his completed works, Protogenes mentioned some small sum (I am not sure how much). Thereupon Apelles made an offer of fifty talents and spread

[19] The proverb is assumed to be: "Never a day without a line," although the exact form of it has not been preserved. See August Otto, *Die Sprichwörter und sprichwörtlichen Redensart der Römer* (Leipzig 1890), p. 194.

the word around that he was buying the paintings in order to sell them as his own works. This ruse aroused the Rhodians to an appreciation of their artist, and Apelles would not give up the pictures except at an increased price.

He also painted portraits which were such exact likenesses that, incredible as it is to say, but as the grammarian Apio has recorded in his writings, a certain one of those men who read the future from the features of the face (whom they call *metoposcopoi*) told from these portraits either the time of [the subjects'] death in the future or the number of years of life that had already elapsed. Apelles had not been in the good graces of Ptolemy[20] when the latter was in Alexander's retinue; when Ptolemy was reigning in Alexandria and Apelles was driven there by the force of a storm, a royal jester was suborned, through a plot of Apelles' rivals, to carry to him a dinner invitation. Apelles came to the dinner and Ptolemy, with great indignation, put his social secretaries on display in order that Apelles might say from which of them he had received the invitation. Apelles picked up a piece of extinguished charcoal from a brazier and drew a portrait on the wall, whereupon the king immediately recognized the face of the jester, even when it was unfinished. He also painted a portrait of King Antigonos,[21] one of whose eyes was missing, and first devised the technique for concealing this defect. For he made a three-quarter view of the king so that the part which was actually lacking in the body might rather seem only to be lacking in the picture, and he showed only that part of the face which he could show as flawless. There are also among his pictures portraits of people who are expiring. Which is the most renowned of his works, however, is not easy to say. His *Aphrodite rising from the Sea*, which is called the *Anadyomene*, was dedicated by Augustus in the shrine of his father [Julius] Caesar . . . The lower part of it was damaged, and it was impossible to find anyone who could restore it; thus the injury itself contributed to the fame of the artist. This picture decayed from age and rottenness, and Nero, in his principate, substituted for it another painting by the hand of Dorotheos. Apelles also began an *Aphrodite* at Kos, which was to be superior even to his earlier one. But death grew envious of him when the work was only partly finished, nor was anyone found who could complete it according to the sketch-lines he had drawn beforehand. He also painted for twenty gold talents an *Alexander the Great Holding a Thunderbolt* in the temple of Artemis at Ephesos.[22] The fingers [in this painting] seem to stand out, and the thunderbolt also seems to project out of the picture (my readers will remember that all this was done with only four colors). He received the fee for this picture in gold coin measured by weight, not by number. He also painted a *Procession of*

[20] Ptolemy son of Lagos (*c.* 367–283 B.C.) became Ptolemy I, king of Egypt after Alexander's death.

[21] Antigonos *Monophthalmos*, "the one-eyed" (*c.* 382–301 B.C.), one of the generals involved in the Wars of the Successors after the death of Alexander the Great.

[22] See p. 100. It has been suggested by Mingazzini (Bibliography 78) that a painting in the House of the Vettii in Pompeii may be based on the original by Apelles. See Pollitt, *AHA*, p. 23, fig. 9.

the Megabyzus, the priest of Artemis at Ephesos, a *Kleitos*[23] with his horse hastening into battle, and an armor-bearer holding out a helmet to a man who has asked for it. How many times he painted Alexander and Philip would be superfluous to enumerate. Greatly admired are his *Habron* at Samos, his *Menander King of the Karians*, and his *Antaios*; at Alexandria his *Gorgosthenes* the tragic actor; and at Rome his *Kastor and Pollux with Victory and Alexander the Great*, and his representation of *War*, with his hands tied behind his back, riding in triumph on a chariot along with Alexander. Both of these pictures the deified Augustus dedicated with modest restraint in the most frequently visited parts of his forum. The deified Claudius, however, thought it better to cut out the face of Alexander from both pictures and to add portraits of Augustus. People are also of the opinion that the *Herakles with his Face Turned* in the temple of Diana is by Apelles' hand and that the painting actually displays Herakles' face more truly than it suggests it, which is a very difficult feat. He also painted a *Nude Hero*, and in this picture he challenged nature itself. There is, or at least was, a horse by him, painted in a competition, in connection with which he made his appeal for judgment to dumb quadrupeds, taking it away from men. For becoming aware that his rivals were prevailing against him by bribery, he had some horses led in and showed them the pictures one by one, and they neighed only at the horse of Apelles. And this always happened again in later trials, so that it was shown to be a valid test of artistic quality. He also made a *Neoptolemos* fighting against the Persians from horseback, an *Archelaos with his Wife and Daughter*, and *Antigonos* armed with a breastplate and marching along with his horse.[24] Those who are connoisseurs of the art prefer before all his other works a portrait of the same king [Antigonos] seated on a horse and his *Artemis* mingling with a group of virgins who are offering sacrifice, a work which seems to surpass the verses of Homer describing the same subject.[25] He also painted things which [supposedly] cannot be represented in painting – thunder, lightning, and thunderbolts, which they call [in Greek] *bronte, astrape*, and *keraunobolia*.

His inventions in the art were useful to others as well. There was one, however, that no one could imitate; this was that he coated his finished works with a black varnish so thin that while it accentuated the reflection of the brightness of all the colors and protected the painting from dust and dirt, the varnish was visible only to one inspecting it close at hand; but this also involved considerable theoretical calculation, lest the brightness of the colors offend the eye, as in the case of those who look through a transparent colored stone, and also so that, from a distance, the same device might, though hidden, give somberness to the colors which were too bright.

[23] Several Macedonian soldiers of the time of Alexander bore this name. The best known of them was Kleitos the son of Dropides, whom Alexander killed in a fit of anger in 328 B.C.

[24] Neoptolemos and Archelaos, as well as Antigonos, were officers in Alexander's army.

[25] Possibly a reference to *Odyssey* 6.102–9.

Although Apelles is frequently mentioned elsewhere in ancient literature, there are only a few references that add anything to the information given in Pliny's long commentary. One of these is Lucian's description (ekphrasis) of an allegorical painting apparently called the Calumny. *It is reasonably certain that Lucian, and Lucian's audience, assumed that the artist who painted the* Calumny *was the famous Apelles, the contemporary of Alexander the Great. As Lucian tells it, Apelles' rival Antiphilos accused him of complicity in a plot organized by one "Theodotos" to overthrow King Ptolemy. To demonstrate the injustice of the slander, Apelles is said to have painted the picture that Lucian describes.*

In describing the plot against Ptolemy, Lucian seems to be referring to an actual historical event, but the event in question took place not in the fourth century B.C. but rather in 219 B.C., when an officer named Theodotos organized a conspiracy to overthrow King Ptolemy III Philopator. This has led some scholars to conclude that the painting was not by the well-known Apelles whose career is described by Pliny but by a later painter who was active in the Hellenistic period. (See the summary, with references, in Cast, Calumny of Apelles, *p. 10 (Bibliography 78).) It is equally possible, however, that Lucian simply confused two separate events in the history of the Ptolemaic dynasty. Antiphilos, Apelles' accuser, was clearly active in the fourth century B.C., and Pliny's description of his career confirms that Apelles did spend some time at the court of Ptolemy I.*

Lucian's description enjoyed an influential second life during the Renaissance and inspired a number of recreations, most notably Botticelli's Calumny of Apelles.

Lucian, *Calumniae Non Temere Credendum* 4: Apelles, mindful of dangers that surrounded him, defended himself against the slander with a picture of the following sort. On the right is a man with huge ears, which are only just short of being like those of Midas, stretching out one hand from afar to "Calumny" who is still coming forward. Flanking him stand two women, who seem to me to be "Ignorance" and "Suspicion." On the other side "Calumny" comes forward, a small woman of extreme beauty, heated with passion and in a state of great excitement, the sort of woman who puts madness and rage on display; in her left hand she holds a lighted torch and in her right she drags along by the hair a certain youth, who stretches out his hands to heaven and bears witness before the gods. A man who is sallow and ugly leads them, glancing around sharply and wearing that look people get when they have been withered by a long disease. One would suppose that this was "Jealousy." There are also two other female figures who accompany "Calumny" and are in the act of exhorting, protecting, and adorning her. According to the guide who explained the features of the picture to me, one of these women was "Treachery" and the other was "Deception." Behind them comes another figure, represented as if in mourning, and dressed in black raiment, which is torn in shreds; she, I think, is said to be "Repentance." She turns around in tears and with a great sense of shame toward "Truth" who looks up to heaven as she approaches. Thus did Apelles reproduce his own danger in the painting.

Melanthios of Sikyon

As has already been indicated, Melanthios, a pupil of Pamphilos, was the artist to whom Apelles acknowledged his inferiority in dispositio. *He was also one of the "four-color painters" (see p. 229) and wrote a book about painting.*

Diogenes Laertios 4.18: And he [Polemon][26] was just such a man as Melanthios describes in his book on painting. For he says that one should strive to put a certain willfulness and harshness into one's paintings, just as they are found in the actual characters.[27]

Plutarch, *Life of Aratos* **13.1–3** (continuing the passage given above, p. 158): And when he freed the city [Sikyon], Aratos immediately took down all the other portraits of the tyrants, but in the case of a portrait of Aristratos, who was in power in the time of Philip, he deliberated for a long time. For Aristratos, standing by a chariot which bore a figure of Victory, had been painted by Melanthios and his circle, and, according to the geographer Polemon, Apelles even had a hand in the painting. It was a work of remarkable quality, so much so that Aratos was tempted to spare it because of its artistry; eventually, however, led on by his hatred for the tyrants, he ordered that it be taken down and destroyed. They say that the painter Nealkes, who was a friend of Aratos, appealed to him not to do so and even wept, but when he could not persuade him he said: "The battle should be against the tyrants, not those with the tyrants. Let us save therefore the chariot and the Victory. I will take charge of getting Aristratos out of the picture for you." When Aratos gave him permission, Nealkes erased the figure of Aristratos and painted in its place a single palm tree, but he did not dare to vie with the original by adding anything else. They say, however, that the feet of the erased Aristratos, which showed beneath the chariot, escaped notice [and hence were not erased].

Pausias of Sikyon

Pliny, *N.H.* 35.123–7: There is also a tradition that Pamphilos, the teacher of Apelles, not only painted in encaustic but also taught it to Pausias of Sikyon, who was the first to become well known in this technique. He was the son of Bryetes and was at first a disciple of his father. He himself also did some brush paintings[28] on walls at Thespiai, at a time when some paintings of Polygnotos were being restored, and he was deemed, when compared [with Polygnotos], to

[26] Polemon – a follower of Plato and head of the Academy from 314 to *c.* 270 B.C.

[27] The meaning of the statement is probably that portraits should reflect the real nature, even though harsh, of the subject.

[28] As compared with encaustic paintings which were done with a *cestrum*, a kind of spatula used in applying wax.

have been far outclassed, since he had competed in a category that was not his
strong point. Pausias also first introduced the practice of painting paneled
ceilings, for before his time it was not the custom to decorate vaulted chambers
in this way; he also used to paint small panels, mostly of children. The
interpretation of his rivals was that he did this because his method of painting
was very slow. In reaction to this charge and to give himself a reputation for
speed, he finished in one day a panel, with a boy painted on it, which is called the
Hemeresios [*One-day Boy*]. In his youth he was in love with a girl from his home-
town named Glykera, who was the inventor of crowns made of flowers, and in
competing with and imitating her, he introduced a great many varieties of
flowers into the art [of painting]. Eventually he painted a picture of this girl
herself seated and wearing a garland, which is one of the best-known pictures
and is called the *Stephanoplocos* [*Girl Weaving a Garland*], or, by others, the
Stephanopolis [*The Girl Selling Garlands*] because Glykera had eked out a poor
living by selling garlands. A copy of this painting, which is called in Greek an
apographon, was bought by L. Lucullus for two talents . . . [the copy was made
by][29] Dionysios of Athens. Pausias, however, also made large pictures such as
that which was to be seen in the portico of Pompey representing the *Immolation
of an Ox*, a work which many later imitated, but none equalled. For the most
remarkable feature of all was that, although he wished to show the longitudinal
extension of the ox, he painted it in a facing position, rather than sideways, and
yet its full size is clearly conveyed. Thereupon, whereas all other artists render
the things that they wish to appear prominent in bright colors, and those that
they wish to suppress in dark, he painted the whole ox black and gave body to
this dark shade from shade itself, an achievement of great artistic skill because it
conveys a forward projection even on a flat plane and makes everything seem
solid on a surface that is in fact broken up in patches [of color]. This artist spent
his life in Sikyon, which was for a long time the homeland of the art of painting.
But eventually all the pictures were confiscated from public ownership because
of a community debt and were transferred from there [Sikyon] to Rome during
the aedileship of Scaurus [58 B.C.].

Pausanias 2.27.3 (at Epidauros): There has been built nearby a circular building
of white marble called the *Tholos*,[30] a building worth seeing. In it there is a
picture painted by Pausias of Eros, who has put aside his bow and arrows and
holds a lyre that he has taken up instead of them. Also there is a picture of *Methe*
["Drunkenness"] drinking from a glass cup, this too being a work of Pausias.
You may see in this painting both the glass cup and the woman's face showing
through it.

[29] There is a lacuna in the text. *Quod fecit* or a similar phrase should probably be restored.
[30] The architect was Polykleitos the Younger; see p. 195.

The Sikyonian School in the Later Fourth Century:
Nikophanes, Aristolaos, Socrates, Perseus, and Ktesilochos

Pliny, N.H. 35.111: . . . Nikophanes [was a painter] whose style was so elegant and harmonious that few artists may be compared to him for beauty. But in the dramatic and serious aspect of art he was much inferior to Zeuxis and Apelles. Perseus, who was Apelles' disciple and the person to whom Apelles addressed his writings about painting, belonged to the same period.

Pliny, N.H. 35.137: Aristolaos, the son and disciple of Pausias, was among the most severe of painters. By him are an *Epaminondas*, a *Pericles*, a *Medea*, a *Virtue*, a *Theseus*, an image of the *Athenian Populace*, and an *Immolation of an Ox*. There are also some to whom Nikophanes, a disciple of the same Pausias, is pleasing because of his precision [*diligentia*], which is of a sort that only artists appreciate; he was otherwise rather hard in his use of color and free in his use of yellow ochre. As for Socrates, he is rightly pleasing to all. By him there are such pictures as *Asklepios with his Daughters Hygieia* ["Health"], *Aigle* ["Brightness"], *Panacea* ["Remedy"], *and Iaso* ["Cure"], and also his picture of a slothful man called *Oknos*,[31] who is twisting a grass rope on which an ass is chewing.

Pliny, N.H. 35.140: Ktesilochos, the disciple of Apelles, became famous for his impudent picture representing *Zeus Suffering Labor Pains over Dionysos*, showing the god wearing a woman's headdress and moaning like a woman among the goddesses, who are acting as midwives.

The Attic School

The earliest painters connected with this school were Euxeinidas and the elder Aristeides (see p. 157). The latter had two prominent pupils – his son Nikomachos, and Euphranor.

Nikomachos, Son of Aristeides

See also pp. 151, 223, 229–30.

Pliny, N.H. 35.108–10: Nikomachos, the son of Aristeides, should be numbered among these artists. He painted a *Rape of Persephone*, which was once in the shrine of Minerva on the Capitoline just above the chapel of *Iuventas* ["Youth"]; also on the Capitoline was a painting that the general Plancus[32] put there, representing *Victory Hurrying Aloft in a Quadriga*. He was the first to add a felt cap to the representation of Odysseus. He also painted an *Apollo and Artemis*

[31] This figure was also represented in the *Nekyia* of Polygnotos. See p. 134.
[32] Plancus – Lucius Munatius (consul in 42 B.C.), Roman soldier and politician, who served under both Julius Caesar and Augustus.

and a *Mother of the Gods Seated on a Lion*, also a well-known picture of *Bacchantes with Satyrs Creeping up to Them*, and a *Skylla*, which is now in Rome in the temple of Peace. No other artist ever worked more rapidly in this art. For there is a tradition that he took a commission from Aristratos,[33] the tyrant of Sikyon, to paint a monument that Aristratos was erecting to the poet Telestes, and agreed that it should be finished on a predetermined date; he did not arrive, however, until shortly before that date, and the tyrant, incensed, threatened punishment; but he finished off the work in a few days with remarkable rapidity and artistic skill.[34] He had as his disciples his brother Ariston and his son Aristeides and also Philoxenos of Eretria [see p. 169].

Euphranor

Euphranor, as we have already seen, was also a well-known sculptor (see pp. 93–4). On the iconographical traditions and subtleties of Euphranor's paintings, see Palagia, Euphranor, chapter 8 (Bibliography 81).

Pliny, N.H. 35.128–9: After him [Pausias] by far the most distinguished painter was Euphranor the Isthmian, who was active in the 104th Olympiad [364 B.C.] and whom we have already mentioned among the sculptors. He made colossal statues and works in marble, and also carved reliefs; he was the most intellectual [*docilis*] and industrious of artists, excelling in every genre of art and always maintaining his artistic standard. He seems to have been the first to express the dignified qualities of heroes and to have made *symmetria* his special province,[35] although [the proportions he used] for the whole body were too thin and those for the head and the limbs[36] were too large. He also wrote volumes about *symmetria* and about colors. Works by him are a *Cavalry Battle*, *The Twelve Gods*, and a *Theseus*, in connection with which he said that the Theseus by Parrhasios had been fed on roses, but his own was fed on meat. There is a well-known panel by him in Ephesos representing Odysseus simulating insanity by yoking together an ox and a horse, while some men who are cloaked in mantles contemplate the scene and their leader conceals his sword.

The Theseus *and the* Cavalry Battle *mentioned by Pliny were seen by Pausanias on a wall of the* Stoa of Zeus Eleutherios *in the Agora in Athens.*

Pausanias 1.3.3–4: Behind these [statues of Zeus and of the Emperor Hadrian] a stoa has been built which has paintings of the gods who are called *The Twelve*.

[33] This was the same Aristratos whose portrait was erased at the command of Aratos (p. 164). He was a contemporary of Philip of Macedon and hence active in the middle of the fourth century B.C.

[34] Nikomachos's reputation for painting rapidly may suggest that he often worked in the fresco technique. Andronikos has speculated that the painting of the Rape of Persephone in Tomb I at Vergina may be by, or at least influenced by, Nikomachos (see Bibliography 80).

[35] *Usurpasse symmetrian.* Parrhasios, as we have seen, was credited with having first introduced *symmetria* into painting. Euphranor presumably refined and developed it.

[36] Limbs – *articuli.* The word can also mean "joints."

On the wall adjacent a *Theseus* is depicted, along with "Democracy" and *Demos*
["The People"]. The picture indicates that it was Theseus who established
political equality among the Athenians . . . Also depicted is the exploit of the
Athenians around Mantineia, when they were sent to give aid to the Lakedai-
monians[37] . . . In this painting there is a cavalry battle, in which the most
prominent figures are, among the Athenians, Grylos the son of Xenophon, and
amidst the Boeotian cavalry, Epaminondas the Theban. These pictures were
painted for the Athenians by Euphranor, and he also made the image of Apollo,
who is called *Patroös*, in the temple nearby. In front of the temple is an Apollo
by Leochares; Kalamis made the one called the *Alexikakos*.

*The following anecdotes, perhaps contradictory, are told about Euphranor's
painting of the* Twelve Gods *mentioned above.*

Valerius Maximus 8.11.ext. 5: For when he [Euphranor] painted the *Twelve
Gods* in Athens, he composed the image of Poseidon with colors of the most
extraordinary splendor, and afterwards in the same way he intended to make the
image of Zeus considerably more august. But all the inspiration behind his
conception had been spent on the earlier work, and his later attempts were not
able to rise to the level toward which he was striving.

Eustathios, *Commentary on the Iliad* 145.11 (Overbeck, *SQ* 1793): There is a
story that Euphranor, when he was painting the *Twelve Gods* in Athens and was
at a loss as to what model he should paint his Zeus from, happened to pass by a
poetry class. And hearing the following verses: "His ambrosial locks" and so on,
he said that he now had his model. And, going on his way, he proceeded to paint
it accordingly.[38]

Aristeides the Younger

*This artist was the son of Nikomachos and the grandson of the elder Aristeides (see
pp. 157, 166–7).*

Pliny, *N.H.* 35.98–100: Contemporary with him [Apelles] was Aristeides the
Theban. He first depicted the character and mental sensibilities of man, which
the Greeks call *ethe*, and also the emotions[39] but was a little hard in his use of
colors. His works include a picture showing the capture of a town, with an
infant crawling toward the breast of its mother, who is dying from a wound;
one is made to feel that the mother is conscious of it and is afraid lest, with her
milk failing as she dies, the child may suck blood. Alexander the Great
transferred this picture to Pella in his fatherland. The same artist also painted a
battle against the Persians, and after incorporating into it one hundred men, he

[37] This occurred in 362 B.C., when Epaminondas and the Thebans invaded the Peloponnesos.
[38] The verses Euphranor is said to have heard were from the *Iliad*. Compare the story about
Pheidias's inspiration for the Zeus at Olympia, p. 62.
[39] "Emotions" – Greek *pathe*. See pp. 155–6, 230.

drove a bargain for it with Mnason, the tyrant of Elateia, for ten minae per figure. He also painted *Quadrigas Racing*, a *Suppliant* (who almost seems to have a voice), *Hunters with Captured Game*, *Leontion* [the mistress] *of Epicurus*, and a *Woman Expiring* [*Anapauomene*] on account of her love for her brother,[40] also a *Dionysos and Ariadne*, which could once be seen in the temple of Ceres in Rome, and a *Tragic Actor and a Boy* in the temple of Apollo. (The quality of grace in this particular picture was destroyed by the ignorance of a painter whom M. Iunius, the praetor, commissioned to clean it in preparation for the day of the festival games of Apollo.) Also once on display in the temple of Fides on the Capitoline was his picture of an *Old Man with a Lyre Teaching a Boy*. He also painted an *Invalid*, which is praised endlessly, and he was so proficient in this art that King Attalos is reputed to have bought one of his pictures for a hundred talents.

Philoxenos of Eretria (Pupil of Nikomachos)

Pliny, *N.H.* 35.110: . . . Philoxenos of Eretria painted a picture for King Kassander,[41] which must be considered inferior to none; it contained the *Battle of Alexander Against Darius*.[42] He also painted a lascivious picture in which three Satyrs revel riotously. This artist followed the rapidity of his teacher and invented certain even more rapid short cuts[43] in painting.

Nikias (Son of Nikomedes) and Antidotos

Pliny, *N.H.* 35.130–3: Antidotos, however, was a pupil of Euphranor. Works by him are an *Armed Fighter with a Shield* at Athens, a *Wrestler*, and a *Trumpeter*, which is particularly praised. He emphasized precision rather than varieties of composition[44] and was severe in his colors; his chief claim to fame was his disciple Nikias the Athenian, who painted women in a most detailed manner. He kept a careful watch on light and shade and took great care so that the painted figures should stand out from the panel.[45] Works by him are a *Nemea* which was brought from Asia to Rome by Silanus[46] and placed, as we have said, in the

[40] Possibly a reference to the myth of Kanake and Makareus (Ovid, *Heroides* 11), or that of Biblis and Kaunos (Ovid, *Metamorphoses* 9, lines 454ff.).

[41] Kassander – ruler of Macedonia from 319 to 297 B.C.

[42] It has often been suggested that this painting was the original from which the famous Alexander Mosaic (from Pompeii, now in Naples) was copied. See H. Fuhrmann, *Philoxenos von Eretria* (Göttingen 1931) and Bibliography 83.

[43] Short cuts – *compendiareae*. The term has sometimes been interpreted as referring to an impressionistic technique, but it may equally well refer to technical innovations in preparing the paint, the painted surface, etc. See Pollitt, *Ancient View*, pp. 327–34.

[44] "Precision . . . composition" – *diligentior quam numerosior*; *diligens* was the translation of the Greek *akribes*; *numerus* was used to translate the Greek *rhythmos*. See under these terms in Pollitt, *Ancient View*.

[45] A. Rumpf has suggested that Nikias's achievement was to apply the technique of *skiagraphia* to the female figure. See Bibliography 84.

[46] Silanus was a common cognomen for members of the *gens* of the Junii. The Silanus mentioned here is probably D. Iunius Silanus, consul in 63 B.C., or possibly M. Iunius Silanus, consul in 25 B.C.

Curia [Senate House], also a *Dionysos* in the temple of Concord, a *Hyakinthos*,[47] which Augustus Caesar took delight in and brought back with him after he took Alexandria (because of this Tiberius Caesar dedicated this picture in his [Augustus's] temple), and a *Danaë*; at Ephesos there is a *Sepulchre of a Megabyzus*, the priest of Artemis at Ephesos, and at Athens the *Nekyomanteia* ["Invocation of the Dead"] after Homer [*Odyssey*, book 11]. This picture he refused to sell to King Attalos [read "Ptolemy;" see below] for 60 talents and gave it rather to his home town, since he had plenty of money already. He also did some large pictures, among which are a *Calypso*, an *Io*, and an *Andromeda*; also the very excellent *Alexander* in the porticoes of Pompey and a *Seated Calypso* are ascribed to him.

Of four-footed animals he rendered dogs best. It was this Nikias of whom Praxiteles used to say when asked which of his own works he valued the most, "Those to which Nikias has applied his hand"; so greatly did he pay tribute to the way he [Nikias] applied paint to a surface. It is not quite clear whether this refers to another artist of this name or the same one [whom we have been discussing], whom some place in the 112th Olympiad [332 B.C.].[48]

The Nemea *mentioned above is further elaborated upon by Pliny.*

Pliny, *N.H.* 35.27: Augustus also had imbedded into the wall of the Curia which he consecrated in the *Comitum*, a *Nemea*, seated on a lion and carrying a palm branch, next to whom stands an old man with a staff over whose head hangs a picture of a two-horse chariot – a picture on which Nikias wrote that he did it in the encaustic technique[49] . . .

The Nekyomanteia *mentioned by Pliny is also cited by Plutarch, who identifies Ptolemy I as the king who offered 60 talents for it. Since Attalos I (ruled 241–197 B.C.) and Attalos II (ruled 159–138 B.C.) lived well after the time of Nikias, Plutarch is certainly correct.*

Plutarch, *Non posse suaviter vivi secundum Epicurum* 11 (*Moralia* 1093D–E): For if men who have to paint are so carried away by the appeal of their works – as in the case of Nikias, who, when he was painting the *Nekyia*, frequently asked his attendant whether he [Nikias] had had breakfast and, when King Ptolemy sent him 60 talents for the picture after it was finished, would not take the money and would not sell the painting – [how much greater must the joy of Euclid have been in geometry, etc.].

An epigram in the Anthologia Graeca *apparently also refers to this painting.*

[47] On this painting see also p. 26.

[48] Some modern editors feel that the Nikias who painted the statues of Praxiteles was an "elder Nikias," who should be distinguished from Nikias the pupil of Antidotos. That this need not necessarily be the case is convincingly argued by H. Brunn, *GgK*[2] II, pp. 111–12.

[49] Pliny adds here *tali usus est verbo*, "such is the word he used," perhaps referring to the Greek ἐνέκαεν that he uses elsewhere (*N.H.* 35.122) in discussing the origin of the encaustic technique. See pp. 229–30.

Anthologia Graeca **9.792** (by Antipater of Thessalonike, late first century B.C. –
early first century A.C.): This is the painstaking work of Nikias. I have been
fashioned to represent the eternal realm of the dead, the tomb of people of every
age. The halls of Hades were explored by Homer, and I have been designed
above all after his archetypal picture.

*The lively personality and strong feelings about art that Pliny and Plutarch seem to
ascribe to Nikias also come out in the following anecdote.*

Demetrios, *On Style* **76:** Nikias the painter used to say that no small part of the
painter's art was to select and depict a subject with an impressively big scale, and
not to cut up the art into little subjects like birds or flowers; on the contrary, he
felt that a painter ought to depict naval battles and cavalry battles, where he
could show many compositions for the horses – some galloping, for example,
some being reined in, and some crouching down – as well as many men
throwing spears and many others falling off their horses. For he thought that this
principle was a part of the painter's art in the same way that legendary stories
were part of the art of the poets.

Another work seen by Pausanias is probably by the same Nikias.

Pausanias 7.22.6 (at Triteia in Achaia): Before you enter the city there is a grave
monument of white marble that is worth seeing, especially for the paintings on
the gravestone, which are by Nikias. There is a chair of ivory and on it sits a
young woman of fair appearance, by whom stands a maid carrying a parasol.
There is also a young man who stands upright and does not yet have a beard; he
is dressed in a tunic and has a purple travelling cloak thrown over it. By him is a
servant who has some javelins and leads dogs of the sort with which men hunt. I
was not able to learn the names of these people; but anyone would be able to
surmise that a husband and wife are buried here together.

*The grave of Nikias was seen by Pausanias on the road from Athens to the Academy.
It was placed near those of such famous men as Miltiades, Kimon, Zeno the Stoic, and
Harmodios and Aristogeiton.*

Pausanias 1.29.15: Here too is buried . . . Nikias the son of Nikomedes, the best
of all the painters of his day in painting living figures . . .

The Ionic School

Protogenes of Rhodes

*Aspects of Protogenes' career have already been discussed in connection with Apelles (see
pp. 159–61).*

Pliny, N.H. 35.101–6: Protogenes, as was said, flourished in the same period [as
Apelles and Aristeides]. His home was in Kaunos [in Karia], a community

subject to the Rhodians. At the beginning of his career he was extremely poor and very intent about his art, with the result that he was not very prolific. Whoever it was who taught him was not, they think, well known. Indeed up to his fiftieth year he is thought to have painted ships; the argument for this conclusion is that when he was doing some paintings in an extremely famous place in Athens, the Propylon of the sanctuary of Athena, where he painted the well-known *Paralos* and the *Hammonias*[50] (which some call the *Nausikaa*), he added some small pictures of warships next to these (the sort of pictures which they call *parergia*)[51] in order that it would be apparent from what sort of beginnings his works had risen to the pinnacle of prominence. Among his pictures the first prize must go to his *Ialysos*,[52] which is dedicated at Rome in the temple of Peace; there is a tradition that while he was painting this, he lived on wet lupines and thus sustained his hunger and thirst but did not blunt his senses by too much sweet food. On this picture he used four layers of color so that there should be three sub-layers to guard against injury and old age, for as the outer layer disappeared the one below would succeed it. In this painting there is a dog which was done in a miraculous manner, as if art and chance had painted together. For he judged that he had not successfully expressed in this work the foam of the panting dog, which was extremely difficult, although in the other parts he had satisfied himself. The artistry itself, however, displeased him; nor was he able to tone it down and it seemed to diverge too much and too far from what was true – the foam appeared only to be painted and not actually to have originated in the dog's mouth. Tormented by this anxiety in his mind (since he wanted reality to exist in his picture and not simply verisimilitude), he frequently wiped off the paint and changed to another brush, but he could not get himself to approve of the work by any method. Finally, irritated with his art because it was so obviously detectable, he dashed a sponge against the hated spot in the picture. And this sponge put back the colors he had removed in the form that all his effort had striven for, and thus chance produced nature in the picture.

It is said that, following this example, Nealkes achieved a similar success in painting the foam on a horse, that is, by throwing a sponge in the same way, when he was painting a picture of a man making a clucking noise while restraining his horses. Thus Protogenes, too, demonstrated the effect of luck.

It was on account of this *Ialysos* that King Demetrios,[53] when he could only capture Rhodes by attacking from that part of the city [i.e., where the picture was kept], did not set fire to the city, and thus, in sparing the picture, lost his chance for victory. Protogenes was then in his suburban garden, which was within the area of Demetrios's encampment; he was not disturbed by the battles in progress nor did he abandon his incomplete works for any reason until he was

[50] These were the flagships of the city of Athens and were used for various diplomatic and ritual functions. [51] *Parergia* – a Latin form of the Greek term *parerga*, literally "side products."
[52] *Ialysos* – a mythical Rhodian hero, founder of the city of Ialysos on the island of Rhodes.
[53] Demetrios *Poliorketes* (336–283 B.C.), son of Antigonos. As a part of his father's plan to reunite Alexander's empire he laid siege to Rhodes in 305 B.C.. He became king of Macedonia in 294 B.C.

summoned by the king and asked in what he put his trust when he continued to go about his business outside the walls; he responded that he knew the king was at war with the Rhodians but not with the arts. The king then stationed guards for his protection, rejoicing that he could safeguard the hands he had spared; also, lest he call him [Protogenes] away from his work too often, he, an enemy, came of his own accord to visit him; and with the prayers for his own victory forgotten amidst the defense of the city and the attack on its walls, he gazed at [the work of] the artist. The story survives in connection with a picture done at that time, that Protogenes painted it beneath a sword. This was a picture of a *Satyr*, which they call the *Anapauomenon* ["Resting"]; and lest it be felt that there was something lacking in the security that he felt at that time, the satyr holds flutes.

He also made a *Kydippe and Tlepolemos*, a *Philiskos, the Tragic poet, in Meditation*, an *Athlete, King Antigonos*, and *The Mother of the Philosopher Aristotle*; it was Aristotle who used to advise him that he should paint the exploits of Alexander the Great because of their eternal influence. The natural bent of his mind and a certain sensuality about art led him rather to do work of the sort mentioned above. His latest work was an *Alexander and Pan*. He also made statues in bronze.

Plutarch elaborates on the Ialysos *and on Demetrios's appreciation of Protogenes.*

Plutarch, *Life of Demetrios* 22.2–3: It happened that Protogenes the Kaunian was painting the story of *Ialysos* for the Rhodians and that the picture was little short of completion when Demetrios seized it in one of the suburbs. Sending a herald, the Rhodians begged him to spare the picture and not to destroy it, to which he replied that he would sooner burn the portraits of his father rather than this great labor of art. For it is said that Protogenes worked on the painting for seven years. Further, they say that when Apelles saw the work he was so astounded that his voice left him; but later he said that although the labor was great and the work was marvellous, it did not have his own *charis*, through which the figures painted by him touched heaven itself.

Other Painters of the Fourth Century

Asklepiodoros

Pliny, *N.H.* 35.107: In the same period [as Apelles, Protogenes, and others] lived Asklepiodoros, who was admired by Apelles for his ability in *symmetria*.[54] For his picture of the *Twelve Gods* the tyrant Mnason gave him 300 minae for each god.

[54] Pliny's index to Book 35 records that Asklepiodoros wrote a book about *symmetria*. Apelles, it will be remembered, acknowledged his inferiority to Asklepiodoros in *mensurae* (see p. 159).

Antiphilos

Antiphilos, as already noted (p. 163), was a rival of Apelles for the favor of Ptolemy I. Quintilian also praises him for his facilitas in painting (see p. 222).

Pliny, N.H. 35.114: . . . Antiphilos. For he painted a well-known picture of *Hesione* and an *Alexander and Philip with Athena*, which are now in the school in the Porticoes of Octavia; in those of Philippus[55] there is a *Dionysos*, an *Alexander as a Boy*, and a *Hippolytos Greatly Dreading the Unleashed Bull*; while in those of Pompey there are a *Cadmus* and a *Europa*. He also painted a figure in a ridiculous garb, which had the humorous name *Gryllos*, and it is after this that there is a genre of pictures called *Grylloi*. He himself was born in Egypt and was taught by Ktesidemos.

Pliny, N.H. 35.138: Antiphilos is praised for his *Boy Blowing on Fire*, in which the beautiful room as well as the boy's face are illuminated; also for his *Spinning of Wool*, in which the tasks of all the women are being briskly attended to; also his *Ptolemy Hunting*, but, most famous of all, his *Satyr with a Panther Skin*, which they call the *Aposkopeuonta*.[56]

Athenion of Maroneia (in Thrace)

Pliny, N.H. 35.134: Athenion of Maroneia, a pupil of Glaukion of Corinth, is compared and sometimes preferred to Nikias; he was more austere in his colors, but in this austerity he was more pleasing, so that his erudition glittered within the picture itself.[57] He painted a *Phylarchos*[58] in the temple at Eleusis, and at Athens an *Assembly of Relatives*, which they call the *Syngenikon*, also an *Achilles Disguised in the Garb of a Virgin Being Discovered by Odysseus*,[59] a group of six figures in one picture,[60] and a *Groom with a Horse*, by which he became very well known. Had he not died in his youth, no one would have been comparable to him.

Helen

This obscure passage preserves a unique reference to a female artist in the Greek world.

Ptolemaios Chennos, from Photius, *Lexicon* (Overbeck, SQ 1976): Likewise the painter Helen belongs in this catalogue [of women bearing that name],

[55] That is, the porticoes built either by L. Marcius Philippus, the step-father of Augustus, or by his son. [56] *Aposkopeuonta* – One who shades his eyes as he looks at something.

[57] This sentence seems to reflect the technical and critical terminology of an ancient theory of color in painting. *Austeritas* refers to the choice of certain groups of colors (see p. 229), and *iucundus* ("pleasing") probably refers to the style used in applying these colors. See under these terms in Pollitt, *Ancient View*.

[58] *Phylarchos* – the commander in charge of the cavalry furnished by each Athenian tribe.

[59] This painting may be echoed in a painting from the House of the Dioscuri in Pompeii. See Curtius, fig. 124.

[60] Whether this refers to the painting of Achilles and Odysseus, or to another picture is unclear.

the daughter of Timon the Egyptian, who painted the battle of Issos [333 B.C.] and lived in that era. This painting was set up in the *Templum Pacis* of Vespasian [in Rome].

Kydias

Pliny, N.H. 35.130: Active at the same time [as Euphranor] was Kydias, whose picture of the Argonauts[61] was bought for 144,000 sesterces by the orator Hortensius, who made a temple for it in his villa in Tusculum.

Aëtion (and Therimachos)

Pliny, N.H. 35.78: Aëtion and Therimachos were outstanding artists in the 107th Olympiad [352 B.C.]. Well-known paintings by Aëtion are his *Dionysos*, his *Tragedy and Comedy*, his *Semiramis Ascending to the Throne after Being a Maid-Servant*, and an *Old Woman Leading the Way with a Wedding Torch and a New Bride*, [the latter] notable for her shyness.

Lucian also gives a detailed ekphrasis of a picture by a painter named Aëtion representing the Marriage of Alexander and Roxane. Although Lucian's text provides no explicit evidence about the date of the painter, most scholars ascribe the picture to the fourth-century Aëtion.

Lucian, *Herodotos sive Aëtion* 4–6 (Lucian has been discussing how Herodotos and the early philosophers and sophists gained fame for their works by giving public recitations of them at festivals): But why do I speak to you of those old sophists and historians and other prose writers when, finally,[62] they say that the painter Aëtion, after painting a picture of the Wedding of Alexander and Roxane, took it to Olympia and put it on display, with the result that Proxendias, who was then one of the *Hellanodikai* [judges at the Olympic Games] and was pleased with the art, made Aëtion his son-in-law.

And what was the marvellous quality in this painting of his, one might ask, which had the result of making an Olympic judge give his daughter in marriage to a man who was not even from the same region? The picture is in Italy, and I have seen it, and hence I am able to describe it to you. There is a very beautiful chamber and a marriage bed, and on it Roxane is seated, represented as a virgin of great beauty whose eyes are cast down toward the ground in modesty since Alexander stands nearby. There are also some smiling Cupids. One of them, standing behind her, draws the veil from her head and shows Roxane to the

[61] Rumpf, *Malerei und Zeichnung der klassischen Antike* (Munich 1953), p. 129, suggests that the Argonaut episode on the famous *Ficoroni Cista* in the Villa Giulia in Rome is a copy of this work.

[62] The Greek here says *ta teleutaia*, which could also mean "last of all" or "the last time" and might be taken to imply that Lucian thought the painting was a product of his own time. Thus K. Kilburn, the editor of the Loeb edition of this essay, translates " . . . when there is the recent story of Aëtion the painter who showed off his picture . . .".

bridegroom; another, in the manner of a true servant, is taking the sandal from her foot as if he were already preparing her for bed; still another figure, this one also being a cupid, has taken hold of Alexander's mantle, and is pulling him toward Roxane, using all his strength to drag him. The king himself holds out a kind of garland to the girl, while Hephaistion, who drove the bridal chariot and brought the bridge from her house, stands by holding a flaming torch, and leans on a very handsome lad who, I think, is Hymenaios [the god of marriage], although the name is not inscribed. On the other side of the picture are more Cupids who are playing with the armor of Alexander; two of them are carrying his spear and are represented like men who are weighed down with a great burden, as they are when they bear the weight of a beam. Two others are dragging one of their own group who reclines on the shield – he must be their king, I suppose – holding on to the shield by the handle. Another one has gotten into the corselet, which is lying there with the chest part facing upward, and seems to be waiting in ambush, in order to frighten the others when they reach that point as they drag the shield.

These features are not simply childish amusements, nor has Aëtion wasted his time on them; on the contrary they make clear Alexander's love of military pursuits and indicate that while he loved Roxane, he was not unmindful of his armor. But besides all this, the picture was conspicuous for having had another connection with an actual marriage, since it courted the daughter of Proxenidas for Aëtion. And so he himself came away with a wife, a by-product of the marriage of Alexander, with the king himself serving as the man who escorted the marriage, thus getting a real marriage as payment for the one that had been represented by imagination.

A Hellenistic mosaic found in Alexandria preserves what seems to have been the spirit of Aëtion's painting and may have been influenced by it. See Pollitt, AHA, fig. 136.

Chapter 10

Painting and mosaics: the Hellenistic period

Nealkes

This painter has already been mentioned in connection with Protogenes (p. 172) and Melanthios (p. 164). Since Nealkes was a contemporary of Aratos of Sikyon, his career must be assigned to the mid-third century B.C.

Pliny, N.H. 35.142: Nealkes painted an *Aphrodite* . . . he was an inventive and clever artist, as is confirmed by the fact that when he painted a *Naval Battle of the Persians and Egyptians* and wanted to indicate that it took place on the Nile (the waters of which look just like the sea), he expressed by the use of subject-matter what he was unable to express by technique: for he painted a donkey drinking on the shore and a crocodile lying in wait for it.

Pliny (N.H. 35.145) also mentions a pupil of Nealkes named Erigonos who began his career by grinding colors for Nealkes. Erigonos in turn had a disciple named Pasias. No specific works by either artist are cited.

Artemon

Pliny, N.H. 35.139: Artemon painted a *Danaë* with pirates admiring her, a *Queen Stratonike*,[1] and a *Herakles and Deianeira*; however his best-known works, which are now in the buildings of Octavia, are his *Herakles* ascending to heaven from Mt Oeta in Doris by the consent of the gods after his mortal nature had been purged, and [his painting of] the role of Herakles and Poseidon in the story of Laomedon.

Ktesilas [or Ktesikles]

Pliny, N.H. 35.140: Ktesilas[2] became famous because of his insult to Queen Stratonike, for since he was denied honor by her, he painted a picture of her

[1] Either the daughter of Demetrios *Poliorketes* who was married first to Seleukos I (ruled 312–281 B.C.) and then to Antiochos I (ruled 281–261 B.C.) or her daughter (by Antiochos), who later married Demetrios II of Macedonia (c. 276–229 B.C.).

[2] The reading of this name in the manuscripts is uncertain.

rolling about with a fisherman, with whom rumor said that she was in love. He put his picture on view in the port of Ephesos and made a hurried escape by ship. But the Queen, [feeling that] the likeness of both figures was marvellously expressed, forbade that the picture be taken down.

Herakleides and Metrodoros

Pliny, N.H. 35.135: Herakleides of Macedon should also be noted. He started his career by painting ships and after the capture of King Perseus[3] he migrated to Athens where he was active at the same time as Metrodoros; the latter was both a painter and a philosopher and had a great reputation in both disciplines. Consequently when L. Paullus, after conquering Perseus, made a request to the Athenians that they send him the most respected philosopher available for the education of his children and also a painter to adorn his triumphal procession, the Athenians selected Metrodoros, professing that he was the most outstanding man for both requirements, a judgment with which Paullus concurred.

Demetrios the "Topographos"

Diodoros 31.18.2: Ptolemy [VI *Philometor, c.* 186–145 B.C.] the king of Egypt, after being driven out of his kingdom by his own brother, arrived at Rome in the wretched condition of an ordinary man accompanied by one eunuch and three slave boys, and when he perceived along the road the lodging of Demetrios the topographer, he sought out this man and took lodging with him, since the latter had been entertained by him many times during his residence in Alexandria.

Valerius Maximus 5.1.1: Nor indeed was Egypt deprived of the experience of Roman humanity. For when King Ptolemy was robbed of his throne by his younger brother, he came to Rome in a state of squalor, along with a few servants, in order to seek allies and found lodging there in the house of an Alexandrian painter.

It may be that Demetrios specialized in abbreviated landscape vignettes with Egyptian subject-matter such as are found in the "Barberini Mosaic" from Praeneste. See Bibliography 88.

Timomachos of Byzantium

Pliny, N.H. 35.136: Timomachos of Byzantium, in the period when Caesar was dictator [46–44 B.C.], painted an *Ajax* and a *Medea*, which were placed by Caesar, after he bought them for 80 talents, in the temple of Venus Genetrix . . .

[3] Perseus, the last of the kings of Macedonia, was defeated by the Roman consul and general L. Aemilius Paullus at Pydna in 168 B.C. and subsequently taken prisoner.

Equally-praised works by Timomachos are his *Orestes*, his *Iphigeneia among the Taurians*, his picture of *Lekythion*, the trainer in agility, a family portrait of well-known people, and his picture of two men in Greek cloaks, whom he has painted as about to speak, one standing and the other seated. His art seems to have been exceptionally successful, however, in his painting of a *Gorgon*.

The Ajax *and* Medea *by Timomachos were especially famous. The following poems give an idea of their content.*

Anthologia Graeca 16.135 [Anonymous]: The art of Timomachos has mixed together the hate and love of Medea, as her children are being drawn to their death; for at one moment she had been nodding in assent toward the sword, but now she refuses, wishing both to save and to kill the children.[4]

Anthologia Graeca 16.83 [Anonymous]: Ajax, son of Timomachos more than of your father, art has seized upon your nature. The painter saw you raving and painted you. His hand grew mad like the man, and he mixed those blended tears from out of all your pains.[5]

MOSAIC

Although the art of making mosaic pavements had a long history in Greece and reached a high level of development in the Hellenistic period, it received only scant attention in the literary tradition. The work of one Pergamene mosaicist, however, caught Pliny's attention.

Sosos

Pliny, N.H. 36.184: Paved floors had their origin among the Greeks and were at first decorated with painting, until this was superseded by mosaics [Greek: *lithostrota*]. The most famous artist in this genre was Sosos, who laid the floor in Pergamon which they call the *asarotos oikos* [the "unswept room"] because, by means of small *tesserae* tinted in various colors, he depicted on a paved floor the debris from a meal and other such things as are customarily swept away, making it seem as if they had been left there. A marvellous feature in that place [Pergamon] is a dove drinking water and casting the shadow of its head upon it, while other doves sun and preen themselves on the rim of a large drinking vessel.

Whether the "unswept room" and the preening doves were part of one composition or two separate mosaics is unclear. Both subjects appear in Roman mosaics, and it is likely that the Roman works echo in some way the originals of Sosos. See Pollitt, AHA, figs. 232–3.

[4] Echoes of the *Medea* of Timomachos may be preserved in a painting in the House of the Dioscuri in Pompeii and in another fragment from Herculaneum. See Curtius, Tafeln VII, VIII.

[5] *Anthologia Graeca* 16.136–40 also describe the *Medea*, and the *Ajax* is mentioned in Philostratos, *Life of Apollonios of Tyana* 2.22.

Another interesting, if obscure, text relating to Hellenistic mosaics is a fragmentary Egyptian papyrus in Cairo dating to around the middle of the third century B.C. It describes the plan for the decoration of two circular structures (tholoi) within a bath complex at Philadelphia in the Fayum. The document is in the form of specifications for a contractor. The mosaic described seems to have been a pebble mosaic, the type used in the Classical period, rather than a mosaic made of small cubes (tesserae), the type that evolved in the Hellenistic period. The decorative features described are paralleled in extant mosaics. See Bibliography 90.

Zenon Papyrus (Cairo 59665), lines 3-15: . . . [the contractor] will fill in the remaining area with sixty containers of pebbles [Greek: *psephoi*]. The [circular] paved floor of the women's *tholos* he will situate at a distance of one cubit and two palms from the gateway, and he will surround it with a black border having a width of two fingers, and he will then put in place an [inner] decorative band depicting sea-shells, having a width of ten fingers, and then another single border into the middle of which he will fit a poppy design, one cubit in diameter. He will fill the remaining space with sixty containers of pebbles.

Chapter 11

Architecture

EARLY DEVELOPMENTS

Theodoros and Rhoikos

On Theodoros's career as a sculptor and gem-maker see pp. 27–8 and 215.

The Temple of Hera at Samos[1]

Pliny, N.H. 34.83: Theodoros, who made the labyrinth at Samos, also made a portrait of himself in bronze.

Herodotos 3.60 (for the rest of this passage see below, p. 185): [At Samos there exists] . . . the largest temple of all the temples I have seen; the first architect of it was Rhoikos, the son of Phileas, a local man.

Pliny, N.H. 36.90: Concerning the Cretan labyrinth enough has been said. The Samian[2] labyrinth, which was similar to this one, was more remarkable insofar as it had 150 columns, of which the drums, when they were suspended in the workshop, were so well balanced that they could be turned on their axes by a boy. The architects were local men, Zmilis,[3] Rhoikos, and Theodoros.

Vitruvius 7, praef. 12: . . . Theodoros and Rhoikos published a volume on the Ionic temple of Hera[4] at Samos.

[1] Several temples were built on this site. The remains of the one associated with Theodoros and Rhoikos date from about 560 B.C. See Bibliography 91 (and major handbooks).

[2] The text says Lemnian, not Samian, but since the architects were said to be *indigenae* of the place where the labyrinth was built, since Theodoros and Rhoikos were Samian, and since no appropriate structure exists on Lemnos, most modern scholars feel that Pliny made a mistake or that the original wording has been distorted in the manuscript tradition, and that the passage actually refers to the *Heraion* at Samos, which, with its forest of Ionic columns, would have seemed labyrinthine.

[3] A name otherwise unknown. Possibly Smilis is meant.

[4] For the context of this passage see p. 233.

Other Projects

Pausanias 3.12.10 (in Sparta): There is another road leading out from the agora, on which a structure has been built for them which is called the *Skias*,[5] where even now they meet in public assembly. They say that this *Skias* is the work of Theodoros of Samos, who first discovered how to cast iron and mold images from it.

Diogenes Laertios 2.103: There were twenty men named Theodoros. The first was a Samian, the son of Rhoikos. It was he who advised the placing of a layer of coal beneath the foundations of the temple in Ephesos. For the ground in that place is very moist, and he said that coal, which is free of wood-fiber, would create a solid stratum that was impervious to water.

Chersiphron and Metagenes

Pliny, *N.H.* 36.95–7 (the temple of Artemis at Ephesos): As a true testimony to the magnificence of Greece there is still extant the temple of Ephesian Artemis, which was worked on by all of Asia Minor over a period of 200 years.[6] It was constructed on marshy ground, so that it would be neither subject to earthquakes nor in danger of landslips; on the other hand, in order that such a massive work would not be placed on shifting and unstable foundations, they were underlaid with a layer of packed coal, and after that with a layer of wooly sheepskins. The length of the temple as a whole is 425 feet and its width is 225 feet; its 127 columns were contributed by different kings and are 60 feet in height; thirty-six of these are carved in relief, one by Skopas.[7] The architect who was in charge of the work was Chersiphron. It was a remarkable achievement that he was able to raise the epistyle blocks of such a great work. He accomplished this with wicker baskets full of sand, which he heaped up in a sloping ramp that reached to the top of the column capitals, and by gradually emptying the lower baskets the work settled into place. But he encountered the greatest difficulty with the lintel which he was placing in position above the doors. For this was the greatest block, and it would not settle into its resting place; and in his anxiety the artist debated whether his final resolution should be for death. They say that with this thought in mind, worn out as he was, he saw in

[5] The name is presumably connected with the Greek word *skia*, "shade."

[6] The temple in question was built around 560 B.C. with the financial aid of the Lydian king Croesus. It was destroyed by fire in 356 B.C. and subsequently rebuilt. The time between these two building periods is about 200 years; Pliny seems to have viewed it as one long building period.

[7] Reading *una a Scopa*. Manuscript readings vary, and some of them would make a reference to Skopas doubtful or non-existent (e.g., *imo scapo*, "on the lowest drum"). The column base supposedly carved by Skopas belonged to the fourth-century rebuilding. Some identify it with a drum found at Ephesos and now in the British Museum. See R. Lullies and M. Hirmer, *Greek Sculpture* (2nd edn., New York 1960), fig. 223.

his sleep during the night the goddess for whom the temple was being built actually present before him and exhorting him to go on living: because she herself had put the stone in place; and in the light of the following day, it turned out to be so. The block appeared to have settled in place by its own weight. The other ornaments of the temple would occupy a good many volumes, since none of them is connected with prototypes in nature.

Vitruvius 3.2.7: The dipteral temple has eight columns at the ends, but has double rows of columns on the long sides,[8] like the Doric temple of Quirinus and the Ionic temple of Artemis of Ephesos, built by Chersiphron.

Vitruvius 10.2.11–12: It is not outside the scope of our subject to describe an ingenious procedure of Chersiphron's. For when he wished to transport the shafts of the columns from the quarries to the temple of Artemis at Ephesos and lacked confidence in wagons (because he feared that, on account of the size of the load and the softness of the roads in the level country, their wheels would be engulfed), he devised the following procedure. He arranged and fastened together four *trientes* [beams of timber one third of a foot, i.e. *c.* 10 cm, thick] so that two of them served as cross beams equal in length to the column drums, and he inserted iron pivots into the ends of the column drums with lead, dovetailing them, and then fixed circular sockets into the wood in which the pivots could rotate. He also fastened pieces of wood as buffers onto the ends of the column drums. The pivots fastened into the sockets, however, were left completely free to turn. Thus, when the oxen were yoked to the frame and drew it, the drums turned like wheels by revolving endlessly on the pivots in the sockets.

When they had transported all the column drums and were taking up the problem of transporting the blocks of the epistyle, Metagenes, the son of Chersiphron, adapted the method of transporting the column drums to the problem of hauling the epistyle blocks. He made wheels about twelve feet in diameter, and fixed the ends of the epistyle blocks into the middle of the wheels. By the same method he connected pivots and sockets to the ends;[9] so, when the frames of *trientes* were drawn by the oxen, the pivots which were fitted into the sockets moved the wheels, and the epistyle blocks which were fixed into the wheels like axles by the same method as had been the case with the column drums, arrived at the building site without delay. A parallel for this will be seen in the way in which cylindrical rollers level the walkways in palaestras. Nor would this have been possible in the first place had not the two sites been near to one another – for it is not more than eight thousand paces [*c.* 12 km] from the quarry to the sanctuary, and there is no hill but rather a level plain.

[8] The text says literally that a "*dipteros* is octastyle in the *pronaos* and in the back" and that it has two rows of columns "around the sanctuary."

[9] That is, the wheels which were fastened on the inside to the blocks, were again fastened to a wooden frame on the outside.

Descriptions of Ancient Temples and Other Structures

The Temple of Hera at Olympia (built *c*. 600 B.C.)

Pausanias 5.16.1: It remains for me after this to describe the temple of Hera and as many objects[10] within the temple as are worthy of interest. It is said by the Eleans that it was the Skillountians, the people of one of the cities of Triphylia, who built the temple eight years after Oxylos attained the kingship in Elis. The order of the temple is Doric, and columns stand all around it. In the *opisthodomos* one of the columns is of oak. The length of the temple is . . .[11] Whoever the architect was, they do not remember.

The "Alkmaionid" Temple of Apollo at Delphi

Herodotos 5.62: The Alkmaionidai, an Athenian family in exile under the Peisistratidai, when their attempt, along with the other Athenian exiles, to achieve their return by force was of no avail, and they suffered greatly as they attempted to reestablish freedom in Athens (they had fortified Leipsydrion above Paionia), these Alkmaionidai, making use of every possible device against the Peisistratidai, contracted with the *Amphiktyones*[12] to build the temple in Delphi, the one which is there now, but did not exist at that time. Being wealthy men and of distinguished lineage, they finished off the temple in a manner that made it more beautiful than its original design, and, among other things, although the plan called for the temple to be made of local limestone, they made the front of it of Parian marble.

The temple, the fifth temple of Apollo on the site, was built c. 513–505 B.C. Fragments of it, including some of the pedimental sculptures, survive and confirm Herodotos's contention that at least some of its "front" was made of marble. See Bibliography 93.

The Siphnian Treasury at Delphi

Herodotos 3.57: . . . The affairs of the Siphnians were at the peak of their prosperity at that time, and they were much richer than the other islanders. Their prosperity came from gold and silver mines that existed on the island, mines so rich that, with a tithe from the money derived from them, the Siphnians constructed a treasury at Delphi equal to the richest ones there.[13]

[10] Some of these objects have been described previously, pp. 21, 89; see also pp. 210–15.

[11] The measurements of the temple, which followed, are lost in the text. In modern units, the dimensions of the stylobate are *c*. 61 × 162½ feet (18.76 × 50.1 m).

[12] The representatives of various states who were the overseers of the sanctuary at Delphi.

[13] Much of the sculptural decoration of this treasury is now in the museum at Delphi. See R. Lullies, M. Hirmer, *Greek Sculpture*, pls. 48–55; Boardman, *Archaic Period*, figs. 210–12. According

Great Achievements in Engineering at Samos

Herodotos 3.60: I have spoken at unusual length about the Samians, because three of the greatest works among all the Hellenes were built by them. There is a mountain there 900 feet in altitude[14] and through the base of it runs a tunnel with mouths on either side of the mountain. The length of the tunnel is seven stades,[15] while the height and the width are each eight feet. Through the whole length of it there is another cutting 20 cubits in depth and three feet in width, through which water, carried along in pipes, is supplied to the city from a large spring. The architect of this tunnel was the Megarian Eupalinos, son of Naustrophes. This is one of the three things; the second is a mole built out into the sea around the harbor, twenty fathoms deep; the length of the mole is more than two stades. The third thing built by them is a temple, the largest of all the temples that I have seen; the first architect of it was Rhoikos, the son of Phileas, a local man.

Remains of the monuments described above survive. See Bibliography 95.

THE FIFTH CENTURY B.C.

The Temple of Zeus at Olympia

The temple was built c. 470–457 B.C. from the spoils taken by the Eleans, in a war with Pisa (see p. 58). The foundations and many of the architectural members of the temple may still be seen in situ, and most of the famous pedimental and metope sculptures are now in the Archaeological Museum in Olympia. See Bibliography 96.

Pausanias 5.10.2–10: The style of the temple is Doric, and it has a peristyle around the outside. It is made of local stone. Its height up to the pediment is 68 feet, its width 95 feet, and its length 230 feet.[16] Its architect was Libon, a local man. The roof tiles are not of terracotta, but of Pentelic marble carved in the form of tiles. They say that this was the invention of a man from Naxos named Byzes, by whom they say there are statues in Naxos on which the following inscription is written:

> To the offspring of Leto Euergos the Naxian dedicated me, the son of Byzes, who first wrought tiles of stone.

This Byzes was a contemporary of Alyattes and of Astyages the son of Cyaxares who ruled over the Medes [*c.* 610–560 B.C.]. At Olympia a gilt

to Herodotos, the era of prosperity in Siphnos came to an end shortly after the building of the treasury, when the island was plundered by an expedition of Samian mercenaries. The Samian raid is dated to the year 525/4 B.C. See also Pausanias 10.11.2.

[14] Literally 150 *orguiai*, or fathoms, which equals about 900 feet.

[15] A stade equalled about 600 feet.

[16] In modern feet the measurements are approximately 91 by 210½ feet (27.68 × 64.12 m).

cauldron is placed at each corner of the roof, and in the middle, at the point of the pediment, stands a Victory, which is also gilt.[17] Beneath the image of Victory a gold shield has been put in place, with Medusa the Gorgon worked in relief upon it. [Pausanias then gives the inscription on the shield which states that it was a Spartan votive commemorating their victory over the Athenians at Tanagra in 457 B.C.] . . . On the frieze that runs around above the columns of the temple at Olympia on the outside there are twenty-one gilt shields, dedications by the Roman general Mummius after he had won his war against the Achaeans, taken Corinth, and made the Dorian Corinthians abandon their houses [146 B.C.]. Turning to the pediments, the one in front [east] represents the struggle of Pelops and Oinomaos in chariot-racing, just about to get under way, with both sides still involved in the preparation for the actual race. An image of Zeus is placed in the center of the pediment, and to the right of Zeus is Oinomaos who has a helmet on his head, and by him is his wife Sterope, one of the daughters of Atlas. Myrtilos, who drove the chariot for Oinomaos, sits in front of the horses, which are four in number. After him there are two men. There are no names for them, but they too must be under Oinomaos's orders to attend to the horses. On the very end Kladeos is reclining. In other ways as well he is the most honored of rivers by the Eleans after the Alphaios. To the left of Zeus are Pelops and Hippodameia, the charioteer of Pelops, the horses, and two men, who again seem to be grooms for the horses, in this case serving Pelops. The pediment once again grows narrow, and in the angle on this end Alphaios is represented. The name for the man who is Pelops' charioteer in the Troizenian version of the story is "Sphairos," but the guide in Olympia alleges that it was "Killas." The figures in the front pediment are by Paionios, who was born in Mende, in Thrace; those in the rear pediment are by Alkamenes, a man who was a contemporary with Pheidias and was second in skill only to him as a maker of images.[18] The sculptures by him in this pediment represent the battle of the Lapiths against the centaurs at the wedding of Peirithoös. In the center of the pediment is Peirithoös.[19] Next to him, on one side, is Eurytion who has seized the woman who is Peirithoös's wife and Kaineus defending Peirithoös, and on the other side is Theseus defending himself against the centaurs with an axe. One centaur has seized a maiden, and another has seized a handsome youth. Alkamenes represented these figures, it seems to me, because he had learned from the poems of Homer that Peirithoös was a descendant of Zeus and because he knew that Theseus was a great grandson of Pelops.

Also represented at Olympia are most of the labors of Herakles.[20] Above the

[17] This Victory was the work of Paionios of Mende; see p. 71.

[18] The reasons for doubting Pausanias's ascription of the pediments to Paionios and Alkamenes have already been discussed (p. 71). Pausanias may have confused his information about the *akroteria* with that about the pediments.

[19] Modern scholars usually take this figure to represent Apollo.

[20] The reference is to the metopes of the temple. These number twelve in all and were part of the frieze at the front and rear of the *cella*; six metopes belong to each frieze.

doors of the temple is the hunt after the boar from Arcadia, and also Herakles' exploits against Dionysios of Thrace and against Geryones in Erytheia; he is also shown as he is about to receive the burden from Atlas and again cleansing the earth of dung for the Eleans. Above the doors of the *opisthodomos* he is shown taking the Amazon's girdle, and also represented there are his exploits against the stag, against the bull of Knossos, the birds at Stymphalos, the Hydra, and the lion in the territory of Argos. As you enter through the bronze doors, there is, in front of the column on the right, [a statue of] Iphitos being crowned by a woman, "Ekecheiria" ["Truce"], as the elegiac inscription on it says. Columns also stand inside the temple, and there are colonnades placed on a higher level with an approach through them to the image.[21] A winding ascent up to the roof has also been constructed.

The Periclean Building Program

Plutarch, *Life of Pericles* 12.1–13.8: What afforded the most pleasure and adornment to Athens, and the greatest astonishment to other men, and is the sole witness on behalf of Greece that she does not lie in speaking of her power and her ancient wealth, was his [Pericles'] building of public monuments; and it was this his enemies disparaged and slandered, shouting in the assembly: "The populace has lost its good reputation and is ill-spoken of as a result of having appropriated for itself the common treasury of the Greeks from Delos. And that which is the most reasonable of excuses for it to use against its accusers, namely, that, in fear of the barbarians, it has taken the common funds away to a safe place to guard them, even of this excuse Pericles has deprived it. Greece, it seems, is dealt a terrible, wanton insult and is openly tyrannized over, when she sees us using money contributed under necessity to the war effort for gilding our city and embellishing it, like some pretentious woman bedecked with precious stones, with images and thousand-talent temples."

Pericles, in reply, informed the people that they did not owe an accounting of the money to the allies as long as they protected them and kept off the barbarians; for the allies supplied "not a single horse, nor ship, nor soldier but only money, which belongs, not to those who give it but to those who receive it, providing that they furnish the services for which they receive it. And it was necessary, now that the city was sufficiently supplied with the necessities for war, to devote the surplus of the treasury to the construction of these monuments, from which, in the future, would come everlasting fame, and which, while in construction, would supply a ready source of welfare by requiring every sort of workmanship and producing a wide variety of needs; these in turn would call into service every art, make every hand busy, and in this way provide paid employment for almost the whole city, thus ornamenting and sustaining it at the same time."

[21] The chryselephantine Zeus of Pheidias. See pp. 58–62.

Just as military expeditions furnished those who were of the requisite age and strength with support from public funds, so too it was his wish that the disordered mass of common workmen gain a portion of the profits and not spend their time in lazy idleness. Thus he brought forth and proposed to the people great building projects and far-reaching artistic programs requiring an extended application of labor, so that, no less than those who were in the fleet or guarded the borders, or took part in military expeditions, the population at home would have a claim to derive benefit from and have a share in the public funds. For this undertaking the materials used were stone, bronze, ivory, ebony, and cypress-wood, and the artists who labored on them and wrought works of art were builders,[22] modellers, bronze-workers, stone-cutters, dyers, workers in gold and ivory, painters, embroiderers, and engravers; and those concerned with the organization and transport of the materials were, on the sea, the merchants, sailors, and ships' pilots, and, on land, the wagon-makers, those who bred draught animals, wagon-drivers, rope-makers, linen-weavers, road-workers, and miners. Thus each art, just as each general has his own army under him, had its own private throng of laborers organized like an army, acting as an instrument and body of public service; so, to sum the whole thing up, briefly, the opportunities for service reached every age and type, and they distributed the wealth accordingly.

(Sec. 13): As the works rose, shining with grandeur and possessing an inimitable grace of form, and the workmen strove to surpass one another in the beauty of their workmanship, the rapidity with which they were executed was especially marvellous. For the projects, each of which people thought would require several successive generations to reach completion, were all being completed together in the prime of one man's administration. [The anecdote about Agatharchos's rapidity in painting, given on p. 146, appears at this point.] ... For that reason the works of Pericles are even more admired – though built in a short time they have lasted for a very long time. For, in its beauty, each work was, even at that time, ancient, and yet, in its perfection, each looks even at the present time as if it were fresh and newly built. Thus there is a certain bloom of newness in each building and an appearance of being untouched by the wear of time. It is as if some ever-flowering life and unaging spirit had been infused into the creation of these works.

Pheidias directed all the projects and was the overseer of everything for him [Pericles], although there were also great architects and artists employed on the works. The *hekatompedon*[23] *Parthenon* was executed by Kallikrates and Iktinos; Koroibos began the building of the *Telesterion*[24] in Eleusis, for it was he who set the columns in place on the floor and connected them with the epistyle. Upon

[22] "Builders" – *tektones* or what would now be called "construction workers."

[23] *Hekatompedon* – 100 feet in length. The term had also been applied to earlier temples on the Acropolis, presumably those on the site of the *Parthenon*.

[24] *Telesterion* – the building in which the secret rites of the Eleusinian mysteries took place.

his death, Metagenes of Xypete set in place the frieze and the upper columns. Xenokles of Cholargos roofed the opening over the *Anaktoron*.[25] The long wall,[26] which Socrates says he himself heard Pericles propose, was undertaken by Kallikrates. Kratinos makes fun of this work because it was completed so slowly:

> With words Pericles raised the wall long ago,
> But with deeds he doesn't budge it.

The *Odeion*, in its interior arrangement, consisted of many seats and columns, and in the style of its roof it was made so as to slope and descend from a single peak, an arrangement which, they say, was a reproduction of the tent of the [Persian] king;[27] Pericles had charge of this too. And on account of it, Kratinos, in his play *The Thracian Women*, once again makes fun of him:

> Here comes the pointed-headed Zeus
> Wearing the Odeion on his head
> Since the time for ostracism has passed.

It was then that Pericles, always eager for honor, first had a resolution passed establishing a musical contest in the Panathenaic festival; and he himself, having been selected as a judge, made arrangements for how the competitors should play the flute, and sing, and play the *kithara*. It was in the Odeion that they used to view the musical contests, both then and at other times.

The *Propylaia* of the Acropolis were built over a five year period with Mnesikles as the architect. A remarkable occurrence took place during their construction, indicating clearly that the goddess was not standing aloof, but that, on the contrary, she was involved in the work and was helping to bring it to completion. The most able and eager man among the workmen slipped and fell from a height and lay there in wretched condition, given up for dead by the doctors; and as Pericles was brooding dejectedly, the goddess appeared to him in a dream and prescribed a course of therapy by means of which, when he applied it, Pericles quickly and easily cured the man. To commemorate this incident, he set up a bronze image of Athena *Hygieia* on the Acropolis, near the altar which, at least so they say, was once there.

Vitruvius maintains that Iktinos was also the architect of the Telesterion at Eleusis. Plutarch, as we have seen, associates only Koroibos and Metagenes with this building. It may be that each architect supervised the construction at a different stage.

Vitruvius 7.praef. 16: At Eleusis Iktinos roofed over the sanctuary of Demeter and Kore, a chamber of immense size, using the Doric order without exterior columns in such a way that there was more usable space for sacrificial rites.

[25] *Anaktoron* – the innermost shrine, within the *Telesterion*, at Eleusis.
[26] The "long wall" (actually two parallel walls) ran between Athens and Peiraeus.
[27] This tent was seized by the Greeks after the battle of Plataea. See Herodotos 9.82.

A substantial number of inscriptions have been found which record the allocation of funds for the Periclean building program. Many of them are worn and fragmentary; hence their readings are in some cases controversial, and they remain very much the province of the specialist in Greek epigraphy. Notable among them are: (a) the accounts of expenses for Pheidias's Athena Parthenos (I.G. I³ 453–60); (b) the financial decrees proposed by Kallias, probably in 434 B.C. (I.G. I³ 52), which deal with the allocation of funds for various projects; (c) inventories of the treasuries of the Parthenon from c. 434 to 404 B.C. (I.G. I³ 317–42); (d) the building accounts of the Parthenon, dating from 447 to 432 B.C. (I.G. I³ 436–51); (e) the building accounts of the Propylaia, dating from 437 to 432 B.C. (I.G. I³ 462–6); (f) the decree of disputed date authorizing plans for the temple of Athena Nike (I.G.I³ 35); and (g) the extensive building account for the Erechtheion, dating mainly to the years 409–406 B.C. (I.G. I³ 474–9). See Bibliography 100.

Most of these inscriptions make interesting reading only to the initiated epigrapher, but since they are among the few contemporary documents for the art of the Classical period, a few excerpts that are of particular interest to art historians are given here.

I.G. I³ 35 (specifications for the sanctuary and temple of Athena Nike on the Acropolis): . . . [Glau]kos made the motion: that, for Athena Nike, a priestess . . . shall be appointed from among the Athenian women and that the sanctuary shall be furnished with doors, according to the specifications that Kallikrates draws up. The controllers of revenue shall arrange for the contracts in the prytany of the tribe of Leontis. The priestess shall be paid 50 drachmas [annually] and also get the legs and hides from public sacrifices. A temple shall be built according to the specifications of Kallikrates and also an altar made of stone.

Hestiaios made a motion: Three men shall be chosen from the Council. These, after reviewing the specifications along with Kallikrates, shall report to the Council about how the contracts have been arranged . . .

I.G. I³ 449, lines 395–403 (from the building accounts of the *Parthenon*, 434–433 B.C.; text partly restored):

Expenses

. . . [numbers missing] 200
. . . 2 drachmas, 1 obol purchases
. . .

Wages

. . .
20,000 [plus ?] drachmas to those who quarried the stones in Pentele
2 obols and loaded them on the wheeled vehicles
16,392 drachmas to the sculptors for the pedimental sculptures
1,800 to those hired by the month

I.G. I³ 474, lines Iff. (excerpts from a report of 409/8 B.C. on the condition of the *Erechtheion*):

The commissioners for the temple in which the ancient image is kept – Brysonides of Kephisia, Chariades of Argyle, Dionides of Kephisia, the architect Philokles of Acharnai, the secretary Etearchos of Kydathenaion – recorded the works on the temple as they found them, according to the decree of the people proposed by Epigenes, both fully finished and partially worked, in the archonship of Diokles, in the first prytany of the tribe of Kekropis, in the session of the Council in which Nikophanes of Marathon was the first secretary:

The following parts of the temple were found partially worked.

In the corner toward the *Kekropion:*

4 . Plinths, not set in place, four feet long, two feet wide, one and one-half feet thick

. . .

(lines 29ff.) One column capital for the open space in the interior [three] feet long, one and one-half feet wide, one and one-half feet thick

5 . Epistyle blocks not in place, eight feet long, two feet wide, and two feet thick

. . .

(lines 40ff.) All the rest of the work around the perimeter begins with the Eleusinian stone[28] to which the figures [are to be attached], three blocks have been put in place by this commission

. . .

(line 83) On the porch toward the *Kekropion* it is necessary to do the relief carving on three ceiling blocks over the maidens,[29] thirteen feet long, five feet wide, five feet thick. The rosettes on the epistyle need to be carved

. . .

I.G. I³ 475 (expenses for the *Erechtheion*, 409/8 B.C.):

(line 5) . . . For setting in place blocks six feet long, two feet high, and one foot in thickness, to Simon living in Argyle, for five blocks: 37 drachmas, 3 obols. For putting in place one block, two feet high, one foot thick, two feet long, to Simon living in Argyle: 2 drachmas, 3 obols . . .

. . .

[28] The Ionic frieze of the *Erechtheion* was made of dark Eleusinian limestone.
[29] The "maidens" are the caryatids of the south porch of the *Erechtheion*.

(line 250) To the workmen the fees agreed upon and
 day labor. For laying tiles above the ceiling on
 the roof, to Kteson of Lakiadai: 24 drachmas.
 For putting in place the rafters and the cross
 pieces each day, to Gerys: six days, 6 drachmas
 . . .

(line 257) For setting in place the intercolumnar parti-
 tions facing the *Pandroseion*, to Komon living
 in Melite: 40 drachmas. For turning the bosses
 for the coffer-lids, to Mikon, living in Kolly-
 tos: 3 drachmas, 1 obol. To the sawyer for
 sawing a beam into coffer-lids, to Rhadios,
 living in Kollytos: 5 drachmas
 . . .

I.G. 1³ 476 (further expenses on the *Erechtheion*, 408/7–407/6 B.C.):
(line 25) For erecting scaffolding for the painters in
 encaustic, in the interior, below the ceiling, to
 Manis living in Kollytos: 1 drachma, 3 obols
 . . .

(line 46) To the painters in encaustic, for painting the
 cymatium on the inner face of the epistyle, at
 five obols per foot, the contractor being
 Dionysiodoros living in Melite, the guarantor
 being Herakleides of Oa: 30 drachmas. The
 sum total to the painters in encaustic: 30
 drachmas. To the gilders, for gilding the
 bronze rosettes, we give the sum owed from
 the previous prytany . . .
(line 109) To the architect Archilochos of Argyle: 37
 drachmas

 *The next section records expenses paid to certain sculptors for the marble reliefs that
were attached to the dark limestone frieze of the* Erechtheion.
(lines 161ff.) . . . the man holding the spear 60 drachmas.
 Phyromachos of Kephisia for the young man
 with the breastplate: 60 drachmas. Praxias
 living in Melite, for the horse and the man
 who is visible behind it and who strikes its
 flank: 120 drachmas. Antiphanes from Kera-
 meis, the chariot, the young man, and the
 horse being harnessed: 240 drachmas. Myn-
 nion living in Argyle, the horse and the man
 striking it and the stele which he added later:

127 drachmas. Sosklos living in Alopeke, the man holding the bridle: 60 drachmas. Hiasos of Kollytos, the woman and the small girl pressed against her: 80 drachmas. Total sum for the making of the images: 3,315 drachmas.

Iktinos and the Temple of Apollo at Bassai

Pausanias 8.41.7–9: On it [Mt Kotilios in Arcadia] is the place called Bassai and the temple of Apollo *Epikourios*; both it and the roof are of stone. Of all the temples in the Peloponnesos, this one might be looked upon, after the one in Tegea,[30] as the most admirable for the beauty of its stone and on account of its harmony. This name was given to Apollo because he had sent help during a plague, just as he received the name "Averter of Evil" from the Athenians for having turned the plague away from them too. It was during the war between the Peloponnesians and Athenians that he also stayed the plague for the Phigalians, and not at any other time.[31] The points of evidence for this are that both the surnames for Apollo have about the same meaning and that Iktinos, who was the architect of the temple in Phigalia, was a contemporary of Pericles and built the temple called the *Parthenon* for the Athenians.

The Origin of the Corinthian Order

Vitruvius begins the fourth book of the De Architectura *by discussing the origins of the orders of Greek architecture. His sections on the Doric and Ionic orders are fanciful, mythological interpretations, but his treatment of the Corinthian order, which follows, may have a kernel of truth in it.*

Vitruvius 4.1.8–10: The third order, however, which is called the "Corinthian," is an imitation of the slenderness of a maiden, because maidens, on account of the tenderness of their age, are represented as slighter in build and allow more beautiful effects in ornamentation. Now the invention of that capital is recorded to have happened as follows. A maiden who was a citizen of Corinth and already old enough for marriage was attacked by a disease and died. After her funeral, her nurse collected the goblets in which the maiden had taken delight while she was alive, and, after putting them together in a basket, she took them to the grave monument and put them on top of it. In order that they should remain in place for a long time, she covered them with a tile. Now it happened that this basket was placed over the root of an acanthus. As time went on the acanthus root, pressed down in the middle by the weight, sent forth, when it was about springtime, leaves and stalks; its stalks growing up along the

[30] On the Tegea temple, built by Skopas, see p. 96.
[31] The plague occurred in 430–429 B.C. See Thucydides 2.47ff.

sides of the basket and being pressed out from the angles because of the weight of the tile, were forced to form volute-like curves at their extremities. At this point Kallimachos, who, because of his elegance and subtlety in the art of working marble, was given the name *Katatechnos* [see p. 74] by the Athenians, happened to be going by and noticed the basket with this gentle growth of leaves around it. Delighted with the order and the novelty of the form, he made columns using it as his model and established a canon of proportions for it. From that he distributed the proportions of the Corinthian order throughout the details of the work.

Hippodamos of Miletos and Town-Planning

*Although philosophical prescriptions for the ideal town are given by both Plato (*Laws *778B–779D) and Aristotle (*Politics *7.10–11), ancient sources preserve relatively little information about the realities of town-planning in Antiquity. One ancient town-planner, however, Hippodamos of Miletus, seems to have attained considerable renown. Our sources suggest that he was an eccentric political theoretician who perhaps became interested in town-planning during the time when Miletos was being rebuilt after the sack of the town by the Persians in 494 B.C. Examples of the grid system, which Hippodamos was thought to have invented, have been revealed by a number of excavations. Some of them clearly pre-date Hippodamos. See Bibliography 103.*

Aristotle, *Politics* 2.5.1–2 (1267b22): Hippodamos, the son of Euryphon, a Milesian (it was he who invented the dividing up of cities and cut up [that is, applied a grid plan to] Peiraeus, and who, in regard to the other aspects of his life, was rather extravagant owing to a need for recognition, to such an extent, in fact, that he seemed to some people, with his mass of hair and expensive jewelry and, along with that, his cheap but warm clothing [which he wore] not only in the winter but also during the warm parts of the year, to live a decidedly peculiar existence; and yet who wished to become learned in the whole of natural science) was the first man of those not actually involved in politics to make proposals about the best form of constitution. He equipped his [ideal] city with a population of ten thousand, divided into three classes. He proposed one class of artisans, another of farmers, and a third to fight for the state in war and to bear arms. He also divided the area of the town into three parts, one of sacred land, one of public land, and another of private land: sacred land on which they could make the customary offerings to the gods, public land off of which the military class could live, and private land for farmers . . .

Aristotle, *Politics* 1330b21: The disposition of private homes [in a city] is thought to be more pleasant and more useful for practical purposes if it is cut up neatly in the modern manner, that is, according to the Hippodamian system, but, for safety in war, the opposite plan, the type they used to have in early times, is better.

Hesychios, *Lexicon* (c. 5th cent. A.C.), s.v. Hippodamian division: Hippodamos, the son of Euryphon, the astronomer, divided up Peiraeus for the Athenians. This man was a Milesian who participated in the colonization of Thourioi.[32]

THE FOURTH CENTURY B.C.

Works by Polykleitos the Younger at Epidauros

Pausanias 2.27.5: The Epidaurians have a theater in the sanctuary that is, in my opinion, well worth seeing. The theaters of the Romans are much superior to those anywhere in their ornamentation, and that of the Arkadians at Megalopolis is superior in size. For harmony and beauty, on the other hand, what architect could be considered worthy of competing with Polykleitos? For it was Polykleitos who made this theater, and also the circular building.[33]

The Temple of Asklepios at Epidauros

The long inscription recording expenses involved in building the temple of Asklepios at Epidauros (c. 380–370 B.C.) has already been cited in connection with the sculptor Timotheos (see pp. 104–5). The following excerpt conveys the character of the inscription and gives an idea of the type and number of jobs involved in building a Greek temple. For a full translation of the inscription and a thorough study of its background, see Burford, The Greek Temple Builders at Epidauros (Bibliography 105).

I.G. IV² 102, side A1, lines 43–67: Sotairos contracted to provide elm and lotus-wood and box-wood for the doors and also for the workshop:[34] 840 drachmas. Thrasymedes contracted to make the ceiling and the inner doorway and also the doorway between the columns: 9,800 drachmas. His guarantors were Pythokles, Theopheides, and Agemon. Eukleon contracted to put the tile roof on the temple: 235 drachmas, 3 obols. Eudamos contracted to finish the thresholds: 700 drachmas. His guarantor was Thiares. For the block and tackle equipment, to Archedamas: 260 drachmas. Binding materials for the doors and for the wood up above: 803 drachmas, 2 obols. For the encaustic painting on the *akanthoi* to Dorkon, Anaxilas, Xenophon, and Protagoras: 312 drachmas. Echetimos contracted to make the pavement for the temple: 759 drachmas, his

[32] Thourioi, a Panhellenic colony in South Italy, was settled in 443 B.C. The re-designing of Peiraeus also took place around the middle of the fifth century B.C., which must be taken as Hippodamos's principal period of activity. Strabo 14.2.9 records but does not affirm a tradition that Hippodamos designed the plan for the new city of Rhodes in 408 B.C.

[33] The foundations and substantial portions of superstructure of the circular building, commonly referred to as the *tholos*, survive at Epidauros. The famous theater is, of course, also well preserved. See Bibliography 105.

[34] A workshop was built at the same time for the artists who were working on the temple.

guarantors were Kallias and Atlatidas. To Theodotos[35] for another year: 350 drachmas. Mnasikleidas contracted for the tiles: 799 drachmas, his guarantor was Aristomedes. Timastheos contracted for the polishing of the *prodomos* [= *pronaos*]: 265 drachmas. To Axiochos for the coffer slabs with faces:[36] 128 drachmas. To Kleinias, Protagoras, and Aristomachos for the cymas, moldings, and coffer slabs without faces: 272 drachmas, 5 obols. Protagoras contracted to do the encaustic painting on the beam-support and on the cyma: 767 drachmas; his guarantor was Sotimos. Phrikon contracted to work the iron for both doors: 708 drachmas, his guarantor was Aristolaidas. Damophanes contracted for the nails and the hinge sockets and the handles and hinge pins for the doors between the columns: 1,400 drachmas, his guarantor was Aristophylos. Sotairos contracted to furnish the ivory, as much as is needed for the door: 3,150 drachmas. Marsyas contracted for the fluting of the columns both outside and inside: 1,336 drachmas, his guarantors were Antikritos and Aristophylos . . .

The Mausoleum at Halikarnassos

Pliny, *N.H.* 36.30-31: The rivals and contemporaries of Skopas were Bryaxis, Timotheos, and Leochares, whom we must discuss at the same time since they too did carvings for the Mausoleum. This was the tomb built by Artemisia, the wife of Mausolos, the governor of Karia, who died in the second year of the 107th Olympiad [351 B.C.].[37] These artists put their utmost effort into this work with the result that it came to be included among the Seven Wonders of the World. Along the south and north sides it extends for a length of 63 feet, but it is shorter on the front side, the total length of the circuit being 440 feet;[38] the tomb is 25 cubits high and is surrounded by 36 columns. They call these surrounding columns a *pteron* [in Greek]. Skopas did the carving on the east side, Bryaxis on the north, Timotheos on the south, and Leochares on the west, but before they had completed the work the queen died. They did not stop working, however, until it was finished, having already decided that it would be a monument both to their own glory and to that of their art; and even today their hands rival one another. A fifth artist also worked on it. For above the *pteron* there is a pyramid equal in height to the lower part and tapering toward the top, as a pyramid does,

[35] Theodotos the architect received this sum as an annual wage. The temple took roughly four and one-half years to complete. Five regular payments were made to the architect, the last being for six months of work.

[36] The technique of painting coffered ceilings in encaustic was an invention which Pliny ascribes to the painter Pausias (see p. 165). This and other details of the temple mentioned in the inscription are discussed in G. Roux, *L'Architecture de l'Argolide aux IV^e et III^e Siècles avant J.C.* (Paris 1961) pp. 84–130; see especially pp. 123–9.

[37] Mausolos was a Satrap (regional governor) under the Persian kings Artaxerxes II and Artaxerxes III; he actually died in 353 B.C.

[38] If the building itself was 440 feet in circumference, 63 feet could quite obviously not be the length of the longest side. Perhaps the term *circumitus*, translated here as "circuit," refers to the dimensions of the platform of the Mausoleum, not to the building itself. Others take the 63 feet to refer to the *cella* of the Mausoleum.

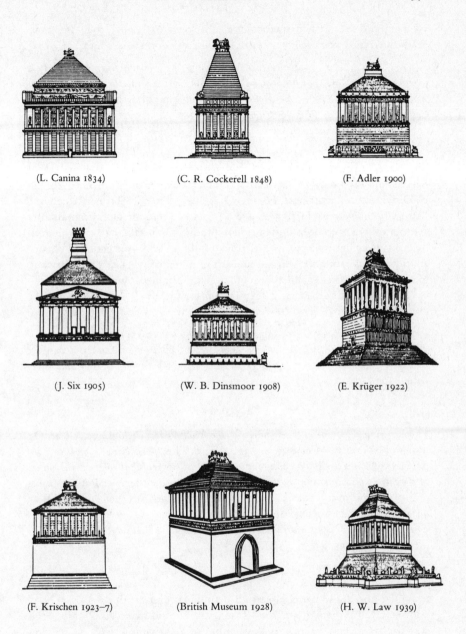

(L. Canina 1834) (C. R. Cockerell 1848) (F. Adler 1900)

(J. Six 1905) (W. B. Dinsmoor 1908) (E. Krüger 1922)

(F. Krischen 1923–7) (British Museum 1928) (H. W. Law 1939)

Fig. 7. The Mausoleum at Halikarnassos, nine proposed restorations (adapted from J. Van Breen).

in 24 steps. At the top there is a four-horse chariot in marble, which Pythis made. With this added, the total height of the building comes to 140 feet.

Pliny's text poses many problems, and the readings of the manuscripts, particularly in regard to numbers, are often doubted. Many attempts to reconstruct the appearance of the Mausoleum, based on Pliny's description and surviving fragments, have been attempted. See the particularly useful compilation by Van Breen (Bibliography 106).

"Pythis" may be identical with Pythios, whom Vitruvius identifies as one of the architects of the temple.

Vitruvius 7.praef. 12–13: . . . concerning the Mausoleum [the architects] Satyros and Pythios [wrote a treatise]. Upon these men good fortune [*felicitas*] conferred the highest tribute. For their art is judged to have distinctive qualities that are praiseworthy in all ages and to possess a sempiternal freshness; after planning them with deep thought, they produced outstanding works. Individual artists undertook separate sections of the façade, competing with one another in decorating the building and assuring its quality – Leochares, Bryaxis, Skopas, and Praxiteles, and also, some think, Timotheos; and the outstanding excellence of their art created a reputation for the work that caused it to be classed among the Seven Wonders of the World.

Most of the surviving sculptures from the building are now in the British Museum. Attempts have frequently been made to assign portions of them to one or the other of the named sculptors, but these attempts have invariably been inconclusive and often contradictory.

Pythios

In addition to being one of the architects of the Mausoleum, Pythios also designed the temple of Athena at Priene (begun c. 335 B.C., although possibly not completed until considerably later (see Bibliography 107)). Vitruvius also records that he was the author of a treatise on architecture (possibly a commentary on the temple at Priene). It was probably in this treatise that he criticized the Doric order and recommended that an architect should have training in all the arts. It must be noted that the manuscripts give a variety of versions of this artist's name and that it is not entirely certain that the same person is being referred to in all instances.[39]

Vitruvius 1.1.12: So those who from a tender age are instructed in all the different branches of learning recognize the same qualities in all sciences and recognize the interrelationship of all disciplines, and by this very fact they understand all of them more easily. Thus one of the old architects, Pythios, who was the renowned builder of the temple of Athena at Priene, says in his *Commentaries* that an architect should be able to do more in all the arts and sciences than those who, by their industry and exertions, bring single disciplines to the highest renown.

[39] Among the variants in Pliny and Vitruvius are, for example, Pytheos, Pythis, Pithios, Protheos, Phyleos, and Phileos.

Philon of Eleusis

Philon was active in the second half of the fourth century. His two known projects were a grandiose porch which he added to Iktinos's Telesterion at Eleusis and a famous "arsenal" (skeuotheke) in Peiraeus, a storage building for the sails, rigging, and the like of the Athenian fleet. He was apparently a theoretician as well as a practicing architect. His treatise on the proportions of temples and a commentary on his arsenal at Peiraeus are both mentioned by Vitruvius (see below, p. 233), who also mentions the porch at Eleusis.

Vitruvius 7. praef. 17 (following the passage on Iktinos and the *Telesterion*, see p. 189): Afterwards, however, when Demetrios of Phaleron was in charge of affairs at Athens [*c.* 317–307 B.C.], Philon placed columns in front of the temple along its façade and thus made it into a prostyle structure; by expanding the building with a porch he provided increased space for the initiates and caused it to be held in the highest esteem.

Philon's arsenal achieved a considerable reputation in Antiquity, possibly as a result of his book about it. According to Plutarch (Life of Sulla 14, see also Strabo 9.1.15) the building was burned by Sulla when he sacked Athens in 86 B.C.

Cicero, *de Oratore* 1.14.62: For if the architect Philon, who made the arsenal for the Athenians, is agreed to have explained the theory of his work to the people with great eloquence, this eloquence must be ascribed not so much to his skill as an architect as to his skill in oratory.

More important than these literary sources, however, is a very well-preserved inscription found in Peiraeus that gives in minute detail the specifications for the arsenal which were agreed upon before it was built. Dinsmoor once observed that we learn more about the building from this inscription than we could learn from the discovery of its remains, and the excavation of portions of its foundations in 1988 has done nothing to invalidate his observation.[40] *It provides a step by step account of how an ancient building was constructed from its foundation through its interior supports to the roof and the final interior details.*

I.G. II² 1668 (347–346 B.C.): The Gods: Specifications of Euthydomos, son of Demetrios of Melite, and Philon, son of Exekestides of Eleusis, for the stone *skeuotheke* to be used for storage of sailing equipment. To construct the *skeuotheke* for storing the sailing equipment in Zeia,[41] beginning from the *Propylaia* of the agora and running behind the ship sheds which have a common roof, to have a length of four *plethra* [about 405 feet], a width of 55 feet including

[40] Dinsmoor, *The Architecture of Ancient Greece* (London 1950) p. 241. On the recently discovered remains see *Archaeological Reports for 1988–89* (published by the Society for the Promotion of Hellenic Studies and the British School at Athens), p. 35.

[41] An area near one of the smaller harbors of Peiraeus.

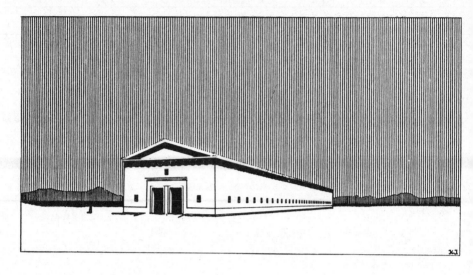

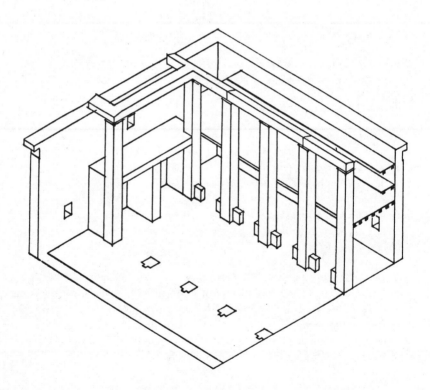

Fig. 8. The *Skeuotheke* of Philon in Peiraeus; restorations by Kristian Jeppesen.

the walls; having dug a trench to a depth of three feet from the surface at the deepest point, and having thoroughly cleared the rest of the area, one will pave the space with a stone foundation and will erect the structure upright and level in accordance with a stonemason's rule, and lay foundations for the piers at a distance of 15 feet from each wall, including the thickness of the pier. The number of the piers of each row shall be 35, leaving a passage-way for the public through the middle of the *skeuotheke*. The space between the piers shall be 20 feet. One will make the foundation four feet thick, placing the stones alternately crosswise and lengthwise. And one shall build the walls and the piers of the *skeuotheke* of stone from the promontory, having established a *euthynteria* for the walls with blocks three feet in width, a foot and a half thick, and four feet long, but at the corners four feet and three palms. And on the *euthynteria* one shall place orthostates around the middle of the *euthynteria*, with a length of four feet and a thickness of two and a half feet and one finger, and a height of three feet, with those at the corners deriving their length from the measurement of the triglyphs, leaving doorways at the ends of the long axis of the *skeuotheke*, two on each, nine feet wide. And one shall construct a center wall[42] on each end between the doors, two feet wide and running ten feet into the interior. And one shall make angles in the wall running up as far as the first of the piers, against which each door shall open. On top of the orthostate course one shall build the walls with squared blocks, four feet long, two and a half feet wide (but at the corners of a length taken from the measurement of the triglyph), and one and a half feet thick. One shall make the height of the wall from the *euthynteria* 27 feet including the triglyph beneath the geison, with the height of the doors 15½ feet. And one shall set into position lintels of Pentelic marble, 12 feet long, with a width equal to the walls, and a height of two courses, doing this after having put in door jambs of Pentelic or Hymettian marble, and thresholds of Hymettian marble. One will also place a geison over the lintels, one and a half feet high. And one shall place windows all around opposite each intercolumniation, and three along the width at each end, three feet high and two feet wide. And into each window there shall be fitted bronze grates of the proper size. And one shall place cornices all around the walls and shall make pediments and put cornices on the pediments. One shall also set up the columns[43] on a stylobate level with the *euthynteria* [with blocks] one and a half feet thick, three feet and one palm wide, and four feet long. The thickness of the columns below shall be two feet and three palms, the length, including the capital, 30 feet, each with seven drums, four feet long except the first which will be five feet long. One shall place capitals on the columns of Pentelic marble. And one shall put in place wooden epistyle blocks fastening them to the top of the columns, two and a half feet in width with the height of the upper part being at the most nine palms, 18 in number, over each row [of columns]. And one shall place cross-beams on the

[42] The word used here is *metopon*. It might also refer to a pier attached to the wall between the doors. [43] The word translated here is *kion*, which could mean either "column" or "pier."

piers, over the aisle, of a width and height equal to the epistyle blocks. One shall then put in place rafters, seven palms in width, and five palms and two fingers in height without the sloping surface, after having put a base in each cross-beam, three feet in length and one and a half feet wide. One shall fit the rafters on the cross-beams at angles, and shall put on planks, ten fingers thick, three palms and three fingers wide, spaced at an interval of five palms. And having put boards on top of them, half a foot in width and two fingers thick, placing them at intervals of four fingers from one another, and having put sheathing planks on these, a finger thick and six fingers wide, and fastening them in place with iron nails, and having coated these, one shall make the roof with Corinthian tiles, fitting them together. One shall also place over the doors on the walls that separate them on the inside a stone ceiling of Hymettian marble. And one shall put doors on the *skeuotheke* fitting the doorways, making them of bronze on the outside. And one shall pave the floor on the interior with stones which all fit together with one another and make it level and even on the top. [A section giving specifications for interior storage facilities is omitted.] . . . And so that there may be coolness in the *skeuotheke* when one builds the walls of the *skeuotheke*, one shall leave an interval in the joints of the wall blocks, as the architect may direct. All these things shall be executed by those who are hired according to the specifications and the measurements and the model, as the architect advises, and they will make delivery at the times which are arranged by contract for each of the jobs.

For reconstruction drawings of the skeuotheke *and analysis of problems presented by the text of the inscription, see Bibliography 108, especially Jeppesen,* Paradeigmata. *Jeppesen also provides text, translation, and commentary for the long inscription containing specifications for Philon's porch at Eleusis (*I.G. *II^2 1666).*

The Temple of Apollo at Didyma

The oracular temple of Apollo at Didyma was destroyed by the Persians when they sacked Miletos in 494 B.C. After the Persians were driven out of Asia Minor in 333 B.C. by Alexander, a rebuilding was begun. Although work on it continued for centuries, the basic design of the temple belonged to the later fourth century.

Strabo 14.1.5: Next after the Milesian *Poseidion*, as you go inland for 18 stades, is the oracular shrine of Apollo *Didymaios* at Branchidai [another name for Didyma]. This was burned down by Xerxes, as were all the other sanctuaries except Ephesos. The *Branchidai* [the priests of the temple] betrayed the treasures of the gods to the Persian king and accompanied him when he withdrew, lest they be required to pay the penalty for temple-robbing and treason. Later the Milesians built the largest[44] of all temples, although on account of its size it

[44] This is a slight exaggeration, unless Strabo is referring to the total area of the sanctuary. The *Heraion* at Samos, the temple of Artemis at Ephesos, and the *Olympieion* at Agrigento were larger.

remained without a roof.[45] For the circuit wall of the sacred enclosure is large enough to hold a village settlement and there is a lavish grove both inside and out. The other sacred enclosures contain the oracle and other shrines. The myth of Branchos and the love of Apollo is set here. The sanctuary is adorned with offerings of ancient works of art, very expensive ones.

Extensive remains of the temple survive. See Bibliography 109.

Hermogenes

Hermogenes seems to have been the most influential architectural theoretician of the Hellenistic period. Remains of two of the temples attributed to him by Vitruvius, those of Dionysos at Teos and of Artemis at Magnesia on the Maeander, survive, and other temples are sometimes attributed to him by modern scholars. There is general agreement that he was active in the first half of the second century B.C., although the exact dates of the beginning and end of his career are disputed. See Bibliography 110.

Vitruvius 4.3.1: Some ancient architects maintained that sacred temples should not be made in the Doric order because faulty and ill-fitting proportions used to arise in it. For this reason it was criticized by Arkesias, Pythios,[46] and above all by Hermogenes. For the last-mentioned, when he had prepared a supply of marble to build a temple in the Doric order, changed his plan and made the Ionic temple of Dionysos from the same supply of marble. It is not that the appearance of it [that is, the Doric order] is unlovely or that it lacks order and dignity in its form, but rather that the distribution of the triglyphs and metopes is troublesome and unharmonious.[47]

Vitruvius 3.2.6: Pseudodipteral temples should be so arranged that there are eight columns in front and behind, with fifteen on the sides including the corners. But the walls of the *cella* are to be lined up with the four middle columns in front and behind. Thus there will be a space all around, between the walls and the outer colonnade, of two intercolumniations plus the diameter of one column. There is no example of this in Rome but at Magnesia there is the temple of Artemis by Hermogenes and at Alabanda there is the temple of Apollo by Menesthes.[48]

Vitruvius 3.3.6–9 (on the arrangement of temples known as *eustyle* and other arrangements discussed by Hermogenes): The theory of the *eustyle* arrangement

[45] Actually the design of the *Didymaion* consisted of a "temple within a temple." Within a huge Ionic dipteral and hypaethral outer temple (*c.* 51 × 109 m) there was a small tetrastyle *naïskos*.

[46] Arkesias wrote on the Corinthian order (see p. 233) and was probably a Hellenistic architect. Pythios, as has been indicated, was one of the architects of the Mausoleum (see p. 198).

[47] Vitruvius refers here to the difficulty in the Doric order of placing corner triglyphs over the center of the corner columns and at the same time keeping consistent proportions in both the triglyphs and metopes. On this problem see D.M. Robertson, *Greek and Roman Architecture* (2nd edn., Cambridge 1943), pp. 106–13 and J.J. Coulton, *Ancient Greek Architects at Work* (Ithaca, N.Y. 1977), pp. 60–4. [48] Menesthes is otherwise unknown.

must now be discussed; it is a style which deserves the highest commendation since its theoretical basis takes into account practical use, beauty of appearance, and solidity. For the space in the intervals should be two and one-quarter column diameters, but the middle intercolumniation, one of which shall be in the front, another in the back, shall have a width of three column diameters. Thus the building shall have beauty of design, its entrance shall be accessible without impediments, and the ambulatory around the *cella* shall have impressiveness... (**Sec. 8**) We have no example of this at Rome, but in Asia there is the hexastyle temple of Dionysos at Teos.

These proportions were established by Hermogenes, who also first developed the *exostyle* or pseudodipteral plan. For he removed the inner rows of thirty-four columns from the specifications of the dipteral plan, and by this arrangement he reduced the labor that was needed and made a saving. He produced through this admirable alteration a wider space for walking around the *cella* but did nothing which would detract from the appearance of the temple, and so, without making one feel the lack of the superfluous parts, he preserved, by this arrangement, the impressiveness of the whole work. (**Sec. 9**) For this theory of the *pteroma* [ambulatory] and of the disposition of the columns around the temple was devised so that the appearance of the building, owing to the sharp quality of the intercolumniations, would have impressiveness; and if a heavy rainstorm should catch a multitude of people by surprise and force them indoors, there would be a wide and unobstructed space for them to wait in within the temple around the *cella*. These then are the explanations underlying the pseudodipteral plan of temples. It would thus seem that the effect of the works of Hermogenes must have been one of great and acute skill and that he produced and left behind sources, from which later generations could derive the theoretical principles for their own training.

Hermogenes' temple of Artemis is also praised by Strabo.

Strabo 14.1.40: In the city today there is a sanctuary of Artemis *Leukophryene*, which, in the size of the temple and in the number of votives, falls short of that of Ephesos, but in its harmonious appearance and the artistic skill displayed in the construction of the sacred enclosure, is much superior. In size it surpasses all those in Asia except two, that in Ephesos and that at Didyma.

Cossutius and the *Olympieion* in Athens

While ancient literature frequently makes mention of Greek artists in the service of Romans, examples of Roman artists in the service of Greeks are almost unknown. One rare example is that of the Roman architect Cossutius, who was hired by the Seleukid king Antiochos IV Epiphanes (ruled 175–164 B.C.) to supervise the rebuilding of the temple of Olympian Zeus in Athens. This huge temple had been begun in the late sixth century B.C. in the Doric order, but only the foundations were completed before work

was abandoned. When Cossutius took up the work again in the mid-second century B.C., he decided to employ the Corinthian order. This project was also left incomplete and the temple was not finished until the time of the emperor Hadrian (117–38 A.C.).[49]

Vitruvius 7.praef. 15 and 17: For at Athens the architects Antistates, Kallaischros, Antimachides, and Porinos laid the foundations for Peisistratos [governed 560–527 B.C.] when he was making the temple of Zeus *Olympios*, but after his death, because of the interruption resulting from [the establishment of] the republic [510–509 B.C.], they left it unfinished. Accordingly about four hundred years later, when King Antiochos promised to pay the expenses for the work, a Roman citizen named Cossutius, an architect of the highest skill and learning, designed in a noble fashion the dimensions of the *cella* and the placement of the dipteral colonnade around it and also established symmetrical relationships for the epistyle and the rest of its ornamentation. As a result this work is revered for its magnificence not only by the general public but also by the select few ... (**Sec. 17**) And it is recorded that the building of the *Olympieion* in the city, designed as it was with its ample module and its Corinthian measurements and proportions (as discussed above), was undertaken by Cossutius, by whom, however, there is no commentary extant.

Part of the temple survives. See Travlos (1971), figs. 521–31 (Bibliography 111).

[49] Pliny, *N.H.* 36.45, records that the temple was still unfinished in his own time and that Sulla transported some columns from the site (whether from the temple itself or from its surrounding precinct is unclear) to Rome in order to use them in the rebuilding of the temple of Jupiter on the Capitoline, which had been destroyed by fire in 83 B.C. (See *The Art of Rome*, p. 64.) Suetonius 2.60 implies that Augustus also undertook, or at least intended to undertake, work on the temple.

Chapter 12

The decorative arts

THE ARCHAIC PERIOD

The Greek word toreutike *meant the art of working the surface of an object with borer (*toros*), punch, hammer, drill, and so forth, that is, the art of "chasing." It applied equally to the working of the surface of a bronze statue, cauldron, or ring, to a stone gem, and to the working of ivory, wood, and other materials. Although there can be no sharp distinction between* toreutike *and "sculpture," we include under the heading "decorative arts" all examples of* toreutike *used to decorate the surface of objects other than statues and architectural reliefs.*

The Bequests of the Lydian Kings to Delphi and Other Sanctuaries

Herodotos I.14: When Gyges[1] became ruler, he sent offerings to Delphi which were by no means insignificant; in fact, most of the offerings that are made of silver at Delphi were sent by him; besides the silver he dedicated a vast number of gold offerings, among which the most worthy of mention are six gold kraters.[2] These stand in the Corinthian treasury and weigh thirty talents.[3] To be quite accurate, however, this is not really the treasury of the Corinthian people but rather of Kypselos, the son of Eëtion. This Gyges was the first of the barbarians whom we know to have set up offerings at Delphi after Midas, the son of Gordias, the king of Phrygia. For Midas set up the royal throne on which he used to sit when he gave judgments, an object well worth seeing. This throne

[1] The first ruler of the Mermnad dynasty. He usurped the throne of Lydia *c.* 685 B.C. and ruled until *c.* 657 B.C.

[2] Krater is the term for a large vessel with a wide mouth, handles, and usually a foot or stand, most commonly used for mixing wine and water. A large bronze example of the Archaic period found at Vix in France may give an example of what the kraters described in this and the following passages were like. See R. Joffroy, *Le trésor de Vix* (Paris 1962); Robertson, *HGA*, figs. 45, 46a.

[3] The weight of the talent ranged from about 26 to about 38 kilograms in the different Greek regional weight standards.

stands right by the kraters of Gyges. The gold and silver that Gyges set up is called "Gygian" by the people of Delphi in honor of the donor.

Herodotos 1.25: Alyattes[4] the Lydian died just after completing his war against the Milesians and after a reign of 57 years. Earlier, after recovering from his illness, he made offerings at Delphi (being the second man of his house to do so) of a great silver krater and a welded iron krater-stand, an object particularly worth seeing among all the votives in Delphi, the work of Glaukos of Chios, who alone of all men invented the welding of iron.

This stand made by Glaukos for Alyattes' krater remained in Delphi for many centuries and is described in greater detail by later writers.

Pausanias 10.16.1: Of the offerings which the Lydian kings sent to Delphi, the only one that still remains is the iron stand for the krater of Alyattes. This is the work of Glaukos of Chios, the man who invented the art of welding iron. Each plate of the stand is connected with another plate not by pins or rivets, but rather the welding alone connects them and is itself the binding matter for the iron. The shape of the stand is similar to that of a tower, wider at the bottom and tapering as it rises. Each side of the base is not solid throughout, but there are cross-bars of iron like the rungs of a ladder. The upright iron plates are curled outwards at the top, so as to form a seat for the krater.

Athenaios, *Deipnosophistai* 5.210C: [The stand by Glaukos of Chios] is truly worth seeing on account of the small figures which have been wrought upon its surface as well as other animal and vegetable forms . . .

Herodotos 1.50–2: . . . Croesus[5] propitiated the god in Delphi with great sacrifices. For he sacrificed 3,000 sacrificial animals, and when he had heaped up into a great pyre couches gilt with gold and silver as well as golden offering bowls and purple robes and tunics, he burned them, hoping by such offerings to win the favor of the god. Moreover he commanded each and every one of the Lydians to sacrifice whatever he could. After the sacrifice had taken place, he melted down a vast quantity of gold and cast ingots from it, making them six palms in length, three palms in width, and one palm in thickness; the number of them was 117. Four of them were of pure gold, weighing two and a half talents each, while the others were of white gold[6] and weighed two talents each. He also made an image of a lion in pure gold, having a weight of ten talents. The lion, when the temple in Delphi was burned, fell from the ingots (for it had been set up on top of these); it is now situated in the treasury of the Corinthians and weighs only six and a half talents, for three and a half of its talents melted away.

When he completed these offerings, Croesus sent them to Delphi, and other things along with them. There were two kraters of great size, one of gold, the

[4] King of Lydia from *c.* 610 to 560 B.C.
[5] Ruled 560–546 B.C. The last and best known of the Lydian kings.
[6] White gold: that is, alloyed.

other of silver, of which the golden one stood on the right as you entered the temple, and the silver one on the left. These two were moved as a result of the burning of the temple; the golden one is now in the treasury of the Klazomenians and weighs eight and a half talents plus twelve *minae*, while the silver one is in a corner of the *pronaos* of the temple and holds 600 *amphorae*.[7] It is filled by the Delphians at the time of the Theophania. The Delphians also say that it is the work of Theodoros of Samos, and I believe it, for it impresses me as a work of more than average quality. He also sent four silver storage jars, which now stand in the treasury of the Corinthians, and two lustral vases, one golden, the other silver. On the gold one "of the Lakedaimonians" is inscribed, and the Lakedaimonians claim that it is their votive, although they are inaccurate in saying so. For this too is an offering of Croesus, and one of the Delphians wrote the inscription, wishing to please the Lakedaimonians. I know his name but I will not record it. The boy, through whose hand water runs, is a votive of the Lakedaimonians, but this is certainly not true of either of the lustral vases. Along with these Croesus sent other offerings of less import, including round silver bowls and also a gold statue of a woman three cubits high, which the Delphians say is the baking woman of Croesus. In addition he dedicated the necklaces and the belts of his own wife. These were the things he sent to Delphi; and to Amphiaraos, of whose excellence and misfortune he was aware, he dedicated a shield completely of gold and also a solid gold spear, the shaft along with the head being completely of gold. Both of these were still in existence in my time, stored in the temple of Ismenian Apollo in Thebes.

Herodotos 1.92: There are many other offerings in Greece by Croesus besides those already mentioned. For example in Thebes in Boeotia there is a gold tripod, which he dedicated to Ismenian Apollo, while at Ephesos the golden bulls and the majority of the columns are his offerings; and in the temple of [Athena] *Pronaia* at Delphi there is a great golden shield. These offerings were still in existence in my time, while others have been destroyed. In Branchidai in the territory of the Milesians there were offerings by Croesus, which, I am told, were of an equal weight and of a similar quality to those in Delphi.

A Spartan Gift to Croesus

When Croesus was preparing for his war against Persia, he sought to form an alliance with the strongest of the Greek states and finally decided that Sparta was the most promising potential ally. Herodotos here describes some side aspects of the negotiations.

Herodotos 1.69–70: [The Spartans on an earlier occasion] had sent envoys to Sardis to buy gold, wishing to use it for a statue (the one of Apollo that is now set

[7] More than 4,000 gallons.

up in Thornax in Lakonia), and Croesus gave the gold as a gift to the men who had come to buy it.

For this reason the Lakedaimonians accepted the alliance, and also because he had chosen them to be his allies out of all the other Greeks. Accordingly they remained ready to answer his summons for aid, and they also made a bronze krater decorated with animals along the outside of the rim and large enough to hold 300 *amphorae*,[8] their intention being to make a gift if it to Croesus in return for his gifts. But this krater never did get to Sardis, and there are two versions of the reasons for this. The Lakedaimonians say that when it reached Samos, in the process of being transported to Sardis, the Samians heard about it, and, putting to sea in their warships, seized it. The Samians say, however, that the Spartans who were bringing it arrived too late, and when they perceived that both Sardis and Croesus had fallen into enemy hands, they sold the krater in Samos; furthermore they say that the buyers, who were private citizens, set it up in the sanctuary of Hera. Of course, it is quite natural that those who sold it would say, when they returned to Sparta, that the Samians had stolen it.

The Art of Weaving

The art of weaving was highly developed at the earliest stages of Greek history and is frequently mentioned in Homer. Akesas and Helikon from the city of Salamis on Cyprus appear to be the first artists known by name who won fame as weavers. While no date is preserved for them, the tradition that they made the first robe for Athena Polias *(presumably the venerable statue of Athena* Polias *on the Acropolis in Athens, which was clothed in a new robe as part of the Panathenaic festival) suggests a date at least as early as c. 566 B.C. when a quadrennial expanded version of the festival, known as the Greater* Panathenaia, *was established.*

Athenaios 2.48B: The art of weaving fine fabrics reached its peak at the time when the Cypriotes Akesas and Helikon were the outstanding practitioners of this art. They achieved fame as weavers. Helikon, moreover, was the son of Akesas . . . At Delphi, at any rate, there is an inscription on one of the works which reads:

> Helikon the Salaminian, son of Akesas, fashioned
> this, into whose hands
> The lady Pallas breathed divine grace.

Zenobios, *Proverbs* 1.56: The works of Akesas and Helikon: these belong in the class of those works that are worthy of wonder. For these men were the first who wrought the peplos for Athena *Polias*. Akesas[9] was born in Patara, and Helikon was a Karystian.[10]

[8] About 2,000 gallons.　　[9] The text at this point gives the name as "Akeseus."

[10] Patara was in Lycia on the southern coast of Asia Minor; Karystos is in Euboia. Possibly the artists later migrated to Cyprus.

Plutarch, *Life of Alexander* 32.6: [Alexander] also wore a shoulder mantle, which was fancier than the rest of his armor. This was the work of the venerable[11] Helikon and was a mark of honor from the city of Rhodes, whence it had come as a gift.

The Chest of Kypselos at Olympia

Kypselos was tyrant of Corinth from c. 655 to c. 625 B.C. Pausanias's description of the chest dedicated at Olympia is one of the primary literary sources for information about the themes of Archaic art.[12]

Pausanias 5.17.5–5.19.10 (omitted sections are summarized in brackets): There is also a chest made of cedar-wood and on it are figures, some made of ivory, some of gold, and some carved out of the cedar-wood itself. It was in this chest that the mother of Kypselos, the tyrant of Corinth, hid him when the Bacchiadai[13] were eager to find him just after his birth. In gratitude for the saving of Kypselos, his descendants, who were called "Kypselids," set up the chest as an offering at Olympia. The Corinthians of that time called chests *kypselai*, and it is from this that the name "Kypselos" was given to the child. Near most of the figures on the chest there are inscriptions, written in the archaic characters. Some of the letters run straight along, but others are arranged in the scheme which the Greeks called *boustrophedon*. It is like this: at the end of a line of words the second line turns back again like a racecourse that has two stretches. In addition to this, the inscriptions on the chest are written in twisting characters, which are difficult to make out. Beginning our inspection of the chest from the lower section, we find that the content of the first space is as follows. Oinomaos is shown pursuing Pelops, who holds Hippodameia. Each of them has two horses, but those of Pelops are endowed with wings. Next is shown the house of Amphiaraos and some old woman, who carries the infant Amphilochos. Before the house stand Eriphyle holding the necklace, and by her are her daughters Eurydike and Demonassa, as well as the boy Alkmaion, who is naked. Asios, in his epic, makes out Alkmena to be the daughter of Amphiaraos and Eriphyle. Baton, who is the charioteer for Amphiaraos, holds the reins in one hand and a spear in the other. Amphiaraos has already placed one foot up on the chariot, but he holds an unsheathed sword and, having turned around toward Eriphyle, is so beside himself with anger, that he just barely restrains himself from striking her.[14] After the house of Amphiaraos come the games in honor of Pelias and also

[11] The Greek *palaios* implies that Helikon was already considered ancient at the time of Alexander's campaigns, 333–323 B.C.

[12] Several attempts have been made to reconstruct the appearance of the chest; see Bibliography 113.

[13] Bacchiadai: the ruling clan of Corinth, which was eventually overthrown by Kypselos.

[14] A scene very similar to the one described appeared on a Corinthian vase of *c.* 575–550 B.C. known as the "Amphiaraos krater" (destroyed or lost during the Second World War). See Robertson, *HGA*, fig. 84b.

the spectators who watch the contestants. Herakles is depicted there seated on a throne and behind him there is a woman. For this woman, whoever she may be, the inscription is lacking, but she is playing Phrygian pipes and not Greek ones. . . .

[*There follows an enumeration of the particular events in the games and the contestants involved.*]

Tripods are also set up here, obviously as prizes for the victors, and the daughters of Pelias are also shown. The name is inscribed for only one of them, Alkestis. Iolaos, who of his own free will shared in the labors of Herakles, is shown on his chariot after he has won a victory. After this the games in honor of Pelias come to an end, and the Hydra is shown, the creature in the river Amymone, being shot at with a bow by Herakles as Athena stands by. Inasmuch as Herakles is not unfamiliar both because of his exploits and also because of the scheme by which he is represented, the name is not inscribed by him. Also there is Phineus the Thracian and the sons of Boreas, who chase the Harpies away from him.

(Sec. 18.1): In my perusal of the second area on the chest, I had better begin from the left. A figure of a woman is represented there holding a white child, which is asleep, on her right arm, and on her other arm she holds a black child similar to the one who is sleeping; both children have their feet twisted. The inscriptions make it clear (and one could figure it out without the inscriptions) that the figures are Death and Sleep, with Night as nurse of both. There is also a beautiful woman who chastises an ugly one by choking her with one hand, while with the other she beats her with a staff; it is Justice [*Dike*] who does this to Injustice [*Adike*]. There are also two other women pounding mortars with pestles; they are supposed to be skilled in the art of medicine, since there is otherwise no inscription to identify them . . .

[*A series of scenes follows illustrating the themes of deception and violence in love and adventure: Idas leading home Marpessa, whom Apollo had abducted; Zeus seducing Alkmene; Menelaos threatening to kill Helen after the sack of Troy; Jason, Medea, and Aphrodite; Apollo and the Muses, a scene perhaps connected with the Idas and Marpessa story; Herakles attempting to trick Atlas into giving him the apples of the Hesperidai; Ares leading Aphrodite, possibly a reference to the tale of illicit love told in the* Odyssey *8.266–369; Peleus wooing Thetis; and the sisters of Medusa pursuing Perseus.*]

(Sec. 18.6): Military scenes are placed on the third section of the chest. The majority of the figures are shown as foot-soldiers, but some cavalrymen are shown on two-horse chariots. As far as the soldiers are concerned, one may infer that they are going into battle and that as they go into battle they will recognize and greet one another . . .

[*Pausanias then discusses the meaning of this scene and decides that it is a reference to the struggle of the ancestors of Kypselos to gain admission to Corinth as settlers.*]

(Sec. 19.1): On the fourth section of the chest as you go around from the left

Fig. 9. The Chest of Kypselos at Olympia; restoration by Wilhelm von Massow.

is Boreas, who has abducted Oreithyia; he has serpent tails instead of feet; and there is also the struggle of Herakles against Geryones. The latter is represented as three men joined together. Theseus holds a lyre, and by him is Ariadne, who holds a wreath. There also is the fight between Achilles and Memnon, whose mothers stand by them; Melanion is also represented, and by him is Atalanta holding a fawn. After that is the single combat of Hector against Ajax resulting from the former's challenge, and between them stands Strife [*Eris*] in the form of an extremely ugly woman. In addition to this figure of Strife, Kalliphon of Samos made another one, which is in the temple of Artemis at Ephesos, incorporating it into his picture of the battle by the ships of the Greeks. Also on the chest are the Dioskouroi, one of whom has as yet no beard, and between them is Helen. Aithra the daughter of Pittheus, clothed in black, lies thrown on the ground at Helen's feet. [An inscription, the text of which is distorted, follows] . . . Iphidamas, the son of Antenor, is shown as fallen, and Koön is fighting for him against Agamemnon. On Agamemnon's shield is Fear [*Phobos*], who has the head of a lion. [Inscriptions follow] . . .

Then there is Hermes who leads the goddesses to Alexander, the son of Priam, in order that their beauty may be judged, and the inscription by them says:

> This is Hermes, who indicates to Alexander that he must judge between
> The beauty of Hera, Athena, and Aphrodite.

I do not know the reason why Artemis has wings on her shoulders; she also holds a leopard in her right hand and a lion in her left. Also represented is Kassandra whom Ajax drags away from the image of Athena, and the inscription says:

> Ajax the Lokrian is dragging Kassandra away from Athena.

Of the children of Oedipus Eteokles is shown advancing against Polyneikes, who has fallen on one knee. Behind Polyneikes stands a woman with teeth no less savage than those of a beast. The nails on her fingers are curved like claws. The inscription by her says that she is Doom [*Ker*], suggesting that Polyneikes was carried off by fate and that Eteokles' end came to him with some justice. Dionysos is shown reclining in a cave; he is bearded, holds a golden cup, and is dressed in a tunic reaching to his feet. There are vines around him and also apple trees and pomegranate trees.

(Sec. 19.7): The uppermost area – for they are five in number – offers no inscription, and one is left to guess at the meaning of the reliefs. To proceed then, there is a cave, and in it a woman is sleeping with a man upon a couch. I guessed that they were Odysseus and Circe, basing my guess on the number of servant women who are placed before the cave and on the things they are doing. For there are four women, and they are engaged in the tasks which Homer mentions in his epic.[15] There is also a centaur whose legs are not all like those of a horse, for

[15] *Odyssey* 10.348–59.

the two front legs are those of a man.[16] Next come two-horse chariots, and there are women shown standing on these. The horses have golden wings, and there is a man who is giving armor to one of the women. All these things suggest that the scene deals with the death of Patroklos. The women on the chariots must be Nereids, and it must be Thetis who takes the armor from Hephaistos, for, besides the other evidence, the man who is giving the armor is not very sturdy in the feet, and a servant follows behind him carrying fire-tongs. It is said of the centaur that he is Cheiron, now set free from the world of men and deemed worthy to dwell among the gods, who has come to provide whatever solace he can to Achilles in his grief. Two maidens riding a wagon drawn by mules, one holding the reins, the other wearing a veil on her head, are thought to be Nausikaa the daughter of Alkinoös and her handmaiden, driving to the washing pools. There is also a man shooting arrows at centaurs, some of whom he has killed; this archer is clearly Herakles, and the scene is one of the deeds of Herakles.

As to who the person was who made the chest, I have been able to form no idea at all; the inscriptions on it, although some other person might conceivably have composed them, are most probably, by any conjecture, to be ascribed to Eumelos of Corinth . . .

The Ring of Polykrates

Herodotos 3.41: [During the heyday of his rule (*c.* 540–522 B.C.), Polykrates, the tyrant of Samos, was advised by Amasis, the king of Egypt, to give up his most prized possession and thus avoid the possibility of the gods' growing jealous of his fortune.] When Polykrates read the letter and concluded that Amasis had given him good advice, he debated in his mind which of his possessions it would vex him the most to lose, and after thinking it over he decided as follows. He wore a signet-ring made of an emerald set in gold, the work of Theodoros the son of Telekles, the Samian. When he decided that it was this that he would throw away, he did the following. [He put out to sea in a ship and threw the ring away, but eventually it came back to him in the belly of a fish. Polykrates interpreted the return of the ring as a mark of divine favor, but it actually signified that the gods had already decreed his downfall.]

Strabo 14.1.16: Polykrates was such an illustrious man, both in his fortune and in personal forcefulness, that he became ruler of the seas. The story is told, as an indication of his good fortune, that he deliberately threw into the sea a certain ring made of an expensive engraved stone . . .

Pliny, *N.H.* 37.4: [After summarizing the story of the ring] it is agreed that the gem was a sardonyx, and they now have it on display in Rome, if we are willing

[16] This scheme appears on some of the earliest mythological vase paintings. See J. D. Beazley, *The Development of Attic Black Figure* (revised edition, Berkeley and London 1986), pls. 4 and 5.

to believe it [i.e., that this is really the gem from the ring of Polykrates], in the temple of Concord, set in a horn of gold, a gift of the empress [Livia?] . . .

Pliny, N.H. 37.8: The gem that is exhibited as that of Polykrates is uncut and unengraved . . .

Since Herodotos's story clearly implies, and Strabo specifically states, that the ring of Polykrates was engraved, Pliny's skepticism about the genuineness of the stone exhibited in Rome seems justified.

THE FIFTH CENTURY B.C.

Myron, Pheidias, and Mentor

In the Roman period certain famous works of silver plate were claimed to be by Myron, Pheidias, and other famous Greek sculptors. The most colorful references to such works occur in the Epigrams *of Martial.*

Martial 4.39:

> You have collected all types of silverware.
> Only you have ancient works by Myron;
> Only you have the handiwork of Praxiteles and Skopas;
> Only you have works chased by the graver of Pheidias;
> Only you possess the labors of Mentor;
> Nor are there lacking to you real works of Grattius,
> Nor works which are lined with Callaician gold,
> Nor relief sculpture from ancient tables.
> I marvel, however, that in all this chased silver,
> You, Charinus, have nothing which is chaste.

Martial 6.92:

> Since a serpent is engraved on your cup,
> Ammianus, a work of art by Myron,
> You drink Vatican wine; that is, you drink venom.[17]

Pheidias's reputation as an engraver and jeweler is also supported by an observation by the Emperor Julian the Apostate.

Julian, *Epistola* 67 (377A, B): The wise Pheidias was known not only for his statues in Olympia and in Athens, but also for having condensed a work of great art in a small gem, as they say he did with his grasshopper and a bee, and if you please, with a fly. And each of these, though its nature was of bronze, came to life through his art.

[17] The wine of the Vatican region of Rome was apparently of a very low order. An ironic contrast between the expensive cup and the cheap wine is intended.

Mentor, who is mentioned in the first of the epigrams of Martial given above, was perhaps the most famous silversmith of the ancient world.[18] His exact date is not known, but he was probably active in the fifth century B.C.; it is at least certain that he was active before 356 B.C., when, according to Pliny (see p. 234) some of his works were destroyed in the fire that consumed the Artemision at Ephesos.

Cicero, in Verrem 2.4.18.38: Diodoros of Malta . . . has lived in Lilybaeum now for many years . . . in connection with him Verres was told that he [Diodoros] had an excellent collection of engraved art objects, among them some cups, of the kind called *Therikleia*,[19] works made by Mentor with the utmost skill of hand. When this man [Verres] heard about them, he was so inflamed with cupidity not simply to inspect them but indeed to carry them off, that he summoned Diodoros to him and demanded them.

Pliny, N.H. 33.147: The orator Lucius Crassus has two cups [*skyphoi*] chased by the hand of the artist Mentor and costing 100,000 sesterces;[20] it is admitted, however, that, out of a sense of shame, he never dared to use them.

Scholiast on Lucian, Lexiphanes 7 (Overbeck, SQ 2172) (explaining the word *Mentourges*, used by Lucian in connection with some cups): *Mentourges* is derived from a certain glass-worker named Mentor, who made use of cups with this form: they were equipped with large handles that ran down to their foot, for which reason Lucian calls them "easy to grasp."

On Mys, another prominent toreutes of the fifth century B.C., who worked on the Athena Promachos of Pheidias, see pp. 63 and 234.

THE FOURTH CENTURY AND THE HELLENISTIC PERIOD

On the younger Kalamis and other practitioners of toreutike in the fourth century see pp. 94 and 234.

Pyrgoteles

Pliny records a tradition that Alexander made Pyrgoteles his official gem-carver, in the same way that he had made Lysippos his official sculptor and Apelles his official painter.

Pliny, N.H. 7.125: The Emperor Alexander also decreed that no one other than Apelles should paint his portrait, no one other than Pyrgoteles engrave it, and no one other than Lysippos cast it in bronze; and there are a number of famous examples in each of these arts.

[18] For other references to Mentor by Roman poets, see Overbeck, SQ, nos. 2173–81.
[19] *Therikleia* – a type of cup, named after the Corinthian potter Therikles, who invented it.
[20] The reading of the number is not certain.

Pliny, *N.H.* 37.8: Much later [i.e., after the time when the ring of Polykrates was made], in the time of Ismenias, it appears that even emeralds were engraved. This view is confirmed by the fact that Alexander the Great issued an edict by which he forbade anyone to engrave his image other than Pyrgoteles, who was without a doubt the most illustrious master of this art.

The Funeral Carriage of Alexander the Great

When Alexander died in Babylon an elaborate funeral carriage was prepared in order to carry his remains back to Macedonia. The funeral cortège, of which the vehicle was the principal feature, was intercepted by the governor of Egypt, Ptolemy (later King Ptolemy I), who proceeded to take Alexander's remains to Egypt and build a famous shrine for them. The funeral vehicle was probably incorporated into that shrine. The fusion of Greek and oriental features and the emphasis on the iconography of kingship in the decoration of the carriage marked the beginning of what would become major trends in Hellenistic art. (For attempts to reconstruct the appearance of the carriage and discussions of problems involved in the text, see Bibliography 115.)

Diodoros 18.26.3–18.28.4: First a hammered gold sarcophagus, fitting the body, was made, and they placed inside it spices that could both give the body fragrance and preserve it. On top of the casket a gold cover was placed, fitting it exactly and connecting with it around its upper periphery. On top of this was placed a splendid purple robe embroidered with gold, beside which they placed the armor of him who had passed away, wishing that the whole impression be in keeping with the deeds that he had performed in his lifetime. After this they placed it beside the carriage that was to carry it, over which a vaulted gold roof decorated with scales studded with jewels was constructed, 8 cubits wide and 12 cubits long; beneath the roof and running around the whole work was a gold cornice, rectangular in design, with goat-stag protomes done in high relief, from which gold rings two palms wide were hung, and through which, in turn, there ran a processional garland splendidly decorated with flowers of all sorts of colors. At the ends there was a tassel made of netting holding good-sized bells, so that the sound would reach those who were approaching it from a great distance. At the corners of the vault on each side there was a gold Nike bearing a trophy. The peristyle which supported the vault was of gold, and had Ionic column capitals. Inside the peristyle there was a gold net made from woven strands which had the thickness of a finger and [on this] were four pictures hung on the same level and equal in length to the walls.[21]

Of these pictures, the first represented a chariot with embossed decoration and in it was seated Alexander, holding a splendid scepter in his hands. Around the king there was one fully armed retinue of Macedonians and another of

[21] The gold netting apparently served as walls, and the pictures were arranged to adjoin one another in the manner of an Ionic frieze.

Persian "Apple-bearers,"[22] and in front of these were weapon bearers. The second picture showed the elephants which followed the retinue, arrayed in a warlike manner; mounted on them were Indian drivers in front and Macedonians, armed with their customary equipment, behind. The third picture showed troops of cavalry drawn up into their battle formations; the fourth picture showed ships fitted out for a sea battle. By the entrance to the vaulted chamber there were golden lions which looked at those who were entering. Along the central axis of each column there was a gold acanthus which extended from the bottom, going from one stage to the next, up to the capitals. Atop the vaulted roof, in the middle of its crowning ridge, there was displayed beneath the open sky a purple flag, having on it a gold olive wreath of good size, on which the sun, when it struck it with its rays, made such a radiant and shimmering glow that, from a great distance, its appearance was like that of a lightning bolt.

The platform of the vehicle beneath the vaulted chamber had two axles, on which turned four Persian wheels; the naves and spokes of these were gilded, but the part which struck against the ground was of iron. The hubs of the axles were gold and had lion protomes which held hunting spears in their teeth. Half-way down their length the axles had a bearing which was mechanically connected to the center of the vaulted chamber, the purpose being that through this device the vaulted chamber would be cushioned from the shocks caused by the uneven places. There were four poles on each of which four teams of animals were yoked, four mules being in each team so that altogether there were sixty-four mules, chosen for their strength and stature. Each of them was crowned with a gilded garland, and by their jaws on either side there hung a golden bell, and around their necks the harnesses were studded with jewels.

This then was what the construction of the carriage was like and the impression made by the actual sight of it was even more impressive than its description; it attracted many sightseers because of its far-flung renown. For the whole population from every city along its route always turned out to meet it and again escorted it as it moved on, nor were people ever satiated with the delight of looking at it. As an appropriate accompaniment to its grandeur, a crowd of road-workers and technicians followed it, as well as the soldiers who were sent along as its escort.

Arrhidaios,[23] having spent nearly two years in the preparation of the work, brought the body of the king from Babylon to Egypt. Ptolemy, as a mark of respect for Alexander, came with a force as far as Syria to meet it, and, receiving the body, deemed it worthy of the greatest attention. He decided for the time being not to send it to Ammon,[24] but rather to put it to rest in the city founded

[22] The honor guard of the Persian king had spears topped with golden apples. Herodotos 7.41.

[23] Arrhidaios – one of Alexander's generals, who was assigned the task of transporting the king's body to the oracle of Zeus Ammon.

[24] Ammon – the Egyptian god Amun was called Zeus Ammon by the Greeks. There was an oracle of the god at the oasis of Siwa in the Libyan desert. Tradition held that when Alexander visited the oracle the priests greeted him as the god's own son. See Plutarch, *Life of Alexander* 27.3–7.

by Alexander himself [Alexandria], which came close to being the most
illustrious city of the inhabited world. He constructed there a sanctuary which
was worthy of the glory of Alexander in its size and elaborateness . . .

On the decorative arts in Alexandria and their influence see The Art of Rome, *pp.
34-40.*

The Table by Kolotes at Olympia[25]

Pausanias 5.20.1–3: There are other offerings here . . . [including] a table on
which crowns for the victors are laid out beforehand . . . The table is made of
ivory and gold and is the work of Kolotes. They say that this Kolotes was from
Herakleia, but those who have devoted considerable attention to the study of
sculptors say that he was a Parian and a pupil of Pasiteles, and also that Pasiteles
himself was a pupil of . . . [lacuna]. Represented on it are Hera, Zeus, the Mother
of the Gods, Hermes, and Apollo with Artemis. Behind is a scene representing
the games. On one side of it are Asklepios and Hygieia, one of the daughters of
Asklepios; also Ares and, by him, *Agon* ["Contest"]. On the other side are Pluto,
Dionysos, and also Persephone and the Nymphs, one of whom carries a ball. As
for the key – for Pluto holds a key – they say that the place which is called Hades
has been locked up by Pluto and that no one will ever come back from it again.

[25] Many, if not most, modern scholars have ascribed this table to Kolotes the pupil of Pheidias
(see p. 68), and their ascription may be correct. But since Pausanias clearly says that this Kolotes was a
pupil of Pasiteles (and the only Pasiteles is the late Hellenistic master from south Italy), he may have
been a Hellenistic artist whom some historians confused with the earlier Kolotes, who was perhaps
from Paros.

Chapter 13

Art history, aesthetics, and comparative criticism

This section contains passages that put groups of artists into historical perspective, compare the styles of different artists, discuss technical innovations, and express characteristic attitudes toward art in the ancient world.

GENERAL

Quintilian's History of Greek Art

See Introduction, p. 5.

Quintilian, *Institutio Oratoria* 12.10.1–10: [The works produced by any art] differ greatly from one another; for they differ not only by species – as statue differs from statue, picture from picture, and action from action – but also in genus – as statues in the Etruscan style differ from Greek statues, and the Asiatic style of rhetoric differs from the Attic. Moreover just as these different genera of works of which I speak have authors, so too do they have devotees; and the result is that there has not yet been a perfect practitioner of any art, not only because some qualities are more eminent in one artist than in another, but also because one form is never pleasing to everybody; this is partly because of the circumstances of times and places, and partly because of the judgment and point of view of each person.

The first artists whose works should be inspected not only for the sake of their antiquity [but also for their artistic merit] are said to have been those famous painters Polygnotos and Aglaophon, whose simplicity of color has still such zealous advocates that these almost primitive works, which are like the primordial beginnings of the great art of the future, are preferred to the works of artists who came after them – a judgment prompted, in my opinion, by the urge to appear as a connoisseur. Afterwards Zeuxis and Parrhasios – who were not very far removed from one another in time (for they both were active around the time of the Peloponnesian War, since a conversation of Socrates with Parrhasios is to be found in Xenophon) – contributed much to the art of

painting. Of the two, the first discovered the calculation [*ratio*] of lights and shades, while the second is reputed to have concentrated on subtlety of line. For Zeuxis gave more emphasis to the limbs of the body; he thought that this made his art grander and more august, and in this respect, they think, he followed Homer who likes to use the most mighty form in every case, even in the case of a woman. Parrhasios, on the other hand, drew all types of outlines so well that they call him the "proposer of laws," since other artists follow the representations of gods and heroes that have been handed down by him as if there were some sort of necessity to do so. The art of painting flourished primarily, however, from around the time of Philip down to the successors of Alexander, although [different artists were distinguished] for various points of excellence [*virtutes*]. Thus Protogenes was outstanding for laborious care, Pamphilos and Melanthios for theoretical knowledge, Antiphilos for ease of execution,[1] Theon of Samos for imaginary visions which they call *phantasias*,[2] and Apelles for ingenuity and grace [*ingenium et gratia*], the last of which, he himself boasted, was best revealed in his own art. What makes Euphranor worthy of admiration is that while he was classed among the foremost men in other fields of study, he was also gifted with marvellous skill in both painting and sculpture.

The same differences exist among the sculptors. For Kallon and Hegesias made works that are rather hard and close to the Etruscan style; Kalamis made works that were less rigid and Myron made his even softer than those artists spoken of so far. Precision and appropriateness appeared above all in the art of Polykleitos, to whom the victor's branch is awarded by many critics, although, lest no fault be found in him, they hold that he lacked weightiness [*pondus*]. For while he gave to the human form an appropriateness which surpassed the ordinary,[3] he seems not to have expressed the impressiveness of the gods. On the contrary it is said that he shied away from representing the more mature age level and did not dare to undertake anything more challenging than smooth cheeks.[4] But those qualities in which Polykleitos was lacking are attributed to

[1] "Ease of execution" – *facilitas*. Quintilian elsewhere uses this word to translate the Greek term *hexis*, which means a trained habit or skill developed by long practice.

[2] Theon's date is not known, but he probably belonged to the early Hellenistic period. Pliny (*N.H.* 35.144) and Plutarch (*de Recta ratione audiendi*, 3) attribute to him a painting of Orestes afflicted with insanity after having killed his mother. In later Antiquity *phantasia* came to mean something like "imagination" or "spiritual inspiration" (see Introduction, p. 5 and also pp. 223–4). Aristotle uses the term to mean "imagination" in a simpler sense, that is, the re-presentation to the mind of images which are based on sense experience but can occur when sense perception is not present (*de Anima* 428a ff.). In a more general sense the word can be used to refer to an "appearance" or "apparition" that is very similar to actual sense perception and hence seems real (for example, Plato, *Theaetetus* 152c). It is probably this last meaning of the term that applies in the case of Theon. Aelian (*Var. Hist.* 2.44) relates that Theon painted a picture of a young soldier hastening to the aid of his country; in order to make the *phantasia* of the picture more vivid Theon ordered that a military trumpet should be sounded, and that, while the trumpet was sounding, his picture should be unveiled before the public. Theon's *phantasia*, in other words, referred to painted images that were made more persuasive by the use of theatrical side effects.

[3] "Surpassed the ordinary" – *supra verum*. The meaning is probably that Polykleitos created ideal forms in which the proportions were more perfect than those found in any living person.

[4] That is, he represented beardless young men.

Pheidias and Alkamenes. Pheidias, however, is credited with being more skillful at making images of gods than of men, and in working in ivory he is thought to be far beyond any rival and would be so even if he had made nothing besides his Athena in Athens and his Olympian Zeus in Elis, the beauty of which seems to have added something to traditional religion; to such an extent is the majesty of the work equal to the majesty of the god. They affirm that Lysippos and Praxiteles were most successful in achieving realism. Demetrios, however, is criticized because he was too realistic and was hence more fond of verisimilitude than of beauty.

Cicero's History of Greek Art

Cicero, *Brutus* 70: Who, of those who pay some attention to the lesser arts, does not appreciate the fact that the statues of Kanachos were more rigid than they ought to have been if they were to imitate reality? The statues of Kalamis are also hard, although they are softer than those of Kanachos. Even the statues of Myron had not yet been brought to a satisfactory representation of reality, although at that stage you would not hesitate to say that they were beautiful. Those of Polykleitos are still more beautiful; in fact, just about perfect, as they usually seem to me. A similar systematic development exists in painting. In the art of Zeuxis, Polygnotos, and Timanthes and the others who did not make use of more than four colors,[5] we praise their forms and their draughtsmanship [*lineamenta*]. But in the art of Aëtion, Nikomachos, Protogenes, and Apelles, everything has come to a stage of perfection.

Late Hellenistic Idealism

As pointed out in the introduction to this volume, one of the principal ideas of the late Hellenistic theory of art history which Quintilian and Cicero preserve in the above passages was that the high point of ancient art was reached in the art of Pheidias. The greatest achievement of Pheidias was thought to have been his ability to visualize and give form to the sublime qualities of the gods; and the supreme examples of this achievement were his Zeus at Olympia and his Athena Parthenos. Although Cicero omits this key idea in the passage above, he develops it fully in the following passage.

Cicero, *Orator* 8–9: . . . I thus affirm that nothing in any genre is so beautiful that the thing from which it is copied is not more beautiful, as is the case with a mask copied from the face. That which cannot be perceived with the eyes or the ears or with any other sense, we can, however, conceive in the mind through meditation. So in the case of the statues of Pheidias (than which we see nothing more perfect of that kind) and in the case of those paintings which I have named, we are nevertheless able to visualize something even more beautiful. Surely that artist, when he made the form of his Zeus or his Athena, was not contemplating

[5] On the four-color painters, see p. 229.

any human model from whom he took a likeness, but rather some extra-ordinary vision of beauty resided in his own mind, and, fixing his mind on this and intuiting its nature, he directed his hand and his art towards making a likeness from it.

This picture of Pheidias as a contemplative idealist continued to be popular up to the end of Antiquity. It appears briefly, for example, in such diverse authors as the Elder Seneca and Plotinos.

Seneca, *Controversiae* 10.34: Pheidias did not actually see Zeus, but neverthe-less he made [a statue of] him as the thunderer, nor did Athena stand before his eyes, but nevertheless his spirit was equal to the task of conceiving those deities by his art and of representing them.

Plotinos, *Enneads* 5.8: When Pheidias carved his Zeus, he did so not by basing it on any model which was perceptible to the senses but rather by taking from his mind an image that reflected the way Zeus would appear if he did in fact decide to make himself visible to our eyes.

The most thorough presentation of the idea that Pheidias's power of contemplation was a higher power than the ordinary artist's ability to imitate the external world is presented in the following passage.

Philostratos, *Life of Apollonios of Tyana* 6.19: "Did artists like Pheidias and Praxiteles," he said, "after going up to heaven and making mechanical copies of the forms of the gods, then represent them by their art, or was there something else that stood in attendance upon them in making their sculpture?" "There was something else," he [Apollonios] said, " a thing full of wisdom." "What is that?" he asked. "Certainly you would not say that it was anything other than imitation [*mimesis*]?" "Imagination [*phantasia*]," Apollonios answered, "wrought these, an artificer much wiser[6] than imitation. For imitation will represent that which can be seen with the eyes, but *phantasia* will represent that which cannot, for the latter proceeds with reality as its basis; moreover, panic often repels imitation, but never *phantasia*, which proceeds undismayed toward that which it has set up as its goal."

Comparison of Rhetoric with the Visual Arts

Dionysios of Halikarnassos, *de Isocrate* 3: It seems to me that it would not be beside the point if one were to liken the rhetoric of Isocrates to the art of Polykleitos and Pheidias for its holiness, its grandeur, and its dignity; whereas one might liken the rhetoric of Lysias to the art of Kalamis and Kallimachos on account of its subtlety and grace. For just as the latter group was more successful in works which were more modest and on the human level, and the former

[6] "Wiser" – *sophotera*. The word can also mean "more skillful," or "cleverer."

group was more adept in representing grandiose and divine subjects, so is it with the orators . . .

Dionysios of Halikarnassos, *de Demosthene* **50:** For sculptors and the apprentices of painters, if they did not have that experience which comes from exercising their power of sight over a long period, would not be able to distinguish easily between the techniques of the different ancient artists, nor would they be able to say with assurance (without having learned it by traditional hearsay) and this work is by Polykleitos, this one by Pheidias, and this one by Alkamenes; nor with painters that this is by Polygnotos, that by Timanthes, and this by Parrhasios.

Dionysios of Halikarnassos, *de Thucydide* **4** (illustrating the reason why he presumes to criticize writers who are superior to himself in genius): Certainly because we do not have the ability of Thucydides, and of other men, we are not deprived of our ability to evaluate them. For neither, in the case of Apelles, Zeuxis, Protogenes, and of the other painters, are those who lack the same skill as these artists hindered from judging them, nor do only craftsmen of the same ability judge the works of Pheidias, Polykleitos, and Myron.

Dionysios of Halikarnassos, *de Dinarcho* **7:** To sum up, one might identify two ways of distinguishing original works from their imitation. Of these, one is the natural way, which comes from word of mouth information and from a general familiarity with the subject. The other, which follows upon the first, comes from first-hand knowledge of the precepts of the art. Concerning the former, what is there that one can say? But concerning the latter one might say something like this: that in the case of original works, there is a certain natural grace and a fresh quality; while in those works made in imitation of them, even though the imitation is of the highest order, there is nevertheless a certain contrived, labored quality that does not arise in a natural way. And on the basis of this first-hand knowledge, not only do rhetoricians evaluate other rhetoricians, but painters distinguish the works of Apelles from those of other artists who imitate him; and modellers do the same with the works of Polykleitos; and those who carve sculpture do the same with the works of Pheidias.

Demetrios, *de Elocutione* **14:** Therefore the expressive style of the early writers has a certain polished and well-ordered quality, like those ancient images in which the art seemed to have compactness and leanness, while the style of those who came later resembles the works of Pheidias in that it already has a certain grandeur and, at the same time, the quality of precision.[7]

Dionysios of Halikarnassos, *de Isaeo* **4:** Suppose there were some ancient paintings, executed with simple colors and having none of the variety that

[7] Among the "earlier writers" Demetrios mentions specifically Herodotos and Hekataios of Miletos; among the later writers he refers specifically to the rhetoricians Gorgias, Isocrates, and Alkidamas.

comes from the mixing of colors, but precise in their lines and having much in them that was graceful. Then imagine some that were later than these, less excellent in draughtsmanship, but more fully worked out, varied by light and shade, and having their strength in their great number of mixed colors. Lysias would be like the older of these in his simplicity and grace; Isaios would resemble those which were more labored and technically accomplished.

Perfection in the Arts

Diodorus Siculus 26.1: Neither poet nor prose writer nor any artist in any literary discipline can please all his readers in every respect. It is not possible for human nature, even if it has attained its goal with complete success, to arrive at a state where it is without blame and pleasing to all. It was not possible for Pheidias, who was marvelled at for making images in ivory, nor for Praxiteles, who instilled the very passions of the soul into his marble works, nor for Apelles or Parrhasios, who by their experienced skill in mixing colors brought the art of painting to its highest point – it was not possible even for these men to be so successful in their works that they could put on display a finished product of their skill which was considered completely flawless.

SCULPTURE

A Sculptors' Competition in the Fifth Century B.C.

Pliny, N.H. 34.53: The most highly praised artists have also entered into competition with one another (although they belonged to different age groups), since they all made statues of Amazons; and, when these [Amazons] were dedicated in the temple of Artemis at Ephesos, it was resolved that the most praiseworthy of them was to be selected by the judgment of the artists themselves, who were present. Then it became apparent that there was one which each artist judged to be second to his own [and it became the winner]. This was the one by Polykleitos; next to it came the one by Pheidias, third that of Kresilas, fourth that of Kydon, and fifth that of Phradmon.[8]

Pausanias on the Aeginetan and Attic Schools

Pausanias, as we have noted, was a reticent critic, but there are indications that he had an "eye" for style. One example of this is his frequently demonstrated ability to distinguish at sight between works of the Aeginetan and Attic schools of sculpture.

[8] Several Amazon types are known in Roman copies, and these are frequently associated with the contest described by Pliny. The attribution of particular types to the various sculptors and the dates of the putative originals are, however, matters of considerable controversy; and a few scholars (e.g. Ridgway) doubt that such a contest ever took place. See Bibliography 117.

Pausanias 5.25.13: . . . This Onatas, even though his images are in the Aeginetan style, I would class as inferior to none of those who are descendants of Daidalos and belong to the Attic school.

10.17.12 (in a discussion about the animals found on the island of Sardinia): The he-goats do not exceed those elsewhere in size, but their form resembles that of a wild ram as one would make it in the Aeginetan style of sculpture, except that the hair around their breast is thicker than the way it is represented in Aeginetan art. The horns do not stand out from the head but curl straight back by the ears.

1.42.5 (at Megara): The ancient temple of Apollo was made of brick. The emperor Hadrian, however, later rebuilt it in white marble. The image of Apollo called the "Pythian" and the *Dekatephoros* ["Tithe-bringer"] is very much like Egyptian carved images, but the one called *Archegetes* is similar to Aeginetan works. All of them are made of ebony.

7.5.5 (on the ancient image from the temple of Athena at Priene): The image is not like those called Aeginetan, nor is it like most ancient images of Attica, but rather, if it is anything, it is distinctly Egyptian.

8.53.11 (on the road from Tegea to Lakonia): . . . there is a sanctuary of Artemis called *Limnatis* [of the marshes] with an image made of ebony-wood. The style of its workmanship is that which is called "Aeginetan" by the Greeks.

10.37.8: . . . The port of Delphi is Kirrha. It possesses a temple dedicated to Apollo, Artemis, and Leto with images of great size done in the Attic style.

The Status of the Sculptor

In view of the many praises showered upon Pheidias and Polykleitos in ancient literature, the following two passages may seem surprising. Perhaps their attitude is more characteristic of the Roman period than of Classical Greece.

Plutarch, *Life of Pericles* **2.1:** Working with one's own hands on menial tasks calls the labor expended on useless things as a witness to one's indifference to finer things. No gifted young man, upon seeing the Zeus of Pheidias at Olympia, ever wanted to be Pheidias nor, upon seeing the Hera at Argos, ever wanted to be Polykleitos . . . For it does not necessarily follow that, if a work is delightful because of its gracefulness, the man who made it is worthy of our serious regard.

Lucian, *Somnium* **6–9** (In this autobiographical reminiscence, Lucian recalls a dream he once had at a time when he was contemplating becoming a sculptor: In the dream two women appeared to him; one was *Hermoglyphike* ("the Art of Statuary") and the other was *Paideia* ("Education"). The two women fought for possession of him and tried to win him over to their respective sides by speeches. *Hermoglyphike* is described as being a rough, manly-looking woman with

callused hands and unkempt clothing; *Paideia*, on the other hand, is described as having a beautiful face and an orderly appearance. The first speech and part of the second follow): In the end they decided to let me be the judge of which one of them I wanted to go with. The hard and manly-looking one spoke first. "I, my boy, am the Art of Statuary, which you began to learn yesterday. I am one of your relatives and come from the same household. For your grandfather (she was speaking of my mother's father) was a stonecutter and likewise your two uncles earned fine reputations thanks to me. If you decide to put aside the idle chatter and babbling of this one here (and she pointed to the other woman) and to follow me and dwell with me, first you will grow up to be a sturdy fellow, and you'll have broad shoulders; not only that but you will be free of all envy, and you will never go wandering in foreign lands, deserting your homeland and your relatives. Nor will everyone praise you just for your words. Don't feel disgusted at the unkempt condition of my body and the squalid condition of my clothing. After all, it was setting out from such beginnings that Pheidias created his Zeus, that Polykleitos made his Hera, that Myron won praise, and that Praxiteles came to be marvelled at. These men are now worshipped along with the gods. If you should become one of these, how could you help but become famous among all men? You will make your father an envied man and bring renown to your homeland." These and many more things the Art of Statuary said to me, stammering at every point in her foreign accent as she strung her words together in an attempt to persuade me. But I no longer remember it all; most of it has already slipped out of my memory.

When she finally stopped, the other woman began as follows: "I, my child, am Education, and am already your intimate acquaintance and friend, even if you have not yet tried to know all about me. Here then are the benefits which, according to this lady, you will get by being a stonecutter. You will be nothing more than a workman, doing hard physical labor and putting the entire hope of your life into it; you'll be an obscure person, earning a small ignoble wage, a man of low esteem, classified as worthless by public opinion – neither courted by friends, feared by enemies, nor envied by your fellow citizens – but just a common workman, one face in a great crowd, always cowering before the man who is a leader and serving the man who has power over words, living the life of a hare, just a tool to help a better man along. Even if you should become a Pheidias or a Polykleitos and produce many marvellous works, all will praise your art, but not one of those who see your art, if he were in his right mind, would pray to be like you. For this is what you will be: a common workman, a craftsman, one who makes his living with his hands."

PAINTING

The Use of Color

Pliny, *N.H.* 35.29–30: We discussed what the single colors used by the first painters were when we treated the question of pigments derived from metals,

from which come the different varieties of paintings called "monochromes"[9]
... In the course of time the art differentiated itself and discovered light and
shades, with the alternating contrast of colors heightening the effect of one and
then the other. Afterwards *splendor*[10] was finally added, which is something
different from "light." Those qualities which exist between these [light and
splendor] and shades is called *tonos* ["tension"], while the joining together and
transition of colors is called *harmoge*.[11]

There are moreover "austere colors" and "florid colors." Both types occur
naturally and also by mixture.[12]

Pliny, *N.H.* 35.38: Burnt ceruse [paint made from white lead] was discovered
by chance when some of it was burned in some pitchers during a fire in Peiraeus.
This was first used by Nikias ... Eretrian earth[13] gets its name from that place.
Nikomachos and Parrhasios made use of it.

Pliny, *N.H.* 35.42: Polygnotos and Mikon, those very famous painters, made
black paint from grape lees, giving it the name *tryginon*. Apelles invented a way
of making black paint by burning ivory, a type which is called *elephantion*.

Pliny, *N.H.* 33.160: Polygnotos and Mikon first instituted the practice of
painting with yellow ochre, using only that which comes from Attica.

Pliny, *N.H.* 35.50: These artists made immortal works with only four colors
(from the whites they used *Melinum*; from the yellows, Attic ochre; from the
reds, *Pontic Sinopis*; and from the blacks, *atramentum*) – Apelles, Aëtion,
Melanthios, and Nikomachos, famous painters, seeing that single paintings by
them would sell for the value of whole towns.[14]

The Encaustic Technique

Pliny, *N.H.* 35.122–3: There is no agreement as to who first contrived the
technique of painting with wax and of doing a picture in encaustic. Some think
that it was the invention of Aristeides, and that it was later perfected by

[9] "From which ... monochromes": the text is corrupt and is translated here in accordance with
the editor's idea of what the phrase might have meant. Others take it to mean that the pigments were
called "monochromes" after the type of painting in which they were used.
[10] *Splendor*, "shine," or "highlight" is perhaps a translation of the Greek *auge*, and may refer to
the reflection of highlights from a glossy surface. This was perhaps the quality employed by Pausias
in his famous painting of an ox (see p. 165).
[11] *Tonos* and *harmoge* are Greek terms. They probably played an important role in the writings
on color by Euphranor and other painters.
[12] Pliny goes on to enumerate the pigments used in each class. Apparently shades of red, blue,
purple, and yellow were considered *floridi colores* and the rest were *austeri*.
[13] "Eretrian earth" was probably another white pigment with a magnesium base.
[14] All these painters belonged to the fourth century, and hence four-color painting belonged to a
very sophisticated stage of Greek painting. Cicero (see p. 223) mistakenly assumes that the use of
only four colors was a primitive limitation of an early stage of Greek painting. His ascription of
Polygnotos to the group is probably erroneous. The original of the Alexander Mosaic in Naples,
presumably of the late fourth century and certainly a highly sophisticated work, appears to have
been an example of four-color painting.

Praxiteles. But there were encaustic paintings which were considerably older, such as those of Polygnotos, Nikanor, and Mnasilas of Paros. There was also Elasippos of Aegina, who inscribed *enekaën* ["burned in"] on one of his pictures, which he certainly would not have done if encaustic had not been invented.[15]

The Fame of Unfinished Paintings

Pliny, *N.H.* 35.145: Indeed it is an extremely unusual fact and worth remembering that the last works of artists and their unfinished pictures, such as the *Iris* of Aristeides, the *Tyndaridai* of Nikomachos, the *Medea* of Timomachos, and the *Aphrodite* of Apelles, which we have discussed, are held in greater admiration than finished works; for in these the sketch-lines remain and the actual thoughts of the artists are visible; and, even as one is charmed by their excellence, there is sadness because the artist's hand was stilled while he was working on the picture.

Aristotle and Ethos

The term ethos *(see above, pp. 155–6 and p. 168) referred to the inner character or personality (as opposed to emotions or* pathe, *which were reactions to experience in the external world). In discussing the role of* ethos *in Greek drama, Aristotle selects convenient parallels from Greek painting.*

Aristotle, *Poetics* 1450a23: Further there cannot be a tragedy without action, but there could be one without character. For the tragedies of most of the modern dramatists are without character, and there are, in general, many poets of this sort, poets who, to use painters as an analogy, are just like Zeuxis when compared to Polygnotos. For Polygnotos was a good *ethographos* [painter of character], but the painting of Zeuxis has no *ethos*.

Aristotle, *Poetics* 1448a1: Since people who are the subject of imitations are represented as being engaged in action, these imitations must of necessity be either of worthy men or inferior men (for characters [*ethe*] almost always fall into these categories alone, since all characters are differentiated on the basis of evil or virtue), that is to say men who are better than us, or worse, or of the same sort, as it is with the painters. For Polygnotos represented men as better, Pauson represented them as worse, and Dionysios represented them as they are.

Although ethos *(and the forms derived from it) normally signified "character" in the most general sense – that is, it referred equally to "good character" or "bad character" – there are occasions when, like the English word "character" itself,* ethos *could specifically suggest "good character" (as in the English phrase "a man of character"). An example of this usage in connection with painting occurs in Aristotle's* Politics.

[15] On encaustic see also under Pausias, p. 164.

Aristotle has been discussing the psychological effects of music, and he brings painting into the discussion to demonstrate how the visual arts are less effective in portraying ethos than music is.

Aristotle, *Politics* 1340a33: These [visual images] are still not likenesses of character, but rather the poses and colors which result are simply signs of character, and these signs appear in the body in the course of experiencing emotions. That is not to say, of course, that there is not some difference in the effect resulting from our observation of these signs, and thus the young should not look at the works of Pauson but rather at those of Polygnotos or any other painter or sculptor who is *ethikos* . . .

Plato and Imitation

In the tenth book of the Republic *Plato presents at length his reasons for excluding poetry from his ideal state. The basis of his reasoning, in brief, is that poetry and the mimetic arts in general can only imitate the external world, which is itself merely a weak reflection of the ultimate reality – the world of "ideas." By enticing individuals to become emotionally involved in an illusion within an illusion, art distracted them from the pursuit of the highest knowledge.*

Although it is of interest because it expresses a major theory about the nature of artistic representation, this passage is really more important in the history of philosophy than in the history of art, since it seems to have had no significant influence on the latter.

Plato, *Republic* 10.596E–597E (The interlocutors are Socrates and Glaukon. Socrates has just said that there is a sense in which a craftsman, like a cosmic god, can be the creator of all things. When Glaukon asks how that is possible, Socrates answers): "You could do it quickly, if you wish, by carrying around a mirror everywhere. For you would quickly make the sun and the heavenly bodies, quickly also the earth, and yourself and the other living creatures, and manufactured objects and plants and all the other things that were spoken of just now."

"Yes," he said, "but these would be appearances, and not things which had any real existence."

"Quite right," I [Socrates] said, "and you are coming to the aid of our argument. For it is to this category of creators that the painter, I think, belongs. Isn't that so?"

"How could it be otherwise?"

"But you will say, I suppose, that the things that he makes are not real. And yet there is a certain sense in which a painter makes a couch, is there not?"

"Yes," he said, "he too makes an appearance of one."

(Sec. 597): "Well what about the couch-maker? Didn't you just say that he does not actually make the form, which we said is the real couch, but rather that he makes a specific couch?"

"That is what I said."

"Well then if he does not make that which really exists, he should not be looked upon as making something which is real, but only something which is like that which is real but is, in fact, not real. But if anyone should say that reality belongs completely to the product of the couch-maker or of any other artisan, he would not be speaking the truth, would he?"

"That is how it would seem to those who devote time to such arguments."

"We should not marvel then if this turns out to be a kind of dim existence when compared to reality."

"No, we shouldn't."

"Is it agreeable to you," I said, "if we seek to find the true nature of the imitator, whoever he may be, from these examples?"

"If you wish," he said.

"There are then, these three sorts of couches. One of them, which exists in nature, and which we would say, I think, is made by God; or is it someone else?"

"No, no one else, I think."

"And one of them again is made by the craftsman."

"Yes," he said.

"And still another one is made by the painter. Isn't that so?"

"Let it be so."

"The painter, then, and the couch-maker, and God are three commissioners in charge of three types of couches."

"Yes, there are three."

"Now God, either because he did not wish to or because there was some necessity laid upon him not to make more than one couch in nature, accordingly made only one couch, which is the real couch. But two or more of this sort were never created in nature by God nor will they be."

"How is that?" he said.

"Because," I answered, "if he should make two, one couch would again appear of which these two would reflect the form, and this would be the real couch, not the other two."

"You're right," he said.

"Knowing this, I think, and wishing to be the maker of the real couch, God, and not just some couch-maker who is the maker of one particular couch, created only one unique couch in nature."

"It seems that way."

"Do you agree then that we should call him its natural creator or something of the sort?"

"Fair enough," he said, "since he has made this and all the other things in nature."

"And what about the human artisan? Is he not the maker of a couch?"

"Yes."

"And as to the painter, is he the creator or maker of something of this sort?"

"Not at all."

"What do you say, then, is his relation to the couch?"

"This," he said, "seems to me to be the most accurate thing to call him – the imitator of that which others create."

"Well then," I said, "would you call him one who produces an imitation which is three stages[16] away from the real existence?"

"Yes, I would indeed," he said.

ARCHITECTURE

Writers on the Theory and Practice of Architecture

Vitruvius 7.praef. 12 and 14: Afterwards Silenos wrote a volume about the proportions [*symmetriae*] of Doric buildings; Theodoros and Rhoikos wrote one about the Ionic temple of Hera at Samos; Chersiphron and Metagenes about the Ionic temple of Artemis at Ephesos; Pythios about the Ionic temple of Athena at Priene; Iktinos and Karpion about the Doric temple of Athena on the Acropolis in Athens; Theodoros of Phokaia about the *Tholos* in Delphi; Philon about the proportions of sacred buildings and about the arsenal which was at the harbor in Peiraeus; Hermogenes about the pseudodipteral Ionic temple of Artemis in Magnesia and about the monopteral temple of Dionysos at Teos; Arkesias about the proportions of the Corinthian order and about the Ionic temple of Asklepios in Tralles, which,[17] it is said, he made with his own hand; and Satyros and Pythios wrote about the Mausoleum . . . **(Sec. 14)** In addition many less well-known writers have written on *symmetria*, such as Nexaris, Theokydes, Demophilos, Pollis, Leonidas, Silanion, Melampos, Sarnakas, and Euphranor.[18] To no less a degree have there been writers on machinery such as Diades, Archytas, Archimedes, Ktesibios, Nymphodoros, Philon of Byzantium, Diphilos, Demokles, Charias, Polyidos, Pyrrhos, and Agesistratos. As to the things from these commentaries that I have recognized as being useful to our subject, I have collected all these into one body, primarily because I noticed that, while many volumes had been produced on this subject by the Greeks, there were very few indeed by us [the Romans].

THE DECORATIVE ARTS

The Art of Chasing in Silver

Pliny, N.H. 33.154–7: It is a cause for wonder that, in the art of chasing gold, no one has become famous, but in the art of chasing silver many have. The most

[16] "Three stages" counting the first; in other words, "twice removed."

[17] It is not clear whether this "which" refers to the temple or to a statue of Asklepios.

[18] Demophilos was a painter and Pollis was a sculptor (Pliny, *N.H.* 35.61 and 34.91). Silanion was a sculptor (see pp. 92–3), and Euphranor was both a painter and a sculptor (see pp. 93–4 and 167–8).

highly praised, however, is Mentor, of whom we have spoken above. Four pairs [of silver vessels] were all he made, and none of these is now said to be extant, owing to the conflagrations of the temple of Artemis at Ephesos [356 B.C.] and of the Capitoline [probably the fire of 83 B.C.]. Varro writes that he possessed a bronze statue by him. Next after Mentor in admiration were Akragas, Boëthos, and Mys. Works by all these artists exist today on the island of Rhodes; by Boëthos [some works] in the temple of Athena at Lindos, by Akragas some drinking cups [*skyphoi*] engraved with centaurs and Bacchantes in the temple of Dionysos in Rhodes itself, and by Mys [goblets with] Sileni and Cupids in the same temple. The representation of hunting scenes on cups by Akragas achieved great fame. After these Kalamis was renowned, and Antipater was said actually to have placed on a bowl a satyr who was heavy with sleep rather than simply to have engraved it;[19] subsequently Stratonikos of Kyzikos, Tauriskos, and Ariston and Eunikos are praised,[20] and, around the time of Pompey the Great, Pasiteles, Poseidonios of Ephesos, Hedys, Thrakides,[21] who engraved battles and armed soldiers, and Zopyros, who engraved the court of the Areopagos and the judgment of Orestes on two cups valued at 12,000 sesterces. There was also Pytheas, one of whose works sold at the rate of 10,000 denarii per two ounces: an offering bowl on which the decorated relief represents Odysseus and Diomedes stealing the Palladium. He also made cooks, called the *Magiriskia*, out of small-sized drinking vessels,[22] from which it was forbidden even to make copies by the use of molds, so subject to injury was its subtlety of detail. Teucer also became famous as an embosser,[23] but suddenly this art degenerated to such an extent that it is now only considered valuable for its age,[24] and esteem is accorded to works which are worn with use, even if the design cannot be discerned.

[19] An epigram in the *Greek Anthology* (*Anth. Graec.* 16.248) – "Diodoros actually put this satyr to sleep; he did not simply engrave him. If you prod him, you will wake him. For the silver is overcome with sleep" – suggests that the artist who made the sleeping satyr may have been named Diodoros. Antipater may have been the author of the epigram (although the anthology attributes it to a writer named Plato) or he may have been the client for whom it was made, possibly the poet Antipater of Sidon (late second century B.C.) or Antipater the regent of Macedonia (397–319 B.C.).

[20] These were probably all Hellenistic sculptors. The name Stratonikos is connected with the Pergamene school, and Tauriskos with the school of Rhodes.

[21] "Hedys" and "Thrakides" – the names were reconstructed by Furtwängler. One of the better manuscripts reads "hedystrachides," which could also be a name. The other manuscripts have less intelligible readings.

[22] *Magiriskia* is a Greek word meaning "little chefs." Pytheas probably made little drinking vessels in the shape of cooks.

[23] "Embosser" – the term used here is *crustarius*, one who works the *crusta* or outer surface of an object by embossing, inlaying, and the like.

[24] "For its age" – only in examples which were old.

Bibliography

The following bibliography emphasizes works that deal directly with the literary sources on Greek art or that supplement our knowledge of the personalities and monuments described in the sources. Topics are arranged in the order in which they appear in this book. In most cases the references are listed in chronological order. In cases where the bibliography is unusually extensive (e.g., Polykleitos, Lysippos), however, I have taken a few basic and comprehensive works out of their chronological place and listed them first.

Almost all the artists discussed in this book are listed in such basic encyclopedic works as:

Pauly–Wissowa, *Real-Encylopädie der klassischen Altertumswissenschaft* (Stuttgart 1894–present)

Thieme–Becker, *Allgemeines Lexicon der bildenden Künstler von der Antike bis zur Gegenwart* (Leipzig 1907–1950)

Enciclopedia dell'Arte Antica (Rome 1958–1966)

Heinrich Brunn, *Geschichte der griechische Künstler* (2nd edition, Stuttgart 1889), is still the best general treatment of the ancient literary testimonia concerning artists of all types.

Unless their treatment of a topic seemed particularly thorough or unusual, I have normally not cited the individual entries in these reference works.

Likewise, I have not always cited separate sections within Martin Robertson's *A History of Greek Art* (Cambridge 1975). Readers will find it useful to consult this excellent survey for most topics, and its omission from the individual bibliographies should not be taken to mean that it is not recommended.

1. Collections of Texts

Overbeck, J., *Die antiken Schriftquellen zur Geschichte der bildenden Künste bei den Griechen* (Leipzig 1868)

Stuart Jones, H., *Select Passages from Ancient Writers Illustrative of the History of Greek Sculpture* (London 1895; reprint Chicago 1966)

Reinach, A., *Textes grecs et latins relatifs à l'histoire de la peinture ancienne* (Paris 1921; reprint, Chicago 1981)

2. Ancient Art History and Art Criticism

Urlichs, H. L., *Über griechische Kunstschriftsteller* (Würzburg 1887)

Robert, C., *Archäologische Märchen aus alter und neuer Zeit* (Philologische Untersuchungen) (Berlin 1886)

Petersen, E., "Rhythmus," *Abhandlungen der Königlichen Gesellschaft der Wissenschaften zu Göttingen. Phil.-Hist. Klasse*, n.s. 16 (1917) 1–104

Schweitzer, B., "Der bildende Künstler und der Begriff des Künstlerischen in der Antike," *Neue Heidelberger Jahrbücher*, n.F. 2 (1925) 28–132

Schweitzer, B., "Xenokrates von Athen," *Schriften der Königsberger Gelehrten Gesellschaft. Geisteswissenschaftliche Klasse* 9 (1932) 1–52

Schweitzer, B., "Mimesis und Phantasia," *Philologus* 89 (1934) 286–300

Lawrence, A. W., "Cessavit Ars: Turning Points in Hellenistic Sculpture," *Mélanges d'archéologie et d'histoire offerts à Charles Picard* (Paris 1949) II, 581–5

Venturi, L., *History of Art Criticism* (New York 1936) chap. 2

Becatti, G., *Arte e gusto negli scrittori latini* (Florence 1951)

Pollitt, J. J., "Professional Art Criticism in Greece," *GBA* 64 (1964) 317–27

Pollitt, J. J., *The Ancient View of Greek Art* (New Haven 1974)

Linfert, A., "Pythagoras und Lysipp – Xenokrates und Duris," *Rivista di Archeologia* 2 (1978) 23–8

Alsop, J., *The Rare Art Traditions* (New York 1982) esp. chap. 7

3. Commentaries on Particular Authors

A. Pliny

Jahn, O., "Über die Kunsturteile des Plinius," *Berichte Sächsische Akademie der Wissenschaft, Leipzig* (1850) 105–42

Urlichs, L., *Chrestomathia Pliniana* (Berlin 1857)

Furtwängler, A., "Plinius und seine Quellen über die bildenden Kunst," *Jahrbuch für klassische Philologie*, suppl. 9 (1877) 3–78

Münzer, F., "Zur Kunstgeschichte des Plinius," *Hermes* 30 (1895) 499–547

Sellers–Jex-Blake, *Chapters*

Kalkmann, A., *Die Quellen der Kunstgeschichte des Plinius* (Berlin 1898)

Ferri, S., "Note esegetiche ai guidizi d'arte di Plinio il Vecchio," *Annali della Scuola Normale Superiore di Pisa* (1942) 69–116

Ferri, S., *Plinio il Vecchio. Storia delle arti figurative* (Rome 1946)

Bieber, M., "Pliny and Graeco-Roman Art," *Hommages à Joseph Bidez et à Franz Cumont* (Collection Latomus 2) (Brussels 1949) 39–42

Bailostocki, J., "Topoi antiques dans des biographies d'artistes" [in Polish with Latin summary], *Meander* 15 (1960) 226–30

Coulson, W. D. E., "Studies in Chapters 34 and 36 of Pliny the Elder's Natural History, I–II" (Ph.D. Dissertation, Princeton University, 1968)

Patera, B., "Aspetti e momenti della critica d'arte nell'età classica e tardo-antica," *Annali del Liceo classico G. Garibaldi di Palermo* 7–8 (1970–1971) 431–62

Isager, J., "The Composition of Pliny's Chapters on the History of Art," *Analecta Romana Instituti Danici* 6 (1971) 49–62

Greenhalgh, M., "Pliny, Vitruvius and the Interpretation of Ancient Architecture," *GBA* 116 (1974) 297–304

Coulson, W. D., "The Reliability of Pliny's Chapters on Greek and Roman Sculpture," *The Classical World* 69 (1976) 361–72

André, J. M., "Nature et culture chez Pline l'Ancien," *Recherches sur les arts à Rome* (Paris 1978) 7–17

Preisshofen, F., "Kunsttheorie und Kunstbetrachtung," *Le classicisme à Rome aux 1ers siècles avant et après J.C.* (Fondation Hardt, Entretiens 25) (Geneva 1979) 263–77

Daneu Lattanzi, A., "A proposito dei libri sulle arte," *Plinio il Vecchio sotto il profilo storico e letterario. Atti del Covegno di Como, 5–6–7 ottobre 1979. Atti della Tavola rotonda nella ricorrenza centenaria della morte di Plinio il Vecchio, 16 decembre 1979* (Como 1982) 97–107

Gualandi, G., "Plinio e il collezionismo d'arte," *Plinio il Vecchio sotto il profilo storico e letterario. Atti del Covegno di Como, 5–6–7 ottobre 1979. Atti della Tavola rotonda nella ricorrenza centenaria della morte di Plinio il Vecchio, 16 decembre 1979* (Como 1982) 259–98

B. Pausanias

Kalkmann, A., *Pausanias der Perieget* (Berlin 1886)

Gurlitt, W., *Über Pausanias* (Graz 1890)

Heberdey, R., *Die Reisen des Pausanias* (Vienna 1894)

Robert, C., *Pausanias als Schriftsteller* (Berlin 1909)

Petersen, E., "Pausanias der Perieget," *RhM* 64 (1909) 481–538

Pasquali, G., "Die schriftstellerische Form des Pausanias," *Hermes* 48 (1913) 161–223

Imhoof-Blumer, F. and P. Gardner, *Ancient Coins Illustrating Lost Masterpieces of Greek Art. A Numismatic Commentary on Pausanias.* Edited by A. N. Oikonomides (Chicago 1964). Original article: *JHS* 7 (1886) 57–113

Strid, O., *Über die Sprache und Stil des Periegeten Pausanias* (Stockholm 1976)

Heer, J., *La personalité de Pausanias* (Paris 1979)

Zakrzewska, G., "Die Analyse der Kunstdenkmäler im Werk des Periegeten Pausanias" [in Polish with German summary], *Eos* 69 (1981) 199–220

Habicht, C., "Pausanias and the Evidence of Inscriptions," *Classical Antiquity* 3 (1984) 40–56

Habicht, C., *Pausanias' Guide to Ancient Greece* (Berkeley 1985)

C. Vitruvius

Sontheimer, L., *Vitruvius und seine Zeit* (Leipzig 1908)

Watzinger, C., "Vitruvstudien," *RhM* 64 (1909) 202–23

Pellati, F., "Vitruvio e la fortuna del suo trattato nel mondo antico," *Rivista di filologia e d'istruzione classica* 49 (1921) 305–35

Pellati, F., "Nuovi elementi per la datazione del trattato di Vitruvio," *Atti del III Congresso di Studi Romani* (Bologna 1935) 48–51

Pellati, F., *Vitruvio* (Rome 1938)

Schlikker, F. W., *Hellenistische Vorstellungen von der Schönheit des Bauwerks nach Vitruvius* (Berlin 1940)

Ferri, S., "Problemi di estetica vitruviana," *La Critica d'Arte* 6 (1941) 97–102

Tomei, P., "Appunti sull'estetica di Vitruvio," *Bollettino del Reale Istituto di Archeologia e Storia dell'Arte* 10 (1943) 57–73

Riemann, H., "Vitruv und der Griechische Tempel," *AA* 67 (1952) 1–38

Ferri, S., "Note archeologico-critiche al testo di Vitruvio," *ParPass* 8 (1953) 214–24

Ferri, S., *Vitruvio (dai libri I–VIII). De architectura quae pertinent ad disciplinas archaeologicas* (Rome 1960)

Edelstein, F., "L'idée de l'évolution dans l'oeuvre de Vitruve" [in Romanian with French summary], *Studii Clasice* 8 (1966) 143–53

Frézouls, E., "Sur la conception de l'art chez Vitruve," *Antiquitas Graeco-Romana ac tempora nostra. Acta Congressus internationalis habiti Brunae diebus 12–16 mensis Aprilis MCMLXVI* (Prague 1968) 439–49

Greenhalgh, M., "Pliny, Vitruvius and the Interpretation of Ancient Architecture," *GBA* 116 (1974) 297–304

Scranton, R. L., "Vitruvius' Arts of Architecture," *Hesperia* 43 (1974) 494–9

Gros, P., "Vie et mort de l'art hellénistique selon Vitruve et Pline," *Revue des études latines* 56 (1978) 289–313

Wesenberg, B., "Vitruvs griechischer Tempel," *Vitruv-Kolloquium des Deutschen Archäologen-Verbandes, durchgeführt an der Technischen Hochschule Darmstadt, 17–18 June 1982* (Darmstadt 1984) 65–96

D. Plato

Schuhl, P. M., *Platon et l'art de son temps* (Arts plastiques) (Paris 1933)

Webster, T. B. L., "Plato and Aristoteles as Critics of Greek Art," *SymbOslo* 29 (1952) 8–32

Schweitzer, B., *Plato und die bildende Künste der Griechen* (Tübingen 1953)

Lodge, R. C., *Plato's Theory of Art* (London 1953)

Bianchi Bandinelli, R., "Osservazioni storico-artistiche a un passo del «Sofista» platonico," *Studi in Onore di U. E. Paoli* (Florence 1956) 81–95

Schweitzer, B., *Plato und die Kunst seiner Zeit* (Tübingen 1958)

Weil, R., *L'archéologie de Platon* (Études & Commentaires 32) (Paris 1959)

Maguire, J. P., "Beauty and the Fine Arts in Plato. Some aporiae," *Harvard Studies in Classical Philology* 70 (1965) 171–93

Ringbom, S., "Plato on Images," *Theoria* 31 (1965) 86–109

Bianchi Bandinelli, R., "Plato und die Malerei seiner Zeit," *Antiquitas Graeco-Romana ac tempora nostra. Acta Congressus internationalis habiti Brunae diebus 12–16 mensis Aprilis MCMLXVI* (Prague 1968) 426–7

Cavarnos, C., "Plato's Critique of the Fine Arts," *Philosophia* 1 (1971) 296–314

Oates, W. J., *Plato's View of Art* (New York 1972)

Keuls, E., "Plato on Painting," *American Journal of Philology* 95 (1974) 100–27

Demand, N., "Plato and the Painters," *Phoenix* 29 (1975) 1–20

Brumbaugh, R. S., "Plato's Relation to the Arts and Crafts," *Facets of Plato's Philosophy.* Edited by W. H. Werkmeister (Assen 1976) 40–52

Keuls, E., *Plato and Greek Painting* (Leiden 1978)

Alexandrakis, A. and J. Knoblock, "The Aesthetic Appeal of Art in Plato and Aristotle," *Diotima* 6 (1978) 178–85

E. Aristotle

Butcher, S. H., *Aristotle's Theory of Poetry and Fine Art* (4th edn., London 1907)
Webster, T. B. L., "Plato and Aristoteles as Critics of Greek Art," *SymbOslo* 29 (1952) 8–32
Charlesworth, M. J., *Aristotle on Art and Nature* (Auckland 1957)
Propris, A. de, "L'estetica classica e le prospettive moderne. Definizione dell'arte in Aristotle," *Rivista di Studi Classici* 6 (1958) 165–89
Davies, J. C., "Aspects of Aristotelian Aesthetics," *Euphrosyne* 5 (1972) 111–20
Alexandrakis, A. and J. Knoblock, "The Aesthetic Appeal of Art in Plato and Aristotle," *Diotima* 6 (1978) 178–85

F. Writers on Rhetoric

Becatti, G., *Arte e gusto negli scrittori latini* (Florence 1951)
Tatarkiewicz, W., "Classification of the Arts in Antiquity," *Journal of the History of Ideas* 24 (1963) 231–40
Preisshoffen, F. and P. Zanker, "Reflex einer eklektischen Kunstanschauung beim Auctor ad Herrennium," *Dialoghi di Archeologia* 1 (1970/71) 100–19
Michel, A., "Rhétorique, philosophie et esthétique générale. De Cicéron à Eupalinos," *Revue des études latines* 51 (1973) 302–26
Preisshofen, F., "Kunsttheorie und Kunstbetrachtung," *Le classicisme à Rome aux 1ers siècles avant et après J.C.* (Fondation Hardt, Entretiens 25) (Geneva 1979) 263–82
Teyssier, M. L., "Cicéron et les arts plastiques. Peinture et sculpture," *Caesarodunum* 19bis (1984) 67–76

4. Linear B Tablets

Ventris–Chadwick, *DMG*
Palmer, L. R., *The Interpretation of Mycenaean Texts* (Oxford 1963)
Chadwick, J., *The Mycenaean World* (Cambridge 1976) chap. 8

5. Mycenaean Monuments

Webster, T. B. L., *From Mycenae to Homer* (New York 1958)
Marinatos, S. and M. Hirmer, *Crete and Mycenae* (New York 1960)
Mylonas, G. E., *Mycenae and the Mycenaean Age* (Princeton 1966)
Hood, S. *The Arts in Prehistoric Greece* (Harmondsworth and New York 1978)

6. Telchines

Herter, in *RE*, s.v. "Telchinen," (1934) 197–224

7. Daidalos

Déonna, W., *Dédale* II (Paris 1931) 21–7
Rumpf, A., "Daidalos," *BonnJbb* 135 (1930) 74–83

Hanfmann, G. M. A., "Daidalos in Etruria," *AJA* 39 (1935) 189–94

Becatti, G., "La legenda di Dedalo," *RömMitt* 60–1 (1953–1954) 22–36

Frontisi-Ducroux, F., "Dédale et Talos. Mythologie et histoire des techniques," *Revue historique* 94 (1970) 281–96

Frontisi-Ducroux, F., "Dédale. Recherche sur le vocabulaire, les techniques et les traditions légendaires," *Annuaire de l'École pratique des Hautes Études, Vᵉ section*, 80–81, 2 (1972–1973 and 1973–1974) 106–7

Frontisi-Ducroux, F., *Dédale. Mythologie de l'artisan en Grèce ancienne* (Paris 1975)

Philipp, H., *Tektonon Daidala* (Berlin 1968)

Boardman, J., "Daedalus and Monumental Sculpture," *Proceedings of the Fourth National Cretological Congress (Herakleion 1976)*, vol. AI (Athens 1980) 44–7

8. Homer and the Arts

Nilsson, M. P., *Homer and Mycenae* (London 1933)

Lorimer, H. L., *Homer and the Monuments* (London 1950)

Webster, T. B. L., *From Mycenae to Homer* (London 1958)

Hurwit, J., *The Art and Culture of Early Greece* (Ithaca and London 1985) esp. chap. 3

SCULPTORS

The following bibliographies concentrate on special studies devoted to particular artists and to particular extant sculptures. Although I have not always cited individual sections within some of the basic survey works that deal with the careers of Greek sculptors, readers will find it useful to consult the following works in most cases:

Furtwängler, Adolf, *Meisterwerke der griechischen Plastik* (Leipzig 1893). English translation, with revisions, by E. Sellers, entitled *Masterpieces of Greek Sculpture* (London 1895; revised reprint, Chicago 1964)

Picard, Charles, *Manuel d'archéologie grecque: La sculpture* (Paris 1935–64)

Richter, G. M. A., *The Sculpture and Sculptors of the Greeks* (4th edn., New Haven 1970)

Stewart, Andrew, *Greek Sculpture: An Exploration* (New Haven 1990)

9. The Daidalidai

A. Dipoinos and Skyllis

Déonna, W., *Dédale* II (Paris 1931) 130–1

B. Endoios

Lechat, H., "Le sculpteur Endoios," *REG* 5 (1892) 385–402

Payne, H. and G. M. Young, *Archaic Marble Sculpture from the Acropolis* (2nd edn., London 1950) 46–7

Rumpf, A., "Endoios, ein Versuch," *Critica d'Arte* 14 (1938) 41–48

Raubitschek, A. E., "An Original Work of Endoios," *AJA* 46 (1942) 245–53

Raubitschek, *Dedications* (1949), nos. 7 and 70, pp. 491–5

Stucchi, S., "Una recente terracotta siciliana di Atena Ergane ed una proposta intorno all'Atena Delta di Endoios," *RömMitt* 63 (1956) 122–8
Bombelli, A., "Kallias," *ArchCl* 8 (1956) 45–6
Deyhle, W., "Meisterfragen der archaischen Plastik Attikas," *AthMitt* 84 (1969) 1–64
Knigge, U., "Zum Kuros vom Piräischen Tor," *AthMitt* 84 (1969) 76–86
Waele, J. A. de, "The Athena of Endoios in Erytheia. A Crux in Pausanias (7.5.9)," *Platon* 32–33 (1980–1981) 263–4

C. Smilis

Lacroix, *Reproductions* 206–16

D. Klearchos

Franciscis, A. de, "Klearchos di Regio," *Klearchos* 1 (1959) 26–30

E. Megarian Treasury at Olympia

Bol, P. C., "Die Giebelskulpturen des Schatzhauses von Megara," *AthMitt* 89 (1974) 65–74

10. Sculpture in Early Sparta: Bathykles and Gitiadas

A. Bathykles

Fiechter, E., "Amyklae, Der Thron des Apollon," *JdI* 33 (1918) 107–245
Klein, W., "Zum Thron des Apollo von Amyklae," *AA* 37 (1922) 6–13
Martin, R., "Bathykles de Magnésie et le trône d'Apollon à Amyklae," *RA* (1976) 205–18

B. Gitiadas

Dickins, G., "Laconia, I. Excavations at Sparta, 1907. 7: The Hieron of Athena Chalkioikos," *BSA* 13 (1906–1907) 137–54
Pick, B., "Athenische Statuen auf Münzen," *Festgabe H. Blümmer* (Zurich 1914) 489ff.
Comfort, H., "Pausanias III.17.7f. and v.24.31," *AJA* 35 (1931) 314–18
Lacroix, *Reproductions* 217–20
Dontas, G., "*Lakon komastes*," *BCH* 93 (1969) 39–55

11. Theodoros and Rhoikos (as sculptors)

Brunn, *GgK* 23–9
Schmidt, G., "Zwei altsamische Meister," *AthMitt* 86 (1971) 31–41

12. Archermos and the School of Chios

Raubitschek, *Dedications* (1949) 484

Scherrer, P., "Das Weihgeschenk von Mikkiades und Archermos auf Delos," *ÖJh* 54 (1983) 19–25
Sheedy, K., "The Delian Nike and the Search for Chian Sculpture," *AJA* 89 (1985) 619–26

13. Butades, Demaratos, and Early Sculptors in Terracotta

Williams, C. K., "Damaratus and Early Corinthian Roofs," *STELE* 345–50

14. Kleobis and Biton

Richter, *Kouroi* 49–50
Pollitt, *Art and Experience in Classical Greece* (Cambridge 1972) 7–9
Vatin, C., *BCH* 106 (1982) 509–25 (challenges identification)

15. Earliest Portrait Sculpture

Zinserling, V., "Die Anfänge griechischer Porträtkunst als gesellschaftliches Problem," *Acta Antiqua Academiae Scientiarum Hungaricae* 15 (1967) 283–95
Robertson, *HGA* 110–11

16. Ageladas

Frickenhaus, A., "Hagelades," *JdI* 26 (1911) 24–34
Lacroix, *Reproductions* 227–32
Robinson, C. A., "The Zeus Ithomatas of Ageladas," *AJA* 49 (1945) 121–7
Beyen, H. G. and C. W. Vollgraff, *Argos et Sicyone* (The Hague 1947) 1–39
De la Coste-Messelière, P., "L'offrande delphique des Tarentins 'du bas'," *Mélanges d'archéologie et d'histoire offerts à Charles Picard* (Paris 1949) II 522–32
Gross, W. H., "Kultbilder, Blitzschwinger und Hagelades," *RömMitt* 70 (1963) 13–19

17. Kanachos

Kekulé von Stradonitz, R., "Über den Apoll des Kanachos," *Sitzungsberichte der königlich Preussischen Akademie der Wissenschaften* 45 (1904) 786–801
Lacroix, *Reproductions* 221–6
Beyen, H. G. and C. W. Vollgraff, *Argos et Sicyone* (The Hague 1947) 49–80
Carretoni, G., "L'Apollo della fonte di Giuturna e l'Apollo di Kanachos," *BdA* 34 (1949) 193–7
Brommer, F., "Vorhellenistische Kopien und Wiederholungen von Statuen," *Studies Presented to D. M. Robinson on his 70th Birthday* I (St Louis 1951) 664–82 esp. 677
Simon, E., "Beobachtungen zum Apollon Philesias des Kanachos," *Charites. Studien zur Altertumswissenschaft E. Langlotz gewidmet* (Bonn 1957) 38–46

18. Kallon of Aegina

Raubitschek, *Dedications* (1949) 508–9

243

19. Kallon of Elis

Dörig, J., "Kalon d'Élide," *Mélanges d'histoire ancienne et d'archéologie offerts à Paul Collart* (Lausanne and Paris 1976) 125–46

20. Hegias (Hegesias)

Furtwängler, *Masterworks* 53, 171
Anti, C., "Alto relievo di stile severo da Eleusi," *ASAtene* 4–5 (1921–1922) 71–95
Picard, *Manuel* II (1939) 43–5
Raubitschek, *Dedications* (1949) no. 94 and pp. 504–5
Congdon, L. O. K., "The Mantua Apollo of the Fogg Art Museum," *AJA* 67 (1963) 7–13

21. Onatas

Dörig, J., *Onatas of Aegina* (Leiden 1977)

Homann-Wedeking, E., "Zu Meisterwerken des strengen Stils," *RömMitt* 55 (1940) 196–218
Raubitschek, *Dedications* (1949) no. 236, p. 287; no. 257, pp. 520ff.
Amandry, P., "Notes de topographie et d'architecture delphique. II: Le monument des Tarentins du Haut," *BCH* 73 (1949) 447–63
Schuchhardt, W. H., "Zur Athena-Gigantengruppe aus Laurion," *Charites. Studien zur Altertumswissenschaft E. Langlotz gewidmet* (Bonn 1957) 59–62
Schefold, K., "Die Aigineten, Onatas und Olympia," *AntK* 16 (1973) 90–6
Hafner, G., "Taras und Phalanthos," *Klearchos* 24, 1982 (1985) 95–122

22. Antenor

Studniczka, F., "Die beiden Fassungen der Tyrannenmördergruppe," *NJbb* 17 (1906) 545–9
Schefold, K., "Kleisthenes. Der Anteil der Kunst an der Gestaltung des jungen attischen Freistaates," *MusHelv* (1946) 59–93, esp. 62ff.
Payne, H. and G. M. Young, *Archaic Marble Sculpture from the Acropolis* (2nd edn., London 1950) 31–3, 63–5
Becatti, G., "I Tirannicidi di Antenor," *ArchCl* 9 (1957) 97–107
Langlotz, E., "Aristogeitonkopf des Antenor?" *AthMitt* 71 (1956) 149–52
Schunck, K. D., "Die Aufstellung der beiden Tyrannenmördergruppen," *Das Alterthum* 5 (1959) 142–52
Deyhle, W., "Meisterfragen der archaischen Plastik Attikas," *AthMitt* 84 (1969) 1–64, esp. 39–46
Dörig, J., "La tête Webb, l'Harmodios d'Anténor et la problème des copies romaines d'après des chefs-d'oeuvre archaïques," *AntK* 12 (1969) 41–50
Moggi, M., "In merito alla datazione dei Tirannicidi di Antenor," *Annali della Scuola Normale Superiore di Pisa* 1 (1971) 17–63
Ridgway, *Archaic Style* 206–10

23. Menaichmos and Soidas

Studniczka, F., "Die archaische Artemisstatuette aus Pompeii," *RömMitt* 3 (1888) 277–302

Anti, C., "L'Artemis laphria di Patrai," *ASAtene* 2 (1916) 181–99

Gardner, P., *New Chapters in Greek Art* (London 1926) 182–7

Lacroix, *Reproductions* 232–8

Giuliano, A., "Fuit apud Segestanos ex aere Dianae simulacrum," *ArchCl* 5 (1953) 48–54 (statue from Pompeii)

24. Kritios and Nesiotes

Brunnsåker, S., *The Tyrant Slayers of Kritios and Nesiotes* (2nd edn., Stockholm 1971)

Raubitschek, *Dedications* (1949) nos. 120–3 and 160–1, pp. 513–17

Schunck, K. D., "Die Aufstellung der beiden Tyrannenmördergruppen," *Das Alterthum* 5 (1959) 142–52

Shefton, B., "Some Iconographic Remarks about the Tyrannicides," *AJA* 64 (1960) 173–9

Ridgway, *Severe Style* 79–83

Calabri Limentani, I., "Armodio e Aristogitone, gli uccisi del tiranno," *Acme* 29 (1976) 9–27

Weber, M., "Die Gruppe der Tyrannenmörder bei Lukian," *AA* (1983) 199–299

Taylor, M. W., *The Tyrant Slayers. The Heroic Image in 5th Century B.C. Athenian Art and Politics* (New York 1981)

25. Pythagoras

Lechat, H., *Pythagoras de Rhegion* (Lyons 1905)

Waldhauer, O., "Der Torso Valentini," *AA* (1926) 326–30

Langlotz, E., *Frühgriechische Bildhauerschulen* (Nuremberg 1927) 147–52

Langlotz, E., "Epimetheus," *Die Antike* (1930) 1–14

Orsi, P., "Templum Apollonis Alaei ad Crimisa-Promontorium," *AttiMGrecia* (1932) 7–182, esp. 135–70

Picard, *Manuel* II (1939) 111–24

Franciscis, A. de, "Pythagoras di Regio," *Klearchos* 2 (1960) 5–56

Hofkes-Brukker, C., "Pythagoras von Rhegion: ein Phantom?" *BABesch* 39 (1964) 107–14

Knigge, U., *Bewegte Figuren der Grossplastik im strengen Stil* (Diss. Munich 1965)

Linfert, A., "Pythagoras – Einer oder Zwei?" *AA* (1966) 495–6

Rolley, C., "Sculptures nouvelles à l'agora de Thasos," *BCH* 88 (1964) 496–524

Inan, J., "Three Statues from Side," *AntK* 13 (1969) 17–33

Ridgway, *Severe Style* 83–4

Frel, J., "L'auriga die Mozia. Un'opera di Pitagora di Reggio," *ParPass* 40 (1985) 64–8

26. Kalamis

Orlandini, P., *Calamide. Bibliografia e sviluppo della questione dalle origini ai nostri giorni* (Bologna 1950)

Orlandini, P., *Calamide. 1. Le fonti, 2. Ricostruzione della personalità di Calamide attraverso le fonti, 3. Il problema della Sosandra* (Bologna 1950)

Reisch, E., "Kalamis," *ÖJh* 9 (1906) 199–268
Studniczka, F., "Kalamis," *Abhandlungen der Sächsischen Akademie der Wissenschaften zu Leipzig. Philologisch-historische Klasse* 25, no. 4 (1907)
Six, J., "Kalamis," *JdI* 30 (1915) 74–95
Anti, C., "Calamide," *AttiVen* (1922–1923) 1105–20
Thompson, H., "Buildings on the West Side of the Athenian Agora," *Hesperia* 6 (1937) 1–222, esp. 109
Picard, *Manuel* II (1939) 45–66
Raubitschek, *Dedications* (1949) 505–8
Napoli, M., "Una nuova replica della Sosandra di Calamide," *BdA* 39 (1954) 1–10
Frel, J., "Un document nouveau sur l'Apollon de Kalamis" [in Bulgarian with French summary], *Bulletin de l'Institut Archéologique Bulgare* 21 (1957) 203–9
Dörig, J., "Alkmene, ein Werk des Kalamis?" Summary in *AntK* 6 (1963) 82
Rolley, C., "Sculptures nouvelles à l'agora de Thasos," *BCH* 88 (1964) 496–524
Dörig, J., "Kalamis-Studien," *JdI* 80 (1965) 138–265
Croissant, F. and C. Rolley, "Deux têtes féminines d'époque classique," *BCH* 89 (1965) 317–31, esp. 317–23
Manzova, L., "Nouvelles études sur la stèle d'Anaxandre d'Apollonia" [in Bulgarian with German summary], *Bulletin de l'Institut Archéologique Bulgare* 32 (1970) 255–75
Ridgway, *Severe Style* 87
Calder, W. M., "Kalamis Atheniensis?" *Greek, Roman and Byzantine Studies* 15 (1974) 271–7
Frel, J., "A Hermes by Kalamis and Some Other Sculptures," *The J. Paul Getty Museum Journal* 1 (1974) 55–60
Lorber, F., "Alkmene des Kalamis?" *Tainia. Roland Hampe zum 70. Geburtstag am 2. Dezember 1978 dargebracht von Mitarbeitern, Schülern & Freunden* (Mainz 1980) 197–200
Hedrick, C. W., "The Temple and Cult of Apollo Patroos in Athens," *AJA* 92 (1988) 185–210, esp. 195–8

27. Myron

A. General

Arias, P. E., *Mirone, Quaderni per lo studio dell'archeologia* (Florence 1940)

Furtwängler, *Masterworks* 161–219
Mirone, S., *Mirone di Eleutere* (Catania 1921)
Bulle, H., "Die samische Gruppe des Myron," *Festchrift Paul Arndt zu seinem 60. Geburtstag* (Munich 1925) 62–86
Jenkins, C.K., "The Reinstatement of Myron," *Burlington Magazine* 49 (1926) 182–92; "The Reinstatement of Myron, II," *Burlington Magazine* 50 (1927) 189–96; "The Reinstatement of Myron, III," *Burlington Magazine* 53 (1928) 36–43; "The Reinstatement of Myron, IV," *Burlington Magazine* 56 (1930) 147–54
Picard, *Manuel* II (1939) 223–56
Poulsen, V. H., "Myron. Ein stilkritischer Versuch," *ActaA* 11 (1940) 1–42

Homann-Wedeking, E., "Zu Meisterwerken des strengen Stils," *RömMitt* 55 (1940) 196–218

Ridgway, *Severe Style* 85–6

Fuá, O., "L'idea dell'opera d'arte 'vivente' e la bucula di Mirone nell'epigramma greco e latino," *Rivista di Cultura classica e medioevale* 15 (1973) 49–55

B. *Diskobolos*

Paribeni, E., "Il discobolo Lancelotti," *BdA* 34 (n.s. 4) (1949) 289–92

Paribeni, E., *Sculture greche. Museo Nazionale Romano* (Rome 1955)

Sümeghy, V., "Das Problem des Myronischen Diskobol," *Atti del settimo Congresso internazionale di Archeologia classica, Rome–Naples 6–13 Sept. 1958* I (Rome 1961) 281–5

Anschütz, W. and M. L. Huster, "Im Olympiajahr 1984. Der Diskobol zwischen Leitungssport und Regelzwang. Wie musste er werfen? *Hephaistos* 5–6 (1983–1984) 71–89

C. *Athena and Marsyas Group*

Sauer, B., "Die Marsyasgruppe des Myron," *JdI* 23 (1908) 251–62

Andrén, A., "Der lateranische Silen und die Gruppe von Athena und Marsyas," *Opuscula Archaeologica* 3 (1944) 1–36

Schlaf, J., "Grupa Myrona. Marsjasz i Atena" [in Polish with Latin summary], *Meander* 19 (1964) 214–26

Schlaf, J., "Herméneutique du groupe de Marsyas et Athéna de Myron" [in Polish with Latin summary], *Meander* 20 (1965) 371–82

Schauenburg, B. and K., "Torso der myronischen Athena Hamburg," *Antike Plastik* 12 (1973) 47–67

Weis, H. A., "The Marsyas of Myron. Old Problems and New Evidence," *AJA* 83 (1979) 214–19

Paribeni, E., "Una postilla sull'Athena mironiana Frankfurt," *Studies in Classical Art and Archaeology. A Tribute to Peter Heinrich von Blanckenhagen* (Locust Valley, N.Y., 1979) 89–90

Daltrop, G., *Il gruppo Mironiano di Atena e Marsia nei Musei Vaticani* (Vatican 1980)

D. *Other Attributions*

Dörig, J., "Myrons Erechtheus," *Antike Plastik* 6 (1967) 59–62

Berger, E., "Zum samischen Zeus des Myron in Rom," *RömMitt* 76 (1969) 66–92

Bol, P. C., "Zur Basis Albano im Kapitolinischen Museum," *RömMitt* 77 (1970) 185–8

Bruskari, M., "Über einen kolossalen Marmorkopf in Akropolismuseum," *ÖJh* 54 (1983) 99–101

28. Telephanes

Furtwängler, *Masterworks* 57

Arvanitopoulos, A. S., "The Bronze Statue from the Sea off Artemiseion," *Polemon* I (1929) fasc. 2 79–94 [in Greek]

Langlotz, E., "Die Larisa des Telephanes," *MusHelv* 8 (1951) 157–70

29. Pheidias

A. General

Léchat, H., *Phidias et la sculpture grecque au Ve siècle* (Paris 1924)
Hekler, A., *Die Kunst des Phidias* (Stuttgart 1924)
Schrader, H., *Phidias* (Frankfurt 1924)
Schweitzer, B., "Prolegomena zur Kunst des Parthenon-Meister," *JdI* 53 (1938) 1–89
Schweitzer, B., "Zur Kunst des Parthenon-Meister," *JdI* 54 (1939) 1–96
Picard, *Manuel* II (1939) 308–521
Schweitzer, B., "Pheidias der Parthenon-Meister," *JdI* 55 (1940) 170–241
Langlotz, E., *Phidias-probleme* (Frankfurt 1947)
Buschor, E., *Pferde des Phidias* (Munich 1948)
Buschor, E., *Phidias der Mensch* (Munich 1948)
Langlotz, E., "Phidias," *Vermächtnis der antiken Kunst* (Heidelberg 1950) 71–9
Becatti, G., *Problemi Fidiaci* (Milan 1951)
Frel, J., *Feidias* (Bratislava 1953)
Schweitzer, B., "Neue Wege zu Pheidias," *JdI* 72 (1957) 1–18
Laurenzi, L., *Umanità di Fidia* (Studia archaeologica 3) (Rome 1961)
Donnay, G., "Art et politique dans l'Athènes classique," *GBA* 104 (1962) No. 59, 5–20
Mallwitz, A. and W. Schiering, *Die Werkstatt des Pheidias, I* (Berlin 1964)
Schweitzer, B., *Alla ricerca di Fidia* (Milan 1967)
Gavela, B., "Phidias. Leben, Werk, und Bedeutung," *Altertum* 19 (1973) 207–21
Innes, D. C., "Phidias and Cicero, Brutus 70," *CQ* 28 (1978) 470–1
Ridgway, *Fifth Century* 161–71

B. Trial

Pareti, L., "Il processo di Fidias e un papiro di Ginevra," *RömMitt* 24 (1909) 271–316
Nicole, J., *Le procès de Phidias dans les chroniques d'Apollodore d'après un papyrus inédit de la collection de Genève* (Geneva 1910)
Bijvanck, A. W., "Le procès de Phidias," *Symbolae ad ius et historiam antiquitatis pertinentes I. C. van Oven dedicatae* (ed. M. David, B. A. van Groningen, and E. M. Meijers) (Leiden 1946) 82–91
Jacoby, F., *Die Fragmente der griechischen Historiker. III: Geschichte von Städten und Völkern. B, Suppl.: Commentary on the Historians of Athens* (Leiden 1954) 484–96
Lendle, O., "Philochoros über den Prozess des Phidias," *Hermes* 83 (1955) 284–303
Donnay, G., "La date du procès de Phidias," *AntCl* 37 (1968) 19–36
Prandi, L., "I processi contro Fidia Aspasia Anassagora e l'opposizione a Pericle," *Aevum* 51 (1977) 10–26
Triebel-Schubert, C., "Zur Datierung des Phidiasprozesses," *AthMitt* 98 (1983) 101–12

C. Parthenon Sculptures (Basic references only)

Michaelis, A., *Der Parthenon* (Leipzig 1870–1)
Smith, A. H., *The Sculptures of the Parthenon* (London 1910)

Brommer, F., *Die Metopen des Parthenon* (Mainz 1967)
Brommer, F., *Die Giebel des Parthenon* (Mainz 1975)
Brommer, F., *Der Fries des Parthenon* (Mainz 1977)
Brommer, F., *The Sculpture of the Parthenon. Metopes, Friezes, Pediments, Cult-Statues* (London 1979)
Parthenon-Kongress: Basel 4.–8. April 1982. Referate und Berichte (Mainz 1984) [large collection of recent studies on all aspects of the building and its sculptures]
Boardman, J., *The Parthenon and its Sculptures* (London 1985)

D. Zeus

Sieveking, J. and E. Buschor, "Niobiden," *Münchner Jahrbuch für bildenden Kunst* 7 (1912) 111–46, esp. 138–46
Winter, F., "Des Zeus und die Athena Parthenos des Pheidias," *ÖJh* 18 (1915) 1–16
Giglioli, G. Q., "Il trono dello Zeus di Fidia in Olimpia," *MemLinc* ser. 5, 16 (1922) 219–376
Guidi, G., "Lo Zeus di Cirene," *Africa Italiana* 1 (1927) 3–40
Langlotz, E., "Die Niobidenreliefs des fünften Jahrhunderts," *Die Antike* 4 (1928) 31–41
Mustilli, D., "Studi Fidiaci: Asklepios e Zeus," *BullComm* 61 (1933) 7–24
Eichler, F., "Thebanische Sphinx. Ein Bildwerk aus Ephesos," *ÖJh* 30 (1937) 75–110
Schrader, H., "Das Zeusbild des Pheidias in Olimpia," *JdI* 56 (1941) 1–71
Pfeiffer, R., "The Measurements of the Zeus at Olympia," *JHS* 61 (1941) 1–5
Schuchhardt, W. H., "Die Niobidenreliefs vom Zeusthron in Olympia," *Mitteilungen des Deutschen Archäologischen Instituts* 1 (1948) 95–137
Santangelo, M., "Una terracotta di Falerii e lo Zeus di Fidia," *BdA* 33 (1948) 1–16
Liegle, J., *Der Zeus des Phidias* (Berlin 1952)
Morgan, C. H., "Pheidias and Olympia," *Hesperia* 21 (1952) 295–339
Franciscis, A. de, "Una nuova replica del fregio dei Niobidi," *Bollettino di Storia dell'Arte del Magistero di Salerno* 3 (1953) 24–7
Kunze, E., "Die Ausgrabungen in Olympia im Winter 1954–1955," *Gnomon* 27 (1955) 220–4 and 28 (1958) 318–20
Morgan, C. H., "Footnotes to Pheidias and Olympia," *Hesperia* 24 (1955) 164–8
Kunze, E., *Neue deutsche Ausgrabungen in Mittelmeergebiet und im vordern Orient* (Berlin 1959) 277–91
Herington, J., "The Temple of Zeus at Cyrene. Studies and Discoveries in 1954–1957. II: The Cult Statue," *BSR* 26 (1958) 41–61
Eichler, F., "Nochmals die Sphinxgruppe aus Ephesos," *ÖJh* 45 (1960) 5–22
Harris, B. F., "The Olympian Oration of Dio Chrysostom," *Journal of Religious History* 2 (1962) 85–97
Richter, G. M. A., "The Pheidian Zeus at Olympia," *Hesperia* 35 (1966) 166–70
Fink, J., *Das Spätwerk des Phidias. Der Zeus-Thron von Olympia* (Munich 1967)
Vasić, R., "The Date of Phidias' Zeus," *Ziva Antika* 18 (1968) 129–40
Pannuti, U., "Lo Zeus e l'ergasterion di Fidia ad Olimpia," *RendNap* 43 (1968) 3–18
Mingazzini, P., "Lo Zeus di Dresda, lo Zeus di Cirene, lo Zeus di Faleri et lo Zeus di Fidia," *ASAtene* 31–32 (1969–1970) 71–84
Mallwitz, A., *Olympia und seine Bauten* (Darmstadt–Munich 1972) 255–66
Gentili, G. V., "Il freggio fidiaco dei Niobidi alla luce nuovo frammento da Modena," *BdA* 59 (1974) 101–5

Vogelpohl, C., "Die Niobiden vom Thron des Zeus in Olympia. Zur Arbeitsweise römischer Kopisten," *JdI* 95 (1980) 197–226

Shefton, B., "The Krater from Baksy," *The Eye of Greece. Studies in the Art of Athens* [Festschrift M. Robertson] (Cambridge 1982) 149–81, esp. 162ff

E. Athena Parthenos

I. GENERAL

Leipen, N., *Athena Parthenos: A Reconstruction* (Royal Ontario Museum, Toronto 1971)

Stevens, G.P., "Remarks upon the Colossal Chryselephantine Statue of Athena in the Parthenon," *Hesperia* 24 (1955) 240–76

Herington, C. J., *Athena Parthenos and Athena Polias* (Manchester 1955)

Richter, G. M. A., "Was there a Vertical Support under the Nike of the Athena Parthenos?" *Studi in onore di A. Calderini e R. Paribeni* (Milan 1956) III, 147–53

Gerkan, A. von, "Das Gold der Parthenos," *Wissenschaftliche Zeitschrift der Ernst Moritz Arndt Universität Greifswald* 5 (1955–1956) 55–8 and 304

Brommer, F., *Die Athena Parthenos des Phidias* (Opus nobile 2) (Bremen 1957)

Carpenter, R., "The Nike of Athena Parthenos," *ArchEph* 1953–1954, B' (1958) 41–55

Stevens, G.P., "Concerning the Parthenos," *Hesperia* 30 (1961) 1–7

Schuchhardt, W.H., "Athena Parthenos," *Antike Plastik* 2 (1963) 31–53

Nocentini, S., "Sintassi decorativa nell'elmo della Parthenos fidiaca," *ParPass* 20 (1965) 246–60

Donnay, G., "Les comptes de l'Athéna chryséléphantine du Parthénon," *BCH* 91 (1967) 50–86

Donnay, G., "L'Athéna chryséléphantine dans les inventaires du Parthénon," *BCH* 92 (1968) 21–8

Botta Morizio, V., "L'Athena Parthenos della Galleria Borghese," *Annali della Facoltà di Lettere e Filosofia, Bari* 15 (1972) 7–60

Prag, A.J.N.W., "Athena Macuniensis. Another Copy of the Athena Parthenos," *JHS* 92 (1972) 96–114

Schiff, F., "Athena Parthenos, die Vision des Phidias," *AntK* 16 (1973) 4–44

Fehr, B., "Zur religionspolitischen Funktion der Athena Parthenos im Rahmen des delisch-attischen Seebundes, I," *Hephaistos* 1 (1979) 71–91

Fehr, B., "Zur religionspolitischen Funktion der Athena Parthenos im Rahmen des delisch-attischen Seebundes, II," *Hephaistos* 2 (1980) 113–25

Lewis, D.M., "Athena's Robe," *Scripta classica Israelica* 5 (1979–1980) 28–9

Leipen, N., "Athena Parthenos; Problems of Reconstruction," *Parthenon-Kongress: Basel 4–8 April 1982. Referate und Berichte* (Mainz 1984) 177–81 and 405–6

Vermeule, C., "Athena of the Parthenon by Pheidias: A Graeco-Roman Replica of the Roman Imperial Period," *Journal of the Museum of Fine Arts, Boston* 1 (1989) 41–60

2. SHIELD

Stavropoulos, F., *The Shield of the Athena Parthenos of Pheidias* (Athens 1930) [in Greek]

Schrader, H., "Zu den Kopien nach dem Schildrelief der Athena Parthenos," *Corolla L. Curtius zum sechzigsten Geburtstage dargebracht* (Stuttgart 1937) 81–88

Salis, A. von, "Die Gigantomachie am Schilde der Athena Parthenos," *JdI* 55 (1940) 90–169

Bielefeld, E., *Amazonomachia* (Hallische Monographien 2) (Halle–Saale 1951)

Praschniker, C., "Das Basisrelief der Parthenos," *ÖJh* 39 (1952) 7–12

Walter, A., "Gigantomachien," *AthMitt* 69–70 (1954–1955) 95–104

Buschor, E., *Medusa Rondanini* (Stuttgart 1958)

Favaretto, I., "Una nuova replica della testa dell'Athena Parthenos fidiaca", *AttiVen* 119 (1960–1961) 281–98

Fink, J., "Amazonenkämpfe auf einer Reliefbasis in Nikopolis," *ÖJh* 47 (1964–1965) 70–92

Harrison, E.B., "The Composition of the Amazonomachy on the Shield of Athena Parthenos," *Hesperia* 35 (1966) 107–33

Strocka, V.M., *Piräusreliefs und Parthenosschild. Versuch einer Wiederherstellung der Amazonomachie des Phidias*. Ph.D. Dissertation, Freiburg (Berlin, 1967)

Preisshofen, F., "Phidias-Daedalus auf dem Schild der Athena Parthenos?" *JdI* 89 (1974) 50–69

Hoelscher, T. and E. Simon, "Die Amazonenschlacht auf dem Schild der Athena Parthenos," *AthMitt* 91 (1976) 115–48

Floren, J., "Zu den Reliefs auf dem Schild der Athena Parthenos," *Boreas* 1 (1978) 36–67

Harrison, E.B., "Motifs of the City Siege on the Shield of the Athena Parthenos," *AJA* 85 (1981) 281–317

F. *Athena Promachos*

Dinsmoor, W.B., " Attic Building Accounts, IV: The Statue of the Athena Promachos," *AJA* 25 (1921) 118–29

Pfuhl, E., "Die grosse eherne Athena des Phidias," *AthMitt* 57 (1932) 151–7

Stevens, G.P., "The Pedestal of the Athena Promachos," *Hesperia* 15 (1946) 107–14

Kluwe, E., "Studien zur grossen «ehernen» Athena des Phidias," *Der Krise der griechischen Polis. Görlitzer Eirene-Tagung* (ed. O. Jurewicz and H. Kuch) *10–14. 10. 1967* (Berlin 1969) 21–8

Groothand, M.H., "The Owl on Athena's Hand," *BABesch* 43 (1968) 35–51

Ridgway, *Fifth Century* 169

Linfert, A., "Athenen des Phidias," *AthMitt* 97 (1982) 57–77

G. *Aphrodite Ourania*

Settis, S., *Chelone. Saggio sull'Afrodite Urania de Fidia* (Pisa 1966)

Harrison, E.B., "A Pheidian Head of Aphrodite Ourania," *Hesperia* 53 (1984) 379–88

H. *Athena Areia*

Thiersch, H., "Die Athena Areia des Phidias und der Torso Medici in Paris," *Nachrichten von der Akademie der Wissenschaften in Göttingen* 2, 10 (1936–38) 211–57

I. *Athena Lemnia*

Furtwängler, *Masterworks* 1–26

Waele, J.A. de, "Pheidias' und Euphranors Kelidouchoi? Plinius n.h. 34, 54 und 78," *AA* (1979) 27–30

Hartswick, K., "The Athena Lemnia Reconsidered," *AJA* 87 (1983) 335–46

Palagia, O., "*Erythema . . . anti kranous*, In Defense of Furtwängler's Athena Lemnia," *AJA* 91 (1987) 81–4

Protzmann, H., "Antiquarische Nachlese zu den Statuen der sogennanten Lemnia Furtwängler's in Dresden," *Staatliche Kunstsammlung Dresden, Jahrbuch* 16 (1984) 8–21

Harrison, E.B., "Lemnia and Lemnos: Sidelights on a Pheidian Athena," *Kanon* (1988) 101–7

J. Marathon Group

Berger, E., "Das Urbild des Kriegers aus der Villa Hadriana und die marathonische Gruppe des Phidias in Delphi," *RömMitt* 65 (1958) 6–32

Raubitschek, A.E., "Zu den zwei attischen Marathondenkmälern in Delphi," *Mélanges hélleniques offerts à Georges Daux* (Paris 1974) 315–16

Fuchs, W., "Zu den Grossbronzen von Riace," *Boreas* 4 (1981) 25–8

K. Other Attributions

Dontas, G.S., "Un'opera del giovane Fidia," *ASAtene* 21–22 (1959–1960) 309–20

Metzler, D., "Ein neues Porträt des Pheidias?" *AntK* 7 (1964) 51–5

Strocka, V.M., "Aphroditekopf in Brescia," *JdI* 82 (1967) 110–56

Becatti, G., "Restauro dell'Afrodite seduta fidiaca," *Omaggio a Ranuccio Bianchi Bandinelli* (Rome 1970) (Studi Miscellanei 15) 35–44

30. Alkamenes

A. General

Schröder, B., *Alkamenes Studien* (Berliner Winckelmannsprogramm 79) (1921)

Picard, *Manuel* II, 551–86 (with bibl.)

Langlotz, E., *Alkamenes Probleme* (Berliner Winckelmannsprogramm 108) (1952)

Capuis, L., *Alkamenes. Fonti storiche e archeologiche* (Florence 1967)

Schuchhardt, W., *Alkamenes* (Berliner Winckelmannsprogramm 126) (1977)

Ridgway, *Fifth Century* 174–8

Donnay, G., "A propos d'Alcamène," *Rayonnement grec. Hommages à Charles Dolvoye* (Brussels 1982) 167–76

Barron, J.P., "Alkamenes at Olympia," *Bulletin of the Institute of Classical Studies of the University of London* 31 (1984) 199–211

B. Images in the Hephaisteion

Picard, C., "Le type guerrier de l'Athéna Héphaistia d'Alcamène," *RA* 35 (1950) 189–90

Picard, C., "L'Athéna Héphaistia d'Alcamène," *Miscellanea Galbiati* (Milan 1951) I, 19–25

Boucher-Colozier, E., "Chercel (Caesarea): note sur l'Athéna alcaménienne," *Libyca* I (1953) 265–7

Papspyridi-Karuzu, S., "Alkamenes und das Hephaisteion," *AthMitt* 69–70 (1954–1955) 67–94

Karouzou, S., "Statuette d'Héphaistos en bronze," *RA* (1968) 131–8

Harrison, E.B., "Alkamenes' Sculptures for the Hephaisteion, I: The Cult Statues," *AJA* 81 (1977) 137–78; "Alkamenes' Sculptures for the Hephaisteion, II: The Base," *AJA* 81 (1977) 265–87; "Alkamenes' Sculptures for the Hephaisteion, III: Iconography and Style," *AJA* 81 (1977) 411–26

C. *Aphrodite in the Gardens*

Gullini, G., "Afrodite en Kepois," *RendPontAcc* 21 (1944–1945) 151–62

Langlotz, E., "Aphrodite in den Gärten," *Sitzungsberichte der Heidelberger Akademie der Wissenschaften* (1953–1954) 2 (Heidelberg 1954)

D. *Ares*

Freyer, B., "Zum Kultbild und zum Skulpturenschmuck des Arestempels auf der Agora in Athens," *JdI* 77 (1963) 211–26

Bruneau, P., "L'Arès Borghèse et l'Arès d'Alcamène ou de l'opinion et du raisonnement," *Rayonnement grec. Hommages à Charles Dolvoye* (Brussels 1982) 177–99

E. *Hermes Propylaios*

Winter, F., in *Altertümer von Pergamon* VII: *Die Skulpturen mit Ausnahme der Altarreliefs* (1908) 45–53

Willers, D., "Zum Hermes Propylaios des Alkamenes," *JdI* 82 (1967) 37–109

Hermary, A., "A propos de l'Hermès Propylaios de Délos," *BCH* 103 (1979) 137–49

F. *Hekate Epipyrgidia*

Kraus, T., *Hekate* (Heidelberg 1960) chap. 4

Eckstein, F., "Das Hekatain in der British School zu Athen," *Antike Plastik* 4 (1965) 27–36

Fuchs, W., "Zur Hekate des Alkamenes," *Boreas* 1 (1978) 32–5

Harrison, E.B., *The Athenian Agora, vol. XI, Archaic and Archaistic Sculpture* (Princeton 1965) 86–98 and 122–24

Fullerton, M.D., "The Location and the Archaism of the Hekate Epipyrgidia," *AA* (1986) 669–75

G. *Prokne and Itys*

Knell, H., "Die Gruppe von Prokne und Itys," *Antike Plastik* 17 (1978) 9–19

H. *Other Attributions*

Tamajo, E., "Per la Hera di Alcamenes," *Atti Accademia di Scienze e Lettere Arti di Palermo*, ser. 4, 9.2 (1948–1949) 1–40

31. Agorakritos (See also bibliography for Pheidias)

A. General

Furtwängler, *Masterworks* 171–4
Picard, *Manuel* II (1939) 551–86
Schrader, H., "Agorakritos," *ÖJh* 32 (1940) 179–99
Schefold, K., "Agorakritos als Erbe der Pheidias," *Robert Boehringer, eine Freundsgabe* (Tübingen 1957) 543–72
Despinis, G., *Symbole ste melete tou ergou tou Agorakritou* (*Contributions to the Study of the Works of Agorakritos*) (Athens 1971) [in Greek]

B. Nemesis

Despinis, G., *The Nemesis of Agorakritos* (Thessaloniki 1971) [in Greek]. Basic, with references to earlier studies
Kallipolitis, V.G., "La Base de la statue de Némésis à Rhamnonte" [in Greek with French summary], *ArchEph* 1978 (1980) 1–90

Pallat, L., "Die Basis der Nemesis von Rhamnus," *JdI* 9 (1894) 1–22
Picard, C., "Pourquoi la Némésis de Rhamnonte tenait-elle à sa dextre une coupe ornée de têtes de nègres?" *RA* (1958) I, 98–9
Despinis, G., "Discovery of the Scattered Fragments and Recognition of the Type of Agorakritos' Statue of Nemesis," *Athens Annals of Archaeology* 3 (1970) 407–13
Petrakos, V.C., "La base de la Némésis d'Agoracrite. Rapport préliminaire," *BCH* 105 (1981) 227–53

C. Mother of the Gods

Salis, A. von, "Die Göttermutter des Agorakritos," *JdI* 28 (1913) 1–26
Thompson, H.L., *The Athenian Agora (Agora XIV)* (Princeton 1972) 31 [with additional references to statuettes from the Agora]

D. Other Attributions

Andrén, A., "Due copie dello Hades di Agorakritos?" *RendPontAcc* 35 (1962–1963) 27–48

32. Kresilas

A. General

Furtwängler, *Masterworks* 115–61
Picard, *Manuel* II (1939) 598–615
Schuchhardt, W., "Kresilasstudien," *Bericht über den VI. International Kongress für Archäologie, Berlin 21–26 August 1939* (Berlin 1939) 399–401

Raubitschek, *Dedications* (1949) nos. 131–133, pp. 510–13
Orlandini, P., "I donari firmati da Kresilas e Dorotheos a Hermione," *ArchCl* 3 (1951) 94–8
Orlandini, P., "Kresilas," *MemLinc*, ser. 8, 4 (1952) 273–335
Robertson, *HGA* (1975) 333–9

B. Pericles Portrait

Richter, *Portraits* 102–4
Raubitschek, A.E., "Zur Periklesstatue des Kresilas," *ArchCl* 25–26 (1973–1974) 620–1

C. Wounded Man (Dieitrephes)

Reinach, S., "Le 'blessé défaillant' de Crésilas," *GBA* III 33 (1905) 193–209
Sauer, B., "Die Verwundete von Bavai," *NJbb* 35 (1915) 237–48
Stazio, A., "Su una statua di 'vulneratus' del Museo nazionale di Napoli," *RendNap* (1949–1950) 333–5
Arvanitopoulos, T.A., "Concerning the Bronze Statue of Dieitrephes on the Acropolis, a work of Kresilas," *Polemon* 7 (1958–1962) 65–71 [in Greek]
Frel, J., "The volneratus deficiens by Cresilas," *Bulletin of the Metropolitan Museum of Art* 29 (1970) 170–7

D. Other Attributions

Heintze, H. von, "Kopfreplik des Diomedes," *RömMitt* 72 (1965) 213–16

33. Styppax

Mayer, M., "Splanchnoptes," *JdI* 8 (1893) 218–29
Salis, A. von, "Splanchnoptes," *AthMitt* 31 (1906) 352–8
Greifenhagen, A., *Corpus Vasorum Antiquorum, Bonn, Akademisches Kunstmuseum*, I (Paris 1938) 40
Rizza, G., "Una nuova pelike a figure rosse e lo «Splanchnoptes» di Styppax," *ASAtene* n.s. 21–22 (1959–1960) 321–45
Arias, P.E., "Una nuova rappresentazione di Splanchnoptes," *Studi in onore di A. Banti* (Rome 1965) 23–7

34. Lykios

Anti, C., "Lykios," *BullComm* 47 (1919 (1921)) 55–138
Picard, *Manuel* II (1939) 637–40
Raubitschek, *Dedications* (1949) nos. 135, 138, pp. 517–19
Beschi, L., "Contributi di topographia ateniese," *ASAtene* 45–46 (n.s. 29–30) (1967–1968) section III, 528–31
Jeffery, L.H., "Lykios son of Myron. The Epigraphic Evidence," *STELE* 51–4
Dörig, J., "Neues zum Merkur von Thalwil," *Helvetia archaeologia* 14 (1983) 25–35

35. Paionios

Olympia. Ergebnisse, III (Berlin 1894), 182ff., pl. 48–1, and figs. 210ff.
Carpenter, R., *The Sculpture of the Nike Temple Parapet* (Cambridge, Mass. 1929) 35
Picard, *Manuel* II (1939) 586–98
Lullies R., and M. Hirmer, *Greek Sculpture* (2nd edn., New York 1960) no. 178, p. 81
Hofkes-Brukker, C., "Die Nike des Paionios und der Bassaefries," *BABesch* 36 (1961) 1–40
Hofkes-Brukker, C., "Vermutete Werke des Paionios," *BABesch* 42 (1967) 10–71
Deonna, W., *La Niké de Paeonios de Mendé et le triangle sacré des monuments figurés* (Brussels 1968) 9–64
Hermann, K., "Der Pfeiler der Paionios-Nike in Olympia," *JdI* 87 (1972) 232–57
Hölscher, T., "Die Nike der Messenier und Naupaktier in Olympia. Kunst und Geschichte im späten 5. Jahrhundert v. Chr.," *JdI* 89 (1974) 70–111
Ramonat, W., "Der Nike des Paionios in Olympia," *Thiasos ton Mouson. Studien zu Antike und Christentum. Festschrift für Josef Fink zum 70. Gerburtstag* (Cologne 1984) 77–83

36. Strongylion

Picard, *Manuel* II (1939) 641–4
Lacroix, *Reproductions* 293–4
Raubitschek, *Dedications* (1949) 524–5
[On the Amazon by Strongylion see 117]

37. Kallimachos

Carpenter, R., *The Sculpture of the Nike Temple Parapet* (Cambridge Mass. 1929) 21
Rizzo, G.E., *Thiasos* (Rome 1934)
Picard, *Manuel* II (1939) 615–36
Caputo, G., *Lo scultore del grande bassorilievo con la danza delle Menadi in Tolemaide di Cirenaica* (Monografie di archeologia Libica 1) (Rome 1948)
Paribeni, E., "Ancora delle Menadi di Kallimachos," *BdA* 37 (1952) 97–101
Gullini, G., "Kallimachos," *ArchCl* 5 (1953) 133–62
Fuchs, W., "Zum Aphrodite-Typus Louvre–Napoli und seinen neuattischen Umbildungen," *Neue Beiträge zur klassischen Altertumswissenschaft Festschrift zum 60. Geburtstag von B. Schweitzer* (Stuttgart 1954) 206–17
Fuchs, W., *Die Vorbilder des neuattischen Reliefs* (*JdI*, Ergänzungsheft 20) (Berlin 1959) 72ff. and 90ff.
Tiverios, M.A., "*Saltantes Lacaenae*," *ArchEph* (1981) 25–37 [in Greek]
Fuchs, W., "Zum Beginn des archaistischen Stils," *Boreas* 7 (1984) 79–81
Palagia, O., "A Niche for Kallimachos' Lamp?" *AJA* 88 (1984) 515–21

38. Socrates

Ridgway, *Severe Style* 114–21

39. Polykleitos

A. General

Lorenz, T., *Polyklet* (Wiesbaden 1972)

Furtwängler, *Masterworks* 223–92
Mahler, A., *Polyklet und seine Schule* (Athens–Leipzig 1895)
Anti, C., "Monumenti Policletei," *Monumenti antichi* 26 (1920) 501–784
Bianchi Bandinelli, R., *Policleto* (Florence 1938)
Picard, *Manuel* II (1939) 257–307
Raven, J.E., "Polycleitus and Pythagoreanism," *CQ* 45 (1951) 147–52
Arias, P.E., *Policleto* (Milan 1964)
Donnay, G., "Faut-il rajeunir Polyclète l'Ancien?" *L'Antiquité classique* 34 (1965) 448–63
Vermeule, C.C., *Polykleitos* (Boston Museum of Fine Arts. Boston 1969)
Settis, S., "Policleto fra *sophia e mousike*," *Rivista di Filologia e di Istruzione Classica* 101 (1973) 303–17
Chelotti, M., "Policleto e il pondus in Quintiliano," *Annali della Facoltà de Lettere e Filosofia di Bari* 21 (1978) 39–49
Borbein, A.H., "Polyklet," *Göttingische gelehrte Anzeigen* 234 (1982) 184–241

B. The Canon, the Doryphoros, and the Diadoumenos

Wolters, P., "Polyclets Doryphoros in der Ehrenhalle der Münchner Universität," *Münchner Jahrbuch für bildenden Kunst*, n.F. 11 (1934) 5–25
Ferri, S., "Nuovi Contributi esegetici al 'Canon' della Scultura Greca," *RivIstArch* 7 (1940) 117–42
Stefanini, L., "Ispirazione pitagorica del 'canone' di Policleto," *Giornale critico della filosofia italiana* 28 (1949) 84–94
Schulz, D., "Zum Kanon Polyklets," *Hermes* 83 (1955) 200–20
Cunningham, F. and D.E. Gordon, "Polycleitus' Diadoumenos: Measurement and Animation," *Art Quarterly* (1962) 128–42
Hiller, F., "Zum Kanon Polyklets," *Marburger Winckelmann-Programm* (1965) 1–15
Hill, D.K., "Polykleitos. Diadoumenos, Doryphoros and Hermes," *AJA* 74 (1970) 21–4
Steuben, H. von, *Der Kanon des Polyklet. Doryphoros und Amazone* (Tübingen 1973)
Tobin, R., "The Canon of Polykleitos," *AJA* 79 (1975) 307–21
Philipp, H., "Zum Kanon des Polyklet," *Wandlungen. Studien zur antiken und neueren Kunst Ernst Homann-Wedeking gewidmet* (Munich 1975) 132–40
Schindler, W., "Der Doryphoros des Polyklet. Gesellschaftliche Funktion und Bedeutung," *Der Mensch als Mass aller Dinge. Studien zum griechischen Menschenbild in der Zeit der Blüte und Krise der Polis* (Berlin 1976) 219–37
Stewart, A., "The Canon of Polykleitos. A Question of Evidence," *JHS* 98 (1978) 122–31
Schindler, W., "Abbildtheoretische Aspekte der Werkanalyse nonverbaler Strukturen," *Wissenschaftliche Zeitschrift der Wilhelm-Pieck-Universität, Rostock* 27 (1978) 525–33
Visser-Choitz, T., "Zu Polyklets Kanon. Das 'Hauptproblem' beim Bronzeguss," *Kanon* (1988) 127–33

C. Other Works

Blümel, C., *Der Diskosträger Polyklets* (Berliner Winckelmannsprogramm 90) (1930)

Ferri, S., "Un emendamento a Plinio (Nat. Hist. 34, 56) e l'Herakles de Würzburg," *RendLinc* ser. 6, 11 (1935) 770–4

Robinson, D.M., "The Cyniscos of Policlitus," *Art Bulletin* 18 (1936) 133–49

Ferri, S., "Una statuetta romana di Ercole e un passo di Plinio," *BdA* 29 (1936) 437–41

Mustilli, D., *Il Museo Mussolini* (Rome 1938) 145 (Westmacott athlete)

Richter, G.M.A., *Metropolitan Museum of Art. Catalogue of Greek Sculptures* (Cambridge, Mass. 1954) 30–2 (Diadoumenos)

Paribeni, E., *Museo Nazionale romano. Sculture greche del V secolo* (Rome 1953) 36 (Westmacott athlete), 37 (Herakles)

Hafner, G., *Zum Epheben Westmacott* (Sitzungsberichte der Heidelberger Akademie der Wissenschaften, 1955-1) (Heidelberg 1955) 7–22

Lippold, G., *Die Skulturen des Vaticanischen Museums* III-2 (Berlin 1956) 434 (Herakles)

Mansuelli, G., *Galleria degli Uffizi. Le sculture* (Rome 1958) 1, 33 (Discobolos), 37 (Herakles)

Amandry, P., "A Propos de Polyclite. Statues d'Olympioniques et carrière de sculpteurs," *Charites. Studien zur Altertumswissenschaft E. Langlotz gewidmet* (Bonn 1957) 63–87

Ervin, M., "On the Identification of the Polykleitan Hera of Argos," *Peloponnesica (Athènes Myrtidou)* 2 (1957) 414–25

Fleischer, R., "Zwei argivische Bronzestatuetten strengen Stils," *ÖJh* 47 (1964–1965) 117–25

Berger, E., "Zum von Plinius (*N.H.* 34, 55) überlieferten 'nudus talo incessens' des Polyklet," *AntK* 21 (1978) 55–62

Zanker, P., "Eine klassizistische Umbildung des polykletischen 'Diskophoros'," *AntK* 12 (1969) 35–7

Boucher, S., "A propos de l'Hermès de Polyclète," *BCH* 100 (1976) 95–102

Sande, S., "A Polykleitan Head in the National Gallery of Oslo," *SymbOslo* 51 (1976) 159–67

Weber, M., "Die Amazonen von Ephesos," *JdI* 91 (1976) 28–96

Fleischer, R., "Zur Deutung des Diskophoros Polyklets," *ÖJh* 52 (1978–1980) 1–9

Berger, E., "Der sogenannte Diskophoros, eine Theseusstatue (?) des Polyklet," *Numismatica e Antichità classiche* 11 (1982) 59–105

Settis, S., "Policleto, il Diadumeno e Pythokles," *Studi in onore di Edda Bresciani* (Pisa 1985) 489–99

40. Naukydes and the Disciples and Followers of Polykleitos

Arnold, D., *Die Polykletnachfolge. Untersuchungen zur Kunst von Argos und Sykion zwischen Polyklet und Lysipp* (*JdI*, Ergänzungsheft 25) (Berlin 1969)

Linfert, A., *Von Polyklet zu Lysipp. Polyklets Schule und ihr Verhältnis zu Skopas von Paros* (Giessen 1969)

Lippold, G., *Die Skulturen des Vaticanischen Museums* III-2 (Berlin 1956) 79ff., pls. 41–2. With bibliography (Diskobolos)

Willemsen, F., "Mercurio et discobolo . . . censetur," *AA* (1957) 25–31

Bommelaer, J.F., "Note sur les navarques et les successeurs de Polyclète à Delphes," *BCH* 95 (1971) 43–64

Despinis, G., "Zum Hermes von Troizen," *AthMitt* 96 (1981) 237–44

41. Kephisodotos

Reinach, S., "I due Cefisodoti," *RA* 46 (1922) 266–320, esp. 291ff.

Amelung, W., "Neue Beiträge zur Kenntnis des älteren Kephisodot," *RömMitt* 38–39 (1923–1924) 41–51

Rizzo, G.E., *Prassitele* (Milan 1932) 4ff. and 122ff.

Picard, C., "Sur les traces du sculpteur Xénophon d'Athènes," *RA* 14 (1939) 76–7 (Megalopolis)

Picard, C., "Le sculpteur Xénophon d'Athènes à Thèbes et à Mégalopolis," *Comptes rendus des séances de l'Académie des Inscriptions et Belles-lettres* (1941) 204–26

Picard, *Manuel* III (1948) 77–125

Papagiannopoulos-Palaios, A.A., "Archaeology in Peiraeus. The Temenos of Zeus Soter and Athena and the Cult Images and Statues therein," *Polemon* 7 (1958–1959) 26–48 [in Greek]

Schefold, K., "Athene aus dem Piräus," *AntK* 14 (1971) 37–42

Waywell, G., "Athena Mattei," *BSA* 66 (1971) 373–82

La Rocca, E., "Eirene e Plutos," *JdI* 89 (1974) 112–36

Jung, H., "Zur Eirene des Kephisodot," *JdI* 91 (1977) 97–134

Hill, D.K., "Apollo by Kephisodotos the Elder," *J. Paul Getty Museum Journal* 1 (1974) 81–4

42. Praxiteles

A. General

Rizzo, G.E., *Prassitele* (Milan 1932)

Picard, *Manuel* III (1948) 406–632 (bibliography 1932–1954)

Klein, W., *Praxiteles* (Leipzig 1898)

Klein, W., *Praxitelische Studien* (Leipzig 1899)

Perrot, G., *Praxitèle* (Paris 1905)

Collignon, M., *Scopas et Praxitèle, La sculpture grecque au IV^e siècle jusqu'au temps d'Alexandrie* (Paris 1907)

Ducati, P., *Prassitele* (Florence 1927)

Lacroix, *Reproductions* 302–16

Bijvanck, A.W., "La chronologie de Praxitèles," *Mnemosyne*, ser. 4, 4 (1951) 204–15

B. Hermes

Treu, G., *Hermes mit dem Dionysosknaben: ein Originalwerk des Praxiteles gefunden im Heraion zu Olympia* (Berlin 1878)

Blümel, C., *Griechische Bildhauerarbeit* (*JdI*, Ergänzungsheft 11) (Berlin 1927)

Carpenter, R., "Who Carved the Hermes of Praxiteles?" *AJA* 35 (1931) 248–61

Casson, S., "The Hermes of Praxiteles," *AJA* 35 (1931) 262–8

Blümel, C., "Bemerkungen zur griechischen Bildhauerarbeit," *AJA* 35 (1931) 269–76

Richter, G.M.A., "The Hermes of Praxiteles," *AJA* 35 (1931) 277–90

Müller, V., "Some Notes on the Drapery of the Hermes," *AJA* 35 (1931) 291–5

Dinsmoor, W. B., "Architectural Notes," *AJA* 35 (1931) 296–7

Morgan, C., "The Drapery of the Hermes of Praxiteles," *ArchEph* (1937) 61–8

Antonsson, O., *The Praxiteles Marble Group in Olympia* (Stockholm 1937)

Wallace, M., "Sutor Supra Crepidam," *AJA* 44 (1940) 213–21

Kreuzer, A., "Der Hermes eines Praxiteles," *JdI* 58 (1943) 133–53

Blümel, C., *Hermes eines Praxiteles* (Baden-Baden 1948)

Kreuzer, A., *Des Praxiteles Hermes von Olympia* (Berlin 1948)

Carpenter, R., "Two Postscripts to the Hermes Controversy," *AJA* 58 (1954) 1–12

Adam, S., *The Technique of Greek Sculpture* (*BSA* Supplement 3) (London 1966) 124–8

Carpenter, R., "A Belated Report on the Hermes Controversy," *AJA* 73 (1969) 465–8

Hadjiandreou, L. and G. Ladopoulos, "Radiographic Examination on the Statue of Hermes," and Yalouris, N. and I. Trianti, "New Display of the Hermes of Praxiteles in the Museum at Olympia," *Athens Annals of Archaeology* 11 (1978) 273–81 and 263–70 [in Greek with English summary]

Wycherley, R.E., "Pausanias and Praxiteles," *Studies in Athenian Architecture, Sculpture and Topography Presented to Homer A. Thompson* (*Hesperia* Supplement 20) (Princeton 1982) 182–91

C. *Aphrodite of Knidos*

Blinkenberg, C., *Knidia (Beiträge zur Kenntnis der praxitelische Aphrodite)* (Copenhagen 1933)

Charbonneaux, J., "L'Aphrodite de Cnide de la collection Kaufmann," *Revue des Arts* (1951) 175–6

Beau, G.E. and J.M. Cook, "The Cnidia," *BSA* 47 (1952) 171–212

Love, I.C., "A Preliminary Report of the Excavations at Knidos, 1970," *AJA* 76 (1972) 61–70

D. *Eros*

Pfrommer, M., "Ein Eros des Praxiteles," *AA* (1980) 532–44

Laurenzi, L., "Il Prassitelico Eros di Parion," *RivIstArch*, n.s. 5–6 (1956–1957) 111–18

E. *Other Attributions*

Becatti, G., "Un Dodekatheon ostiense e l'arte di Prassitele," *ASAtene*, n.s. 1–2 (1939–1940) 85–137

Brommer, F., *Zur Dresdner Artemis* (Marburger Winckelmann-Programm 1950–1951) (Marburg 1951) 3–12

Becatti, G., "Nuovo frammento del dodekatheon prassitelico di Ostia," *BdA* 36 (1951) 193–200

Charbonneaux, J., "Une tête de Dionysos Tauros au Musée de Narbonne," *Gallia* 18 (1960) 39

Tréheux, J., "Sur le nombre des statues cultuelles du Brauronion et la date de l'Artemis Brauronia de Praxitèle," *RA* (1964) I, 1–16

Effenberger, A., "Die drei Tyche-Statuen des Praxiteles, ein neues archäologisches Märchen," *Klio* 53 (1971) 125–8

Maxmin, J., "A Note on Praxiteles' Sauroktonos," *Greece & Rome* 20 (1973) 36–7

Schwarz, G., "Zum sogenannten Eubouleus," *J. Paul Getty Museum Journal* 2 (1975) 71–84

Pochmarski, E., "Iakchos oder Dionysos," *Grazer Beiträge* 5 (1976) 181–209

Stewart, A., "A Cast of the Leconfield Head in Paris," *RA* (1977) 195–202

43. Demetrios of Alopeke

Picard, *Manuel* III (1948) 126–45

Lewis, D.M., "Notes on Inscriptions II. No. XXIII. Who was Lysistrata?" *BSA* 50 (1955) 1–12

Richter, *Portraits* (1965) 155–6

Robertson, *HGA* (1975) 504–6

44. Leochares

Picard, *Manuel* IV (1963) 754–854

Robertson, *HGA* 460–3

Ashmole, B., "Demeter of Knidos," *JHS* 71 (1951) 13–28

Donnay, G., "La chronologie de Léocharès," *Revue des études anciennes* 61 (1959) 300–9

Donnay, G., 'Un sculpteur grec méconnu, Léocharès," *GBA* 53 (1959) 5–20

Charbonneaux, J., "Le Zeus de Léocharès," *Monuments et mémoires Fondation E. Piot* 53 (1963) 9–17

Toelle, R., "Zum Apollon des Leochares," *JdI* 81 (1966) 142–72

Scheibler, I., "Leochares in Halikarnassos. Zur Methode der Meisterforschung," *Wandlungen. Studien zur antiken und neureren Kunst, Ernst Homann-Wedeking gewidmet* (Munich 1975) 152–62

Peppa-Delmouzou, D., "Artists' signatures, A': Toward a more precise chronology of Leochares; B': The Sculptor Androboulos," *STELE* 430–9 [in Greek]

Fabbrini, L., "L'Apollo di Vicarello e l'inserimento del suo prototipo nell'ambito della scultura attica del IV° secolo a.C.," *RömMitt* 90 (1983) 1–33

Vermeule, C.C., "From Halicarnassus to Alexandria in the Hellenistic Age. The Ares of Halicarnassus by Leochares," *Allesandria e il mondo ellenistico-romano. Studi in onore di Achille Adriani.* (Rome 1983–1984) III, 783–8

Pfrommer, M., "Leochares? Die hellenistischen Schuhe der Artemis Versailles," *IstMitt* 34 (1984) 171–82

45. Bryaxis

Picard, *Manuel* IV (1963) 854–922

Six, J., "Asklepios by Bryaxis," *JHS* 42 (1922) 31–5

Lippold, G., "Sarapis und Bryaxis," *Festschrift Paul Arndt zu seinem sechzigsten Geburtstag*

(Munich 1925) 115–27

Pfuhl, E., "Bermerkungen zur Kunst des vierten Jahrhunderts," *JdI* 43 (1928) 1–53, esp. 47–53

Adriani, A., "Alla ricerca di Briasside," *MemLinc* 8-1, fasc. 10 (1948) 434–73 (with bibliography)

Schwarz, F.F., *Bryaxis. Eine Studie zur Persönlichkeitsforschung in der bildenden Kunst des 4. Jh. v. Chr.* (Graz 1961)

Nock, A.D., "Sapor I and the Apollo of Bryaxis," *AJA* 66 (1962) 307–10

Charbonneaux, J., "Bryaxis et le Serapis d'Alexandrie," *Monuments et mémoires. Fondation E. Piot* 52-2 (1962) 15–26

Faraklas, N., "What stood on the base of Bryaxis?" *ArchDelt* 24 (1969) 59–65 [in Greek]

Stambaugh, J., *Serapis under the Early Ptolemies* (Leiden 1972)

Hermann, W., "Zum Apollo Borghese," *AA* (1973) 658–63

Schwarz, F.F., "Nigra maiestas. Bryaxis, Sarapis, Claudian," *Classica et Provincilia, Festschrift Erna Diez* (Graz 1978) 189–210

Schwarz, G., "Zum sogenannten Eubouleus," *J. Paul Getty Museum Journal* 2 (1975) 71–84

Linfert, A., "Der Apollon con Daphne des Bryaxis," *Damaszener Mitteilungen* 1 (1983) 165–73

46. Silanion

Picard, *Manuel* III (1948) 781–852

Robertson, *HGA* 507–10

Winter, F., "Silanion," *JdI* 5 (1890) 151–68

Schmidt, E., "Silanion der Meister des Platonbildes," *JdI* 47 (1932) 239–303

Böhringer, R., *Platon, Bildnisse und Nachweise* (Breslau 1935)

Richter, *Portraits* 164–70

Lattimore, S., "Ares and the Heads of Heroes," *AJA* 83 (1979) 71–8

47. Euphranor

Palagia, O., *Euphranor* (Leiden 1980) [basic bibliography pp. 72–3]

Dontas, G., "La grande Artémis du Pirée: une oeuvre d'Euphranor," *AntK* 25 (1982) 15–34

Hedrik, C.W., "The Temple and Cult of Apollo Patroos in Athens," *AJA* 92 (1988) 185–210

48. Sculptors of the Sixth Temple of Apollo at Delphi

Van Buren, D., "Praxias," *MAAR* 3 (1919) 91–100

Picard, *Manuel* IV (1963) 932–40, 1128–32

Marcadé, J., *Reçueil des signatures* II (1957) 111

Stewart, A., 'Dionysos at Delphi: the Pediments of the Sixth Temple of Apollo and Religious Reform in the Age of Alexander," *Macedonia and Greece in Late Classical and Early Hellenistic Times* (National Gallery of Art, Studies in the History of Art 10) (Washington 1982) 205–15

49. Skopas

Picard, *Manuel* III (1948) 633–780
Arias, P.E., *Skopas* (Rome 1950)
Stewart, A., *Skopas of Paros* (Park Ridge, N.J. 1977)

Dugas, C. and others, *Le sanctuaire d'Aléa Athéna à Tegée au IV siècle* (Paris 1924)
Linfert, A., *Von Polyklet zu Lysipp. Polyklets Schule und ihr Verhältnis zu Skopas von Paros* (Freiburg 1965)
Lorenz, T., "Mänaden des Skopas," *BABesch* 43 (1968) 52–8
Lattimore, S., "Studies in the Career of Skopas" (Ph.D. Dissertation, Princeton University, 1968)
Mingazzini, R., "Sui quattro scultori di nome Scopas," *RivIstArch* 18 (1971) 69–90
Lattimore, S., *The Marine Thiasos in Greek Sculpture* (Los Angeles 1976)
Lehmann, P.W., "New Light on Skopas," *Bulletin of the American Society of Papyrologists* 15 (1978) 67–71
Delivorrias, A. and A. Linfert, "*Skopadika* II: La statue d'Hygie dans le temple d'Aléa à Tégée," *BCH* 107 (1983) 277–88
Norman, N., "The Temple of Athena Alea at Tegea," *AJA* 88 (1984) 169–94
Palagia, O., "The Hope Herakles Reconsidered," *Oxford Journal of Archaeology* 3 (1984) 107–26
Lattimore, S., "Skopas and Pothos," *AJA* 91 (1987) 411–22

50. Lysippos

A. General

Johnson, F.P., *Lysippos* (Durham, N.C. 1927)
Picard, *Manuel* IV (1963) 423–753
Sjöqvist, E., *Lysippos* (Cincinnati 1966)
Moreno, P., *Testimonianze per la teoria artistica di Lisippo* (Treviso 1973)
Moreno, P., *Lisippo, I: Biografia. Iscrizioni. Fonti. Storia e civiltà* 11 (Bari 1974)
Pollitt, *AHA*, chapters 1 and 2
Chamay, J. and Maier, J.-L., *Lysippe et son influence* (Hellas et Roma 5) (Geneva 1987)

Loewy, E., *Lysipp und seine Stellung in der griechischen Plastik* (Hamburg 1891)
Collignon, M., *Lysippe* (Paris 1905)
Maviglia, A., *L'attività artistica di Lisippo ricostruita su nuova base* (Rome 1914)
Waldhauer, O., *Lisippo* (Berlin 1923)
Schuchhardt, W., "Der junge Lysipp," *Neue Beiträge zur klassischen Altertumswissenschaft, Festschrift zum 60. Geburtstag von B. Schweitzer* (Stuttgart 1954) 222–6
Kleiner, W., "Über Lysipp," *Neue Beiträge zur klassischen Altertumswissenschaft, Festschrift zum 60. Geburtstag von B. Schweitzer* (Stuttgart 1954) 227–39
Lattimore, S., "Lysippan Sculpture on Greek Coins," *California Studies in Classical Archaeology* 5 (1972) 147–52
Linfert, A., "Pythagoras und Lysipp – Xenokrates und Duris," *Rivista di Archeologia* 2 (1978) 23–8
Moreno, P., "Riflessi della teoria artistica di Lisippo in Asia Minore," *Proceedings of the*

Xth International Congress of Classical Archaeology, Ankara–Izmir 23–30.ix.1973, II
(Ankara 1978) 1041–5
Truempelmann, L., "Der Kanon des Lysipp," *Boreas* 5 (1982) 70–7

B. Images of Herakles

Dörig, J., "Lysipps letztes Werk," *JdI* 72 (1957) 19–43
Mustili, D., *Il rilievo romano del I–II secolo d. C. – Lisippo* (Naples 1960)
Visscher, F. de and J. Mertens, "Il colosso di Ercole scoperto ad Alba Fucens," *BdA* 45
(1960) 293–6
Visscher, F. de, *Héraklès Epitrapezios* (Paris 1962)
Scivoletto, N., "L'Alcestis di Euripide e l'Heracles Epitrapezios di Lisippo," *Giornale
Italiano di Filologia* 15 (1962) 97–104
Forti, L., "Nota sulla Herakles di Tarento," *Klearchos* 5 (1963) 18–30
Cutler, A., "The De signis of Nicetas Choniates. A Reappraisal," *AJA* 72 (1968) 113–18
Todisco, L., "L'impresa di Eracle e il toro nel gruppo Lisippeo di Alizia," *Annali della
Facoltà di Lettere e Filosofia, Bari* 18 (1975) 31–56
Vermeule, C.C., "The Weary Herakles of Lysippos," *AJA* 79 (1975) 323–32
Cassimatis, H., "Héraklès et Lysippe. La descendance," *Bulletin de l'Institut Français
d'Archéologie Orientale* 78 (1978) 541–64
Floren, J., "Zu Lysipps Statuen des sitzenden Herakles," *Boreas* 4 (1981) 47–60
Moreno, P., "Iconografia lisippea delle imprese di Eracle," *MélRome* 96 (1984) 117–74
Keuren, F. van, "A Coin Copy of Lysippus' Heracles at Tarentum," *Ancient Coins of the
Graeco-Roman World. The Nickle Numismatic Papers* (ed. W. Heckel and R. Sullivan)
(Waterloo, Ont. 1984) 203–19
Krull, D., *Der Herakles vom Typ Farnese, kopienkritische Untersuchungen einer Schöpfung des
Lysipp* (Frankfurt 1985)

C. Zeus

Dörig, J., "Lysipps Zeuskoloss von Tarent," *JdI* 79 (1964) 257–78
Moreno, P., "Le Zeus de Lysippe à Tarente," *RA* (1971) 289–90

D. Portraits

Koch, H., "Zum Alexander mit der Lanze," *Neue Beiträge zur klassischen Altertumswis-
senschaft, Festschrift zum 60. Geburtstag von B. Schweitzer* (Stuttgart 1954) 240–2
Schwarzenberg, E. von, "Der lysippische Alexander," *BonnJbb* 167 (1967) 58–118
Dontas, G., "Eikonistika," *ArchDelt* 24 (1969) 181–202 [in Greek]
Mingazzini, P., "Su alcuni ritratti di Socrate," *RendPontAcc* 43 (1970–1971) 47–54
Frischer, B., "On Reconstructing the Portrait of Epicurus and Identifying the Socrates of
Lysippus," *California Studies in Classical Antiquity* 12 (1979) 121–54
Hundsalz, B., "Alexander mit der Lanze," *Damaszener Mitteilungen* 2 (1985) 107–21

E. Kairos

Schwarz, G., "Der lysippische Kairos," *Grazer Beiträge* 4 (1975) 243–67
Stewart, A., "Lysippan Studies, I: The Only Creator of Beauty," *AJA* 82 (1978) 163–71

F. Other Attributions

Crome, J.F., "Die goldenen Pferde von San Marco und der goldener Wagen des Rhodier," *BCH* 87 (1963) 209–28

Salis, A. von, *Löwenkampfbilder des Lysipp* (Berliner Winckelmannsprogramm 112) (1956)

Picard, C., "Le Poseidon lysippique du manche de la patère d'argent de Perm (Musée de l'Ermitage, Léningrad)," *RA* (1958) I, 100–2

Filippo, E. di, "Una replica della testa dell'Eros con l'arco di Lisippo nel Museo del Liviano. Studio storico-critico," *AttiVen* 123 (1964–1965) 527–84

Forlati Tamaro, B., "Nuove ipotesi sui cavalli di S. Marco," *RendPontAcc* 37 (1964–1965) 83–104

Rodio, V., "L'Apoxyomenos di Lisippo," *Annali della Facoltà di Lettere e Filosofia, Bari* 13 (1968) 217–46

Bracker, J., "Ein Perseus in Köln," *AA* (1969) 427–35

Costa, M.P., "Testimonianze per i cavalieri del Granico di Lisippo," *Annali della Facoltà di Lettere e Filosofia, Bari* 17 (1974) 115–35

Lauter, H., "Drei Werke des Lysipp," *AthMitt* 92 (1977) 159–69

Moreno, P., "Da Lisippo alla scuola di Rodi," *Storia e civiltà dei Greci. V: La cultura ellenistica. 10: Le arti figurative* (Milan 1977) 412–60

Stewart, A., "Lysippan Studies, II: Agias and Oilpourer," *AJA* 82 (1978) 301–13

Forlati Tamaro, B., "Ancora un'ipotesi sui cavalli di San Marco," *AttiVen* 141 (1982–1983) 1–15

Galliazzo, V., "I cavalli di San Marco. Una quadriga greca o romana?" *Faventia* 6, 2 (1984) 99–126

51. Lysistratos

Carpenter, R., "Observations on Familiar Statuary in Rome," *MAAR* 18 (1941) 74–6

Picard, *Manuel* IV (1963) 923–5

52. Timotheos

Picard, *Manuel* III (1948) 322–87

Schlörb, B., *Timotheos* (*JdI*, Ergänzungsheft 22) (Berlin 1965)

Wolters, P. and J. Sieveking, "Der Amazonfries des Maussoleums," *Archäologisches Jahrbuch* 24 (1909) 171–91

Crome, J.F., *Die Skulpturen des Asklepiostempels von Epidauros* (Berlin 1951)

Leoncini, G., "Contributo per una riconstruzione della personalità di Timotheos," *Aevum* 32 (1958) 303–39

Pollitt, *Ancient View* (1975) 272–93

Rieche, A., "Die Kopien der Leda des Timotheos," *Antike Plastik* 17 (1978) 21–55

Yalouris, N., "Die Skulpturen des Asklepiostempels von Epidauros," *Archaische und klassische griechische Plastik* (Mainz am Rhein 1986) 175–86

53. Thrasymedes

Fowler, H.N., "The Statue of Asklepios at Epidauros," *AJA* 3 (1887) 32–7
Picard, *Manuel* III (1948) 214–22
Lacroix, *Reproductions* 300–1
Krause, B., "Zum Asklepios-Kultbild des Thrasymedes in Epidauros," *AA* (1972) 240–57

54. Daidalos of Sikyon

Loewy, *IgB* nos. 88, 89, 103
Hauser, F., "Eine Vermuthung über die Bronzestatue aus Ephesos," *ÖJh* 5 (1902) 214–16
Preuner, O., "Archäologisch-Epigraphisches," *JdI* 35 (1920) 59–82, esp. 65–9
Picard, *Manuel* III (1948) 275–6, 282–6
Marcadé, J., *Recueil des signatures* I (1953) 22–4
Stewart, A., "Lysippan Studies, III: Not by Daidalos?" *AJA* 82 (1978) 473–82

55. Sthennis

Loewy, *IgB* nos. 83, 103a, 481, 541
Picard, *Manuel* IV (1963) 994–7

56. The School of Lysippos (see also general bibliography under Lysippos)

A. General

Pollitt, *AHA* (1986) 55–8
Bieber, *SHA* (1961) 39–41

B. Eutychides

Dohrn, T., *Die Tyche von Antiochia* (Berlin 1960)

C. Phanis

Furtwängler, A., "Das Mädchen von Antium," *Münchener Jahrbuch der bildenden Kunst* 2.2 (1907) 1–17

D. Doidalsas

Laurenzi, L., "La Personalità di Doidalses di Bitinia," *ASAtene* 24–26 (1946–1948) 167–79
Lullies, R., *Die kauernde Aphrodite* (Munich 1954)

57. The Sons of Praxiteles (Kephisodotos and Timarchos)

Bieber, M., "Der Söhne des Praxiteles," *JdI* 38–39 (1923–1924) 242–75
Marcadé, J., *Recueil des signatures* I (1953) 57, 107

On the portrait of Menander sometimes attributed to the sons of Praxiteles, see Richter, *Portraits* 224–36 and Ashmole, B., "Menander: An Inscribed Bust," *AJA* 77 (1973) 61

58. Polyeuktos

Koch, H., "Zur Statue des Demosthenes," *Festschrift für Fr. Zucker zum 70. Geburtstage* (Berlin 1954) 219–25

Richter, *Portraits* (1965) 215–23

Balty, J.C., "Une nouvelle réplique du Démosthène de Polyeuctos," *Bulletin des Musées Royaux d'Art et d'Histoire, Bruxelles* 50 (1978) 49–74

Pollitt, *AHA* (1986) 62–3

59. Pergamene Sculptors

Hansen, E.V., *The Attalids of Pergamon* (2nd edn., Ithaca and London 1971) 299–303

Künzl, E., *Die Kelten des Epigonos von Pergamon* (Würzburg 1971)

Pollitt, *AHA* (1986) chapter 4

Mahler, A., "Nikeratos," *JdI* 20 (1905) 26–31

Schober, A., "Epigonos von Pergamon und die frühpergamenische Kunst," *JdI* 63 (1938) 126–49

Schober, A., "Zur Geschichte pergamenischer Künstler," *ÖJh* 31 (1939) 142–9

Schober, A., *Die Kunst von Pergamon* (Innsbruck–Vienna 1951)

Marcadé, J., *Recueil des signatures* II (1957) 102

Zevi, F., "Tre iscrizioni con firme di artisti greci. Saggi nel tempio dell'ara rotonda a Ostia," *RendPontAcc* 42 (1969–1970) 95–116

Richter, G.M.A., "New Signatures of Greek Sculptors," *AJA* 75 (1971) 434–5

Andreae, B., "ANTISTHENES PHILOSOPHOS PHYROMACHOS EPOIEI," *Eikones. Studien zum griechischen und römischen Bildnis, Hans Jucker gewidmet* (Bern 1980) 40–8

Coulson, W.D.E., "Phyromachus the Athenian," *Journal of the Theory and Criticism of the Visual Arts* 1, 2 (1982) 5–14

60. Hagesandros, Polydoros, and Athenodoros

A. Summary

Pollitt, *AHA* (1986) 120–6

B. The Laokoon Group *(selection of basic and recent works from a very extensive bibliography)*

Amelung, W., *Die Sculpturen des Vaticanischen Museums* (Berlin 1908) II, 202ff. With bibliography

Bieber, M., *Laocoön: The Influence of the Group Since its Discovery* (New York 1942; second edn., Detroit 1967)

Richter, G.M.A., *Three Critical Periods in Greek Sculpture* (Oxford 1951) 66–70

Prandi, A., "La fortuna del Laocoonte dalla sua scoperta nelle terme di Tito," *RivIstArch*, n.s. 3 (1954) 78–107

Laurenzi, L., "Cronologia e fase stilistica del Laocoonte," *RivIstArch*, n.s. 3 (1954) 70–7

Sichtermann, H., *Laokoon* (Opus Nobile 3) (Bremen 1957)

Jacopi, G., "Gli autori del Laocoonte e la loro cronologia alla luce delle scoperte dell'antro «di Tiberio» a Sperlonga," *ArchCl* 10 (1958) 160–3

Magi, F., *Il ripristino del Laocoonte* (MemPontAcc, ser. 3a, 9) (Rome 1960)

Blankenhagen, P.H. von, "Laokoon, Sperlonga und Vergil," *AA* (1969) 256–75

Simon, E., "Laokoon und die Geschichte der antiken Kunst," *AA* (1984) 643–72

Andreae, B., *Plinius und Laokoon* (Trierer Winckelmannsprogramme 8) (Mainz am Rhein 1987)

Andreae, B., *Laokoon und die Gründung Roms* (Mainz am Rhein 1988)

C. Sperlonga

Jacopi, G., "I ritrovamenti dell'antro cosiddetto «di Tiberio» a Sperlonga" (Rome, Ist. St. Romani, *Orme di Roma* 9) (1958) 1–38

Jacopi, G., "Gli autori del Laocoonte e la loro cronologia alla luce delle scoperte dell'antro «di Tiberio» a Sperlonga," *ArchCl* 10 (1958) 160–3

Blankenhagen, P.H. von, "Laokoon, Sperlonga und Vergil," *AA* (1969) 256–75

Conticello, B. and B. Andreae, *Die Skulpturen von Sperlonga* (Antike Plastik 14) (1974)

Stewart, A.F., "To Entertain an Emperor: Sperlonga, Laokoon, and Tiberius at the Dinner Table," *JRS* 67 (1977) 76–90

Rice, E., "Prosopographika Rhodiaka," *BSA* 81 (1986) 209–50

61. Menekrates, Apollonios, and Tauriskos

Lippold, G., *Kopien und Umbildungen griechischer Statuen* (Munich 1923) 48ff.

Pfuhl, E., "Der Farnesische Stier und das Mosaik von Aquincum," *RömMitt* 41 (1926) 227–8

Becatti, G., "Letture pliniane. Le opere d'arte nei monumenti Asini Pollionis e negli horti Serviliani," *Studi in onore di A. Calderini e R. Paribeni* III (Milan 1956) 199–210

Bieber, *SHA* (1961) 133–4

Börker, C., "Menekrates und die Künstler des Farnesischen Stieres," *Zeitschrift für Papyrologie und Epigraphik* 64 (1986) 41–9

Pollitt, *AHA* (1986) 110, 117–18

62. Rhodian Sculptors (general)

Laurenzi, L., "Problemi della scultura ellenistica. La scuola rodia," *RivIstArch* 8 (1940–1941) 25–44

Blinckenberg, C., *Lindos* II (Copenhagen 1941) 51–9 (signatures of sculptors)

Moreno, P., "Da Lisippo alla scuola di Rodi," *Storia e civiltà dei Greci. V: La cultura ellenistica. 10: Le arti figurative* (Milan 1977) 412–60

Merker, G., *The Hellenistic Sculpture of Rhodes* (Studies in Mediterranean Archaeology 40) (Göteborg 1973)

Gualandi, G., "Sculture di Rodi," *ASAtene*, n.s. 38 (1976) 7–259

63. Boethos

Rumpf, A., "Boethoi," *ÖJh* 39 (1952) 86–9

Marcadé, J., *Recueil des signatures* II (1957) 28–31 pl. XXIX-4 and XXX-2, 4

Bieber, *SHA* (1961) 81–2

Fuchs, W., *Der Schiffsfund von Mahdia* (Tübingen 1963) 11–14 (with extensive references)

Pollitt, *AHA* (1986) 128, 140–1

64. Damophon

Thallon, C., "The Date of Damophon of Messene," *AJA* 10 (1906) 302–29

Dickins, G., "Damophon of Messene," *BSA* 12 (1905–1906) 109–36

Dickins, G., "Damophon of Messene II," *BSA* 13 (1906–1907) 356–404

Dickins, G., "Damophon of Messene III," *BSA* 17 (1910–1911) 80–7

Dickins, G., *Hellenistic Sculpture* (Oxford 1920) 60ff.

Guidi, G., "La decorazione del monto di Despoina nel gruppo di Damofonte di Messene," *ASAtene* 4–5 (1924) 97–115

Becatti, G., "Attikà. Saggio sulla scultura attica dell'ellenismo," *RivIstArch* 7 (1940) 7–116, esp. 40–6

Despinis, G.J., "Ein neues Werk des Damophon," *AA* (1966) 378–85

Lévy, E., "Sondages à Lykosoura et date de Damophon," *BCH* 91 (1967) 518–45

Lévy, E. and J. Marcadé, "Au musée de Lykosoura," *BCH* 96 (1972) 967–1004

Pollitt, *AHA* (1986) 165–6

65. Pasiteles

Borda, M., *La scuola di Pasiteles* (Bari 1953)

66. Euboulides (elder and younger)

Becatti, G., "Attikà. Saggio sulla scultura attica dell'ellenismo," *RivIstArch* 7 (1940) 7–116, esp. 14–16, 52–5

Bieber, *SHA* (1961) 68–70, 158–9

Pollitt, *AHA* (1986) 69, 164–5

Papachatzes, N., *Pausanias's Guide to Greece, Achaia–Arkadia* (Athens 1980) 230–4 [in Greek] (on the head from Pheneos)

Despinis, G., "Zu einigen Künstlern der späthellenistischen Zeit," *XIII Kongress für Archäologie* (Berlin 1988) Resümees, 45

67. Neo-Attic Sculptors

Becatti, G., "Attikà. Saggio sulla scultura attica dell'ellenismo," *RivIstArch* 7 (1940) 7–116, esp. 16ff.

Becatti, G., *Arte e gusto negli scrittori latini* (Florence 1951) 104, 148, 186ff., 280

Coarelli, F., "Polycles," *Omaggio a Ranuccio Bianchi Bandinelli* (Studi Miscellanei 15) (Rome 1970) 75–89

Stewart, A., *Attika* (London 1979) 42–5
Pollitt, *AHA* (1986) chap. 8

PAINTERS

In view of the paucity of surviving monuments, little can be said about most of the famous Greek mural and panel painters beyond what we are told by ancient authors. Hence, except for a few cases (e.g. Polygnotos) where the literary sources are sufficiently extensive to have generated a substantial secondary literature, the bibliography on painters is far more limited than that on sculptors.

The most extensive and useful recent review of the literary evidence and of the few and speculative attempts by scholars to associate some of the literary references with surviving monuments is in Martin Robertson's *A History of Greek Art* (Cambridge 1975).

The older, comprehensive general studies of Ernst Pfuhl, *Malerei und Zeichnung der Griechen* (Munich 1923), Mary H. Swindler, *Ancient Painting* (New Haven 1929), and Andreas Rumpf, *Malerei und Zeichnung* (Handbuch der Archäologie 4.1) (Munich 1953) are also still useful.

The following special studies supplement these general works.

68. Polygnotos

A. General

Robert, C., *Die Marathonschlacht in der Poikile und weiteres über Polygnot* (Hallisches Winckelmannsprogramm 18) (Halle 1895)
Hauser, F., "Nausikaa," *ÖJh* 8 (1905) 18–41
Fornari, F., "Studi Polignotei," *Ausonia* 9 (1914) 93–122
Loewy, E., *Polygnot. Ein Buch von griechischer Malerei* (Vienna 1929)
Weickert, C., *Studien zur Kunstgeschichte des 5. Jahrhunderts v. Chr.* Vol. 1: *Polygnot* (Berlin 1950)
Simon, E., "Polygnotan Painting and the Niobid Painter," *AJA* 67 (1963) 43–62
Arias, P.E., "Considerazione sullo stile polignoteo," *Studi Classici e Orientali* 19–20 (1970–1971) 293–6
Jeppesen, K., "Argousa pou kata to Theiou. Zu Pausanias IX, 42 – über die Gemälde im Tempel der Athena Areia zu Platäa," *ActaA* 42 (1971) 110–12
Kleiner, F.S., "The Kalydonian Hunt. A Reconstruction of a Painting from the Circle of Polygnotos," *AntK* 15 (1972) 7–19
Pollitt, J.J., "The Ethos of Polygnotos and Aristeides," *In Memoriam Otto J. Brendel. Essays in Archaeology and the Humanities* (Mainz 1976) 49–54

B. Paintings at Delphi

Robert, C., *Die Nekyia des Polygnot* (Hallisches Winckelmannsprogramm 16) (Halle 1892)
Robert, C., *Die Iliupersis des Polygnot* (Hallisches Winkelmannsprogramm 17) (Halle 1893)

Schöne, R., "Zu Polygnots delphischen Bildern," *JdI* 8 (1893) 187–217

Robertson, M., "The Hero with Two Swords," *JWarb* 15 (1952) 99–100

Robertson, M., "The Hero with Two Swords. A Postscript," *JWarb* 28 (1965) 316

Robertson, M., "Laomedon's Corpse, Laomedon's Tomb," *Greek, Roman, and Byzantine Studies* 11 (1970) 23–6

Kebric, R.B., *The Paintings in the Cnidian Lesche at Delphi and their Historical Context* (*Mnemosyne* Supplement 80) (Leiden 1983)

Mantis, A., "Krater F160 of the British Museum and the Sack of Troy at Delphi" [in Greek and with English summary], *ArchDelt* 33 (1978 (1984)) 110–20 and 392

Stansbury-O'Donnell, M., "Polygnotos's *Iliupersis*. A New Reconstruction," *AJA* 93 (1989) 203–15 and "Polygnotos's *Nekyia*: A Reconstruction and Analysis," *AJA* 94 (1990) 213–35

69. Mikon

Robert, C., *Die Marathonschlacht in der Poikile und weiteres über Polygnot* (Hallisches Winckelmannsprogramm 18) (Halle 1895)

Loewy, E., *Polygnot. Ein Buch von griechischer Malerei* (Vienna 1929) 15–24

Arias, P.E., "Cratere con Amazonomachia nel Museo di Ferrara," *RivIstArch*, n.s. 2 (1953) 15–28

Howe, T.D., "Sophokles, Mikon and the Argonauts," *AJA* 61 (1957) 341–50

Kraiker, W., *Malerei* (1958) 69–76

Barron, J.P., "New Light on Old Walls: The Murals of the Theseion," *JHS* 92 (1972) 20–45

70. Panainos

Blümner, H., "Die Gemälde des Panainos am Throne des olympischen Zeus," *JdI* 15 (1900) 136–44

Petersen, P., *Ein Werk des Panainos* (Leipzig 1905)

Giglioli, G.Q., "Il trono dello Zeus di Fidia in Olimpia," *MemLinc* ser. 5, 16 (1922) 219–376

Lippold, G., "Zur griechischen Künstlergeschichte," *JdI* 38–39 (1923–1924) 150–8, esp. 150–2

McConnell, B.F., "The Paintings of Panainos at Olympia. What Did Pausanias See?" *Harvard Studies in Classical Philology* 88 (1984) 159–64

71. Paintings in the Stoa Poikile

Wycherley, R.W., *The Athenian Agora, vol. III, Literary and Epigraphical Testimonia* (Princeton 1957) 31–45

Jeffery, L.H., "The *Battle of Oinoe* in the Stoa Poikile: A Problem in Greek Art and History," *BSA* 60 (1965) 41–57

Francis, E.D. and M. Vickers, "The Oenoe Painting in the Stoa Poikile, and Herodotus' Account of Marathon," *BSA* 80 (1985) 99–113

72. Agatharchos

White, J., *Perspective in Ancient Drawing and Painting* (London 1956) 46–52
Pollitt, *Ancient View* (1975) 240–5
Lasserre, F., "D'Agatharchos à Brunelleschi," *La prospettiva pittorica* (Rome 1985) 11–18

73. Apollodoros

Pfuhl, E., "Apollodoros *O Skiagraphos,* " *JdI* 25 (1910) 12–28
Kraiker, *Malerei* (1958) 97–9
Pemberton, E.G., "A Note on Skiagraphia," *AJA* 80 (1976) 82–4
Pollitt, *Ancient View* (1975) 247–54, 436–9
Bruno, *FCGP* (1977) 26–7, 36–8

74. Zeuxis

Lippold, G., "Zur Laokoongruppe," *JdI* 61–2 (1946–1947) 88–94 (echo of a painting by
 Zeuxis in Pompeiian painting)
Kraiker, W., *Kentaurenbild des Zeuxis* (Berliner Winckelmannsprogramm 106) (1950)
Kraiker, *Malerei* (1958) 99–103
Lepik-Kopaczynska, W., "Zeuxis aus Heraklea," *Helikon* 1 (1961) 379–426
Gschwandtler, K., *Zeuxis und Parrhasios. Ein Beitrag zur antiken Künstlerbiographie* (Diss.
 Graz, Vienna 1972)
Bruno, *FCGP* (1977) chap. 2

75. Parrhasios

Rumpf, A., "Parrhasius," *AJA* 55 (1951) 1–12
Tomasello, E., "Rappresentazioni figurate del mito di Penteo," *Siculorum Gymnasium* 11
 (1958) 219–41
Kraiker, *Malerei* (1958) 103–9
Gschwandtler, K., *Zeuxis und Parrhasios. Ein Beitrag zur antiken Künstlerbiographie* (Diss.
 Graz, Vienna 1972)
Cazzaniga, I., "De Atalantae tabula parrhasiana," *Annali della Scuola Normale Superiore di
 Pisa* 4 (1974) 1301–6
Preisshofen, F., "Sokrates im Gespräch mit Parrhasios und Kleiton," *Studia Platonica.
 Festschrift für Hermann Gundert zu seinem 65. Geburtstag am 30.4.1974* (Amsterdam, n.d.)
 21–40
Bruno, *FCGP* (1977) chap. 2

76. Timanthes

Lippold, *Gemäldekopien* (1951) 53–8
Curtius (1929) 290–2

77. Pamphilos

Lepik-Kopaczynska, W., "De Pamphilo pictore Graeco nobilissimo" [in Polish with Latin summary], *Meander* 14 (1959) 546–65

78. Apelles

Rumpf, A., "Anadyomene," *JdI* 65–66 (1950–1951) 166–74

Kraiker, *Malerei* (1958) 125–31

Mingazzini, P., "Una copia dell'Alexandros Keraunophoros di Apelle," *Jahrbuch der Berliner Museum* 3 (1961) 7–17

Lepik-Kopaczynska, W., *Apelles, der berühmteste Maler der Antike* (Lebendiges Altertum 7) (Berlin 1962)

Luria, S., "Herondas' Kampf für die veristische Kunst," *Miscellanea di studi allesandrini in memoria di A. Rostagni* (Turin 1963) 394–415

Schwarz, G., "Zur Artemis des Apelles," *ÖJh* 49 (1968–1971) 77–8

Daut, R., "Belli facies et triumphus," *Festgabe für Otto Hiltbrunner zum 60. Geburtstag (29.12.1973)* (Münster 1974) 56–68

Cast, D., *The Calumny of Apelles* (New Haven 1981)

Charlton, W. and A. Saville, "The Art of Apelles," *Proceedings of the Aristotelian Society, London* 53 (1979) 167–206

Marrone, G., "Imitatio Alexandri in età augustea," *Atene e Roma* 25 (1980) 35–41

Gage, J., "A Locus Classicus of Colour Theory. The Fortune of Apelles," *JWarb* 44 (1981) 1–26

Moreno, P., "Kairós, Akmé e Cháris da una pittura di Apelle," *Dialoghi di archeologia*, series 3, 2 (1984) 115–18

Daut, R., "Belli facies et triumphus," *RömMitt* 91 (1984) 115–23

79. Pausias

Brendel, O., "Immolatio Boum," *RömMitt* 45 (1930) 196–226, esp. 217–19

Bruno, *FCGP* (1977) 79–80

80. Nikomachos

Lippold, *Gemäldekopien* (1951) 102–5

Andronikos, M., *Vergina* (Athens 1984) 90–1

81. Euphranor (as a painter)

Vasić, R., "Some Observations on Euphranor's Cavalry Battle," *AJA* 83 (1979) 345–9

Vasić, R., "Grylus and Epaminondas in Euphranor's Cavalry Battle," *Ziva Antika* 29 (1979) 261–8

Palagia, O., *Euphranor* (Leiden 1980) chap. 8

82. Aristeides

Urlichs, L., "Einige Gemälde des Aristeides," *RhM* 25 (1870) 507–17
Pollitt, J.J., "The Ethos of Polygnotos and Aristeides," *In Memoriam Otto J. Brendel. Essays in Archaeology and the Humanities* (Mainz am Rhein 1976) 49–54

83. Philoxenos

Fuhrmann, H., *Philoxenos von Eretria* (Göttingen 1931)
Lippold, *Gemäldekopien* (1951) 105–15
On the Alexander mosaic from Pompeii:
Andreae, B., *Das Alexandermosaik* (Opus Nobile 14) (Bremen 1959) and *Das Alexandermosaik aus Pompeii* (Recklinghausen 1977) with additional references

84. Nikias

Rumpf, A., "Diligentissime mulieres pinxit," *JdI* 49 (1934) 6–23
Neutsch, B., *Der Maler Nikias von Athen* (Bern–Leipzig 1939)
Lukas, H., "Die Kalypso des Nikias," *ÖJh* 32 (1940) 54–9
Lippold, G., *Gemäldekopien* (1951) 93–101
Wesenberg, B., "Zur Io des Nikias in den pompejanischen Wandbildern," *Kanon* (1988) 344–50

85. Athenion

Six, J., "Athenion of Maroneia," *RömMitt* 36/37 (1921–1922) 1–13
Lippold, G., "Athenion," *Scritti in onore di Benedetto Nogara* (Vatican 1937) 241–5

86. Nealkes

Hauler, E., "Fronto über Protogenes und Nealkes," *RömMitt* 19 (1904) 317–21
Six, J., "Nealkes," *JdI* 22 (1907) 1–6

87. Artemon

Lippold, *Gemäldekopien* (1951) 127, 129

88. Demetrios the Topographos

Pollitt, *AHA* (1986) 207–8
Brown, B., *Ptolemaic Painting and Mosaics and the Alexandrian Style* (Cambridge, Mass. 1957) 80
Nilotic landscapes: Gullini, G., *I mosaici di Palestrina* (Rome 1956)

89. Timomachos

Lippold, *Gemäldekopien* (1951) 61
Guey, J., "L'Ajax de Timomaque sur un patère de l'exposition «Lyon antique» au Musée des Beaux-Arts de Lyon," *Bulletin des Musées Lyonnais* 2 (1957–1961) 160–7

90. Sosos and Hellenistic Mosaics

Salzmann, D., *Untersuchungen zu den antiken Kieselmosaiken* (Berlin 1982) (on the Zenon papyrus see p. 9)
Pollitt, *AHA* (1986) chap. 10 (with bibliography p. 299)

ARCHITECTURE

A full bibliography on Greek architecture is obviously beyond the scope of this book. For general reviews of the monuments and architects referred to in the literary sources see the following comprehensive studies:

Dinsmoor, W.B., *The Architecture of Ancient Greece* (London 1950)
Lawrence, A.W., *Greek Architecture* (London 1957)
Berve, H. and G. Gruben, *Greek Temples, Theaters, and Shrines* (New York 1962)
Gruben, G., *Die Tempel der Griechen* (3rd edn., Munich 1980)

The following special studies deal, at least in part, with problems raised by the literary sources:

91. Theodoros, Rhoikos, and the Heraion at Samos

Reuther, O., *Der Heratempel von Samos* (Berlin 1957)

92. The Temple of Hera at Olympia

Mallwitz, A., "Das Heraion von Olympia und sein Vorgänger," *JdI* 81 (1966) 310–76
Mallwitz, A., *Olympia und seine Bauten* (Munich 1972)
Waele, J.A. de, "Der Entwurf des Heraion von Olympia," *BABesch* 57 (1982) 26–37

93. Alkmaionid Temple at Delphi

De la Coste-Messelière, P., "Les Alcmeionides à Delphes," *BCH* 70 (1946) 271–87
Yoshida, A., "Le fronton occidental du temple d'Apollon à Delphes et les trois frontons," *Revue belge de philologie et d'histoire* 44 (1966) 5–11
Amandry, P., "Notes de topographie et d'architecture delphiques, v: Le temple d'Apollon," *BCH* 93 (1969) 1–38

94. Siphnian Treasury

Some recent studies of this well-known monument, not, in most cases, directly related to the literary sources:

Ridgway, B.S., "The East Pediment of the Siphnian Treasury: A Reinterpretation," *AJA* 69 (1965) 1–5
Watrous, L.V., "The Sculptural Program of the Siphnian Treasury at Delphi," *AJA* 86 (1982) 159–72
Simon, E., "Ikonographie und Epigraphik. Zum Bauschmuck des Siphnierschatzhauses in Delphi," *Zeitschrift für Papyrologie und Epigraphik* 57 (1984) 1–22
Vasić, R., "A Note on the Theme of the Siphnian Frieze," *Boreas* 7 (1984) 34–40

Pinatel, C., "Reconstitutions des façades est et ouest du trésor de Siphnos au Musée des monuments antiques de Versailles, et provenances des moulages réutilisées," *RA* (1984) 29–52

Brinkmann, V., "Die aufgemalten Namenbeischriften an Nord- und Ostfries des Siphnierschatzhauses," *BCH* 109 (1985) 77–130

Moore, M.B., "The West Frieze of the Siphnian Treasury. A New Reconstruction," *BCH* 109 (1985) 131–56

95. Samos, Engineering

Goodfield, J. and S. Toulmin, "How Was the Tunnel of Eupalinus Aligned?" *Isis* 56 (1965) 46–55

Jantzen, U., R.C.S. Felsch, W. Hoepfner, and D. Willers, "Samos 1971. Die Wasserleitung des Eupalinos," *AA* (1973) 89–94

Jantzen, U., R.C.S. Felsch, and H. Kienast, "Samos 1972. Die Wasserleitung des Eupalinos," *AA* (1973) 401–14

Kienast, H.J., "Planung und Ausführung des Tunnels des Eupalinos," *Bauplanung & Bautheorie der Antike. Bericht über ein Kolloquium in Berlin vom 16.11.–18.11.1983* (Berlin 1984) 104–10

96. Temple of Zeus at Olympia

Ashmole, B. and N. Yalouris, *Olympia, The Sculptures of the Temple of Zeus* (London 1967)

Säflund, M.L., *The East Pediment of the Temple of Zeus at Olympia. A Reconstruction and Interpretation of its Composition* (Göteborg 1970)

Grunauer, P., "Der Zeustempel in Olympia. Neue Aspekte," *BonnJbb* 171 (1971) 114–31

Mallwitz, A., *Olympia und seine Bauten* (Munich 1972)

Grunauer, P., "Der Westgiebel des Zeustempels von Olympia. Die Münchener Rekonstruktion. Aufbau und Ergebnisse," *JdI* 89 (1974) 1–49

Alscher, L., "Zu den Giebelkompositionen vom Zeustempel. Ponderation und Rekonstruktion. Das Meisterproblem abermals," and "Zum Anteil verschiedener Bildhauerschulen an der Ausführung der Giebelskulpturen vom Zeustempel. Der Zeus- und der Apollomeister," *Wissenschaftliche Zeitschrift der Humboldt-Universität* 25 (1976) 441–8 and 449–56

Stewart, A.F., "Pindaric Dikè and the Temple of Zeus at Olympia," *Classical Antiquity* 2 (1983) 133–44

97. Periclean Building Program

Burford, A., "The Builders of the Parthenon," *Greece & Rome* (Supplement to volume 10): *Parthenos and Parthenon* (1963) 23–35

Pollitt, J., *Art and Experience in Classical Greece* (Cambridge 1972)

Knell, H., *Perikleische Baukunst* (Darmstadt 1979)

Zinserling, G., "Das Akropolisbauprogramm des Perikles. Politische Voraussetzungen und ideologischer Kontext," *Kultur & Fortschritt in der Blütezeit der griechischen Polis* (Berlin 1985) 206–46

Preisshofen, F., "Zur Funktion des Parthenon nach den schriftliches Quellen," *Parthenon-Kongress Basel* (Mainz 1984) 15–18

Corso, A., *Monumenti Periclei. Saggio critico sulla attività edilizia di Pericle* (Venice 1986)

98. Building Inscriptions (general)

Dinsmoor, W.B., "Attic Building Accounts," *AJA* 17 (1913) 53–80, 242–65, 371–98 and *AJA* 25 (1921) 118–29

Tod, M.N., *A Selection of Greek Historical Inscriptions* (2nd edn., Oxford 1946)

Meiggs, R. and D.M. Lewis, *Greek Historical Inscriptions* (Oxford 1969; revised edn., 1988)

Burford, A., "The Purpose of Inscribed Building Accounts," *Acta of the Vth International Congress of Greek and Latin Epigraphy, Cambridge, 1967* (Oxford 1970) 71–6

Fornara, C., *Archaic Times to the End of the Peloponnesian War* (Translated Documents of Greece and Rome) (2nd edn., Cambridge 1983)

99. Iktinos and Kallikrates

Shear, I.M., "Kallikrates," *Hesperia* 32 (1963) 375–424

Knell, H., "Iktinos, Baumeister des Parthenon und des Apollontempels von Phigalia-Bassae?" *JdI* 83 (1968) 100–17

Carpenter, R., *The Architects of the Parthenon* (Harmondsworth 1970)

Winter, F., "Tradition and Innovation in Doric Design III: The Work of Iktinos," *AJA* 84 (1980) 399–416

McCredie, J.R., "The Architects of the Parthenon," *Studies in Classical Art and Archaeology. A Tribute to Peter Heinrich von Blanckenhagen* (Locust Valley, N.Y. 1979) 69–73

Wesenberg, B., "Wer erbaute den Parthenon?" *AthMitt* 97 (1982) 99–125

100. Erechtheion Building Accounts

Stevens, G.P., L.D. Caskey, H.N. Fowler, and J.M. Paton, *The Erechtheum* (Cambridge, Mass. 1927) 227–422

101 Temple of Apollo at Bassai

Hahland, W., "Der iktinische Entwurf des Apollontempels in Bassae," *JdI* 63–64 (1948–1949) 14–30

Riemann, H., "Iktinos und der Tempel von Bassai," *Festschrift für Friedrich Zucker zum 70. Geburtstage* (Berlin 1954) 299–339

Eckstein, F., "Iktinos, der Baumeister des Apollontempels von Phigalia-Bassai," *Theoria. Festschrift für W.H. Schuchhardt* (Baden-Baden 1960) 52–62

Mallwitz, A., "Cella und Adyton des Apollontempels in Bassai," *AthMitt* 72 (1962) 140–77

Knell, H., "Iktinos, Baumeister des Parthenon und des Apollontempels von Phigalia-Bassae?" *JdI* 83 (1968) 100–17

Cooper, F., "The Temple of Apollo at Bassai: New Observations on its Plan and Orientation," *AJA* 72 (1968) 103–11

Pollitt, J., *Art and Experience in Classical Greece* (Cambridge 1972) 126–31

Hofkes-Brukker, C., and A. Mallwitz, *Der Bassai-Fries* (Munich 1975)

Martin, R., "L'atelier Ictinos-Callicratès au temple de Bassae," *BCH* 100 (1976) 427–42

Winter, F., "Tradition and Innovation in Doric Design, III: The Work of Iktinos,"*AJA*, 84 (1980) 399–416

102. Corinthian Order

Bauer, H., *Korinthische Kapitelle des 4. und 3. Jahrhunderts v. Chr.* (*AthMitt*, Beiheft 3) (Berlin 1973)

Williams, C., "The Corinthian Temple of Zeus Olbios at Uzuncaburç: A Reconsideration of its Date," *AJA* 78 (1974) 405–14

103. Hippodamos of Miletos and City Planning

Gerkan, A. von, *Griechische Städteanlagen* (Berlin–Leipzig 1924)

Martin, R., *L'Urbanisme dans la Grèce antique* (Paris 1956)

Wycherley, R.E., *How the Greeks Built Cities* (2nd edn., London 1962) esp. chap. 2

Castagnoli, F., *Orthogonal Town Planning in Antiquity* (Cambridge, Mass. 1971)

McCredie, J.R., "Hippodamos of Miletus," *Studies Presented to George M.A. Hanfmann* (Mainz 1971) 95–100

Ward-Perkins, J., *Cities of Ancient Greece and Italy: Planning in Classical Antiquity* (New York 1974)

104. Polykleitos the Younger

Picard, *Manuel* III (1948) 312–22 (sculpture)

105. Temple of Asklepios and other Buildings at Epidauros

Defrasse, A., and H. Lechat, *Epidaure, restauration et déscription des principaux monuments du sanctuaire d'Asclépius* (Paris 1895)

Kavvadias, P., *The Sanctuary of Asklepios at Epidauros* (Athens 1900) [in Greek]

Roux, G., *L'architecture de l'Argolide aux IV^e et III^e siècles avant J. Chr.* (Paris 1961)

Burford, A., *The Greek Temple-Builders at Epidauros. A Social and Economic Study of the Building in the Asklepian Sanctuary during the 4th and 3rd cent. B.C.* (Liverpool 1969)

Gounaropoulou, L., *Die Bauabrechnung des Asklepiostempels in Epidauros. Ein archäologische Kommentar* (Ph.D. Dissertation, Vienna 1983)

Tomlinson, R.A., *Epidauros* (Austin 1983)

106. Mausoleum at Halikarnassos

Van Breen, J., *Het Reconstructieplan voor het Mausoleum te Halikarnassos* (Amsterdam 1942)

Jeppesen, K., *Paradeigmata: Three Mid-fourth Century Main Works of Hellenic Architecture Reconsidered* (Aarhus 1958)

Gerkan, A. von, "Grundlagen für die Herstellung des Maussolleions von Halikarnassos," *RömMitt* 72 (1965) 217–25

Ashmole, B., *Architect and Sculptor in Classical Greece* (New York 1972) chap. 6

Jeppesen, K. and J. Zahle, "The Site of the Mausoleum at Halicarnassus Reexcavated," *AJA* 77 (1973) 336–8

Jeppesen, K. and J. Zahle, "Investigations on the Site of the Mausoleum 1970–1973," *AJA* 79 (1975) 67–79

Robertson, *HGA* (1975) 447–63

Schiering, W., "Zum Amazonfries des Maussoleums in Halikarnass," *JdI* 90 (1975) 121–35

Jeppesen, K., "Neue Ergebnisse zur Wiederherstellung des Maussolleions von Halikarnassos (4. Vorläufiger Bericht der dänischen Halikarnassos Expedition)," *IstMitt* 26 (1976) 47–99

Cook, B.F., "The Mausoleum Frieze. Membra Disiectanda," *BSA* 71 (1976) 49–56

Jeppesen, K., "Zur Gründung und Baugeschichte des Maussolleions von Halikarnassos," *IstMitt* 27–28 (1977–1978) 169–211

Waywell, G., *The Free-standing Sculpture of the Mausoleum at Halicarnassus. A Catalogue* (London 1979)

Jeppesen, K., "Zu den Proportionen des Maussoleions von Halikarnass," *Bauplanung & Bautheorie der Antike. Bericht über ein Kolloquium in Berlin vom 16.11.–18.11.1983* (Berlin 1984) 167–74

Jeppesen, K., "What did the Maussolleion look like?" in *Architecture and Society in Hekatomnid Caria* (*Boreas*, Uppsala Studies in Ancient Mediterranean and Near Eastern Civilizations 17) (Uppsala 1989) 15–22

107. Pythios

Neugebauer, A.K., "Pytheos oder Bryaxis," *JdI* 58 (1943) 39–87

Picard, *Manuel* IV. 1 (1954) 69–72 (sculpture)

Drerup, H., "Pytheos und Satyros. Die Kapitelle des Athenatempels von Priene und des Maussoleums von Halikarnassos," *JdI* 69 (1954) 1–31

Tomlinson, R.A., "The Doric Order. Hellenistic Critics and Criticism," *JHS* 83 (1963) 133–45

Riemann, H., in *RE*, s.v. "Pytheos, Architekt des 4. Jhs." (1963) 371–513

Koenigs, E., "Pytheos, eine mythische Figure in der antiken Baugeschichte," *Bauplanung & Bautheorie der Antike. Bericht über ein Kolloquium in Berlin vom 16.11.–18.11.1983* (Berlin 1984) 89–94

Carter, J.C., "Pythios," *XIII. Internationaler Kongress für Klassische Archäologie, Resümees* (Berlin 1988) 37–8

108. Philon of Eleusis

Jeppesen, K., *Paradeigmata. Three Mid-fourth Century Main Works of Hellenic Architecture Reconsidered* (Aarhus 1958)

Meyer-Christian, W., *Das Arsenal des Architekten Philon in Zea/Piräus. Rekonstruktion.* (Ph.D. Dissertation, Karlsruhe 1983)

Untermann, M., "Neues zur Skeuothek des Philon," *Bauplanung & Bautheorie der Antike. Bericht über ein Kolloquium in Berlin vom 16.11.–18.11.1983* (Berlin 1984) 81–6

109. The Temple of Apollo at Didyma

Knackfuss, H., *Didyma, Die Baubeschreibung* (Berlin 1941)

Voightländer, W., *Der jüngste Apollontempel von Didyma (IstMitt,* Beiheft 14) (1975)

Pollitt, *AHA* (1986) 236–8

110. Hermogenes

Gerkan, A. von, *Der Altar des Artemis-Tempels in Magnesia am Maeander* (Berlin 1929)

Tomlinson, R.A., "The Doric Order. Hellenistic Critics and Criticism," *JHS* 83 (1963) 133–45

Hoepfner, W., "Zum ionischen Kapitell bei Hermogenes und Vitruv," *AthMitt* 83 (1968) 213–34

Gros, P., "Le dossier vitruvien d'Hermogénès," *MélRom* 90 (1978) 687–703

Knell, H., "Die Hermogenes-Anekdote und das Ende des dorischen Ringhallentempels," *Vitruv-Kolloquium des Deutschen Archäologen-Verbandes, durchgeführt an der Technischen Hochschule Darmstadt, 17.–18. Juni 1982* (Darmstadt 1984) 41–64

Pollitt, *AHA* (1986) 242–7

111. Cossutius and the Olympieion

Welter, G., "Das Olympieion in Athen," *AthMitt* 47 (1922) 61–71 and 48 (1923) 182–9

Travlos, J., *Pictorial Dictionary of Ancient Athens* (London 1971) 402–11

Rawson, E., "Architecture and Sculpture. The Activities of the Cossutii," *BSR* 43 (1975) 36–47

DECORATIVE ARTS

112. Lydian Votives

Pernice, E., "Glaukos von Chios," *JdI* 16 (1901) 62–8

Themelis, P.G., *The Delphi Museum* (Athens 1981) 36–50

113. The Chest of Kypselos

Massow, W. von, "Die Kypseloslade," *AthMitt* 41 (1916) 1–117

Massow, W. von, *Die Kypseloslade* (Diss., Leipzig, 1922; published 1926)

Méautis, G., "Le coffre de Kypsélos," *REG* 44 (1931) 241–78

Myres, J.L., "Symmetry on the Chest of Cypselus at Olympia (Pausanias V.17–19)," *JHS* 66 (1946) 122

Will, E., *Korinthiaka* (Paris 1955) 412–14

Cosi, P., "Sulla datazione dell'arca di Cipselo," *ArchCl* 10 (1958) 81–3
Hurwit, J., "Narrative Resonance in the East Pediment of the Temple of Zeus at Olympia," *Art Bulletin* 69 (1987) 6–15
Carter, J.B., "The Chest of Periander," *AJA* 93 (1989) 355–78

114. Mentor

Becatti, G., *Arte e gusto degli scrittori latini* (Florence 1951) 67, 76, 205–7, 223, 265, 276, 291

115. Funeral Carriage of Alexander

Müller, K.F., *Der Leichenwagen Alexanders des Grossen* (Leipzig 1905)
Pollitt, *AHA* (1986) 19–20

116. Table of Kolotes

Mingazzini, P., "Il tavolo crisoelefantino di Kolotes ad Olimpia," *AthMitt* 77 (1962) 293–305

117. Sculptors' Contest: Amazons at Ephesos

Weber, M., "Die Amazonen von Ephesos," *JdI* 91 (1976) 28–96 (with full bibliography)
B. Ridgway's skeptical view: "A Story of Five Amazons," *AJA* 78 (1974) 1–17
Harrison, E.B., "Two Pheidian Heads," *The Eye of Greece* (Cambridge 1982) 53–88, esp. 65–88

118. Four-Color Painters

Scheibler, I., "Die 'vier Farben' der griechischen Malerei," *AntK* 17 (1974) 92–102
Bruno, *FCGP* (1977) chap. 6 (with bibliography)

Ancient authors whose works are excerpted in this book

GREEK

Aelian (Claudius Aelianus, *c.* 170–235 A.C.) – Rhetorician, moralist, and popular historian, from Praeneste.

Aeschines (*c.* 397–322 B.C.) – Athenian orator.

***Anthologia Graeca* (the "*Greek Anthology*")** – The name given to a vast collection, organized in sixteen books, of short Greek poems (epigrams, epitaphs, love poems, etc.) which range from the seventh century B.C. to the tenth century A.C. The bases of the collection are the *Palatine Anthology*, compiled in the tenth century and based on the work of the Byzantine scholar Constantinus Cephalas, and the *Planudean Anthology*, compiled *c.* 1300 A.C. by a monk named Planudes. Other poems, not found in either of these collections, have been added by modern editors.

Antipater of Sidon (active *c.* 120 B.C.) – Author of about 75 poems in the *Greek Anthology*.

Antipater of Thessalonike – Author of about 80 poems in the *Greek Anthology*. He was active in Rome in late first century B.C. and early first century A.C.

Aristophanes (*c.* 450–385 B.C.) – The Athenian comic poet.

Aristotle (384–322 B.C.) – The philosopher, born in Stagira in the Chalkidike, but lived and taught mainly in Athens.

Arrian (Flavius Arrianus, second century A.C.) – Historian from Bithynia; a provincial governor under Hadrian. He wrote about Alexander's campaigns, the careers of Alexander's successors, and the cultures of the East.

Athenaios (lived *c.* 200 A.C.) – Rhetorician and antiquarian from Naukratis in Egypt. The *Deipnosophistai* (*Learned Banqueters*) depicts learned conversations at a symposium on a wide variety of topics.

Clement of Alexandria (Titus Flavius Clemens, *c.* 150–216 A.C.) – Christian bishop and apologist, most of whose work was devoted to demonstrating the superiority of Christian philosophy and morality to those of the pagan Greeks.

Demetrios – Rhetorician and literary critic, author of the treatise *On Style* (*Peri Hermeneias*, often referred to by the Latin title *de Elocutione*). His precise dates are unknown, but he was probably active in the late Hellenistic period.

Demetrios (date uncertain) – The author of epigrams about the cow of Myron in the *Greek Anthology*. He was from Bithynia and may have lived in the second century B.C.

Demosthenes (384–322 B.C.) – The Athenian orator.

Dio Chrysostom (*c.* 40–112 A.C.) – Orator and philosopher from Prousa in Bithynia.

Diodoros (active *c.* 60–30 B.C.) – Greek historian, from Sicily.

Diogenes Laertios (first half of the third century A.C.) – Author of a compendium of the lives and doctrines of Greek philosophers.

Dionysios of Halikarnassos (active in the late first century B.C.) – Rhetorician, literary critic, and antiquarian who spent most of his career in Rome.

Dioskorides (active in the later third century B.C.) – Author of about forty epigrams in the *Greek Anthology*.

Euenos (date uncertain) – There seem to be several different poets with this name in the *Greek Anthology*. The one cited here may have been a poet of the fifth century B.C. from Paros.

Eustathios (twelfth century A.C.) – Rhetorician, clergyman, and scholar; a native and resident of Constantinople; author of commentaries on ancient Greek authors.

Galen (*c.* 129–199 A.C.) – Physician and medical writer from Pergamon. He became the court physician to the Emperor Marcus Aurelius.

Glaukos (date uncertain) – Author of several epigrams in the *Greek Anthology*.

Harpokration, Valerius – Lexicographer from Alexandria. His exact date is unknown; possibly second century A.C.

Herodotos (*c.* 480–420 B.C.) – Historian of the war between the Greeks and Persians, from Halikarnassos.

Herondas (third century B.C.) – Also called Herodas. Author of literary mimes. He was associated with the literary culture of Alexandria.

Hesychios (probably fifth century A.C.) – Lexicographer from Alexandria.

Homer – The date of the composition of the *Iliad* and *Odyssey* is usually placed *c.* 750–700 B.C.

Julian the Apostate (Flavius Claudius Julianus, 332–63 A.C.) – Roman emperor from 361 to 363 A.C. Author of letters and orations and a defender of paganism.

Julianus of Egypt (probably sixth century A.C.) – Poet in the *Greek Anthology*. He may have been governor of Egypt in the time of Justinian.

Kallistratos (third or fourth century A.C.) – Nothing is known of the author's life. The *Eikones* consists of rhetorical descriptions of fourteen statues.

Kedrenos, Georgios (eleventh century A.C.) – Greek monk, author of a *Synopsis of Histories*.

Kratinos (fifth century B.C.) – Athenian comic poet.

Libanios (*c.* 314–93 A.C.) – Rhetorician, from Antioch.

Lucian (*c.* 120–200 A.C.) – Rhetorician and satirist, from Samosata on the Euphrates.

Malalas, John (*c.* 491–578 A.C.) – Rhetorician and historian from Antioch.

Niketas Choniates (late twelfth–early thirteenth centuries A.C.) – Byzantine historian.

Pausanias (active *c.* 150 A.C.) – Author of a *Description of Greece* (see Introduction).

Philippos of Thessalonike – Author of about eighty poems in the *Greek Anthology*. He was active in Rome *c.* 40 A.C.

Philo Mechanicus (probably third century B.C.) – Hellenistic writer on technology, from Byzantium.

Philostratos – Works by three authors of this name, apparently belonging to the same family, survive. Flavius Philostratos, the author of the *Life of Apollonios of Tyana*, was born *c.* 170 A.C. He became a member of an intellectual circle patronized by Julia Domna, wife of the Roman emperor Septimius Severus.

Plato (427–347 B.C.) – The Athenian philosopher.

Plato (date uncertain) – Author of several poems in the *Greek Anthology*. Sometimes referred to as "Plato Junior."

Plotinos (*c.* 205–70 A.C.) – Neo-Platonic philosopher, apparently born in Egypt but mainly active in Rome.

Plutarch (*c.* 46–120 A.C.) – Biographer, essayist, and moralist, from Chaironeia in Boeotia.

Poseidippos (active *c.* 270 B.C.) – Poet in the *Greek Anthology*, active in Samos and Alexandria.

Ptolemaios Chennos (active *c.* 100 A.C.) – Scholar and mythographer from Alexandria.

Scholiast – The term for a commentator, usually anonymous, who has affixed explanatory notes to a manuscript preserving the work of an ancient author.

Sextus Empiricus (active *c.* 200 A.C.) – Physician and philosopher, a late proponent of Skepticism, important mainly for his critiques of other philosophical schools and doctrines.

Simonides (*c.* 556–468 B.C.) – Lyric poet, from the island of Keos.

Strabo (*c.* 64 B.C.–21 A.C.) – Geographer and historian from Amaseia in Pontos.

Synesios (*c.* 370–413 A.C.) – Christian Neo-Platonist, orator, and poet, from Cyrene. He became bishop of Ptolemais.

Tatian (Tatianos) (second century A.C.) – Author of treatises on Christian doctrine and of polemical works against paganism. He was apparently a native of eastern Syria.

Thucydides (*c.* 460–400 B.C.) – Athenian historian of the Peloponnesian War. He was an admirer of Pericles and, for a time, an Athenian military officer.

Xenophon (*c.* 428–354 B.C.) – Athenian soldier, essayist, historian, and writer on philosophy.

Zenobios (second century A.C.) – Author of a collection of proverbs. He was active in Rome in the time of Hadrian.

LATIN

Ampelius, Lucius (second or third century A.C.) – His *Liber Memorialis* is a brief compendium of knowledge emphasizing remarkable events, places, and monuments.

Cicero, Marcus Tullius (106–44 B.C.) – Roman orator, statesman, and philosopher.

Martial (Marcus Valerius Martialis, *c.* 40–104 A.C.) – Roman poet, born and educated in Spain but lived in Rome after 64 A.C.

Petronius (first century A.C.) – Author of the partially preserved satirical, bawdy prose narrative known as the *Satyricon*. He is probably identical with Petronius the *Arbiter elegantiae* of Nero's court.

Pliny (the elder) (Gaius Plinius Secundus, 23–79 A.C.) – Roman encyclopaedist, born near Lake Como (see Introduction).

Quintilian (Marcus Fabius Quintilianus, *c.* 30–100 A.C.) – Prominent Roman rhetorician.

Seneca (the elder) (Lucius Annaeus Seneca, *c.* 55 B.C.–37 A.C.) – Roman rhetorician and historian of rhetoric. He was born in Spain but settled in Rome at an early age.

Statius (Publius Papinius Statius, *c.* 45–96 A.C.) – Roman poet, born in Naples. He benefitted from the patronage of the Emperor Domitian.

Valerius Maximus (early first century A.C.) – Moralistic Roman historian, active in the time of Tiberius.

Velleius Paterculus (*c.* 19 B.C.–after 30 A.C.) – Author of a compendium of the history of Rome from its beginnings to his own time.

Vitruvius (late first century B.C.–early first century A.C.) – Roman architect. His *de Architectura* combines various traditions of Greek architectural theory and criticism with Roman engineering.

Index of artists

Geographical index

Aegean Islands: school of sculptors, 27
Aegina: bronze work of, 34; school of sculptors, 226–7
Aigeira: works by Eukleides, 121–2
Aigion: Asklepios, Eileithyia, Hygieia by Damophon, 119; Herakles and Zeus by Ageladas, 33
Aitolia, 19
Akragas (Agrigentum), 47; *Alkmene* by Zeuxis, 149; Asklepios by Myron, 51
Alabanda: temple of Apollo, 203
Alexandria, 220; Serapis by Bryaxis, 92
Ambrakia: statues by Zeuxis, 150
Amyklai: Artemis by Polykleitos, 78; throne of Apollo by Bathykles, 23–6, 60
Antikyra (Phokis): Artemis by Praxiteles, 89
Antioch: Tyche by Eutychides, 109–10
Apollonia: Apollo by Kalamis, 48
Argive Heraion: Hera by Polykleitos, 78, 227, 229
Argos: Dioskouroi and family by Dipoinos and Skyllis, 20; Zeus Meilichios by Polykleitos, 78
Athens

 ACROPOLIS: Athena *Polias*, 63, 209; Artemis *Brauronia*, sanctuary of, 72; Athena by Endoios, 20; Athena Nike *Apteros*, 65, 190; Athena *Parthenos* by Pheidias, 54–5, 56–8, 61, 63, 123, 142, 143, 190, 223; Athena *Promachos* by Pheidias, 62–3; Cavalry Commanders by Lykios, 70; Erechtheion, 73, 190, 191–2; Hekate *Epipyrgidia*, 65–6; Hermes and the Graces by Socrates, 74–5; Hermes *Propylaios*, 66, 74–5; Io and Kallisto by Deinomenes, 74; paintings by Protogenes on the Acropolis, 172; Parthenon, 56, 188, 190, 193; Pergamene dedication, 114; Perseus of Myron, 70; Propylaia, 189, 190, (paintings in) 141, 172; Sosandra of Kalamis, 47; Trojan Horse by Strongylion, 72

 AGORA: Altar of the Twelve Gods, 112; Ares, temple of, 111; Hephaisteion, 66; Metroon, 67, 117; portrait of Demosthenes, 112; Stoa of Zeus, paintings in by Euphranor, 167; *Stoa Poikile*, 60, 126, 141–2, 143–5; temple of Apollo *Patroos*, 48, 91, 94, 168; Tyrannicides group, 41, 43
 Anakeion, 127, 142; Aphrodite "in the Gardens" by Alkamenes, 65; Apollo *Alexikakos* by Kalamis, 47, 168; Athena *Lemnia* by Pheidias, 63; Demeter, Persephone, and Iacchos by Praxiteles, 89; Erechtheus by Myron, 51; Erinyes by Skopas, 96–7; House of Poulytion (Kerameikos), 121; *Nekyomanteia* by Nikias, 170; Odeion of Pericles, 189; Olympieion, 105, 204–5; paintings by Athenion, 174; Periclean buildings, 187–93; Street of the Tripods, 72; temple of Dionysos *Eleuthereus*, 66, 87; Theseion, paintings in, 127, 142–3

Bassai: temple of Apollo *Epikourios*, 193
Bithynia, 111
Branchidai, *see* Didyma

Chios: school of sculptors, 28–9
Chryse: Apollo *Smintheus* by Skopas, 97
Constantinople: Herakles by Lysippos, 101
Corinth: Poseidon of Lysippos, 104; terracotta sculpture of, 29
Crete, 12

Daphne (near Antioch): Apollo by Bryaxis, 91
Delos, 123; Aphrodite by Daidalos, 15; Apollo by Tektaios and Angelion, 22; works by the school of Chios, 29
Delphi: *Alexander's Hunt* by Lysippos, 98, 100; Athenian tribal heroes, by Pheidias, 64; bronze horse by Antiphanes, 81; Herakles by Euthykrates, 108; inscription of Akesas,

288

General subject index

292